Visual Histories of Austria

Günter Bischof, ed.

Martin Kofler, Hans Petschar, Guest Editors

CONTEMPORARY AUSTRIAN STUDIES | VOLUME 30

UNO PRESS *innsbruck* university press

Published in the United States by
University of New Orleans Press
ISBN: 9781608012237

Published and distributed in Europe
by *Innsbruck* University Press
ISBN: 9783991060406

UNIVERSITY OF NEW ORLEANS PRESS *iup*

Library of Congress Cataloging-in-Publication Data

Names: Bischof, Günter, 1953- editor.
Title: Visual histories of Austria / editor: Günter Bischof.
Description: [New Orleans, Louisiana] : University of New Orleans Press,
 [2021] | Series: Contemporary Austrian studies ; Volume 30 | "This
 volume was conceived out of a panel in the 2019 German Studies
 Association meeting Portland, Oregon (Kofler/Siller, Markova, and
 Richter papers)."--Introduction. | Includes bibliographical references.
Identifiers: LCCN 2021023494 | ISBN 9781608012237 (paperback) | ISBN
 9781608012244 (ebook)
Subjects: LCSH: Photography in historiography. | Museums and
 photography--Austria. | Austria--Historiography. |
 Photography--Austria--History--20th century. |
 Photographers--Austria--History--20th century. | Archives--Austria. |
 Pictures as information resources--Austria.
Classification: LCC D16.155 .V57 2021 | DDC 907.2/09436--dc23
LC record available at https://lccn.loc.gov/2021023494

Publication of this volume has been made possible through a generous grant by the Austrian Federal Ministry of Education, Science and Research through Austria's Agency for Education and Internationalization (OeAD). The Austrian Marshall Plan Anniversary Foundation in Vienna has been very generous in supporting Center Austria: The Austrian Marshall Plan Center for European Studies at the University of New Orleans and its publications series. The College of Liberal Arts at the University of New Orleans, as well as the Vice Rectorate for Research and the International Relations Office of the University of Innsbruck provided additional financial support.

Contemporary Austrian Studies

**Sponsored by the University of New Orleans
and University of Innsbruck**

Table of Contents

IV. POSTWAR

V. BOOK REVIEWS

Visual Histories of Austria

Preface

Günter Bischof, Christian Stenico

We are delighted to celebrate thirty years of publishing *Contemporary Austrian Studies* (*CAS*). In the course of these thirty years, we have been working with three publishers. Volumes 1 through 17 were published by Transaction Publishers on the campus of Rutgers University, NJ. Vol. 18 to 30 have been published by UNO Press (in a unique partnership between university presses, volumes 25 to 30 have been published jointly with *innsbruck* university press—the PDFs are produced in New Orleans, and iup then prints the volumes for the European market). The *CAS* volumes have always been a centerpiece of the long-standing University of New Orleans (UNO)—Leopold-Franzens-University of Innsbruck partnership agenda. In Innsbruck, Professor Anton Pelinka, one of Austria's premier political scientists and public intellectuals, partnered with Günter Bischof at UNO.

We worked out a joint program for *CAS*. We have sought to further the study of modern Austria with "an international and comprehensive interdisciplinary approach." We asserted in 1993, when the first volume of *CAS* was published, the need for a field of Austrian Studies separate from German Studies and devoted *CAS* "to a self-confident assertion of separate Austrian identity vis-à-vis Germany." Since its founding it is safe to say that the shadow of Germany over Austria has waned while the shadow of Europe has waxed (Austria joined the European Union in 1994). We aimed at promoting Austrian studies abroad, particularly in the English-speaking world. Our goal of "combining all social sciences" in our interdisciplinary approach has been vigorously pursued.

We have analyzed the number and chronological orientation of all submissions in volumes 10 and 20 and do so again here. While essays with a domestic political/political science focus have been the most numerous in these past ten years, we have tried to cover all periods of post-Habsburg contemporary history. While World War I and II and the period between the two world wars have been covered, the Cold War period after World War II and now also the post-Cold War period since 1989 have been vigorously covered. Environmental history has emerged as a new field, given the specialization of Marc Landry, the Associate Director of Center Austria (he co-edited vol. 27 together with Patrick Kupper in Innsbruck, who

shares his interests). The memory of World War II in postwar Austria has remained another strong focus of *CAS*.

We continue to be proud of our strong book review section and thank all contributors of the past ten years for their critical reviews. We have reviewed seventy-four books and four review essays, next to four Roundtables/Forums on issues such as the 1938 "Anschluss" and the South Tyrol. This constitutes an ongoing conversation with new and recent contemporary history scholarship in and on Austria. We would like to thank all publishers for sharing review copies with us.

Here is the breakdown of statistics of 363 articles and 176 book reviews published over the past thirty years in our editorial offices.

	History										Political Science			Other					Total
	Political/Social	Diplomatic/International	Economic	Intellectual	Memory	Culture/Identity	Religion	Gender	Intelligence	Environmental	Domestic/Political Culture	Foreign Relations/International	European Union	Roundtables/Forums	Review Essays	Book Reviews	Annual Reviews	Introductions	
CAS 1-10																			
1918-1938	2			1				1											
1938-1945	5					2		3	2			2							
1945-1983	5	11	11		12	1		3	3		11								
1984-2000		2	2		1						17	9	6						
unspecified														3	12	51	10	21	209
CAS 11-20																			
pre-1914	2	1		1				1											
1918-1938	11	5	8	2	2	2		1											
1938-1945	8		1																
1945-1983	8	8	4	1	2	6	3	7			3								
1984-2000		2									3								
2000-2010	2	2	4	2	1			5	2		10	3	2						
unspecified														8	15	51	10	9	218
CAS 21-30																			
pre-1914	3	1				1					1								
1914-1918	12	1		1	1														
1918-1938	8				3			2			1	1							
1938-1945	8			1	1														
1945-1983	8	1	5	4	3	2					7	1							
1984-2000	3	4	1		1						1	2							
2000-2010						1					2								
2010-2020	2	3			2	2	1	1			1	12	4	6					
unspecified														4	4	74	4	6	218

Fig. 1: Statistical overview of *CAS* 1–10, 11–20, and 21–30

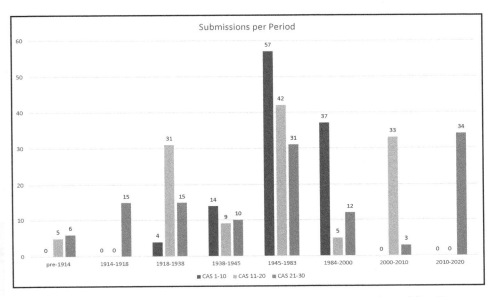

Fig. 2: Submissions per period compared for CAS 1–10, 11–20, and 21–30

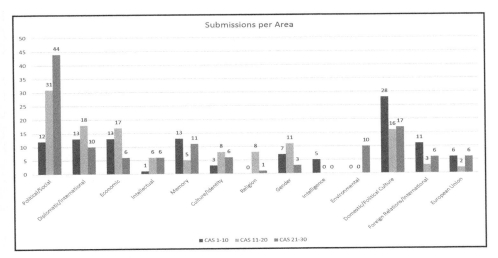

Fig. 3: Submissions per area compared for *CAS* 1–10, 11–20, and 21–30

It goes without saying that such a long-lasting venture would not have been possible without the help of many people and institutions. Gordon "Nick" Mueller was "present at the creation" to get *CAS* going when he was Dean of Metropolitan College and then the Founding Director of Center Austria (as the founder of the UNO International Summer School in Innsbruck in 1976, he also was instrumental in putting together the partnership treaty between UNO and Innsbruck in 1982). More recently, the Deans of the College of Liberal Arts Susann Krantz, and Kim Martin Long have supported the publication of *CAS*—Dean Krantz during difficult years in Louisiana's higher education budgets, asked Bischof to take the publication to UNO Press. In Innsbruck, it was Anton Pelinka's assistant Ellen Palli who for many years helped with soliciting manuscripts and producing photo-ready copy for our publisher. When Anton Pelinka retired, we worked with his colleagues Fritz Plasser (volumes 16 to 25) and then Ferdinand Karlhofer (volumes 22 to 25) as co-editors. The University Senate tasked a number of people to coordinate the agenda with UNO: Erich Thöni, Franz Mathis, Klaus Frantz, Christina Antenhofer, and Gerhard Rampl and Barbara Tasser have been our partners.

UNO's Center Austria: The Austrian Marshall Plan Center for European Studies, is one of the overseas Austrian Centers to receive a doctoral fellow from the Austrian Ministry of Education, Science and Research. UNO's Center Austria uses these "Ministry Fellows" to assist the UNO editors in the preparation of the annual *CAS* volumes. We have been lucky with Eva Maltschnigg, Dominik Hoffmann-Wellenhof, Markus Haberman, Ina Markova, Vera Kropf, Tobias Auböck, Bela Teleky, Vicko Marelić, and Christian Stenico to serve as able assistants. Due to the global Covid-19 pandemic, Christian Stenico could not travel home in June 2020 after his stay at UNO. The Ministry in Vienna agreed that he could serve for a second year and he has done such a superb job in helping to coordinate this volume for publication that we promoted him to Associate Editor. He has produced the statistics for this preface. Birgit Holzner and her team have been our dedicated and reliable partner at *innsbruck* university press. We would like to thank all of them for their hard work in getting *CAS* published year after year. *CAS* has come full circle with Martin Kofler as an Innsbruck student worker at UNO in helping to put the conference on the Marshall Plan for volume 8 together in 1998 and serving as a guest editor for this volume.

UNO Press has been a very solid partner for the publication of *CAS*. Bill Lavender (volumes 18 to 22) and Abram Himmelstein (volumes 23 to 30) have been the publishers in chief of the Press and GK Darby the "point man" in publishing *CAS*. UNO Press furnished excellent copyeditors to

bring the often "Germanic English" into readable English. Lauren Capone, Wren Hanks, Lauren Garcia, and Leah Myers have done this job exceedingly well, and Alex Dimeff has now designed a number of *CAS* volumes.

We would also like to thank our financial backers for making the publication of these volumes possible. The Austrian Cultural Forum in New York for a long time served as the principal sponsor. More recently the funding of Center Austria through the Austrian Marshall Plan Foundation has been crucial. Eugen Stark and Markus Schweiger have been strong supporters of UNO's Center Austria. Ambassador Wolfgang Petritsch, the chairman of the board, has also been instrumental in making the support of the Marshall Plan Foundation possible. Anton Fink, for many years, was the board member that spoke up for the UNO Center Austria agenda. The Austrian Ministry of Education, Science and Research has been supporting Austrian Centers for a number of years. These funds have been essential in keeping this publication series going as well. Barbara Weitgruber, Christoph Ramoser, Ulrike Czura, and Josef Leidenfrost in the Ministry, and Florian Gerhardus and Lydia Skarits in Austria's Agency for Education and Internationalization (OeAD) have all been helpful in making this support possible.

Over the years we also have had a dedicated "Advisory Board" of distinguished scholars. We would like to thank all of them for their dedication (some of them have taken on the duty of serving as peer reviewers—*CAS* has been peer-reviewed from outside the university since 2017).

AUSTRIA

University of Innsbruck
Andreas Exenberger (Economic History)
Ferdinand Karlhofer (Political Science)
Patrick Kupper (Social & Economic History)
Günther Pallaver (Political Science)
Max Preglau (Sociology)
Dirk Rupnow (Contemporary History)
Alan Scott (Sociology)
Rolf Steininger (Contemporary History)

University of Salzburg
Ingrid Bauer (History)
Ernst Hanisch (History)

Reinhard Heinisch (Political Science)
Sonja Puntscher-Riekmann (Political Science)
Reinhold Wagnleitner (History)

University of Graz
Siegfried Beer (History)
Konrad Ginther (Law)
Helmut Konrad (History)
Manfred Prisching (Sociology)
Barbara Stelzl-Marx (Contemporary History)

University of Vienna
Felix Butschek (Economics)
Peter Gerlich (Political Science)
Hanspeter Neuhold (Law)
Helga Nowotny (Social Sciences)
Oliver Rathkolb (History)
Sieglinde Rosenberger (Political Science)
Annemarie Steidl (Social & Economic History)
Dieter Stiefel (History)
Gerald Stourzh (History)

Vienna University of Economics and Business Administration
Peter Berger (History)

Austrian Academy of Sciences
Heidemarie Uhl (History)

Austrian National Library
Hans Petschar (Picture Archives & Graphics Dept.)

CANADA

Hans-Georg Betz (Toronto, Political Science)
Robert Keyserlingk (Ottawa, History)
Joseph Patrouch (Edmonton, History)
Franz Szabo (Edmonton, History)

FRANCE

Jacques Le Rider (Paris, History)
Michael Pollak (Paris, History)

GERMANY

Oscar Gabriel (Stuttgart, Political Science)
Dietmut Majer (Karlsruhe, Law)
Margareta Mommsen (Munich, Political Science)
Wilhelm Kohler (Tübingen, Economics)

CZECH REPUBLIC

Katerina Kralova (Prague, History)

HUNGARY

Sándor Kurtán (Budapest, Political Science)

ITALY

Mario Caciagli (Florence, Political Science)

UNITED KINGDOM

Tim Kirk (Newcastle, History)
Kurt Richard Luther (Keele, Political Science)
Peter Pulzer (Oxford, Political Science)
Ruth Wodak (Lancaster, Linguistics)

UNITED STATES

Jeffrey Anderson (Georgetown, History)
John Boyer (Chicago, History)

Evan Burr Bukey (Arkansas, History)
Gary Cohen (Minnesota, History)
Wolfgang Danspeckgruber (Princeton, Political Science)
Christine Day (UNO, Political Science)
David Good (Minnesota, History)
Malachi Hacohen (Duke, History)
Michael Huelshoff (UNO, Political Science)
Robert Jordan (UNO, Political Science)
Tait Keller (Memphis, History)
Marc Landry (UNO, History)
Howard Louthan (Minneapolis, History)
Pieter Judson (Swarthmore, History)
Radomir Luza (Tulane, History)
Nicole Phelps (Vermont, History)

Ad multos annos!

Larose – New Orleans, April 2021

Dedicated to the memory of Hugo Portisch (1927–2021)

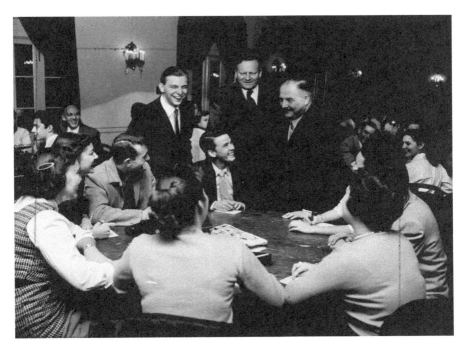

Dr. Hugo Portisch with Austrian Federal Chancellor Julius Raab and Ambassador Dr. Karl Gruber at a press conference for high school students in St. Louis, on Nov. 30, 1954. Hugo Portisch, who worked for the Austrian Information Service in New York from 1953–55, acted as press spokesman for the Austrian delegation during Raab's visit to the US and sent daily reports to the Federal Press Service in Vienna.

Introduction

Günter Bischof, Martin Kofler, and Hans Petschar

Visual materials have been acknowledged in cultural studies since the 1970s as sources of inspiration. In Austria, cultural historian Georg Schmid deserves the honor of introducing film and photography to his students in his lectures at University of Salzburg in the early 1980s. Schmid invited Viennese historians Gerhard Jagschitz, Gerhard Jaritz, and Peter Dusek for lectures, who in their respective fields of research had recognized the relevance and importance of visual materials. Jaritz and his colleagues analyzed all kinds of visual objects at the Institute for Medieval and Early Modern Material Culture in Krems (founded by Harry Kühnel as an institute of the Austrian Academy of Science). Peter Dusek and his colleague Herbert Hayduck built a huge photographic and film archive at the Austrian Broadcasting Corporation (ORF), which the anchorman of the ORF Hugo Portisch used for his legendary TV series on the history of the First and Second Republic of Austria. In fact, the success of Portisch's documentaries proved mainstream academic historians wrong, who only very reluctantly integrated visual sources in their research and teaching practice. History channels and cultural channels in public TV productions and annual exhibitions in the federal states attracted wider audiences in Austria and in Germany and created a new market for historians outside the university environment.

Local museums in the Federal States, the Joanneum in Graz, and the big cultural heritage tanks in Vienna, the Museum of Fine Arts, the Belvedere, the Albertina, and the Austrian National Library flooded national exhibitions with their rich collections and treasures. Besides the historical treasures they inherited from Imperial Austria, many of these institutions created poster archives and impressive photographic collections. While the Albertina extended their graphic collections in creating an archive for photographic art, the flagship for documentary photography in Austria certainly is the Picture Archives and Graphic Department of the Austrian National Library. A regional photo archive in South-Western Austria that has already attracted some attention in its ten years of existence since 2011 when looking at transnational exhibitions, books and projects, as well as education efforts is the Tyrolean Archive of photographic documentation and art (TAP) in Lienz, with a second office in Bruneck/Brunico (South Tyrol/Italy).

Already in the 19th century, the Imperial Court Library and the Private Library of the Habsburg Family started to collect and archive photographs as valuable historical sources. The Court Library collected military photographs and pamphlets during the First World War[1] and its successor library, the Austrian National Library, continued to collect documentary photography in the First and the Second Republic of Austria and even during the National Socialist Period. Many Austrian press photographers and professional photographers like Otto Croy, Ernst Hilscher, or Lothar Rübelt had started their career in the First Republic of Austria and continued their work in the 1930s and during the Second World War. Walter Henisch and Harald Lechenperg worked as photographers for the Deutsche Wehrmacht. Joe Heydecker, who worked as a photo laboratory technician in a Wehrmacht propaganda company, also photographed privately in the Warsaw Ghetto and published his photos in 1981.

Immediately after the annexation of Austria to the German Reich in March 1938, the press, radio photography, and newsreels became the most important tools for the Nazi propaganda in Austria. Jewish journalists and photographers were expelled from their jobs and were forced to emigrate. Leo Ernst, the companion of Albert Hilscher, left Austria and came back only after the war as an American officer. In his early years, the Austrian born photojournalist Ernst Haas photographed postwar Austria and started an international career as a member of the Paris photo agency Magnum, together with Erich Lessing and Inge Morath.

To this day the Austrian National Library holds approximately 2.5 million photographs in its collections, including the photographic archive of the United States Information Services in Austria, the archives of Otto Croy, Albert Hilscher and Leo Ernst, Joe Heydecker, Margret Wenzel Jelinek, Ernst Kainerstorfer, Erich Lessing, Yoichi Okamoto, Lisl Steiner, and Harry Weber. The Library systematically digitizes its photographic collections and integrates them into the Digital Reading Room of their website, where more than 2 million objects are available online. The rich analog and digital visual collections have inspired a new generation of historians, many of them represented in this volume, to reflect the power of images, to analyze and work with visual sources in theory and practice and to create a new, attractive field of research.

The Tyrolean Archive for photographic documentation and art (TAP) has got about 650,000 photographic objects, most of them as gifts and permanent loans. The main collections are the interregional ones of the Town of Lienz/East Tyrol as well as Kneußl;[2] others focus on railway history, World War I, or alpinism. TAP collects and digitizes photographic

sources and presents them in exhibitions and books, as well as on its web-site www.tiroler-photoarchiv.eu or via social media (Facebook, Instagram). Besides the conservation and saving of the cultural treasures of historic photography as a regional storage of memory ("*Gedächtnisspeicher*"), TAP also is a storage of knowledge ("*Wissensspeicher*") and center of competence to train the right handling of old pictures. These efforts are based on the successful EU-Interreg-project "*Lichtbild/Argento vivo*" (2017–19) with partner archives in Bruneck/Brunico, Bozen/Bolzano and Innsbruck: www.lichtbild-argentovivo.eu.

More than anything else, a changing media environment, the develop-ment of new cultural markets, and the change of institutional practices as result of the digital revolution led to an increased interest in visual sources in historical sciences. As Arno Gisinger writes in his essay in this volume: "We have all become photographers" with our smartphones. This volume pays tribute to this trend and encourages more studies to come in the future.

As editors we have the strong feeling that there is room for much more to come: studies on continuities and discontinuities in the careers of pho-tographers between the wars and after the Second World War, the power of images in the perception of history and in memory production, the impact of visuals in social media to name only a few aspects.

"Visual History" does not only mean history of pictures of all kinds, but also refers to a research field in the Humanities that has been established with growing scholarly interest from the 1990s onwards. Initialized by Salzburg historian Georg Schmid in the 1980s, and Vienna contemporary historian Gerhard Jagschitz in the 1990s, "Visual History" in Germany and Austria has mostly been put into force by Gerhard Paul. Looking at pho-tographs and incorporating the Cultural Studies' *iconic/pictorial turn* into historical sciences, there is a two-sided approach using them as important sources as well as seeing them as (active) subjects with an aesthetic and (political) power inside themselves. Visual History is neither a fixed meth-odology nor the unique way ("*Königsweg*") of looking at photographs and other pictures. The immanent references are tradition and heritage, produc-tion and distribution, archiving and aesthetics, as well as influence and (ab)use.[3]

It is quite astonishing that there has been no overall "Visual History of Austria" so far—neither as a monograph nor as an essay collection.[4] The general need for the qualitative scientific use of photographs is out of the question.[5] We live in an era of pictures right now, dominated by an (almost) overkill of uploaded photographs on Facebook, Instagram, et cetera day by day. So, we do need competent answers and useful guidelines that take care

of creators' copyrights and rights on one's own picture even more.[6]

Looking at the power of pictures, of course, you can say that "pictures tell history"—but aside of a gone use as pure illustration, especially photographs must be interpreted and used as critically as written sources. The essays in this collection—both analytical and descriptive—show a wide range of contributions regarding visual sources. They manage to cover the references mentioned above: from the work of single photographers and photo archives, the ways of conservation and transmission up to the present, the education of today's users and producers, the aspect of photographic art, the mighty powers of pictures of war, interwar and post-war periods. Together these essays provide an introduction to the visual histories of Austria in war and peace.

While we were putting the final touches to this volume, Hugo Portisch passed away in Vienna the age of ninety-four on April 1, 2021. We would like to honor the rich *oeuvre* of this remarkable print- and TV-journalist who was a restless and uncompromising fighter for post-World War II Austrian and Central European democracy. The editors would like to dedicate this volume on Austrian visual histories to Hugo Portisch's memory.

This volume was conceived out of a panel in the 2019 German Studies Association meeting Portland, Oregon (Kofler/Siller, Markova, and Richter papers). A second panel in the 2020 GSA meeting was supposed to compliment these papers (Kofler, Petschar, Hoffmann papers). Due to the Covid-19 restrictions in 2020 that GSA meeting only took place online, however, we chose not to participate online—the panel has been resubmitted for the 2021 GSA meeting. The other papers were commissioned to add to these initial papers.

The volume starts out with two essays on regional photo archival collections in the Tyrol—both the Austrian and Italian Tyrol—and Vorarlberg. The EU Interreg project "*Lichtbild*" (2017–19) has been groundbreaking as well as long-lasting in several ways. Besides showing exhibitions, creating an app as well as Open Data, there were two main goals that have been achieved: on the one hand, setting up guidelines for the day-to-day work with historic photographs, and on the other hand making new pictures available in an open access approach. In the end, as the essay by Martin Kofler and Notburga Siller clearly shows, up to this day, we have five freely downloadable guidelines in German/Italian/English and a helpful e-learning course as well as 12,000 digitized photographs under Creative Commons license CC BY to be used for free for private, scientific, or commercial

purposes. All this and more approaches to promote the importance of and the sensibilization for historic photography as a cultural treasure can be found at the project's website www.lichtbild-argentovivo.eu.

In the "analog age" of photography there were many local and regional photo shops that also documented the social everyday life of people all across Austria. Arno Gisinger and a team of experts are preparing an extensive exhibition and book project about the Photo House Hiller (Bezau) in 2023 on behalf of the Vorarlberg Museum. The examples of photographs featured in this submission offer a first glimpse into the ongoing research. The pictures from the Hiller photo studio illustrate essential aspects of the socio-historical and economic development of the Bregenzerwald in the 20th century. They not only accompany the internal and external transformation processes in this region, but they also made them possible, and even visually invented them.

We then go back in time and start with the beginnings of photography in the mid-19th century in Vienna. Ludwig Angerer (1827–79) was the first Viennese photographer to be awarded the title of "Court Photographer." He began as a photographer in the Balkans in 1854 and opened his first studio in Vienna in 1858, where he specialized in the then fashionable "Carte de Visite" photography. The first shot of the Austrian Emperor Franz Joseph that we know of was taken by him. In the 1860s, his studio was considered the most famous in Vienna. What survives of Ludwig Angerer are iconic photographs of Empress Elisabeth and a very extensive photographic documentation of Austria society in the 1860s, the first shots of Bucharest and a documentation of the holdings of the Austrian Museum of Art and Industry. He was always on the pulse of the times, open to all technical innovations and enormously versatile in his photographic oeuvre.

Next to photographs, cartoons are another means of visual expression. Jewish humor has found its way into modern culture in many ways and is often the subject of essayistic and scholarly discussion. The focus here is on written and oral sources. Visual wit and its Jewish authors have mostly received less attention. In this article, Severin Heinisch examines the role of Jewish cartoonists in Central Europe between 1900 and 1945 on the basis of selected biographies and publications.

With regard to the visual history of Austria in the First World War, Markus Wurzer argues that the private photo practice—in stark contrast to official propaganda photography—represents a major research gap. By drawing on a case study, two photo albums of an Austrian officer who was employed at the Italian theater of war, Wurzer addresses the question of how war engagements were remembered after the war individually by the visual

practice of photo albums. Wurzer stresses the methodological importance of analyzing entire photo albums instead of individual photographs. Only via an album's specific materiality and mediality are singular photographs linked to each other and form a visual narrative. Furthermore, Wurzer's particular interest lies in the question how violence is (not) remediated in personal albums. In his analysis Wurzer demonstrates that "ordinary" soldier's photography did not produce a more "authentic" image of war. On the contrary, it was similarly influenced by official guidelines and, therefore, reproduced a normative imagery which tried to make mass violence invisible. Through the comparative reading of the officer's war diary, Wurzer succeeds in making the voids of violence in the visual narrative visible and shows with what the gap was filled instead. War veterans primarily remembered pleasant things as well as pleasurable moments instead of hardship and mass violence.

Two blocks of essays then bring us to the visual history of Austria during and after World War II. Hardly any aspect of the Second World War is as strongly influenced by pictorial perception as the bombing war. And yet the associated image worlds, which are deeply anchored in the collective memory, not least by photographs of the destroyed city of Dresden, were only tentatively adopted by visual history and memory studies. Georg Hoffmann's article is part of these fields and contributes to the current discussion by adding an "Austrian" example: In the "Archive of Aviation Forces" (*"Archiv der Luftfahrtruppen"*) created in 1938 under Nazi aegis in what today is the "war archive" (*"Kriegsarchiv"*) in Vienna, multilayered Nazi constructions reflect a hegemonic imagery, which was weighted differently depending on interpretation and necessity, or changed in its perspective and narrative. Starting from the original attempt to integrate the heroic images of Austro-Hungarian airmen of the First World War into Nazi imaginations, the arc is stretched from the horror visions of the interwar period to the portrayal of an "allied bomb terror" in the Second World War. Hoffmann's article focuses primarily on contrasts and juxtaposes heroic compositions with depictions of enemies, destruction and death, which manifested itself, among other things, in the photo exhibition "The Air Terror" (*"Der Luftterror"*) staged in Vienna in 1943. The article gradually reveals the composition of still existing and dominant image worlds and views itself as an impulse for research to look more closely at the air war in its visual memory.

In his article, Lukas Meissel analyzes five photographs that were taken by SS men at the Mauthausen concentration camp. Contrary to pictures taken during the liberation of the camp or at a later stage at the memorial

site, the SS photos show the concentration camp during its existence. However, the pictures are shaped by those who took them and those who commissioned them, creating a very specific image that reflects the perspective of the perpetrators rather than the reality of the camp. However, as the majority of preserved SS photos were saved by prisoners, another layer of meaning is inscribed in this specific set of visual sources. The initial intention of the SS photographers as well as the acts of resistance by prisoners define the context of the images and ultimately constitute the double-meaning of the visual memory of Mauthausen that lives on in commemoration projects, academic studies of the camp's history and Holocaust education projects.

Ina Markova's article provides an empirically based analysis of visual representations of 1945 in Austrian political memory from 1945 to 2015. Different agents of memory politics have tackled the question of whether 1945 should be interpreted as only the end of the war, as "zero hour," or as liberation. Shortly after April/May 1945, the "victim theory" left its imprint on Austria's official reading of 1945. The author argues that 1945 remains an ambiguous year in Austrian memory politics, despite remarkable changes in the Austrian self-perception as a country of victims and perpetrators. This paper traces the powerful visual narratives and "key images" associated with this historic caesura.

Yoichi Robert Okamoto (1915–85) was an American star photographer of Japanese descent. He came to Europe in the spring of 1945. Okamoto served General Mark W. Clark as official photographer in Postwar Austria. From 1948 to 1954 he led the Pictorial Section of the United States Information Services in Austria. Okamoto, being an outstanding art photographer himself, promoted and influenced a whole generation of young Austrian photographers, including Jeff Rainer, Ernst Haas, and Erich Lessing. In 2019, the Austrian National Library acquired the personal photographic estate of Yoichi R. Okamoto, with over 22,000 negatives and 900 photographic prints documenting life, art and culture in postwar Europe and in Austria. Hans Petschar's essay gives first insights into the work and the early biography of a photographer, who as the official White House photographer of President Lyndon B. Johnson from 1963–69 revolutionized the US presidential photography forever.

The Austrian image—or nation brand—in the United States has long been dominated by classical, aesthetic variables associated with Austrian stereotypes. Hannes Richter's contribution reviews the available evidence on the Austrian image in the US and connects previously established patterns of this brand with new findings from social media-based pilot studies

conducted by the University of Southern California in cooperation with the Austrian Embassy in Washington, DC.

Martin Kofler has served as the Director of the Tyrolean Archive for photographic documentation and art (TAP) since its beginning in 2011. In his essay, Kofler looks at the field of mountain pictures in TAP's vast stocks. The photographs in his essay demonstrate the constant need to get hold of previously unknown collections. You can reflect the pictures' wide time range starting long before WWI and leading way into the 20th century as well as the importance of the entire contextual range of holdings. Contrary to looking at different mountain photographers, Kofler focuses on the wide area of content: from emotional, even philosophical aspects, mountain marketing and climate change up to technical developments—always keeping the mountain in mind as a subject, not an object. The discovery of mountains soon ended in camera shots by professionals as well as amateurs. Photographers have realized the magnetic attraction of peaks and rocks back then—and up to this day.

This is our 30th anniversary issue of *Contemporary Austrian Studies*. For this as well as all the previous volumes we received a lot of outside support. We would like to thank a number of people for their help in making the completion of this volume possible. Working with Martin Kofler and Hans Petschar as the guest co-editors of this volume has been smooth and easy since the very first days of putting this volume together. We are sincerely thankful to all the contributing authors for submitting their essays in a timely fashion and responding favorably to all editing suggestions from our production team. Christian Stenico, the 2020–21 Austrian Ministry of Education, Science, and Research Dissertation Fellow at UNO and PhD student in the Department of American Studies at the University of Innsbruck, has done a fine job in tracking every manuscript through both the copyediting and proofreading processes and toward final publication. He also has been relentless in correcting and aligning footnotes with our style sheet and humoring authors toward completion of their manuscripts. Covid-19 did not allow him to go home after a year in New Orleans, so he decided to stay a second year and the Ministry of Education, Science and Research was kind enough to grant him their UNO fellowship for a second time. This was a great blessing for the production of this anniversary volume and we promoted Christian into the role of Associate Editor.

In a volume of visual history, photo archives become exceedingly important to explain and support the visual narrative. Many archives and archivists

have been helpful in helping us illustrate this volume. In the Picture Archives and Graphics Department of the Austrian National Library, Hans Petschar and Michaela Pfunder could rely on their staff for the illustration of their respective essays, as could Martin Kofler at TAP. Markus Wurzer also relied on TAP for his pictures. Arno Gisinger worked with the archives of Photo House Hiller, now deposited at the Bregenzerwald Archives. We would like to thank Kathrin Netter, its director, for the images in the Gisinger essay. We would like to thank the archivists of the KZ-Gedenkstätte Mauthausen for their support. Katharina Lischka from the Jewish Museum in Vienna was helpful in illustrating the essay by Severin Henisch.

We would also like to thank our anonymous outside peer reviewers for their thorough and timely assessments.

Leah Myers at UNO Press put her enthusiasm into the final round of copyediting the individual manuscripts; Alex Dimeff skillfully typeset the final text of the volume and designed the cover. G.K. Darby and Abram Himelstein, the leadership team at UNO Press, have been hugely supportive to spirit this volume through to final publication. At Center Austria: The Austrian Marshall Plan Center for European Studies, Marc Landry, the Associate Director, was helpful with sage advice. Gertraud Griessner, with the help of Christian Stenico, conducted the Center's daily business with superb efficiency to allow the co-editor to work on managing the completion of this volume. Without the dedicated teams at Center Austria and the UNO Press there would be no CAS series. At *innsbruck* university press, Birgit Holzner was helpful with the production of the cover, the final round of proofreading, and then producing the volume for the European market. Cooperating with her has become a big bonus in the production of these volumes.

As always, we are happy in acknowledging our sponsors and supporters for making the publication of the *Contemporary Austrian Studies* series possible at all, not a small matter in the age of diminishing budgets for higher education in general and the social sciences and humanities in particular. At the Universities of Innsbruck and New Orleans, our thanks go to Vice *Rektor* for Research for a grant towards the printing of this volume, Matthias Schennach, Barbara Tasser, Gerhard Rampl, and Janine Köppen in the New Orleans Office. At UNO, Kim Long, the Dean of the College of Liberal Arts and Education, has given us green lights and much support whenever needed. We are also grateful to President John Niklow and *Rektor* Tilmann Märk for their support of the entire UNO-University of Innsbruck partnership agenda, including its publication series. In the Federal Ministry of Education, Science, and Research and its student

exchange office *Österreichischer Auslandsdienst* (ÖAD), we are grateful to Barbara Weitgruber, Christoph Ramoser, Felix Wilcek, Josef Leidenfrost, Lydia Skarits, and Florian Gerhardus. Markus Schweiger, the executive secretary, Ambassador Wolfgang Petritsch, the chairman of the board, as well as the board members of the Austrian Marshall Plan Foundation have been our strongest supporters for two decades now. It is a great pleasure and privilege to work with them all and acknowledge their unwavering support of Center Austria: The Austrian Marshall Plan Center of European Studies at UNO and its activities and publications.

New Orleans/Vienna/Lienz, March 2021

Endnotes

1 Hans Petschar, "Gathering War: The Collection Effort by the Imperial Court Library in Vienna during World War I," in *1914: Austria-Hungary, the Origins and the First Year of World War I*, Contemporary Austrian Studies 23, ed. Günter Bischof, Ferdinand Karlhofer, and Samuel R. Williamson, Jr. (New Orleans: UNO Press; Innsbruck: Innsbruck University Press, 2014), 249–70.

2 See the virtual Kneußl exhibition at: https://www.lichtbild-argentovivo.eu/de/bilder-zeigen/virtuelle-ausstellung-kneussl.html, accessed March 16, 2021.

3 For an introduction resp. overview see: Gerhard Paul, "Visual History," Version: 3.0, *Docupedia-Zeitgeschichte* (March 13, 2014), accessed March 16, 2021, http://docupedia.de/zg/Visual_History_Version_3.0_Gerhard_Paul [Version 1.0 was published in 2010]; Gerhard Paul, "Visual History," in *Zeitgeschichte: Konzepte und Methoden*, ed. Frank Bösch and Jürgen Danyel (Göttingen: Vandenhoeck & Ruprecht, 2012), 391–419; the pioneering work for Austria is the picture handbook: Gerhard Jagschitz, *Zeitaufnahmen: Österreich im Bild: 1945 bis heute* (Vienna: ÖBV, 1982).

4 Experts have more focussed on the history of photography in Austria itself: *Geschichte der Fotografie in Österreich*, 2 vols. (Bad Ischl: Ferdinand Berger & Söhne, 1983); Timm Starl, *Knipser: Die Bildgeschichte der privaten Fotografie in Deutschland und Österreich von 1880 bis 1980* (Munich: Koehler und Amelang, 1995); Anton Holzer, *Fotografie in Österreich: Geschichte, Entwicklungen, Protagonisten 1890 bis 1955* (Vienna: Metroverlag, 2013); nevertheless, e.g. the power of WWI pictures has been intensively analyzed by: Anton Holzer, *Die andere Front: Fotografie und Propaganda im Ersten Weltkrieg*, 2nd ed. (Darmstadt: Primus Verlag, 2007); for the *German Reich* most recently: Gerhard Paul, *Bilder einer Diktatur: Zur Visual History des "Dritten Reiches,"* 2nd ed. (Göttingen: Wallstein, 2020).

5 Jens Jäger, "Geschichtswissenschaft," in *Bildwissenschaft: Disziplinen, Themen, Methoden*, ed. Klaus Sachs-Hombach (Frankfurt am Main: Suhrkamp Taschenbuch Verlag, 2005), 185–95; Jens Jäger, *Fotografie und Geschichte* (Frankfurt am Main: Campus Verlag, 2009).

6 For a similar approach, but more concerning concepts as well as the additional areas maps, posters, and movies: *Arbeit am Bild: Visual History als Praxis*, ed. Jürgen Danyel, Gerhard Paul, and Annette Vowinckel (Göttingen: Wallstein, 2017).

Introduction

The Interreg-Project "Lichtbild/Argento Vivo" and Its Results to Promote the Importance of Historic Photography[1]

Martin Kofler and Notburga Siller

Mission & Main Goals

"Competent Handling, Open Access, Photography goes Future": This was the mission statement of the Interreg project "Lichtbild/Argento vivo" and it summarizes its main goals. Firstly, to set up guidelines for the day-to-day work with historic photographs and to make these guidelines available to everybody interested. Secondly, to make until now uncharted historical photographs from the participating archives accessible in new and different ways. With the open-access-approach, for example, we used a new method for Tyrol and South Tyrol, namely to offer the photographs as freely downloadable digital files with contextual meta data on www.lichtbild-argentovivo.eu, the project's website. The photographs are published under the Creative Commons license CC BY; this means they are free, even for commercial use.[2]

When we talk about proper handling of historical photographs and making them and the necessary competences accessible to everybody interested, let us look for instance at the digitization of the glass negative portrait of Friedrich Held. He was an amateur cyclist from Innsbruck who had his picture taken by the photographer Hermann Waldmüller in his studio in Bozen/Bolzano in 1896. This photograph shows not only the self-conception of the sitter, but also the techniques used in a photographic studio at the turn of the century in our region. It is the emblematic picture of this successful three-year-long project and adorns the cover of one of our publications. We wanted to provide everybody access to the answers to the questions that come up when working with such a photographic object: What is to be done with an original like this? What kind of envelope, what box, can it be stored in? How can it be scanned? And regarding content, how can someone preserve the known context information that is the metadata, the names of the photographer and the cyclist, the location, the date it was taken, and so on? How can such a photograph be preserved both as a physical copy and as a meaningful object?

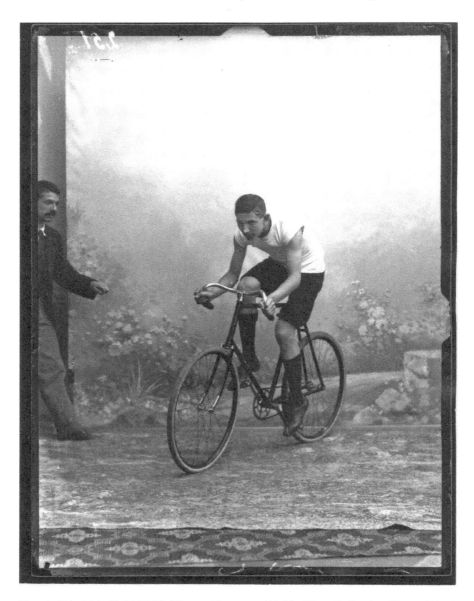

Fig. 1: Friedrich Held,1896 (Photo: Hermann Waldmüller; Collection Photo Wald-
müller – Office for Film and Media, Autonomous Province of Bozen/Bolzano, CC BY
4.0)

We wanted not only to strengthen the importance of visual sources, but also to show how they can be adequately used. We tried out new, different ways of presenting and promoting historical pictures by designing exhibitions, an app, and a website.

Basic Facts

The EU-Interreg project "Lichtbild/Argento vivo" (ITAT3001) was started in January 2017, lasted until December 2019[3] and focused on the region Federal State of Tyrol (Austria) and the Autonomous Province of Bozen/Bolzano (Italy). Interreg is a project funding program of the European Union (EU) and supports cooperation across borders. The project partners had a total budget of 1,348 million euros to cover all personnel and material costs to achieve the many planned results. The Association Tyrolean Archive of photographic documentation and art (TAP), Lienz/Austria (Lead Partner) and from South Tyrol/Italy the Municipality of Bruneck/Brunico, the Office for Film and Media/Department of Culture and the Department Museums, both of the Autonomous Province of Bozen/Bolzano, joined forces to run this project. Four associated partners provided much support regarding both content elaboration and results distribution: the Tyrolean State Museums and the Tiroler Bildungsforum in Innsbruck/Austria, the South Tyrolean Provincial Archive as well as the Euregio Tyrol-South Tyrol-Trentino.[4]

Nothing works without a powerful team. Its members, nominated by the project partners, met in person about biweekly. This ensured the progression of the project as well as a fun work environment, despite a few changes in personnel over the three years.

At the Core

The true centerpiece of all our endeavors was the elaboration of guidelines for the handling of old photographs and the mediation of such abilities in workshops, via handbooks, published both online and in print, and through an e-learning course. Our primary target group were, as we called them, "non-professional enthusiasts," meaning amateur chroniclers and voluntary cultural workers in Tyrolean/South Tyrolean communities, most over the age of fifty. We also wanted to reach the professionals working in museums or archives, and photographers.

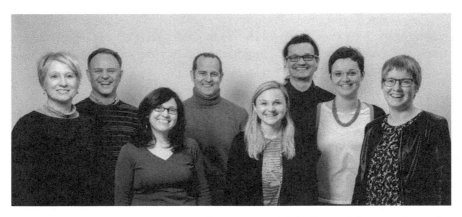

Fig. 2: Team Lichtbild/Argento vivo (from left to right): Gertrud Gasser, Oscar La Rosa, Notburga Siller, Alessandro Campaner, Elisa Mair, Martin Kofler, Verena Malfertheiner, Marlene Huber, 6 February 2018 (Photo: Konrad Faltner, Office for Film and Media, Autonomous Province of Bozen/Bolzano)

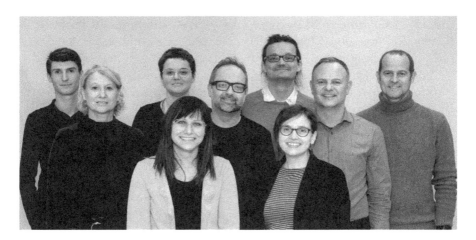

Fig. 3: Team Lichtbild/Argento vivo (from left to right): Arpad Langer, Gertrud Gasser, Verena Malfertheiner, Julia Knapp, Martin Sagmeister, Martin Kofler, Notburga Siller, Oscar La Rosa, Alessandro Campaner, 11 December 2018 (Photo: Konrad Faltner, Office for Film and Media, Autonomous Province of Bozen/Bolzano)

To define these guidelines, we organized five workshops, all of them free of charge, bilingual and with simultaneous translation (German to Italian and vice versa), with international experts from Austria, Italy, Germany, and Switzerland. The aim was to present international and European standards in archival work with photographs, to show examples from different archives, and to recommend practical workflows. At the same time, the events provided a much-appreciated networking opportunity for everybody.

Stemming from the workshops, we put together five handouts in German, Italian, and English, as well as an e-learning course in German and Italian. The workshops took place all over the project area from September 2017 until January 2019, in the Fortress Franzensfeste, the Eurac Bozen/Bolzano, Bruneck/Brunico Castle (all three of them in Italy), the Chamber of Commerce in Lienz, and the Zeughaus of the Tyrolean State Museums in Innsbruck (both in Austria). They were dedicated to the major aspects of "History of Photography in Tyrol and South Tyrol," "Photographic Rights and Creative Commons in Italy and Austria," "How to Preserve and Organize Photographs," "Digitizing and Editing of Photographs," and "Photography and Digital Long-Term Archiving," About 700 people participated overall. We offered talks given by international experts, discussions and question rounds as well as for example a pop-up exhibition with the oldest surviving photograph in the region—a daguerreotype from 1847—and practical examples of the work with photographic originals and the process by which they are cataloged.

The handouts are published as PDF-A-files under CC BY license on the project's website www.lichtbild-argentovivo.eu, where they can be downloaded for free. Additionally, they were also published as a book.[5] The handouts were guided by a hands-on approach and the wish to provide tips for the day-to-day work.

To mediate the contents of the workshops and handouts, we also designed an e-learning course.[6] We added a second layer of learning with interactivity and multimedia channels and collaborated with educational professionals. For example, the workshops' experts explain crucial elements in short and concise videos in the online course. We also offer step-by-step explanations, interactive timelines, and, with our target group in mind, confirmations of participation. The online course is published under a CC BY SA license, and corresponds, just like the handouts, with the international standards of open educational resources.[7]

Fig. 4: Screenshot e-learning course Lichtbild/Argento vivo (Notburga Siller, Office for Film and Media, Autonomous Province of Bozen/Bolzano)

All of these guidelines are available on the bilingual (German/Italian) website www.lichtbild-argentovivo.eu. The website also contains the vast data bank of more than 12,000 newly indexed, geo-localized, digitized, and published historical photographs in high definition, with the describing metadata in the IPTC. They are offered as free downloads under CC BY license and can therefore be used by everybody, including for commercial use, with the only condition being that the name of the photographer and the archive need to be cited upon the use of a photograph. The data bank includes portraits, landscapes, post cards, pictures from historical buildings and villages, or historical events like the First World War, covering the period from the 1890s up to the 1990s. The photographs come from the project partners' archives. The website also provided regular information of our output and the lasting outcome of the project.

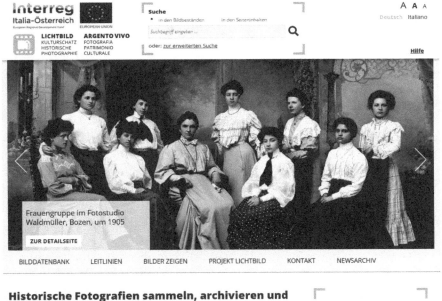

Fig. 5: Screenshot Platform Lichtbild/Argento vivo (Martin Kofler, TAP)

The whole data bank is also available as machine-readable Open Data for further programming use, see https://data.civis.bz.it/de/dataset/tyrolean-historical-photographs. We, the participating archives, wanted to open our cabinets, figuratively speaking, and take the next innovative step. This meant the publication of the data bank in a way that is suitable for automated computer programs. The digital files not only contain the image but are equipped with the corresponding meta data. The data can be used by anyone, the only condition is to adhere to the license conditions (CC BY). Data as a private resource for administrative purposes become a "public good" for public and social purposes. In the interconnected world of today it is increasingly important for archives, museums, and libraries to provide satisfactory answers to the questions of how they interact with their digital visitors and in what way they want to make their collections digitally available and usable. This project explored the possibilities and opportunities of the Open Data approach.

Exhibitions, App, and Hackathon

To emphasize the importance of historical photographs as a visual source about the past, we organized exhibitions, both online and on site. The first exhibition was titled "Platz da! Scesi in piazza" ("Give way!") and focused on historic photographs of major public places. It showed photographs of the major squares in Lienz, Bruneck/Brunico, Bozen/Bolzano and Innsbruck from the 1880s to the 1970s from the partners' photographic archives. The pictures were grouped around themes like politics, mobility, culture and day-to-day-life and showed how monarchies, dictators, and Fascist regimes as well as automobiles, a booming economy and regular people left their marks on the squares in question. The displays were located on the main squares in question and could be visited in the public space in September and October 2018.

The first online exhibition "Kneußl" ("Stations of a family history in Tyrol/South Tyrol/Trentino 1887–1964") published in fall 2018 on the project's website www.lichtbild-argentovivo.eu, curated by Martin Kofler (TAP), enables a quick glimpse into the family's vast photographic archive consisting of 5,000 glass negatives and celluloid positives, all equipped with valuable information on the depicted subjects and dates. This archive is a prime example for the importance and the value of private collections and family documentation as it shows the private visual history of a family living in almost all parts of Tyrol/South Tyrol/Trentino starting from the late 19th century all the way into the 1960s. The Kneußl men were well-off and dedicated their spare time to taking photographs.

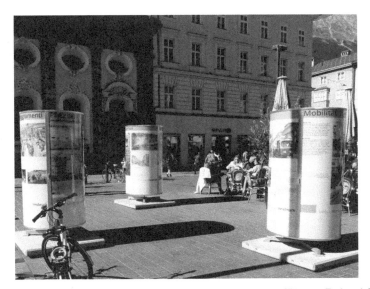

Fig. 6: "Platz da! Scesi in piazza" in Innsbruck, fall 2018 (Photo: Roland Sila, Tyolean State Museums, Innsbruck)

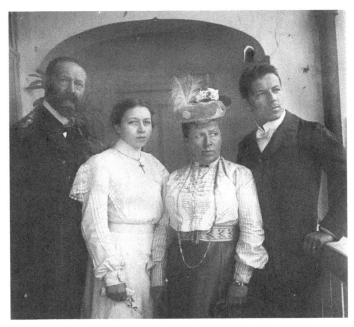

Fig. 7: Kneußl family at home on their balcony in Schwaz/Tyrol, July 1904. From left to right: Anton, Elfriede, Adelinde, Erich (Photo: Unknown; Collection Kneußl – TAP)

The first half of 2019 was dedicated to the conception, planning and realization of the second on-site exhibition called "Frauenbilder – Signora fotograf(i)a – Women in Photography," curated by Giusi Campisi and Luca Bertoldi. A photograph of Elfriede Kneußl, a member of the Kneußl family, was used for the poster as well as the cover for the corresponding book, edited by Martin Kofler and Katia Malatesta from the Autonomous Province of Trento, a partner in this exhibition.[8] Based on the logistics run by Martin Kofler (TAP), five museum spaces in five towns showed the five chapters of this exhibition: Lienz - "Course of Life," Innsbruck - "Female Photographers," Bruneck/Brunico - "Work," Bozen/Bolzano - "Atelier," and Trento - "Lifestyles." Admission was free everywhere in the spirit of openness. The photographs and historical objects on display stemmed from the archives of partners and associated partners, which manage some of the major photo collections in Tyrol, South Tyrol and Trentino. [9]

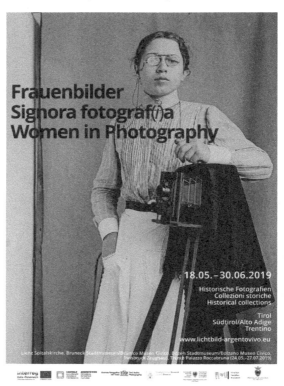

Fig. 8: Poster "Frauenbilder – Signora fotograf(i)a", with Elfriede Kneußl, 1903
(Design: Klaus Dapra, Lienz; Photo: Anton Kneußl; Collection Kneußl – TAP)

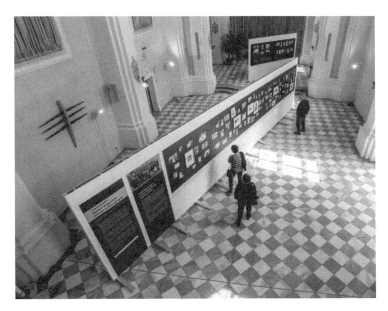

Fig. 9: Exhibition "Frauenbilder – Signora fotograf*(i)*a" in Lienz, spring 2019
(Photo: Klaus Dapra, Lienz)

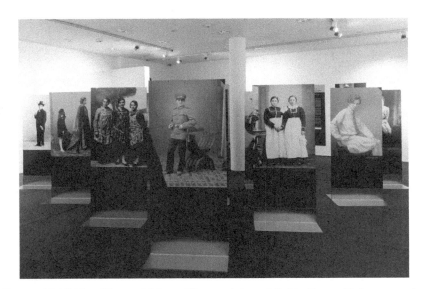

Fig. 10: Exhibition "Frauenbilder – Signora fotograf*(i)*a" in Bozen/Bolzano, spring
2019 (Photo: Gideon de Vries, Office for Film and Media,
Autonomous Province of Bozen/Bolzano)

The second online exhibition on www.lichtbild-argentovivo.eu was curated by Verena Malfertheiner (Autonomous Province of Bozen/Bolzano) and is titled "Ab auf die Piste! Pista!" ("Hit the Slopes"). It showed photographs of skiing in Tyrol/South Tyrol/Trentino from the early 20th century to the 1990s and was published in autumn of 2019.

With the publication of an application for smart phones we tried a different approach to promote old photographs. The project's app "Timetrip Pics" was presented in the fall of 2018 in German, Italian, and English and can be downloaded for free in both the Google Play Store (Android version) and Apple Store (iOS version). Altogether about 160 historic photographs of squares in Innsbruck, Bozen/Bolzano, Bruneck/Brunico, and Lienz are combined with present-day 360-degree-panoramas; another functionality shows the changes in the same viewpoint over time. The app depicts the diverse changes of these squares over nearly 100 years from around 1890 until the 1980s with a historical commentary and tri-lingual audio guides.

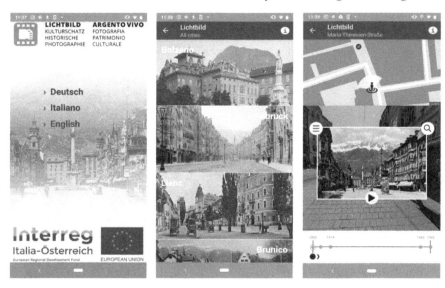

Fig. 11: App "Lichtbild/Argento vivo"
(Screenshots: Bruno Mandolesi, Bruneck/Brunico)

Additionally, we used another way to present and promote old photographs, this time to a user group whose main interest may not be rooted in historical photography. With our Open Data we participated in a Hackathon, a programming marathon, organized by the NOI-Techpark Bozen/Bolzano in November of 2018. We offered our photographs' scans,

metadata and data sets as Open Data to be used by the participants of the Hackathon in their digital projects. The competition showed the attractiveness and diverse possibilities of historical photographs aside all sorts of established approaches. A lot of the teams used the data in their projects about future tourism, mobility, or cultural heritage, which they developed over twenty-four hours.

Summary

Our goal with the Interreg project "Lichtbild/Argento vivo" was to promote the importance of and the sensibilization for historic photography as a cultural treasure. There were "classic," so to speak, established ways of mediation as well as heavy use of innovative technology and new licensing approaches. The vast range includes handouts and an e-learning course to promote competent use, the publication of collections under CC BY license and as a whole data set as Open Data, as well as the presentation of photographic treasures via exhibitions and in an application for smartphones. The project's openness strengthened its visibility.

Historic photographs as visual sources play an important role in the forming of our ideas about the past, about the connections, and developments in today's world. We not only wanted to open our own archives, but also to provide everybody interested with the necessary know-how to not only store photographs appropriately, but also to understand and record them adequately. We received immense positive feedback from our target groups and dare to say that the project was both a success and a decisive basis for potential future endeavors and strategies of education for our transnational network of archives.

Endnotes

1 This article is based on our presentation at the German Studies Association Conference (GSA) in Portland, Oregon, USA, in October 2019 which was funded within the EU Interreg project "Lichtbild/Argento vivo" (ITAT3001).

2 In general, the main focus regarding Tyrol/South Tyrol and photography has been history books and studies on single photographers. The basic studies are: Meinrad Pizzinini and Michael Forcher, *Alt-Tiroler Photoalbum* (Salzburg: Verlag St. Peter, 1979); Florian Pichler, *Südtirol in alten Lichtbildern: Die Anfänge der Photographie in Südtirol und die ältesten Photographien*, 2nd ext. and added ed. (Bozen: Athesia, 1981); Gunther Waibl, ed., *Mariner: Photographen in Bruneck: Ein Stück Kulturgeschichte* (Bruneck: dipdruck, 1982); Gunther Waibl, "Photographie und Geschichte: Sozialgeschichte der Photographie in Südtirol 1919–1945" (PhD diss., Vienna University, 1985); *Zeit-Bilder: 150 Jahre Photographie Tirol, Südtirol, Trentino* (Bozen: Museum für Moderne Kunst, 1989); Richard Piock and Wolfgang Meixner, ed., *Photodokument: Eine Ausstellungsreihe der Firma Durst über Photographie in Tirol – 1. Transit: Die Überwindung der Alpenbarriere in der Photographie* (Brixen: Durst Phototechnik, 1991); Claudia Sporer-Heis, ed., *Dunkelkammer – Wunderkammer: Facetten der Fotografie: Ausstellungskatalog* (Innsbruck: Tiroler Landesmuseum Ferdinandeum, 2001); Michael Forcher and Meinrad Pizzinini, ed., *Tiroler Fotografie 1854–2011* (Innsbruck: Haymon Verlag, 2012); Martin Kofler, ed., *Volldampf: Die Pustertalbahn 1869–1918*, TAP-Forschungen, vol. 1 (Innsbruck: Haymon Verlag, 2013); Kulturabteilung Tirol, Kulturabteilung Südtirol/Ripartizione Cultura tedesca, ed., *Kulturberichte aus Tirol und Südtirol: Film und Fotografie* (Bozen, 2015); Martin Kofler, ed., *Grenzgang: Das Pustertal und der Krieg 1914–1918*, TAP-Forschungen 2 (Innsbruck; Haymon-Verlag, 2014); Alessandro Campaner, "Nascita e sviluppo dell'archivio fotografico dell'Archivio provinciale di Bolzano" in *Archive in Südtirol/Archivi in Provincia di Bolzano: Geschichte und Perspektiven/Storia e prospettive*, ed. Philipp Tolloi (Innsbruck: Universitätsverlag Wagner, 2018), 319–50; Marlene Huber, "Medienarchiv des Amtes für Film und Medien: Foto-, Film-, Audio- und Musikbestände" in ibid., 351–71; Martin Kofler, Richard Piock, and LUMEN, ed., *LUMEN: Museum of Mountain Photography* (Iselsberg-Stronach: Velatum, 2019); Alessandro Campaner "'Markierter Angriff.' Fotografie dal conflitto" in *Manipulus florum: Beiträge Essays und Gedanken: Christine Roilo zum 60. Geburtstag*, ed. Gustav Pfeifer and Karin Dalla Torre (Innsbruck: Universitätsverlag Wagner, 2019).

3 "Projekt 'Lichtbild' erfolgreich abgeschlossen," *Interreg.net* (January 15, 2020), accessed January 28, 2021, http://www.interreg.net/de/news.asp?news_action=4&news_article_id=634202; "Kulturschatz Lichtbild: Historische Fotografie," Europaregion.info (December 16, 2019), accessed January 28, 2021, http://www.europaregion.info/de/kulturschatz-lichtbild.asp.

4 A short overview can be found in: Martin Kofler and Notburga Siller, "Historische Fotografien bewahren," *ferdinandea* 51, February–April 2020, 10.

5 Kofler and Siller, eds., *Fotografien bewahren/Custodire le fotografie: Das Handbuch des Projekts Lichtbild/Il manuale del progetto Argento vivo* (Lienz-Bruneck/Brunico-Bozen/Bolzano: Team Lichtbild, 2019). With contributions by: Simone Aliprandi, Rainer Beck, Alessandro Campaner, Clemens Cichocki, Konrad Faltner, Jasmeen Farina, Gertrud Gasser, Anton Holzer, Marlene Huber, Martin Kofler, Arpad Langer, Verena Malfertheiner, Wolfgang Meighörner, Christian Meingast, Bernhard Mertelseder, Daniela Pera, Michel Pfeiffer, Richard Piock, Meinrad Pizzinini, Ivo Planötscher, Raimund Rechenmacher, Stefan Rohde-Enslin, Marjen Schmidt, Roland Sila, Notburga Siller, Claudia Sporer-Heis, Team Lichtbild, and Gunther Waibl.

6 For a quick summary of the e-learning course see: Notburga Siller, "Wie mit alten Fotografien umgehen?," *Tiroler Chronist* 153 (2020): 37–39.

7 The e-learning is linked on the project's website www.lichtbild-argentovivo.eu.

8 A corresponding German/Italian essay collection was published: Martin Kofler and Katia Malatesta, eds., *Frauenbilder/Signora fotograf(i)a: Historische Fotografien/Collezione storiche: Tirol – Südtirol/Alto Adige – Trentino* (Lienz-Bruneck/Brunico-Bozen/Bolzano-Trento: Team Lichtbild, 2019). With contributions by Luca Bertoldi and Giusi Campisi, Alessandro Campaner, Siglinde Clementi and Gigliola Foschi, Susanne Gurschler, Martin Kofler, Katia Malatesta, Floriano Menapace, Veronica Nassi, Cecilia Nubola, and Notburga Siller.

9 For the story behind the exhibition see: Martin Kofler and Notburga Siller, "'Visual History' in Tirol – Südtirol – Trentino: Die Fotoausstellung 'Frauenbilder/ Signora fotograf(i)a' im Rahmen des Interreg-Projekts 'Lichtbild'," *Fotogeschichte* 155 (2020): 53–58, accessed January 28, 2021, http://www.fotogeschichte.info/ bisher-erschienen/hefte-ab-126/155/forschung-kofler-siller-frauenbilder/.

The Hiller Photo Studio in Bezau, Vorarlberg, and the Advance of Photography on Social Life in Rural Austria

Arno Gisinger

Preliminary Remarks

The Hiller family of photographers in Bezau, Vorarlberg, has left a lasting mark on the collective memory of the Bregenzerwald in the 20th century. A completely preserved archive of more than 100,000 photographic negatives in various formats from the 1920s to the 1990s provides the basis for a research project currently underway on the visual history of the Bregenzerwald. The history of the Hiller photo studio is much more than the success story of a dynasty of photographers in a rural area. It contains many essential aspects of the socio-historical and economic development of an agricultural area towards a self-confident region dominated by tourism, culture, and the crafts with its own narrative. According to our hypothesis, photographic images have actively promoted and even invented the emergence of a specific ideology of the Bregenzerwald (*"Talschaft* ideology").[1]

I had the privilege of meeting the photographer Hedwig Berchtel, née Hiller, when she retired from her active professional life, at a time when the end of the analog age in photography was looming. As a photographer and historian, I have learned a great deal from her about historical photographic practices. Hedwig Berchtel offered me the opportunity to work on the Hiller photographs in the private and business archives early on and to publish a first essay on this topic.[2] I am currently preparing an exhibition and book project with a team of experts about the *Fotohaus* Hiller for the Vorarlberg Museum in 2023. The publication of exemplary pictures presented here offers a first insight into the work carried out in close cooperation with the descendants of the Hiller family.[3]

The Hiller Photo Studio: Creator of Images in the Analog Age

The founder of the photographer's business was Johann Kaspar Hiller. He was born in 1887 in Reuthe in the Bregenzerwald into a family with seven children. In 1904, he trained as a sculptor in Gebrazhofen in the nearby German Allgäu region. During this time he taught himself the craft of photography, initially probably to document his sculptures. After his

return from service in the First World War, Hiller devoted himself more
and more to photography as an independent medium. In 1923, he founded
a photo studio in the house of his in-laws in Bezau, which quickly devel-
oped into a successful family business. All five children from his marriage
to Maria Hiller, née Dünser (1890–1971), were involved in the photog-
raphy business. Two of them, Kaspar Hiller, Jr. (1923–1958) and Hedwig
Berchtel (1927–2017), gradually took over responsibility for the operation
after the death of Johann Kaspar Hiller in 1946. Hedwig Berchtel was the
first woman in Vorarlberg to take the photographers' master examination
in 1959. She represents an unusual woman's success story in a tradition-
ally male-dominated professional field. In the 1960s, she had her parents'
old Bregenzerwald house renovated and extended by the young architect
Leopold Kaufmann (1932–2019) and adapted it to the needs of a modern
photography business with a photo studio, darkroom and sales outlet.[4]

The history of the *Fotohaus* Hiller exemplifies the social tasks and the
position of a photographer in a rural community—a historical role that has
practically dissolved in the digital age of mobile phone photography and
the practice of social networking on the internet. In her essay "Proxy Politics:
Signal and Noise," the German artist and media theorist Hito Steyerl
described digital photography and video in 2014 as a "social projector" that
was no longer based on the classic camera recording device: "The camera
turns into a social projector rather than a recorder. It shows a superposition
of what it thinks you might want to look like plus what others think you
should buy or be. But technology rarely does things on its own." She adds:
"Technology is programmed with conflicting goals and by many entities, and
politics is a matter of defining how to separate its noise from its information."[5]

Our digital images no longer result from a "recording" on a film materi-
al but are calculated from algorithms and embellished accordingly. They are
only similar to what we have called by the collective term "photography" for
almost two centuries. Our "selfie culture" basically no longer needs an exter-
nal image manufacturer. It certainly does not require an original negative
for reordering a print or even a photo shop where you can buy cameras and
rolls of film or have your pictures developed and enlarged. The smartphone
is—to put it in the old terms—both a "recording" and "displaying device"
at the same time. Ninety percent of all images today are taken from our
mobile phones, which we carry with us all the time. We have all become
photographers. In the universe of flowing data streams, however, the images
on our small and large screens evaporate in seconds. They are only mate-
rialized as paper images in exceptional cases. This development began in
the 1990s, exactly at the time when Hedwig Berchtel retired and closed

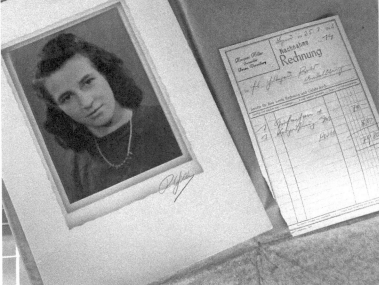

Figs. 1 and 2: An envelope with the enlargement of a portrait and original invoice from 1948 was never picked up; we discovered and opened it more than seventy years later during our research in the *Fotohaus* Hiller Archives in a closed state. Photograph: Arno Gisinger

her photography business. This was not so long ago, and yet today we look back on Hiller's negative holdings as an unusual treasure trove of images, in which the lived time seems to have been suspended in the form of hundreds of postcard views and thousands of portraits.

In her 1936 dissertation, the German photographer Gisèle Freund was one of the first social researchers to investigate the connections between the invention of photography and the visual self-assurance of the bourgeoisie in the 19th century.[6]

In the 1960s, the French sociologist Pierre Bourdieu referred to the importance of photography as a medium of social construction and cohesion, in his collective study *Photography: A Middle-Brow Art*. In particular, he examined their social uses in the form of ritualized and standardized photography.[7] In the latest approaches to the history of French photography, the wide field of "*photographie vernaculaire*"—best translated with "typical of a place" or "native to place"—is now one of the most fertile fields of study.[8] Our project is part of the tradition of such sociological and cultural anthropological research in photography as it was practiced *before* the digital revolution. If we want to do justice to the Hiller Collection out of the pragmatic necessities of its creation, we find that there are two essential, complementary focal points that have created the socialization process through photography. On the one hand, images of human beings in the form of portraits (interior representation and self-assurance), and on the other hand, landscape images in the form of postcards (external representation and external perception). In the following, some such image ensembles we are currently researching will be presented as examples.

Images of Human Beings

In his monumental work "People of the 20th Century," the German photographer August Sander tried to create a comparative sociological study of German society through portrait photography in the interwar period. Sander had originally been a studio photographer. Under the influence of the ideas of modernism in the 1920s, he developed a concept that went beyond the principle of pure documentary photography. Sander's work has taught us that photographic images not only "document" societies and their living conditions, but actively "construct them."[9]

Fig. 3 and Fig. 4: Full-body portraits of a boy and a girl during First Communion weekend, 1938, taken by Johann Kaspar Hiller in his Bezau Studio with natural light and against a painted background.

The application of the same photographic device creates community in the image and through the image. For example, all the Catholic youth of the back portion of the Bregenzerwald Valley were photographed at *Fotohaus Hiller* on the occasion of their First Communion on "White Sunday" (the Sunday after Easter). This process, despite all individual differences, created a visually defined community. Virtually all the parents of these children who took first communion ordered one (or more) photographs as a reminder of this important family day in the Catholic calendar. While the images were kept as objects in the families in the form of prints, the negatives remained in the archive of the photographer's studio for reordering. They were labelled, registered and carefully stored there. They formed, so to speak, the social and economic treasure trove of the photo studio that could potentially be reactivated at any time.

The genre of school photographs was another important task of the photographer. Especially in the case of complex shots of larger groups by means of a large format camera and tripod, the photographer had a monopoly on image production and reproduction. The photographic act required his models to pose in concentration facing the camera. This is demonstrated here by two examples of the two schools in Bezau and Schwarzenberg from the period immediately before the Second World War.

Fig. 5: School Photograph Bezau, 1938–1939 and Fig. 6: School Photograph Schwarzenberg, 1939. Photograph: Johann Kaspar Hiller.

However, the daily core business of Foto Hiller's activities represented the studio portraits. On closer inspection, we notice different practices. We find portrait sessions with different image sections (from headshot to full-body portrait), with or without concrete cause and purpose, but always based on a constructive dialogue between photographer and model. These photographs that over the years have visually captured almost all the inhabitants of Bezau and the surrounding villages, now offer a haunting source of social history. Two examples of studio photographs, taken over half a century apart, make it clear that the objectifying camera view in the same studio makes no distinction between the life backgrounds and the political context of the persons depicted. Nevertheless, the biographies of a person proudly sporting his Nazi badges from the neighboring village of Mellau shortly after the annexation ("Anschluss") of Austria to the Third Reich in 1938 and the two Turkish migrant workers in the early 1970s could not be more different.

Fig. 7: Studio portrait of A. L. with Nazi badge from Mellau, immediately after the "Anschluss" in 1938. Photograph: Johann Kaspar Hiller

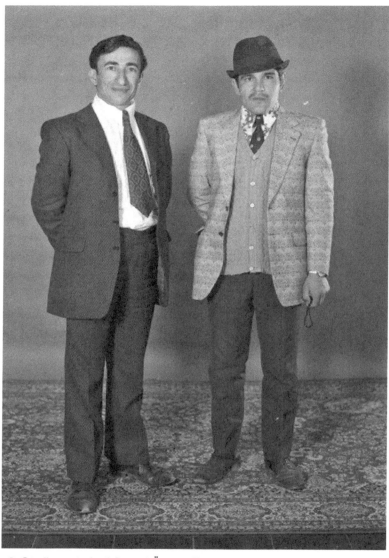

Fig. 8: Studio portrait of C. and Ö., two Turkish migrant workers in Bezau, early
1970s (original in color). Photograph: Hedwig Berchtel

Traditionally, the photographer accompanied an individual's life jour-
ney from the cradle to the grave. Two examples demonstrate this life cycle,
capturing the entry into as well as the farewell from life, figuratively and
symbolically.

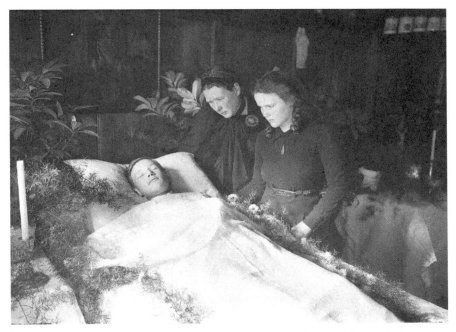

Fig. 9: Deathbed W., Bezau, 1939, Photograph: Johann Kaspar Hiller

Fig. 10: Child of Teacher A., Bezau, 1940, Photograph: Johann Kaspar Hiller

The postmortem photograph from Bezau in 1939 (Fig. 9) allows us to take part in a particularly haunting situation. Mother and daughter mourn their son and brother, who died too early, at the richly decorated deathbed. We can imagine the photographer Johann Kaspar Hiller, who knows the grieving family well. At their request, Hiller takes a final picture to preserve the deceased's memory. Hiller has set up his camera from the window side. The composition of the picture is as simple as it is balanced: on the left a white candle in the foreground with a small side table and a Madonna in the background. Nothing is left to chance. In the middle, the two women stand and look seriously at the peacefully sleepy face of the dead young man. The photographer loads his glass plate negative into the cumbersome apparatus and asks the two women to stand still for a few seconds during the exposure time. He disappears from his own image, so to speak. Eighty years later, we take his place to symbolically participate in this farewell. Until the 1970s, Hedwig Berchtel told me, such pictures were still ordered from the photo studio in the Bregenzerwald. These images hail from a time when the pictorial representation of death was not yet taboo.[10]

Photographs of transitional rites in the Catholic calendar are the visual framework for comparison over several generations of inhabitants of the Bregenzerwald. Wedding pictures—staged portraits in the studio and later also coverage of full weddings—depicted a further central moment in adult life: the foundation of one's own family.

Fig. 11: Wedding picture F., Lingenau, 1945. Photo: Johann Kaspar Hiller

An example of a comparative long-term study of "*Jahrgänger*" (village cohorts of people born in the same year) can be carried out in the portraits of the so-called "*Spielbuben*," a tradition that is maintained in the Alemannic region to the present day. General conscription called for male military service and was preceded by a medical examination. Entire cohorts of boys born in the same year in the same village were called for going through a medical examination ("*Musterung*") on the same day. The "*Spielbuben*" decorated their hats with colorful flowers and colored ribbons, later used as garters for their brides and as ornaments for their first common spinning wheel. It was a custom for the "*Spielbuben*" to walk through the village with a decorated hay wagon and collect money to spend at the village inn. Stopping by the photo studio to capture this important moment was part of the ritual. Here are two examples with a 40-year gap between them.

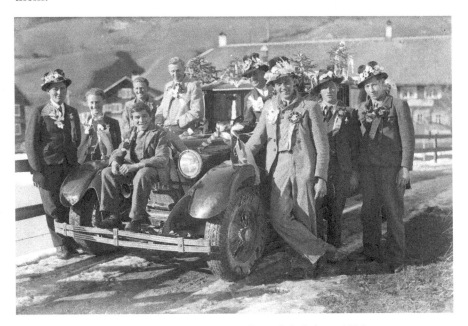

Fig. 12: *Spielbuben* 1913 cohort, Schröcken, 1939.
Photograph: Johann Kaspar Hiller

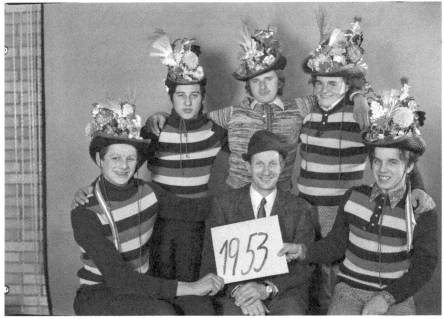

Fig. 13: *Spielbuben* 1953 cohort, Bezau, early 1970s (original in color).
Photograph: Hedwig Berchtel

Landscapes

The extensive collection of negatives of postcards with landscape motifs stretches from the 1930s to the late 1950s (containing over a thousand pictures). But even beyond this time, certain motifs were repeated again and again and continued to be bought. They mainly include photographs taken by Kaspar Hiller Sr. and Jr. In the Hiller photo studio Hedwig Berchtel specialized in portrait photography and was less interested in landscapes. In addition to his own production, Johann Kasper Hiller already in the 1930s had acquired a collection of negatives from Foto Heim in Dornbirn (a total of 211 glass plates); these he integrated into his own collection.[11]

In the case of postcards, the reproduction of the images worked according to the principle of the contact print in the format 1:1: one print (a negative after careful retouching directly on the glass plate) was sufficient to produce hundreds of postcards in the form of "real photographs," thereafter circulated commercially. Johann Kaspar Hiller rightly saw great new market potential in the postcard genre. With his excellently lit and precisely composed landscape images, he contributed significantly to

the visual distribution of the picturesque image of the Bregenzerwald.[12] Postcard production not only allows the construction of an "ideal" view of the Bregenzerwald as a tourism region, but also suggests concrete changes in the region's settlement history and lived environment. The historical landscapes in the form of postcards serve us today as a valuable historical source for the survey of the structural developments and the environmental changes of the Bregenzerwald.[13]

Fig. 14 and Fig. 15 show two ideal postcard views with motifs in summer (Reuthe-Bajen) and in winter (ski area Neuhornbach with a view of the Kanisfluh), 1930s. Photographs: Johann Kaspar Hiller

The Hiller Project: A Methodological Outlook

In photo history research, there has not yet been a study that has systematically researched such a complete photo archive, concentrating on the rural context.[14] Our research project is committed to the methodologies of visual history by trying to look at the Hiller Photo Studio collection from a dual perspective. On the one hand, we take the collection at face value as images of their time. We question the photographs as cultural-historical objects of photo history from the end of the analog age. Particular attention is being given to the social role of the photographer in a rural, Catholic-dominated society. The second perspective examines the images according to their content: what do they represent and how do they do it in each case. This second axis is about photographic images as sources of historical, political, and cultural knowledge in the sense of a new, transdisciplinary visual history.[15]

Examples include pictures with people in their folk costumes (*"Trachten"*). In the Hiller Photo Archives, the wearing of such folk costumes is a recurring motif. Either people allowed themselves to be consciously photographed in their folk costumes, or they were wearing folk costumes by chance. Hiller also staged pictures of people in folk costumes, thus transporting ideas of self-confident people inside the Bregenzerwald, as well as tourist images to the outside. The widespread distribution of these images as postcards suggests that Johann Kaspar Hiller not only passively depicted certain ideas and regional customs, but on top of it actively constructed them. This becomes clear in the explicitly "tongue-in-cheek" studio pictures circulating as postcards. The examples of numerous tourists photographed in the spectacular Bregenzerwald folk costumes are another indicator of this hypothesis.

Only in this sense does our approach see itself as an extension of the documentary concept in photography. Photographs not only "document" historical worlds, they also "construct" them. The Hiller project therefore tries to answer various research questions about their photographic form in the form of a collaborative work process: photography as a *rite de passage* in the rural Catholic context, transformations in the landscape, and the beginnings of modern tourism as mirrored in postcards, the question of women working and emancipation through photography and much more.[16] We are not concerned with a nostalgic view of the most beautiful pictures from the idyllic Bregenzerwald. Rather, economic, political, religious, professional, or gender-specific issues are in the foreground in order to question our image-oriented society today. Maybe analog photography was already a "social projector" that only the systematic exploration of archives and the activation of the negatives can light up.

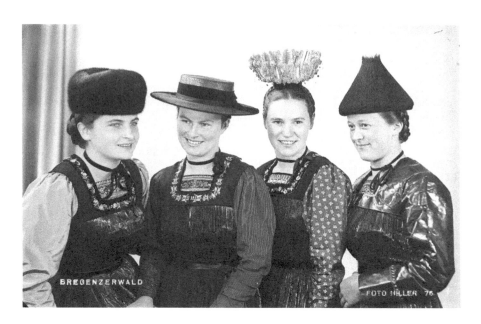

Fig. 16 and Fig. 17: Two postcard motifs with women and children in folk costumes, each staged in the studio and labelled "Bregenzerwald." Photographs: Hedwig Berchtel (above, 1960s), and Johann Kaspar Hiller (below, 1930s).

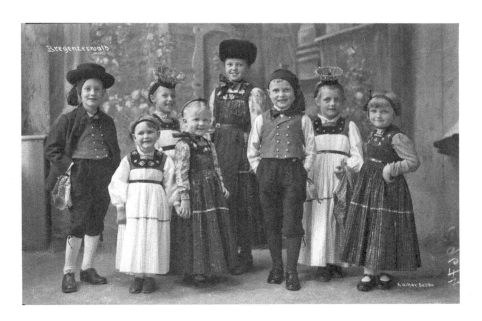

Endnotes

1 On the formation of a 19th century "Talschaft ideology" of the Bregenzerwald, see Alois Niederstätter, *Wäldar ka nüd jedar sin! Eine Geschichte des Bregenzerwalds* (Innsbruck: Universitätsverlag Wagner, 2020).

2 Arno Gisinger, "Im Schatten der Fotogeschichte: die Bezauer Fotografenfamilie Hiller," in *Aus der Wälder Geschichte: Dokumentation der Vortragsreihe "Wälder Geschichtstage" im März 1998*, ed. Silva Brigantina and Wälder Versicherung VaG (no place, 1998) 77–102. This article mainly deals with professional and technical aspects of early photo studio photography in the rural context.

3 The Hiller family has left the entire archives of the original negatives to the Archives of the Bregenzerwald in Egg, which will preserve the collection according to professional standards. The Vorarlberg State Library in Bregenz is another partner in this project. Starting in 2023 they will make some of these pictures digitally accessible on their platform *Volare* https://pid.volare.vorarlberg.at (accessed March 18, 2021).

4 The Vorarlberg architects Innauer Matt are currently planning a redesign into a new house with a different use of the historical part of the current building; yet it will keep the memory of its photographic past alive.

5 Hito Steyerl, "Proxy Politics: Signal and Noise," *e-flux* 60 (December 2014), accessed March 18, 2021, https://www.e-flux.com/journal/60/61045/proxy-politics-signal-and-noise/.

6 Gisèle Freund's dissertation was only published in 1968 in German as *Photographie und bürgerliche Gesellschaft: Eine kunstsoziologische Studie*. Today this book is available as a Rowohlt paperback with the title *Photographie und Gesellschaft* (1997). Recently the exhibition "Nadar" in Paris was dedicated to portrait photography in the urban context. We still do not have a monograph on portrait photography in the rural context that might shine a light on the Hiller collection.

7 Pierre Bourdieu, ed., *Eine illegitime Kunst: Die sozialen Gebrauchsweisen der Photographie* (Frankfurt am Main,1983, new ed. 2014). The original was published as *Un art moyen: Essai sur les usages sociaux de la photographie* (Paris: éditions Minuit, 1965).

8 Clément Chéroux, *Vernaculaires: Essais d'histoire de la photographie* (Cherbourg: Le Point du Jour, 2013); Clément Chéroux, "The Art of the Oxymoron: The Vernacular Style of Walker Evans," in *Walker Evans*, exhibition catalog Centre Pompidou (DelMonico Books/Prestel Verlag, 2017), 8–14; Tina Campt, Marianne Hirsch, Gil Hochberg, and Brian Wallis, eds., *Imagining Everyday Life: Engagements with Vernacular Photography* (Göttingen: Steidl Verlag, 2020).

9 August Sander, *Menschen des 20. Jahrhunderts: Die Gesamtausgabe* (Munich: Schirmer Mosel Verlag, 2002).

10 Arno Gisinger, "Von Tod und Tabu in der Fotografie," in *Ansichten: Frühe Fotografie aus Vorarlberg*, ed. Tobias G. Natter (Bregenz: exhibition catalog

Vorarlberger Landesmuseum, 2008), 44–51. On the general theme of death culture, see Rita Bertolini, ed., *Sterbstund* (Egg: Verlag Rita Bertolini, 2015).

11 Leonhard Heim had a photo studio in Dornbirn. The Dornbirn City Archive is working on digitizing 4,000 negatives from the Heim collection.

12 The power of such images today can be seen from a 2018 commission from the *British Journal of Photography* for the British photographer Catherine Hyland, see Hanna Abel-Hirsch, "When Everything is so Beautiful, What Do You Photograph?," *1854.photography*, May 18, 2018, accessed March 18, 2021, https://www.bjp-online.com/2018/05/catherine-hyland-austria-bregenzerwald/.

13 Robert Gross, a Vorarlberg environmental historian, uses the postcards produced by the photo studio Risch-Lau as historical sources to document the transformation from agrarian landscapes to tourism landscapes in Vorarlberg, see *Die Beschleunigung der Berge: Eine Umweltgeschichte des Wintertourismus in Vorarlberg/Österreich 1920–2010*, Umwelthistorische Forschungen 7 (Vienna: Böhlau, 2019).

14 Recently such a project was done on the 19th century urban context of the German city of Dresden, resulting in a rich publication, see Wolfgang Hesse and Holger Starke, eds., *Die im Licht steh'n: Fotografische Porträts Dresdner Bürger des 19. Jahrhunderts* (Marburg: Jonas Verlag, 2019).

15 Last shown by Irene Ziehe and Ulrich Hägele, eds., *Eine Fotografie: Über die transdisziplinären Möglichkeiten der Bildforschung*, Visuelle Kultur: Studien und Materialien 12 (Münster: Waxmann Verlag, 2017).

16 The researchers of the project are Robert Fabach (architecture), Robert Gross (environment and tourism), Nikolaus Hagen (the era of National Socialism and World War II), Katrin Netter und Stefania Pitscheider-Soraperra (Women's history), Maria Rose Steurer-Lang (folk costumes and ethnography), as well as Helmut Tiefenthaler and Rudolf Berchtel (changing environments).

Austrian Empire & World War I

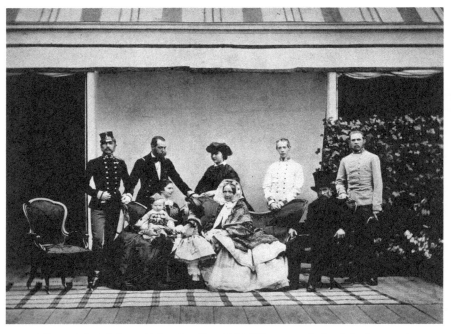

Fig. 1: Allerhöchste Kaiserfamilie, 1860 (Photograph: Ludwig Angerer)

Ludwig Angerer (1827–1879), Court Photographer

Michaela Pfundner

"Wer jemals das Atelier desselben besucht hat, weiss, dass dieser geschickte Künstler in seinen Matrizen das Material besitzt, für sich allein 20 Säle der Ausstellung mit interessanten Bildern zu füllen, indem die ganze Aristokratie der Geburt wie des Genies. welche Oesterreich aufweiset, bei ihm sich wenigstens einmal hat photographiren lassen, und an Vollendung ein Bild wahrhaft mit dem anderen wetteifert."[1]

Twenty years after its invention, photography became increasingly widespread and respected in the Austrian Empire. So much so that the Austrian imperial house recognized the potential of photography as a means of political representation, and thus embarked on the path of modern visual communication.

The first photographs of Emperor Francis Joseph[2] that have come down to us were taken as part of a group photograph of the imperial family, a shot that has been published and reproduced very frequently to this day. We can see the emperor with his wife Elisabeth and their children Gisela and Rudolf, as well as the emperor's three brothers—Archduke Ferdinand Max (later Emperor Maximilian of Mexico) with his wife Charlotte, Archduke Karl Ludwig and the baby of the family, Archduke Ludwig Viktor. Also present are the emperor's parents, Archduchess Sophie and Archduke Franz Karl. (Fig. 1: Allerhöchste Kaiserfamilie, 1860)

This is the only known photograph of the emperor together with his wife and the only known photograph of Elisabeth with her children. The empress often liked to be photographed— alone, with siblings, court ladies, or dogs, but never with her husband or her children. Numerous collages were circulated to remedy the shortcoming of the missing family photos and to give the people the image of an intact imperial family.

The "Allerhöchste Kaiserfamilie" is a picture taken in a less imperial setting by Viennese studio photographer Ludwig Angerer.[3] Arranged neither in a studio, nor in a magnificent interior, nor against the imposing backdrop of a palace, it seems more like a casually taken family photo with improvised furniture. It was taken on the east terrace of Schönbrunn Palace; a terrace with a wooden floor and awnings, located directly next to the cabinet and bedroom of Archduchess Sophie. We can only speculate about the choice

of location; the good lighting conditions or the space available here for the large number of people may have played a role.

The date of the photograph is most likely around the unveiling of the Archduke Karl monument in Vienna on May 22, 1860. In order to attend this ceremonial act, all the people gathered in the family photograph were in Vienna, which was not a matter of course.[4]

As a by-product of this, the first two known individual portraits of the Austrian emperor were taken. One photo shows Francis Joseph in uniform without cap, looking very seriously into the camera. In the second photo, he wears the *Tschako* (cap) on his head, looking similarly slanted and thus a bit dashing as in the family photo; his left hand slightly propped up on the adjacent armchair, his gaze focused directly on the viewer.

Who is the photographer Ludwig Angerer who made these iconic images? Why was he chosen for this assignment and what did these photos mean for his career?

Ludwig Angerer was born in 1827 in Malacky, which is in present-day Slovakia, 35 km north of Bratislava, where he grew up with three brothers and two sisters. His father worked as a clerk in the Palffy family castle there.[5] He studied pharmacy in Bratislava and Budapest and was therefore familiar with chemical processes, which would be very beneficial to his photographic career. Between 1848 and 1853 he worked in Tata (Hungary), Vienna, Graz, and Budapest. In 1854, he entered the service of the army as a field pharmacist.[6] This assignment took him to the Balkans, specifically to the Danubian principalities of Moldavia and Wallachia. Here is where he began to work as a photographer. He captured essential military and politically significant scenes, documented the civilian population, and took the first photographs of Bucharest in 1856.[7] (Fig. 2: Bucharest, 1856) Commissioned by Count Coronini, the supreme commander of the Austrian troops in Bucharest, Angerer photographed for the first time the cathedral of Curtea de Argeș, which houses the burial place of the Romanian dynasty. These outstanding photographs attracted the attention of Archduke Ferdinand Max,[8] who awarded Angerer with a brilliant pin[9]. The photographs began to be reproduced as lithographs in a publication as early as 1860[10].

In 1857, Angerer finished his military service and returned to Vienna. He began to work full-time as a photographer and moved into a studio in the Feldgasse,[11] in what was then the suburb of Wieden. His first documented photographs in Vienna were two images of the Kärntnertor shortly before its demolition as part of the city expansion in 1858,[12] a panorama of Vienna,[13] and a photo documentation of a yard wagon of the Südbahn and its artistic interior design by Franz Schönthaler[14]. In this early period, he

collaborated with the photographer Hugo von Strassern,[15] who had already worked with Angerer on photography previously, in the Balkans.[16]

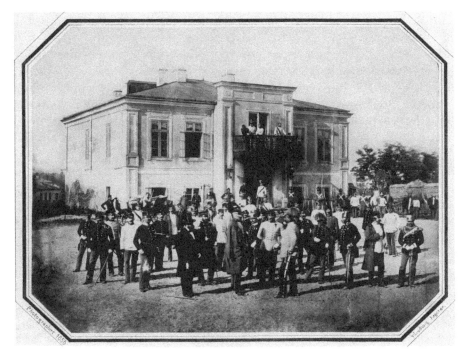

Fig. 2: Bucharest, 1856 (Photograph: Ludwig Angerer)

But these photographic subjects would not remain the focus of Ludwig Angerer's work in the years to come. He increasingly shifted his focus to portraits, especially in the relatively new "Carte de Visite" format, which originated in France and of which he became the most important representative in Vienna. Carte de visite was the first standard size (6x9cm) in photography and made easily reproducible and inexpensive copies possible. The very thin paper prints made of albumen were mounted on cardboards, which in turn served as advertising media for the studios, since on the backs—in addition to the name and address of the studio and any court titles—the participation in photographic exhibitions and the medals or awards won were noted. On the front side, under the pasted photo, there was space for the owner to add the name of the person depicted or personal remarks, providing opportunity for individualization.

Due to the affordable price of these images, it was now possible for a broader segment of the population to have photos of themselves made in

a studio, predominantly a full-body portrait. This type of photography was characterized by a relatively rigid and standardized mode of representation, taken in a studio setting with balustrades, curtains, tables or other accessories. The people portrayed looked seriously into the camera, and so the shots very often appeared stiff and lifeless. Individuality in portrayal was only rarely called for; representation and role clichés determined the pose.

However, it was not just one's own portrait that held interest. In the art shops, one could purchase carte de visite photographs of members of the imperial family, of army leaders, artists, dancers, or actors, thinking that one was thus participating in their fame or bravery, or would like to own them as a souvenir of a visit to the theater or as an early rapturous "star postcard." This led to a lively collecting activity, especially since these pictures were available at a reasonable price.

In families, these small photos were put into specially made albums. In a picture chronicle, they told of one's own life, relatives, acquaintances, and friends, but also of longings and preferences, manifested in the purchased photographs.

Ludwig Angerer advanced to become Vienna's most sought-after studio photographer in less than two years. His familiarity with the Austrian imperial family made a significant contribution to this. One can only speculate how he received the assignment of the imperial family photo—possibly through Count Coronini, a former educator of Emperor Francis Joseph, who got to know and appreciate Angerer in the Balkans, or the at least indirect acquaintance with Archduke Ferdinand Max.

With this photograph of the Austrian imperial family, Angerer was at the photographic height of his time. In 1859, the well-known French photographer André Adolphe-Eugène Disdéri took a photograph in Paris of the French Emperor Napoleon III with his wife and their son. The picture of the emperor in civilian clothes and in an intimate setting was an absolute novelty in the depiction of a sovereign. It sold numerous copies of cartes de visite.

At about the same time as the Austrian imperial family, the successful English photographer John Edwin Mayall took a photo of the British royal family, centering on Queen Victoria. This image also became a much sought-after and popular collector's photo, distinguished by its private view of a "completely normal" family.

Ludwig Angerer's "Allerhöchste Kaiserfamilie" also found its way into the contemporary press, and the newspaper *Der Zwischen-Akt* raved as early as June 1860: "*Ein reizendes Bild: die kaiserliche Familie darstellend, erregt wegen der ausgezeichneten Gruppierung und Schärfe des Porträts allgemeine*

Bewunderung."[17] As a conclusion to the article, a direct recommendation was made: "*Wer ein ausgezeichnetes photographisches Porträt besitzen will, dem rathen wir, Herrn Angerer zu besuchen.*"[18]

Ludwig Angerer, like the photographers Franz Antoine, Andreas Groll, and Adolf Ost,[19] recorded the unveiling of the Archduke Karl Monument. Here he benefitted from his photographic experience outside the studio. He positioned himself on the roof of the Burgtor and documented this festive event, in which the entire imperial family took part, in at least three large-format photographs.[20]

The year 1860 was a key professional year for Ludwig Angerer and led to an enormous career boost. In the fall of that year, the Austrian Empress Elisabeth had herself photographed in his studio shortly before her departure to Madeira. These photographs also became sought-after collector's photos and contribute to the myth of her beauty. Elisabeth looked directly into the camera in these photographs, in contrast to the imperial family photo, in which she tilted her gaze to the side. The empress visited Ludwig Angerer's studio for several more remarkable sessions, including one in 1862 with her favorite brother, Carl Theodor. In 1863, another series of portraits produced the iconic image of the empress with her famous braided hairdo, and in 1864 Angerer photographed two more series showing Elisabeth with her dogs. 1868 was her last visit to Ludwig Angerer's studio. A photograph of this final portrait series—retouched on the occasion of the empress's death in 1898—was widely circulated a second time.

The photograph of the imperial family and the individual portraits of Francis Joseph and Elisabeth were advertised in 1861 in the *Oesterreichische Catalog*[21] and offered for sale at the most important art dealers in Vienna. At this time one could also browse through a list of 438 people, including other members of the imperial family, aristocrats and friendly royal houses, politicians, actors, dancers, and other well-known personalities, who also had been photographed in the Angerer studio. These carte de visite photos were available in the art shop Bermann at a price of 70 Kreuzer[22] per piece and became popular objects of purchase.

At the same time, Angerer also became aware of the dark side of this massive distribution of his carte de visite portraits. The art dealer L.T. Neumann took advantage of the photographer's absence due to summer holiday[23] to have more prints of the imperial family photo made without permission. Angerer defended himself and publicized the fact by means of prominent advertisements in daily newspapers, in which he complained above all about the "*mangelhafte Beschaffenheit der mir zugeschriebenen Abbildung,*"[24] which damaged his reputation as a studio photographer.

Prints with the producer's note "L.T. Neumann" are still circulating today, which actually differ greatly in quality from Angerer's original prints.

The problem of the lack of copyright protection continued to be an issue in the following years, as there were sound economic reasons for advocating regulated protection, especially for the widespread carte de visite photography. The "Photographische Gesellschaft," founded in 1861 with the participation of Ludwig Angerer, also regarded itself as representing the interests of photographers and their business.

The law protecting "literary-artistic" property in force at the time made no mention of photography. As late as 1864, Ludwig Angerer, together with his fellow photographer Julius Leth, filed a lawsuit against two art dealers for unlawful reproduction of photographs created by them.

For Angerer, carte de visite photography was the most lucrative and prestigious branch of his profession, as the dissemination of his images contributed to an ever-increasing level of recognition and more and more jobs.

This reputation was further enhanced by the award of the title of Court Photographer to Ludwig Angerer on December 25, 1860, marking the climax of a very successful professional year. Angerer was the first photographer to receive the title of "Court Photographer."[25] The application for the title was submitted by Ludwig Angerer in November 1860, accompanied by a *"Portefeuille mit Photographien nebst einem Cuvert mit sehr kleinen photographischen Porträts."*[26] These objects were returned to him by the Obersthofmeisteramt on December 26, 1860. Unfortunately, the contents of the portfolio are still unknown. It is possible that these were photographs from his time in the Balkans, and the imperial family photo, and that the very small photographic portraits were probably a representative selection of his carte de visite pictures.

Naturally, Angerer immediately printed the title of the court on the back of his cartons, which led to a further boom in the studio. The Photographische Gesellschaft reported:

"So waren im Atelier des ehemaligen Pharmazeuten Ludwig Angerer wochenlange Vormerkungen notwendig, um endlich zu einem Bilde zu kommen, vor dem Haus standen Wagen an Wagen und brachten das vornehmste Publicum."[27]

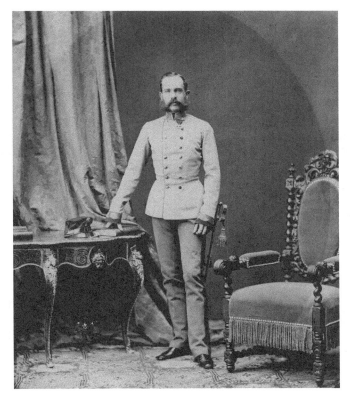

Fig. 3: Portrait of Francis Joseph, 1863 (Photograph: Ludwig Angerer)

The first documented visit by Emperor Francis Joseph to Angerer's studio took place in May 1861, "*nachdem eine kürzlich von Herrn Angerer gelieferte Photographie des Erzherzog Ludwig Viktor und des jungen Grafen Kolowrat das Wohlgefallen Se. Majestät in besonderem Grade gefunden hatte.*"[28] Franz Joseph had himself photographed, both with his children, Rudolf and Gisela, and individually. The pictures were intended as a gift for Empress Elisabeth.[29]

Franz Joseph's mother, Archduchess Sophie, also visited the studio for portraits in July 1862, and again a few years later together with her twin sister, Marie.

Due to the ever increasing number of jobs, Angerer's established studio became too small and not prestigious enough. In 1861 he commissioned the building of a representative house in Theresianumgasse, not far from his current studio, with rooms for his family as well as an imposing glass studio and waiting rooms for the demands of high society, who had their

photographs taken in his studio. His studio caused a great sensation. Alois Nigg reported in the *Photographische Correspondenz*:

> *"Da ich mir hier die Aufgabe gestellt habe, die photographischen Salons ersten Ranges zu besprechen, so sollte ich eigentlich mit dem grossartig-stem derselben, nämlich mit jenem des k.k. Hofphotographen Ludwig Angerer beginnen. Nachdem aber dieses schon bezüglich seiner zu kostspieligen, ganz im Palaststyl durchgeführten Anlage selbst von der haute volée der Lichtbild-Erzeuger kaum mehr eine Nachahmung erleben dürfte, so beschränke ich mich blos auf einige Andeutungen über das Grundprincip alles von diesem Matador der Photographie errichteten Salons."*[30]

Angerer knew about the danger of stereotypes and monotony in carte de visite photography, with the ever same balustrades, columns, curtains, tables, armchairs, and accessories. He tried to counteract these clichés by using particularly high-quality and varied furnishings, and to overcome the danger of confusion—which he of course tries to avoid at all costs—with natural-looking attitudes, or even by using extraordinary poses. He rarely used painted backgrounds so as not to distract from the person portrayed. Nevertheless, a feuilletonist qualified his visiting card pictures as stiff and boring:

> *"Auf den Bildern Angerers herrscht eine Art bureaukratischer Ton. Abgezirkelte Eleganz, ebensofern von der Nonchalance als Extravaganz, sozusagen ein solider Geschmack, ein konservatives Element: Stellung, Toilette, Anordnung bilden ein juste Milieu von steifer Anmuth, bewußtem Anstand wie gemäßigter und geordneter Eleganz. Mit einem Mädchen, das sich jetzt noch, nachdem es das Prestige der Mode theilt, bei Angerer photographiren läßt, wird man nicht ekstatisch, aber ziemlich ruhig und sicher durch's Leben gehen können. Pensionirte Staatsmänner haben eine besondere Vorliebe für diesen Photographen."*[31]

In 1863, a series of photographs of the participants in the so-called "Caroussel"—a charity event of the Austrian high nobility, who, in fanciful historicist dress, presented riding demonstrations to an audience on three evenings—proved to be a particularly high-profile commission.[32] Less than a month later, carte de visite images of all the participating aristocrats in their splendid costumes were on sale at art dealers; both studio shots and extraordinary photographs of the aristocrats with horses

in the lavish garden of Angerer's house. The contemporary press praised in the highest tones:

"Diese Photographien sind die schönsten, die aus dem berühmten Atelier Angerer hervorgegangen und zeichnen sich durch Schärfe, Plastik und Reinheit der Reproduktion als durch Wärme und Schönheit des Tones aus. Sie sind eine Zierde für jedes Album und eine angenehme Erinnerung an das glänzende Carousel für Jeden, der dasselbe zu sehen Gelegenheit hatte, sowie sie Jedem, der es nicht sah, ein treues Bild der pittoresken mittelalterlichen Costume vor Augen zaubern."[33]

Angerer repeatedly left the comfort zone of the studio and worked outdoors, such as for a series of photographs on the occasion of Crown Prince Rudolf's third birthday. In August 1861, he set out for Reichenau to photograph the prince with his older sister Gisela in front of the so-called "hunting lodge," a gift for Rudolf's birthday. In front of the "Rudolfsvilla" in Reichenau, Emperor Franz Joseph and Empress Elisabeth (in side saddle) also posed on horseback in front of Ludwig Angerer's camera on other occasions—separately, of course.

Shots with children caused great difficulties for most photographers at the time, as they were unwilling to assume the required poses, or if they did, it was only for a short time. Here, too, Angerer proved to be a master of his profession, as numerous portraits of children in carte de visite format testify. In addition to the previously mentioned photos of Crown Prince Rudolf and Archduchess Gisela, there are also pictures of the nearly two-year-old Archduke Franz Ferdinand from 1865, who became heir to the throne after the suicide of Crown Prince Rudolf in 1889.

A special trademark of his art became the group pictures, for which he received great approval at numerous photographic exhibitions. In contemporary professional publications, the quality and artistic arrangement of these group pictures were emphasized.

Due to the spaciousness of his newly built studio, and with the help of a large number of high-quality furnishings and accessories, he created impressive photographs, especially of aristocratic families, who were among his most important clients. These images aimed to give the impression of being part of a family conversation or a private piano recital. To this day, the carefully composed photographs appear less stiff and formal than the more common individual portraits. The *Photographische Correspondenz* wrote about Angerer's group photographs on the occasion of the first photo exhibition in Vienna:

"Gruppenbilder (...) wofür sich in der ganzen Ausstellung keine Concurrenz findet, da nicht einmal so viele Ateliers über den dazu nöthigen Raum verfügen. (...) die Vertheilung der Figuren ist so sinnig um verschiedene Centralpunkte geordnet, das Ameublement ein so reiches und geschickt benutztes, dass man glaubt in eine glänzende Gesellschaft zu treten, die sich eben in ungezwungenen Gruppen zu heiterem Geplauder auflöset, so dass nirgends eine Spur des Absichtlichen, des Arrangirten hervortritt."[34]

The English trade journal *The Photographic News* also raved about the quality of the group pictures: "The scene is simple and domestic: a family group at home. The photograph is by Herr Angerer, and is most excellent; the grouping is admirably managed, the photography exquisitely perfect and delicate, at once excellent in definition, light and shade and pictorial effect."[35]

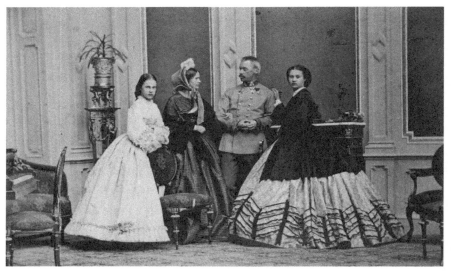

Fig. 4: Group picture, probably 1862 (Photograph: Ludwig Angerer)

In 1864, the Austrian emperor had himself photographed together with his three brothers in various constellations by Ludwig Angerer.[36] A very relaxed-looking Franz Joseph posed with a cigarillo, obviously in a good mood in front of the camera in the studio.

Angerer gained an international profile partially through photographs of foreign sovereigns staying in Vienna, such as the Swedish or Belgian king, but above all through his participation in photographic exhibitions, for instance at the World's Fairs in London in 1862 or in Paris in 1867, or by sending

photographs to several exhibitions of the Societé Française de Photographie. For Angerer, these events meant not only the presentation of his own work, but also an exchange with colleagues from other countries and an acquaintance with innovative equipment or photographic techniques. He also brought back "souvenirs" from his journeys, such as a travel tent from London or rococo-style furniture from Paris for his studio. Angerer's achievements at these exhibitions were also honored in the form of prize medals. In 1862 it was "für Vortrefflichkeit im Allgemeinen und großer Schärfe der ausgestellten Bilder" ("for excellence in general and great sharpness of the exhibited pictures"). In February 1863, he was awarded the "Goldene Verdienstkreuz mit der Krone" for his participation in the London Exhibition.[37]

In addition to his duties in the studio, traveling to photo exhibitions, and lectures in the context of the Photographische Gesellschaft, he devoted himself to other projects. For his "Album der Zeitgenossen"[38] (Album of Contemporaries), a photographic series of well-known personalities from art and culture that was also offered in large size, he drew inspiration from great international role models such as Alois Löcherer and Franz Hanfstaengl, who also offered photographic series in Germany under the name "Album der Zeitgenossen," (1852–53 and 1853–63, respectively) or the English "Photographic Portraits of Living Celebrities," (1856–59) or in France the "Galerie des Contemporains" (1860–62), compiled by several Parisian photographers.

Together with the very ambitious amateur photographer and founding member of the Photographische Gesellschaft, Achilles Melingo, Angerer also took topographical pictures. In 1861, the two traveled to the Salzkammergut and created an "Album von Ischl und seinen Umgebungen."[39] They also took pictures together in Reichenau.[40] (Fig. 5: Ischl, 1862)

In April 1864, Ludwig Angerer's career, which had been on a steep rise, took another milestone: he became head of the photographic studio at the Museum für Kunst und Industrie (The Museum for Art and Industry, now the Museum für Angewandte Kunst/Museum for Applied Arts) in Vienna, in order to document the museum's objects. In December of the same year, the first catalog on Burgundian garments was published.[41] With photographs of objects from the museum, Angerer entered the Paris World's Fair in 1867 and impressed visitors:

"Besonders waren die Leistungen von Ludwig Angerer Gegenstand allgemeiner Aufmerksamkeit. Seine Gemäldereproduktionen, Photographien industrieller Gegenstände, insbesondere aber seine Aufnahmen für das

k.k. österreichische Museum ernteten allgemeinen Beifall. Von Seite der Jury wurde hauptsächlich berücksichtigt, dass durch die photographische Anstalt des Herrn Angerer eine so reichhaltige Serie vorzüglichster Photographien der verschiedenartigsten Gattungen ausgestellt wurde, wodurch die Productivität und Vielseitigkeit dieser Anstalt und ihre eminente Leistungsfähigkeit in fast allen Fächern der Photographie in solcher Weise zur Geltung gelangte, wie dies von keiner anderen auf der Ausstellung vertretenen photographischen Anstalt geschah."[42]

Fig. 5: Ischl, 1862 (Photograph: Ludwig Angerer)

His continued close relationship with the Austrian imperial court manifested in two extraordinary photographs. In June 1867, Angerer was called to Hetzendorf Palace to photograph Archduchess Mathilde at her deathbed, who had died in agony following a tragic fire accident. At the

end of May 1872, he photographed the mother of Emperor Francis Joseph, Archduchess Sophie, also at her deathbed in the Hofburg.[43]

In January 1868, Ludwig Angerer opened a so-called "Stadtatelier" in Johannesgasse in Vienna's first district. Here mainly portraits were taken, and from 1869 they were also in the larger and more modern cabinet format (10x15cm). The spacious glass studio in Theresianumgasse was used more frequently for group shots and object photography by that time. A photo session with Emperor Francis Joseph also took place in the Stadtatelier in September 1872, which was reported in the contemporary press:

> *"Der Kaiser verweilte nahezu eine halbe Stunde im Angerer'schen Atelier, wo er sich in der Obersten-Uniform seines preußischen Leib-Regimentes Kaiser Franz-Garde-Grenadiere aufnehmen ließ. Die Bilder sind für den Hof in Berlin bestimmt."*[44]

In 1874, Ludwig Angerer's health, which had deteriorated some in recent years, worsened, and his twelve-year-younger brother Viktor, also a successful photographer, joined the two studios as a partner. In the following year, Angerer retired completely and handed over the business to Viktor, who was also given the photographic inheritance in Angerer's testament.[45]

On May 12, 1879, Ludwig Angerer died of pneumonia, leaving behind a wife and four minor children.[46] Obituaries in the daily press and in photographic journals testified to his importance for photography.

What survives of Ludwig Angerer are not only the "Allerhöchste Kaiserfamilie," the first known photographs of the Austrian emperor, iconic shots of Elisabeth always preserved as a young empress, but also a very extensive photographic documentation of Austrian society in the 1860s,[47] the first shots of Bucharest, and a documentation of the holdings of the Austrian Museum of Art and Industry. The impression of a "workaholic" manifests itself. He was always on the pulse of the times, open to all technical innovations, courageous in breaking through carte de visite stereotypes and enormously versatile in his photographic œuvre.

It is far too simplistic to see Ludwig Angerer only as one of the most important representatives of the Viennese studio scene and picture chronicler of the imperial family and the Austrian aristocracy.

Endnotes

1 "Anyone who has ever visited his studio knows that this skillful artist has the material in his matrices to fill 20 halls of the exhibition with interesting pictures himself, with the whole aristocracy of both birth and genius that Austria has to offer having had at least one photograph taken by him and one picture truly competing with the other for perfection." (This and other translations by Christian Stenico). Ludwig Schrank, "Programm," *Photographische Correspondenz*, 1864, 1–14 (here 9).

2 The allegedly first photograph of Francis Joseph, taken by Trutpert Schneider 1854, turns out to be a daguerreotype of a painting or lithograph. See this daguerreotype in Leif Geiges, *T. Schneider & Söhne 1847-1921: Vom Dorfschreiner zum Hofphotographen* (Freiburg/Br.: Schillinger, 1989), 13, 66–67.

3 See in detail to this photo: Michaela Pfundner, "Die 'allerhöchste Kaiserfamilie': Eine Spurensuche," in *Der ewige Kaiser*, ed. Hans Petschar (Vienna: Amalthea, 2016), 153–59.

4 See the letter of Archduchess Sophie to Ferdinand Maximilian from the Hofburg, May 7, 1860: "Morgen ziehen Kinder u. Enkelkinder nach Schönbrunn, dann Anfang Juni nach Laxenburg, die Enkel später nach Reichenau. Im Herbst kommt alles wieder nach Schönbrunn. Papa, Ludw. (Viktor) und ich ziehen am 24ten nach Schönbrunn, um noch 8 Tage mit Kindern und Enkeln dort zuzubringen, damit man nicht glaubte, dass wir uns aus dem Weg laufen..." (Tomorrow the children and grandchildren will move to Schönbrunn, then to Laxenburg at the beginning of June, the grandchildren continuing to Reichenau later. Everyone comes back to Schönbrunn in autumn. Papa, Ludw. (Viktor) and I move to Schönbrunn on the 24th to spend 8 more days there with the children and grandchildren so that no one would assume that we avoid each other ...). Quoted from: Gabriele Praschl-Bichler, *Unsere liebe Sisi* (Vienna: Amalthea, 2008), 171.

5 Martin Macejka, "Fotograf Ludwig Angerer: rodák z Malaciek," *malackepohlady.sk* (Aug. 12, 2012), accessed. Dec. 6, 2020, https://malackepohlady.sk/?p=11182.

6 Gesuch des Photographen Ludwig Angerer um Verleihung des Hoftitels 1860, OeStA/HHStA OMeA 731–12, Österreichisches Staatsarchiv.

7 On Angerer's time in the Balkans see in detail: Anton Holzer, "Im Schatten des Krimkriegs," *Fotogeschichte* 93 (2004), 23ff.

8 An obituary in the *Neue Freie Presse* (May 15, 1879, 4) mentions another connection to Archduke Ferdinand Max: "Bald darauf lud ihn der Erzherzog ein, die Fahrt nach Brasilien mitzumachen, allein Angerer hatte sich in der Feldgasse (jetzige Theresianumgasse) bereits ein Atelier gebaut und beschlossen, sich vollständig der Ausübung seiner Kunst zu widmen." ("Soon after the Archduke invited him to join the trip to Brasil, only Angerer had already built himself a studio on the Feldgasse (nowadays Theresianumgasse) and had decided to focus solely on his art.")

9 *Wiener Zeitung*, April 7, 1858, 24.

10 Ludwig Reissenberger, *Die bischöfliche Klosterkirche bei Kurtea d'Argyisch in der Walachei* (Vienna: Österreichische Staatsdruckerei, 1860).

11 since 1862 Theresianumgasse.

12 Harald Stühlinger, "Die Fotografien der k.k. Hof- und Staatsdruckerei von der Stadtmauer von Wien," (master's thesis, University of Vienna, 2007), 79–80. Signature of the pictures in the Austrian National Library: FKB-Vues Österreich-Ungarn, Wien III, Basteien und Thore / Kärnthner Thor 8, FKB-Vues Österreich-Ungarn, Wien III, Basteien und Thore / Kärnthner Thor 9.

13 *Wiener Zeitung*, April 7, 1858, 24.

14 Museum für Angewandte Kunst, Bibliothek und Kunstblättersammlung, KI 7233-3-2.

15 Adolph Lehmann, *Allgemeines Adreß-Buch nebst Geschäfts-Handbuch für die k.k. Haupt- und Residenzstadt Wien und dessen Umgebung* (Vienna: Förster, 1859), 12; Franz Carl Weidmann, *Neuester illustrirter Fremdenführer in Wien: mit einem Plane der Stadt und Vorstädte*, 7th improved ed., (Vienna: Tendler, 1859), 93.

16 The pictures are also labeled with both names.

17 "A lovely picture: depicting the imperial family, garnering general admiration because of the excellent grouping and sharpness of the portrait." *Der Zwischen-Akt*, June 12, 1860, 2.

18 "We advise anyone who wants to own an excellent photographic portrait to visit Mr. Angerer." Ibid.

19 BAG Pk 3002, 160 (Groll), Pk 3002, 162a (Ost), Pk XX (Antoine), Pk 2602a, b; Pk 4575, 1–3 (Angerer).

20 "Auf einem freigehaltenen Platze oberhalb des Burgthores waren mehrere photographische Apparate aufgestellt, von denen die Feier der Enthüllung in verschiedenen Momenten auf bereit gehaltenen Platten aufgenommen wurde" ("Several photographic devices were set up in a cleared space above the castle gates, from which the celebration of the unveiling was recorded at different times on plates that were kept ready"), *Fremden-Blatt*, May 23, 1860, 1.

21 *Oesterreichischer Catalog, Fünfter Theil: Verzeichniss aller im Jahre 1860 in Oesterreich erschienen Kunstsachen, Photographien und Landkarten* (Vienna: Verlag des Vereins der österreichischen Buchhändler, 1861) 20ff.

22 This corresponds to a contemporary price of € 9,90, according to Historischer Währungsrechner der Oesterreichischen Nationalbank, accessed December 13, 2020, https://www.eurologisch.at/docroot/waehrungsrechner/#/.

23 *Ischler Cur-Liste*, August 18, 1860, 4.

24 "poor quality of the image attributed to me." *Fremden-Blatt*, October 11, 1860, 14; *Wiener Zeitung*, October 13, 1860, 6.

25 OeStA/HHStA OMeA 731-12, Gesuch des Photographen Ludwig Angerer um Verleihung des Hoftitels 1860, Österreichisches Staatsarchiv.

26 "Portfolio with photographs and an envelope with miniature photographic portraits." Ibid.

27 "In the studio of the former pharmacist Ludwig Angerer, weeks of reservations were necessary to finally get a picture, with car after car parking in front of the house and bringing the most distinguished audience." *Die k.k. photographische Gesellschaft in Wien 1861–1911* (Vienna: Friedrich Jasper, 1911), 6.

28 "after a photograph of Archduke Ludwig Viktor and the young Count Kolowrat recently supplied by Herr Angerer had met his Majesty's approval to the utmost degree." *Fremden-Blatt,* May 15, 1861, 3.

29 Ibid.

30 "Since I have set myself the task of discussing the first-rate photographic salons, I should actually begin with the greatest of them, namely that of the k.k. court photographer Ludwig Angerer. But since this studio, due to its too expensive arrangement that is carried out entirely in the palace style, is hardly likely to experience imitation even by the haute volée of the photo-makers, I limit myself to merely a few hints about the basic principle of the salon built by this matador of photography." Alois Nigg, "Ueber den Bau der photographischen Salons," *Photographische Correspondenz*, 1868, 63–71, here 66–67.

31 "There is a kind of bureaucratic air to Angerer's pictures. Distinguished elegance, just as free from nonchalance as extravagance, a solid taste, so to speak, a conservative element: pose, garb, and arrangement form a just environment of rigid grace, conscious decency as well as moderate and orderly elegance. With a girl who lets herself be photographed by Angerer now, after sharing the prestige of fashion, one will perhaps not go through life ecstatically, but rather calmly and safely. Retired statesmen have a particular fondness for this photographer." *Die Debatte*, February 2, 1868, 1.

32 *Wiener Zeitung,* March 15, 1863, 6; *Fremden-Blatt*, March 19, 1863, 4–5.

33 "These photographs are the most beautiful that emerged from the famous Atelier Angerer and are characterized by sharpness, plasticity and purity of the reproduction as well as by warmth and beauty of tone. They are an ornament for every album and a pleasant reminder of the shiny Carousel for everyone who has had the opportunity to see it, as well as conjuring up a faithful image of the picturesque medieval costumes for everyone who did not see them." *Salzburger Zeitung*, April 27, 1863, 3.

34 "Group pictures (...) for which there is no competition in the entire exhibition, since few studios even have the space needed. (...) the arrangement of the figures is so sensibly ordered around different central points, the furniture element so richly and skillfully used that one believes to be joining a brilliant company that is about to dissolve into cheerful chatter in informal groups, so that nowhere a trace of the intentional, of the arranged emerges." Alois Nigg, "Ueber den Bau der photographischen Salons," *Photographische Correspondenz*, 1868, 63–71, here 66.

35 *The Photographic News,* June 15, 1866, 287.

36 *Oesterreichische Buchhändler-Correspondenz,* April 1, 1864, 103.

37 *Blätter für Musik, Theater u. Kunst*, February 13, 1863, 4.

38 So far 18 portraits could be identified.

39 *Oesterreichische Buchhändler-Correspondenz*, July 1, 1862, 2; BAG Pk 4618.

40 "Herr Melingo ist bekanntlich Dilettant in der Kunst des Photografirens und hatte vor mehr als einem Jahre die Ehre, bei einem Ausfluge in Begleitung des Künstlers Angerer zu Reichenau von Sr. Majestät bei der Arbeit überrascht zu werden, was damals Anlaß zu einem Gespräche mit dem Kaiser gab" (Mr. Melingo is a known amateur photographer and had the honor, more than a year ago, to be surprised by his Majesty while working on a trip with the artist Angerer, which led to a conversation with the emperor.") in *Morgen-Post*, February 7, 1862, 2.

41 K.K. Österreichisches Museum für Kunst und Industrie, *Die burgundischen Gewänder der k.k. Schatzkammer: Messornat für den Orden vom Goldenen Vliess: 12 Blatt Photographien mit Text* (Vienna: Selbstverlag des K.k. Museums, 1864).

42 "In particular, Ludwig Angerer's achievements were the subject of general attention. His reproductions of paintings, photographs of industrial objects, but especially his pictures for the k.k. Austrian museum garnered general acclaim. The jury mainly took into account that the photographic institute of Mr. Angerer exhibited such a rich series of the most excellent photographs of the most diverse genres, whereby the productivity and versatility of this institute and its eminent performance in almost all subjects of photography were shown to a degree unmatched by any other photographic institution at the exhibition." Franz Xaver Neumann, *Bericht über die Welt-Ausstellung zu Paris* (Vienna: Braumüller,1869), 301.

43 "Die Leiche war im Bett belassen worden und wurde Vormittags 11 Uhr vom Hof-Photographen Angerer photographirt" ("The corpse had been left in bed and was photographed by court photographer Angerer at 11 o'clock in the morning") in *Morgen-Post*, May 29, 1872, 2.

44 "The Emperor stayed for almost half an hour in Angerer's studio, where he was photographed in the uniform of his Prussian household troops, Kaiser Franz Garde Grenadiers. The pictures are intended for the court in Berlin." *Deutsche Zeitung*, September 14, 1872, 6.

45 Testament Ludwig Angerer, Wiener Stadt- und Landesarchiv.

46 BAG Partezettelsammlung (collection of party sheets), Letter A, party sheet Ludwig Angerer.

47 So far, 940 individual portraits of men, 800 of women, 304 double portraits, 99 group portraits, and 160 photographs with children have been researched and verified in archives from Austria to New Zealand.

Draw to Live:
Jewish Cartoonists in Central Europe 1900–1945[1]

Severin Heinisch

The collections and records of Jewish humor as well as their analysis fill entire libraries. Most of the scholarly literature refers to the treasure trove of jokes and anecdotes with which the Ashkenazi tradition in particular is so richly blessed and which has been extensively incorporated into the cultural creativity of modern times. Written and oral forms are in the foreground; visual humor, on the other hand, has received little attention. Mostly also with the reference that Judaism is a non-iconic culture, derived from the second commandment: "Thou shalt not make unto thee any graven image."[2] But Jewish humor is not bound to any genre, and religious commandments are as little immune to Jewish self-irony as anti-Semitic stereotypes, which in their inversion and exaggeration into the ridiculous themselves contribute to iconographic identity formation.

So, it was probably not the $600 prize money that persuaded an international crowd of more than 1,000 Jewish cartoonists in February 2006 to take part in the first "Israeli Anti-Semitic Cartoon Contest." Nor, probably, the additional reward promised to all participants, namely "our famous matzos, baked from the blood of Christian children," as the announcement said. "We are kosher anti-Semites," continues Amitai Sandy, one of the most prominent representatives of the younger generation of Israeli cartoonists and caricaturists, exaggerating the anti-Semitic clichés to the point of revealing all their ridiculousness. Together with Eyal Zusman, he initiated the competition for the best anti-Semitic cartoon via the Internet in February 2006,[3] thus securing the last image in a hysterically and fatally escalated controversy that had begun with the so-called Mohammed cartoons in the Danish daily Jyllands-Posten in September 2005 and reached its saddest climax for the time being with the terrorist attacks on *Charlie Hebdo* and a Jewish supermarket in Paris in 2015 and the murder of a French teacher by decapitation on the street by a Muslim terrorist on October 16, 2020.

But already in 2005 the uproar in the humorless part of the Islamic world was enormous and led to severe diplomatic crises, violent demonstrations, and confrontations, which finally resulted in a wave of anti-Semitism. For who else but the Jews could be behind this outrageous provocation of Islam! At the height of the furor, Iran's largest daily newspaper, *Hamshahri*,

called for an "International Holocaust Cartoon Competition" to, it said, put Western tolerance to the test. The submissions from around the world reflected a savage panopticon of rampant anti-Semitism. To this, the "Israeli Anti-Semitic Cartoon Contest" was the answer a little later, because "we still draw the best Jewish jokes ourselves," or, in the words of Eduard Fuchs, "The best jokes on Jews mostly come from Jews."[4]

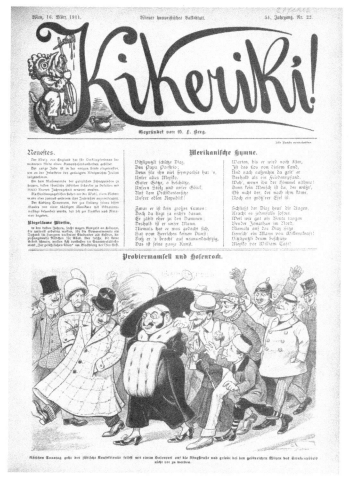

Fig. 1 Mockery of the Jewish owner of the Viennese department store Gerngroß, which was founded as a fashion house in 1879 by Alfred Abraham Gerngroß. Front page of *Kikeriki*, March 16, 1911 (Source: Austrian National Library).

This at least clarified who had the higher degree of self-irony. If there is one characteristic of Jewish caricature—as of Jewish humor in general—it is this: "We have researched in archives and libraries and found many old Yiddish newspapers from the time before World War I, with great self-deprecating drawings, where Jews laugh at themselves. We see ourselves in the long tradition of Jewish humor," says Amitai Sandy. The fact that anti-Semitism itself is the subject of Jewish humor is not an entirely new development. Already the Austrian Jewish writer Alexander Roda Roda, mocked in 1920s Vienna: "Something could already come of anti-Semitism, if only the Jews would take it on."[5]

Anti-Semitic stereotypes occupy a large space in the cultural history of European caricature and found their way into the iconographic arsenal of modern media society with the advent of illustrated mass newspapers. This was already true of the *Fliegende Blätter*, the first and largest German-language humorous magazine in the 19th century and the journalistic home of Wilhelm Busch with his seemingly harmless joke drawings. On the frontispiece of the first issue of 1844, the allegorical figures of German fun society ride through the air on a "flying ribbon," at the end of which a "junk Jew" clings desperately, being pushed into the depths with a drawing pen by a protagonist of German humor.

The tendency of a caricature, however, cannot be decided on a formal level alone, but must be understood contextually and in the larger context of reception. Not every caricature about Jews is anti-Semitic, even if that is difficult or often impossible to decide today in light of historical developments. Among the first caricature magazines in the 19th century there were those that made their jokes about Jews in the same way as they did about the bumpkins, the blue stockings, the lawyers, or the teachers. In principle, they are not to be assessed differently than, conversely, the Jewish jokes about the goy. They claim the right of the humorist to pick out supposed or actual peculiarities of a group of people and to put them in the service of a satirical statement at their expense.

But especially in the 19th century, on the other hand, there was also a growing number of periodicals whose almost sole subject matter was the constantly recurring anti-Semitic stereotypes, in which the Jewish jokes were thus not really "on an equal footing" with jokes made about other social groups. One of the most important anti-Semitic papers in Central Europe can serve as an example: the Viennese *Kikeriki*. It was originally founded in 1861 as a liberal, anticlerical paper, but with the rise of Lueger's Christian Social Party from the late 1880s onward it became the mouthpiece of that party's clientele and shifted to spreading anti-Semitic prejudice. Anything that distressed

the petty bourgeoisie, tradesmen and civil servants—and that was no small matter on the eve of World War I and afterwards—was henceforth implicitly answered with "it's all the Jew's fault." In the 1920s, the paper turned to the German Nationalists and eventually to the illegal NSDAP, before being banned for this reason in 1933 under Austrian Prime Minister Dollfuß.

In this environment, it is not easy to discern the contribution of a "Jewish caricature" to a more differentiated self-image. It was not until the emancipation of the Jews in the 19th century that caricatures drawn by Jews were increasingly produced, which dealt with Jewish peculiarities in a benevolent or affectionately critical, often also biting and sharp manner. With the emergence of their own media, which were aimed decidedly at a Jewish audience, a "Jewish caricature" began that self-deprecatingly reflected on Jewish identity. Jewish caricature magazines, however, remained isolated phenomena that never lasted long.

Schlemiel is a figure in Yiddish anecdotes denoting an unlucky man, possibly related to the Yiddish *"Schlamassel"* (mess), but probably derived from the Old Testament general Semuliel, who lost all his battles unhappily. *Schlemiel* was also the title of a magazine first published by Samuel Moses from 1903–6 and then again as *Schlemiel – Jewish Sheets for Humor and Art* from 1919–20 by Menachem Birnbaum at Welt-Verlag in Berlin. Menachem Birnbaum, born in Vienna in 1893, was the second son of the writer, Zionist and philosopher Nathan Birnbaum and his wife Rosa Korngut. Menachem Birnbaum was a freelance artist, publishing director of the Welt-Verlag, editor of the newspaper *Ashmeday*, and collaborator with several Jewish publishing houses. He lived in Vienna and Berlin before emigrating with his wife Esther and his two children to the Netherlands in 1933, where he still published his volume *Menachem Birnbaum shows caricatures* in The Hague in 1937. In 1943 he was arrested by the Gestapo and after his deportation was murdered in the Auschwitz concentration camp. He produced some of the most touching caricatures of Jewish life, which he published not only in magazines, but also on postcards, which in the decades before World War I took on an enormous upswing as a means of communication and propaganda. The Zionist movement, for example, also used this means to spread its ideas.

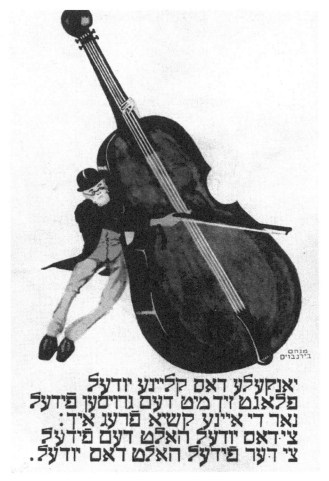

Fig. 2 Cartoon by Menachem Birnbaum: *Little Man Wants to Aim High* (Source: Jewish Museum Vienna, Archive).

In the years 1919 to 1920, the magazine *Schlemiel*, directed by Birnbaum, became a gathering place for Jewish authors and illustrators who dealt in a humorous way with questions of Jewish culture and Jewish everyday life in Central Europe, but also took very clear political positions against the rampant anti-Semitism and the rising National Socialism. They vehemently opposed the assimilation of many Jews, which was perceived as ingratiation and self-slander, and called for a stronger Jewish self-confidence. Even then it was feared that even the best assimilation would not prevent anti-Semitism, which became a tragic reality.

In his caricature *Gegen die Assimilanten und Konvertiten* (Against the Assimilationists and Converts), Ludwig Wronkow put the Jewish "assimilationists" on the same level as the German nationalists: "All assimilationists and other German nationalists are recommended the tried and tested 'anti-Semite' nose shaper"—said nose shaper bringing "Jewish noses" into shape accordingly, as is vividly illustrated. Wronkow dedicated the drawing "to the German citizens of Jewish faith, who wanted so much to become good Prussians."[6] Wronkow, born in 1900, was one of the youngest and at the same time most talented draftsmen of *Schlemiel*, who found here his first publishing platform as a caricaturist. In his series *Types from Future Palestine*, he also took a hard line at the Zionists themselves. "Why do you need a university in Jerusalem?" he has one of them ask. "Isn't a coffee house enough?" Wronkow, himself a passionate coffeehouse patron, was not only active for the *Schlemiel*, but unfolded a rich, journalistic output in the politically left spectrum of the Weimar Republic. Artistically, he was initially close to the Dadaists and in 1931 founded the *Toppkeller* with friends—a surrealist nightclub that briefly became a famous Berlin attraction.

On March 4, 1933, a few days after the Reichstag fire, Wronkow was one of the first journalists to emigrate from Germany. He justified his early flight from the Nazis to Paris with his experiences after World War I. "I had experience and knew that the German beast was back and that no democratic herb grew against it.... I left Germany as early as March 4, 1933, because I didn't want to be incessantly insulted by every radio announcer, by every newspaper headline, and over the pimp song that had been declared the national anthem."[7] In Paris he met Friedrich Torberg, who brought him to the magazine *VU*. In 1934 he went to Prague, which was still a major center of German-language journalism, where his wife Sonja started a bar. In Prague, he was accepted by the renowned *Prager Tagblatt* and later worked in the circle around Adolf Hoffmeister for *Simplicus*, the successor magazine to *Simplicissimus*. In 1938, he emigrated to New York, where, after a difficult start, he worked for *Aufbau*, a Jewish magazine that catered to the growing number of German immigrants and provided existential assistance to many. Until 1945, Wronkow's entire work as a cartoonist and journalist was devoted to the fight against National Socialism and support for American and Allied troops. From 1950 he also began to draw caricatures as a commercial artist and for other American newspapers; he died in 1982 on a trip to Brazil.

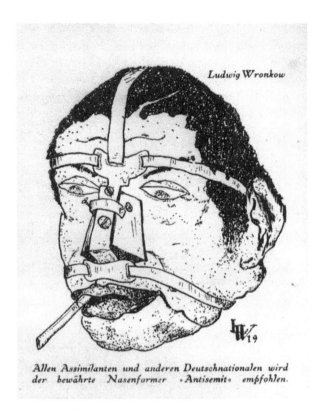

Fig. 3 Caricature by Ludwig Wronkow: "All anti-Semites and other German nationalists are recommended to use the proven nose shaper 'anti-Semite,'" in *Schlemiel* 1919/20 (Source: Jewish Museum Vienna, Library).

The other *Schlemiel* cartoonists also frequently devoted themselves to the themes of Zionism, assimilation, and conversion, although not with the same acuity as Wronkow. Elsa Pohl, one of the few women cartoonists whose carefully drawn black-and-white cartoons are stylistically reminiscent of Aubrey Beardsley, had one of her protagonists sigh in the family circle, "What's the point of being baptized if you're left with Jewish kinship?" And Menachem Birnbaum himself has one Jew say to another in anger, "Don't tempt me—or I'll join your Zionist club—and they're compromised." This is already strongly reminiscent of Groucho Marx's famous line, "I wouldn't dream of joining a club that would be willing to accept someone like me as a member."

Jewish self-irony always came into its own at the *Schlemiel*, and as much as the German nationalists and the nascent National Socialists got their fat,

this was not countered by any Jewish pathos, conversely. On the contrary, the Jews themselves were not spared ridicule. Especially when they sacrificed their Jewishness at the altar of worldly pleasures or profit. Menachem Birnbaum on the cover of number 5 of the 1919 *Schlemiel*: "Let my children convert? Why not? But my war bonds, too? That's where the fun stops." And Elsa Pohl had a pleasure-seeking lady say to her dandified friend, "As soon as a gambling club is built in Jerusalem, I'll become a Zionist."

The positioning of Judaism between Zionism, Orthodoxy and conversion was the actual theme of the *Schlemiel*. While in Menachem Birnbaum a deep religiosity remained visible as the dregs of his mindset, Ludwig Wronkow embodied the intellectual attitude of secularized Judaism. Because of his distance from religion, emigration to Israel was never an option for him. "I did not feel Judaism as a religion," he wrote retrospectively in exile in New York,

> "but I was terribly offended by organized Judaism. This arrogance of the Jews, it drives me crazy. They are so insanely superior to those of other faiths and sometimes feel they are better than them. And these ugly jokes in which the goy comes off so badly. That always upset me terribly.... What bothers me in New York are the many people who walk around in caftans. They're so tradition-bound that they can't ride in the bus, because a woman could get on, and they're not allowed to shake hands with a woman, they can't sit next to a woman, and now I don't know whether we should have respect for these people in the caftan with the temple curls, because they're so true to tradition, or whether we should say to them: 'Now come on out of the Middle Ages!' I don't know, I'm completely at a loss."[8]

The *Schlemiel's* merit is to have given a forum to this range of Jewish identity in an amusing way. In its impact, the *Schlemiel* was naturally largely limited to the readership of the Jewish public, but the *Schlemiel's* authors and cartoonists continued to have an impact in other publications. Ludwig Wronkow alone, who had his first journalistic home in the *Schlemiel*, published over 3,000 caricatures in Germany by 1933.

More controversial than in the *Schlemiel*, and of greater significance in terms of art history and journalism, Jewish humor unfolded elsewhere. In 1896, Albert Langen, a wealthy, polyglot son of a Rhenish industrialist family with a Jewish background (his grandfather Johann Jacob Langen came from Antwerp), founded *Simplicissimus* in Munich and began one of the most successful publishing careers in Germany before World War I. In

terms of its concept, *Simplicissimus* was originally intended as an illustrated art and literature review modeled on the French *Gil Blas Illustré*, which Albert Langen had become acquainted with during his time as a Parisian bohemian. However, the concept was quickly changed in the direction of a caricature and satirical journal, especially under the influence of Thomas Theodor Heine, Albert Langen's co-founder and business partner. From the beginning, *Simplicissimus* caused a sensation because of its garish layout, the page-filling cover picture, and later the red bulldog invented by T. T. Heine, which broke its chains and became the trademark of critical satirical journalism in the German-speaking world.

Simplicissimus was designed to be confrontational, and entire issues of the magazine were often confiscated. In Austria-Hungary, the paper was banned altogether—all the more it was read under the table. Mainly responsible for this was the first caricaturist and founding member of *Simplicissimus* besides Albert Langen: Thomas Theodor Heine. T. T. Heine (actually David Theodor Heine) was the son of the Jewish factory owner Isaac Heine and his wife Esther from Leipzig. Until this time, T. T. Heine was known at best as the "dachshund illustrator" of the *Fliegende Blätter*. This changed fundamentally with the founding of *Simplicissimus*. He shaped the style of the paper from the beginning until 1933 with his illustrations and numerous covers. He was largely responsible for conception and layout, became one of the style-forming illustrators of his generation and the spiritual father of the most influential satirical magazine of its time in Europe. Together with Langen, he gathered the intellectual and artistic avant-garde under the *Simplicissimus* umbrella.

Albert Langen's economic independence made it possible to produce a magazine without concessions. The two founders also recognized the publicity and sales-promoting effect of the media processes, which they consciously accepted. The more Wilhelmine censorship and media justice raged, the more the spirit of T. T. Heine and Co. was incited to new provocations directed against bourgeois morality, the military, officialdom, the church, and Wilhelmine politics. In the writer and lawyer Max Bernstein, they found a congenial legal advisor, with whom the high-profile litigation was planned in advance, which contributed significantly to the increase in circulation.

Already in the third year of the magazine's existence, in October 1898, there was a scandal surrounding the so-called "Palestine Issue" of *Simplicissimus*. The occasion was the trip of the German imperial couple to Palestine, prepared with much fanfare and pomp, where a German church of the Redeemer was inaugurated in Jerusalem and extensive consultations with the sultan and high deputies of the Ottoman Empire (which at that time extended to Palestine) took place in Constantinople. French policy

observed German ambitions with particular suspicion. In Jerusalem, Kaiser Wilhelm II finally met with a Zionist delegation led by Theodor Herzl. The hope that he might support the Zionist movement was not fulfilled, however, and the talks were fruitless.

Heine had depicted Kaiser Wilhelm, represented only pars pro toto by a Prussian "spiked helmet," and Friedrich Barbarossa on the cover. Barbarossa doubles over with laughter, while the crusader Gottfried von Boullion standing next to him says: "Don't laugh so dirty, Barbarossa. Our crusades didn't really have any point either." In addition, a mocking poem by "Hieronymus" is printed inside the sheet under the title "Im heiligen Lande" (In the Holy Land). The author Frank Wedekind hid behind the pseudonym Hieronymus.

The day after the issue appeared, on October 29, 1898, the Munich police raided the editorial office. They were looking for three people: the editor responsible for the current issue, the anonymous poet "Hieronymus" and the illustrator Thomas Theodor Heine. The reason: lese majeste.

Wedekind had to serve seven, T. T. Heine six months in prison, which they served at the Königstein Fortress in Saxony. Only Albert Langen, as the responsible editor, was able to escape the threatened two-year prison sentence by fleeing to France via Switzerland. In 1903, after five years in exile, he was pardoned in the lese majeste affair and was able to return to Munich after paying a fine. In the few years that remained until his untimely death on April 30, 1909, he was mainly involved in founding the liberal, European-oriented cultural magazine *März*, later headed by Theodor Heuß.

Simplicissimus was transformed into a limited liability company in which the leading artists had a stake. It was thus able to continue its success story as the most influential European satirical magazine. In 1912, the magazine became the namesake of the Viennese beer cabaret *Simplicissimus*, which still exists today as *Simpl* with the red bulldog, and where Jewish and Viennese cabaret flourished in the 1920s and then again after 1945 with Fritz Grünbaum, Karl Farkas, Ernst Waldbrunn and many others.

During World War I, *Simplicissimus* abandoned its cosmopolitan, liberal stance, so critical of Wilhelmine Germany, and switched to German hurrah patriotism. After the war, there was only a slow return to the earlier form; few authors and illustrators of the prewar period were still alive, but an effort was made to create the literary and drawing elite of a new generation. In the early 1930s, the magazine enjoyed a final flourish until the National Socialists seized power in 1933. Jakob Wassermann, Arthur Holitscher, Erich Mühsam, Karl Kraus, Kurt Tucholsky, Erich Kästner, and many others wrote for *Simplicissimus*.

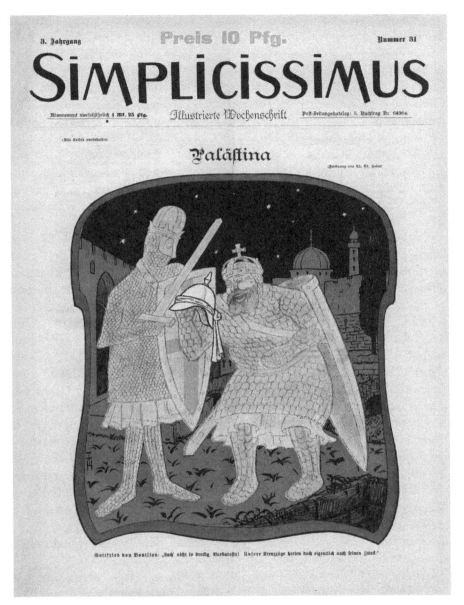

Fig. 4 Caricature by T. T. Heine: *Palestine*. Cover of *Simplicissimus* 1898/99 (Source: www.simplicissimus.info).

Surprisingly, the magazine, which had previously criticized Hitler in the harshest terms, was not shut down by the National Socialists in 1933 but kept alive until 1944—with the exclusion of all Jewish authors and illustrators. The editor-in-chief was expelled, and the remaining editorial staff was politically brought into line. Those who had made it into exile followed with bitterness the partially unproblematic recoloring of their colleagues in Germany and Austria to the point of functionalization within the framework of Nazi propaganda.

Alongside *Simplicissimus's* star pupil T. T. Heine, Walter Trier was another style-forming Jewish cartoonist who worked as a freelance illustrator for *Simplicissimus* as well as for many other magazines. Like T. T. Heine, Walter Trier was able to flee Germany and eventually emigrated via Great Britain to Canada, where he died in 1951.

London was the destination for many Jewish cartoonists fleeing the Nazis, and the British government soon realized that the war against Hitler's Germany would not be won with soldiers alone. It was clear that the media would also play a crucial role in this. Caricature acted as one of the sharpest weapons. The British cartoonists were supported in the front line by their Jewish colleagues who had emigrated from Germany. Along with Walter Trier, Victor "Vicky" Weisz gained some notoriety for his sharp caricatures against Hitler. Victor Weisz was born in Berlin in 1913, worked as a caricaturist for various Berlin newspapers in his youth, and from 1929 published theater and sports drawings for the *12-Uhr BLATT*. In 1935 he was banned from working as a Jew and was finally able to emigrate via Budapest and Prague to London, where he received British citizenship in 1936. He became one of the leading cartoonists in England and was permanently employed by the *News Chronicle* from 1941, later by the *DAILY Mirror*. He also published under the pen name "Vicky" in many other newspapers such as the *Evening Standard* and the *Daily Telegraph*. Although Victor Weisz was enormously successful and became one of the most productive caricaturists in England—even after the war he was in great demand—he suffered from fears of losing his creativity and identity. In 1966, during a creative crisis in London, he committed suicide.

During the first wave of emigration of Jewish artists, which began in 1933, Prague was the first port of call for many. Here there were still a number of German-language publications, cafés, clubs, and a lively Jewish community. The *Prager Tagblatt* was a liberal-minded, respected newspaper, from which many emigrants received their first jobs to secure their livelihood. Here a circle of emigrant artists formed around Adolf Hoffmeister, who tried to organize the journalistic resistance against National Socialist

Germany from Prague. Among them was T. T. Heine. Heine only narrowly escaped the Gestapo, whose arrest list included him. He was able to hide with friends in Berlin for a few weeks in 1933 before he managed to escape to Prague with forged papers. In 1936 he went to Brno, and after the German occupation of the Sudetenland he was able to escape to Norway and later to Sweden. He received Swedish citizenship and died in Stockholm in 1948.

In Prague, with his cooperation, an attempt was made to found a magazine in which the spirit of the old *Simplicissimus* was to be continued. *Simplicus* was published from January 25, 1934, to September 13, 1934, and thereafter under the title *Simpl. Simplicus* was printed in two editions: a German one and a Czech one, the content of which was not identical but geared to the interests of the respective readership. Both issues appeared weekly. The editor-in-chief was the former Ullstein journalist Heinz Pol, but František Bidlo, a well-known Czech cartoonist, was responsible for the masthead. Other contributors included Czech, Jewish, and non-Jewish cartoonists such as Antonin Pelc, Josef Čapek, Adolf Hoffmeister, Fritta (Bedřich Taussig), as well as many émigrés from Germany, including Jappy (Vilém Reichman), Hella Guth, Erich Godal, Ludwig Wronkow, Pjotr (Günther Wagner), E. Katzer, A. Stadler, and Nikl (Johannes Wüsten). The circulation is said to have been between 10,000 and 20,000 copies. The editors' aim was to distribute the journal also in the Sudeten area, Austria, Switzerland and Saarland. But with increasing fascist ideologization in these areas, issues were confiscated more and more often. Accordingly, many booksellers no longer dared to continue selling the newspaper, and it was finally discontinued on 4 July 1935.

The graphic artist Hella Guth deserves special attention as one of the few women in the caricature trade of the time. The daughter of a German-Jewish family studied in Vienna and worked as a graphic artist in Prague from 1930, where she achieved her first successes with political graphics. Her woodcuts to the songs of Mackie Messer from 1932 are among the first depictions of the *Threepenny Opera* and were inspired by the Viennese performance of the play by Bertolt Brecht and Kurt Weill in 1929. She belonged to the circle around Adolf Hoffmeister and was a staff member of the first hour of *Simplicus*. In 1939, Hella Guth fled from the National Socialists via Poland to Great Britain. In the process, a large number of her early originals were lost. From 1951 she lived and worked in Paris and took an active part in feminist projects in art and science.

Another important Jewish artist and caricaturist in Prague was Fritz Taussig. Like Hella Guth, he belonged to the circle around Adolf

Hoffmeister. Even before 1933 he worked under the pseudonym Bedřich Fritta as a recognized illustrator and caricaturist, for example for the *Prager Tagblatt*, as a graphic designer, painter and drawing teacher. On November 24, 1941, he was deported to Theresienstadt. There Fritta became the head of the drawing room in the technical office of the Jewish self-government. In his paintings, mostly drawn in ink, he presents a vivid picture of the everyday horror and life of the prisoners in the Theresienstadt concentration camp. Fritta's strict refusal to cooperate in the so-called beautification of the camp ordered by the Nazis for the visit of the Red Cross delegation may have led to his arrest—as it was then called—"for atrocity propaganda" and internment in the Small Fortress with his wife and three-year-old son Thomas (Tommy) on July 17, 1944. Bedřich Fritta was tortured—as were his painter friends Felix Bloch, Otto Ungar, and Leo Haas; his wife died of starvation in the camp. Together with the painter Leo Haas, Bedřich Fritta was deported to the Auschwitz concentration camp on October 26, 1944, where he died a short time later of blood poisoning. His young son Tommy was adopted after the war by Leo Haas, who survived the concentration camps, and his wife.

Leo Haas, an academically trained painter who had studied with Emil Orlik, among others, also worked as a caricaturist in Prague after the war. The most impressive descriptions of camp life in Theresienstadt are owed to him. A folder with Fritta's drawings for his son Tommy for his third birthday, which Bedřich Fritta had been able to hide behind a wall while still in Theresienstadt, was later found and published as a book by his son Tomáš Fritta Haas.

An equally clear political statement as with *Simplicus* was made with an exhibition organized in the gallery of the Czech artists' association *Manés*, in which emigrants John Heartfield, George Grosz and Otto Dix, among others, participated, as well as T. T. Heine and Erich Godal from *Simplicissimus,* and a number of Czech artists such as Adolf Hoffmeister, Josef Čapek, Antonín Pelc, František Bidlo, Josef Lada, and Zdeněk Kratochvíl. The exhibition, which ran from April to June 1934, provoked angry protests, interventions by the German ambassador, and a delicate diplomatic affair for the Czech government. Individual images, including some of John Heartfield's particularly biting photomontages, were banned by Prague police, which spurred all the more public interest.

For most emigrants, Prague was a stopover on their way to safer countries. This was also the case for Heinrich Sussmann, born in 1904 in Tarnopol, then Austrian Galicia. At the age of ten, his family moved to Vienna under the impact of anti-Semitic sentiment in Galicia. After World War I he studied graphic design, interior design, and stage design in Paris

and Vienna, and worked in Vienna as a commercial artist, stage designer, and as a graphic designer for various newspapers. In 1929 he went to Berlin and worked for the Ullstein publishing house and for UFA, and he became an important caricaturist. In 1933 he fled from the National Socialists, first to Vienna again and finally via Prague and Zurich to Paris. After the Nazi invasion of France, he fled to the unoccupied zone in 1940 and went into hiding in southern France under the pseudonym "Henriesse." In 1942, he joined the Resistance and illegally returned to Paris on their behalf, where he was exposed in 1944 and arrested and deported together with his wife, Anni Sussman, to Auschwitz-Birkenau. They survived until the liberation of the concentration camp by the Red Army and initially returned to France. At the end of 1945 he and his wife decided to return to Vienna. He resumed his work as a stage designer and in his illustrations, graphics, caricatures, posters, and mosaics dealt primarily with his experiences under the Nazi dictatorship and in particular his experiences in Auschwitz. Heinrich Sussmann died in Vienna in 1986.

Other cartoonists were able to emigrate directly from Germany and Austria to Great Britain or the US. Among them was Benedikt Fred Dolbin, born in Vienna in 1883, an artist of the Viennese coffeehouse scene. Among other things, he studied composition with Arnold Schönberg, was a co-founder of the artist group *Die Bewegung*, was influenced by Schiele as a painter, and was self-taught as a draftsman. Dolbin published portraits and portrait caricatures in several Viennese newspapers and moved to Berlin in 1926. There he worked for: *Die Literarische Welt, DER QUERSCHNITT, B. Z. am Mittag, Berliner Tageblatt* and other newspapers. He was known for and in demand for his idiosyncratic, abbreviated portrait drawings ("Kopfstenogramme"). A multi-talented artist, Dolbin also worked as an actor, stage designer, and book illustrator. In 1935 he was banned from working as a Jew, and his art was qualified as "degenerate," whereupon he briefly returned to Vienna before managing to escape to New York, where he had close contact with Ludwig Wronkow from 1938. Despite occasional work as a caricaturist, he had difficulty gaining a professional foothold in the United States. Together with other emigrants, he drew cartoons against the National Socialists for *Free World* and worked as a press artist for various business magazines under the pseudonym Ben Bindoll. In 1971 he died in Jackson Heights, New York. A similar fate was suffered by Budapest-born Jewish draftsman and cartoonist Tibor Gergely, who went from Vienna to New York in 1938, where he died in 1978.

Leo Glückselig, on the other hand, was more successful in his New York exile, to which he had fled from Vienna in 1938. After his military

service as a volunteer with the US Army, which brought him back to the battlefields of Europe, he made a career as a successful illustrator and commercial artist following his return to New York. He worked for *TIME LIFE* and wrote features for the *New York Times*. Reminiscences and allusions to his native Vienna recur in his drawings and biting cartoons. In his memoirs he wrote: "America is my home, finally and at last it helped save my life. I went through the terrible but intense experience of military service. My daughter was born here, my parents are buried here, my brother, my wife. So America is my home. But *Heimat* has remained forever and ever this damned Austria. I almost can't admit it to myself, I've been so hurt, so insulted, that this homeland has been taken away from me, this feeling that as a Jew I'm one with what makes up Austria: art and culture and passion."[9] Leo Glückselig died in New York in 2003.

Endnotes

1 The text is the expanded, revised and translated version of the article Severin Heinisch, "Judentum und Karikatur," in *Alle MESCHUGGE? Jüdischer Witz und Humor*, ed. Marcus G. Patka and Alfred Stalzer (Vienna: Amalthea, 2013), exhibition catalog Jewish Museum Vienna, 116–26.

2 Edward Portnoy, "Auserwählte Cartoons: Juden zeichnen in Amerika," in *Alle MESCHUGGE?*, 43–52 (here 43).

3 Henryk M. Broder, "Koschere Antisemiten," *Der Spiegel* 16/2006, 172.

4 Eduard Fuchs, *Die Juden in der Karikatur* (Munich: Langen, 1921), 304.

5 Broder, "Koschere Antisemiten," 172.

6 Hans Bohrmann, ed., *Ludwig Wronkow: Berlin-New York: Journalist und Karikaturist bei Mosse und beim "Aufbau": Eine illustrierte Lebensgeschichte* (Munich: Saur, 1989), 33.

7 Bohrmann, 61.

8 Bohrmann, 198.

9 Leo Glückselig, *Gottlob kein Held und Heiliger: Ein Wiener "Jew Boy" in New York* (Vienna: Picus, 1999), 15.

In/Visibility of Violence:
The First World War in Austrian Private Photo Albums

Markus Wurzer

The First World War certainly marks a watershed event in Austria's visual history. This is mainly due to the visual revolution, which came along with the invention of photography in the late 19th century. New inventions had made photography cheaper, easier to handle, and more mobile right before the outbreak of the war. Hence, in 1914, more photo cameras than ever before entered the global battlefields along with the armies. For the first time in history, photography was incorporated systematically into warfare, for example in the fields of propaganda and reconnaissance.[1] Until 1918, state agencies as well as the military produced enormous visual archives of the war. In recent years scholarship has mostly concentrated on either photographs produced by the military or from an official and published perspective.[2] This is also true for the Austrian-Hungarian case. Anton Holzer, who has been influential in shaping the field of the history of photography in Austria for more than two decades, conducted two research projects which dealt with propaganda and photography in the Habsburg army on the one hand, and with visualized violence against civilian populations on the other hand.[3]

However, Jay Winter argues that the existing body of scholarship on photography of the First World War is partially misleading because it generates an incomplete idea about the war's visual history. Therefore, Winter points towards what he calls "soldier's photography" as the "missing link"[4] in war photography. Besides advancements in official, commercial, and artistic photography, the before mentioned visual revolution gave rise to this fourth type of war photography.[5] Whereas photography had been practiced either by commercial photographers or wealthy amateurs who could afford such a luxury hobby around 1900, the visual revolution had made photo cameras widely available before the outbreak of the war in 1914. However, even though Winter labels this process as a visual "democratization,"[6] it cannot be stressed enough that most of the photographers were either officers or noncommissioned officers.[7] Finally, "common" soldiers usually did not have the necessary socioeconomic position to afford a camera as well as the necessary photographic accessories. Although photography had become much cheaper before the war, it remained an expensive practice. That changed due

to the boom of the visual industry in the 1930s, also shown by the many amateur pictures of German *Wehrmacht* soldiers in the Second World War. The final transformation of photography from luxury to a popular everyday practice only happened in the afterwar period.[8]

Winter claims "that millions of soldiers' private photos, not earmarked for sale, placed in family albums or boxes, form a largely unexplored visual archive of what soldiers saw of the war and what they tried to photographically capture of their war experience."[9] So, besides the exception of France,[10] private war photography—in contrast to official—represents a large research gap.[11] This is not accounted for by a lack of historical interest regarding the war experiences of "common" soldiers. Since the 1980s historians—influenced by the cultural studies—had begun to investigate the war "from below" ("*von unten*"). This research perspective stood in contrast to military and social history, which consider ordinary soldiers only as collectives without agency. This change of perspective came along with the "discovery" of personal testimonies such as diaries and letters as "new" sources, stemming from the First to the Second World War.[12]

Unsurprisingly, this is also true for the Austrian case: Over the last decades, but especially over the last ten years, a lot of historians have conducted research on written self-testimonies of German-speaking[13] soldiers.[14] Apart from that, visual testimonies have mostly been ignored.[15] Probably the main reason for this is the fact that visual sources—like any other testimonies—are largely inaccessible to historians because a lot of them are still with their families and have not found their way into public archives.[16] That might change now due to several initiatives which were launched around the centennial in 2014. Inspired by the initiative "Great War Archive," which was founded at the University of Oxford in 2008, the crowdsourcing project Europeana 1914–1918, for instance, started a worldwide call in 2011 with the aim of collecting, digitizing, and sharing private documents from the First World War online.[17] Despite such projects, which will enable further transnational research, it should be stressed that public archives and museums in Austria do store private photo collections of the First World War mostly as parts of estates of deceased persons. The *Heeresgeschichtliche Museum* in Vienna, for instance, has a lot of albums in its inventory just waiting to be "discovered" as historical sources.[18] Though, the integration of private documents into public archives, however, carries quite the risk of decontextualization which can decline the value of sources.[19]

Both, the sources' accessibility and the existing research gap suggest that there is another reason which slows down research. Even though photography has been considered a part of the canon of sources for up to twenty

years now, it seems that contemporary historians' perception of private photographs may still be dominated by certain methodological reservations. The strong link between biography and photographic memories fostered the idea that war photographs would only represent a narrow segment of the war's reality which in the end was and still often is considered a deficit. But the opposite is the case. Precisely this nexus between biography and the war's individual visualization is the methodological strength of such collections[20]—if the personalized memorization of war of over 60 million veterans is at stake.

Drawing on a case study, the albums of Bernhard Veitl, an Austrian officer, I am going to address the question of how war engagements were remembered individually by the visual practice of photo albums post 1918. My particular interest lies in the inquiry how Veitl did (not) remediate violence. This focus is based on the fact that the aforementioned visual revolution co-occurred with a revolution of violence. The visual experience was mainly shaped by the perception of industrialized mass violence.[21] This, however, is a different approach than Bodo von Dewitz or Jay Winter took. While their semiotic analyses are dedicated to specific motives (of violence), I address the usage of photographs within the particular commemorative practice of album creation. This approach is primarily interested in the materialities and appropriations of photographs than in its motifs.[22]

Since there are no comparable studies of the First World War, methodological stimuli mainly come from the body of recent scholarship on private photography of the Second World War, which evolved from the methodologically rich discussion around the exhibition *Vernichtungskrieg. Verbrechen der Wehrmacht 1941 bis 1944* in the 1990s.[23] It transpired that the photographs' contextualization is the key to analyze form, content, function, and thus meanings. This is because the conventional significance[24] of cultural products largely depends on the creator's social (prewar) biography as well as on his soldierly functions during the war.[25] Furthermore, private photographs do not show the war's "real" face in contrast to official photography. As scholarship on the Second World War argues, amateurs had been influenced by propaganda, too. If anything, private war visualizations do not offer a truer but a complementary view on the war.[26] Furthermore, single photographs do not provide historical narratives but rather proto-narratives which are selective and incomplete glimpses of an elapsed past.[27] Their polyseme character considerably complicates any analysis. Therefore, what remained outside the frame is as important as the staged people and things inside of it.

The creation of an album represents a private photo practice which enables single photographs to overcome their non-narrative character.

This approach rejects the traditional idea that albums are merely neutral storage containers. Due to their specific media characteristics, they rather create their own contexts of meaning.[28] The album creation begins with an intuitive selection process in which aesthetic, social, and formal criteria are relevant.[29] Once the creator has decided which stories are to be visualized and once the pictures have been selected, they are lined up, arranged on the empty album pages, pasted in and provided with texts.[30]

Therefore, an album analysis not only needs to take the contexts of production and storage into account but also has to differentiate between the dual origin of the individual photographs and the album and to extend the usual source criticism including questions of authorship and use. In the following I am going to address Bernhard Veitl's biography. Afterwards I approach his albums in order to break down forms, motif focuses, and narrative motives. Finally, I analyze the in-/visibility of violence drawing on single album pages as examples.

1 Albums and Biographical Context

1.1 Bernhard Veitl's Biography[31]

Bernhard Veitl was born as son to Karl and Maria Theresia Veitl in Livinallongo/Buchenstein in 1896. There, Karl worked as a general practitioner.[32] Still in the same year, the family moved to Rohrbach in the Crownland of Austria above the river Enns, due to work: Karl was appointed as Rohrbach's district doctor.[33] However, the family did not stay there for long. Following a short stay in Schärding, where young Bernhard attended primary school, the family finally settled down in Linz.[34] Due to Karl's profession, the Veitls were a well-off bourgeois family. Karl and Maria Theresia educated their children according to their social status. Subsequently, Bernhard attended the humanistic *k.k. Staats-Gymnasium zu Linz*, where he obtained his high school diploma in 1914.[35] After Bernhard had passed his final exams, he got a photo camera as a present (maybe the Zeiss-Ikon Compur which accompanied him to war in 1916). This is because Bernhard had developed a strong interest in photography during his school years. Other suitable bourgeois hobbies of him were tennis, hiking, fishing, and hunting (of which there was a strong tradition in his family).[36]

In the summer of 1914—when the world already stumbled towards war—Bernhard undertook a journey to Tyrol with some friends. After hiking in the Dolomites, they spent some days at Lake Garda. Right there, he learnt about Austria-Hungary's declaration of war on Serbia.[37] There

as well as on his way home he witnessed the war enthusiasm, which led to his wish to volunteer. His father, however, forbade him and Bernhard relented. For the time being he enrolled for the study of medicine at the University of Innsbruck.[38] Yet, six months later Bernhard obtained his draft call. As a medical student he was assigned to the medical service of the *X. Marschbataillon* of the 14th Infantry Regiment. Just like his father,[39] Bernhard signed as a one-year volunteer aiming at becoming a reserve officer.[40] After completing a short training in mountain warfare, Veitl was transferred to the Italian front in October 1915.[41] By that time, Austria-Hungary had already been at war with Italy for almost four months.

Even though Veitl had occupied the rank of a non-commissioned officer at that time, as a one-year volunteer he already held a position which gave him certain advantages in contrast to an ordinary soldier. According to the usual practice in the Habsburg army he, for instance, obtained better rations and accommodation. With the beginning of his promotion to the rank of a cadet he also obtained a personal orderly.[42]

After arriving in Trento/Trient Veitl was deployed along with the *X. Marschbataillon* on several sections of the alpine theater of war on Tyrol's Southern border over the following year. These intensive months were only punctuated with a few weeks of recovery behind the frontlines. Following his first combat experience at the Seven Communes Plateau, Veitl saw both heavy fighting on the glaciers of the Adamello and the Austrian-Hungarian offensive, the so-called "punitive expedition," in May/June 1916 again at the Seven Communes Plateau.[43]

As a non-commissioned officer of the medical service, Veitl experienced the skirmishes on the sharp end. He had to command a group of stretcher-bearers. When the fighting started, it was Veitl's duty to look for wounded soldiers, provide first aid, and to transport them safely to the closest *Hilfsplatz*. These were places of first aid, whose purpose was to divide wounded soldiers into lightly and heavily wounded persons, to treat most urging injuries, and to organize the soldiers transport further backward.[44] That means that in fulfilling his war-specific duty, Veitl had to expose himself to enemy fire as he remembers in his diary, too.[45] On 30 August 1916, in the course of an Austrian assault towards an Italian outpost in the Val Sugana/Suganertal, Veitl was wounded in action: a bullet hit his left shoulder.[46]

In the following days, Veitl received first aid and was then taken first to a field hospital and later to Linz. Almost two weeks after he got wounded he arrived at Weißenberg Castle.[47] This castle was used as convalescent home (*Rekonvaleszentenheim*) for the 14th Infantry Regiment.[48] Soon after Veitl

had recovered, he had to enlist again for military service. However, for the moment, Veitl was not sent back to the frontline but was ordered to work at the convalescent home in Weißenberg Castle. During these months, he experienced the happiest days of his soldierly life. He was able to see his family, and go hunting and fishing.[49]

In May 1917 Veitl was ordered to rejoin his regiment in the Tyrolean theater of war. When he did so, he returned in a different rank: Shortly after being wounded, Veitl received his hardly awaited promotion to the officer's rank of an ensign in September 1916.[50] Due to this preferment his duties changed, too. This is clearly shown by his diary notes about his experiences on the Isonzo front. After a short furlough in July 1917, Veitl did not return to the *X. Marschbataillon* but was assigned to the 4th battalion which was redeployed to the Isonzo front in September 1917 in order to reinforce the endangered frontline. From the 10 until the 16 September Veitl took part in the eleventh Isonzo battle at the Monte San Gabriele. As medical ensign it was not Veitl's duty anymore to retrieve wounded soldiers but to work at one of the regiment's *Hilfsplätze* just behind the frontline. There, his task was to prepare the wounded for further transport to a field hospital. This meant applying definitive bandages, performing life-saving operations if necessary, and equipping the wounded with diagnostic charts showing the nature of the injury and the help provided.[51] In the course of the battle, Veitl was ordered to take over the command of a forwardly deployed *Hilfsplatz*.[52]

In the following year, Veitl experienced the twelfth Isonzo battle, the advance to the Piave, the collapse of the armed forces, and the armistice in November 1918. Fortunately for him, he escaped capture and was able to make his way across Tyrol towards home.[53]

1.2 Photo Albums as 'Sites' of Personal War Remembrance

The importance that Veitl attached to his war service throughout his life may be expressed in the abundance of materials he preserved (see Fig. 1). Besides popular veteran's literature of Fritz Weber[54] he also preserved his war diary as well as his photo apparatus, a Zeiss-Ikon Compur, plus its pocket and glass slabs. On the lower left side of Fig. 1, Veitl's two war albums are visible. After Bernhard Veitl died in 1973, his son Wolfgang found his war memorabilia in his bedside table. He stored and preserved the items for decades until 2017[55], when he decided that he wanted to donate them to a public institution. Therefore, Wolfgang Veitl got in touch with the Department of Contemporary History at the University of Linz. At that time, I was employed at the department as a university assistant and made Veitl acquainted with Martin Kofler, the director of the *Tiroler Archiv*

für photographische Dokumentation und Kunst (TAP). The *TAP* is a transnational photo archive with seats in Lienz as well as Brunico/Bruneck.[56] It collects private and professional photographic collections of Tyroleans as well as of Tyrol and South Tyrol.[57] Hereafter, Veitl relinquished his father's collection to the archive as a permanent loan. Thus, Veitl's diary and visual records became accessible for research.

So, Veitl was one of the many (non-commissioned) officers in the Austrian-Hungarian army who were in the possession of an own photo camera. In his diary entries he mentions several times that he took photographs.[58] Unfortunately, when Veitl created his albums cannot be determined with certainty. He could have done it during his recovery at Weißenberg Castle in late 1916,[59] during one of his rare furloughs or—since the last photograph dates from November 1917—towards or after the end of the war.[60] After the war, however, Veitl did not keep his photographic treasure to himself. He provided several images for ex-officers of both his battalion and regiment who wrote their chronicles in the Interwar period.[61]

Both albums consist of 211 black and white photographs, whereby with twenty-five pages and 144 pictures the first one is more comprehensive than the second one with twenty pages and sixty-seven images. The first album's form is special: On the cover's upper left corner an iron cross with the letter W is depicted. W stands for the German emperor Wilhelm II; the iron cross was one of the highest military distinctions in the German army. Below is written in silver letters: "*Kriegserinnerungen,*" war memories. This commercially sold album form reflects the popularity of private photographic practice in the First World War. The album's form also structured the visual narration: Not only the photograph's format but also its position, alignment, and number were predetermined. No more than six horizontal images fit one page. The second album features a similar form: Veitl could not arrange more than four horizontal images on one page. Due to this rigid format vertical images had to be turned ninety degrees.

While Veitl added hand-written captions in the first album, he did not do so in the second one. Why this is, we do not know. In any case, they suggest that the visual narration is structured mainly chronologically rather than thematically. It starts off with Veitl's deployment at the Seven Communes Plateau,[62] continues with the battalion's recovery in Trento/Trient,[63] which is then followed by its assignment at the Adamello frontline.[64] The first album ends with the Austrian-Hungarian offensive in May/June 1916.[65] The second album's narration opens with Veitl's stay in a position at Monte Cimone,[66] closely followed by images of clashes in Val Sugana/Suganatal in August 1916,[67] where he was wounded. At this point Veitl stopped adding

captions. This makes it almost impossible to reconstruct his further narrations.[68] Only two townscapes could be identified: a photograph of Bolzano/Bozen as well as one of Dobbiaco/Toblach.[69] According to his diary Veitl visited these places in May 1917 and February 1918,[70] which suggests that the narration continues chronologically. Depicted architectures as well as landscapes at least suggest that the remaining images were taken at the Tyrolean theater of war. In fact, only two pictures can be linked with the Isonzo front for sure, namely those of a 30.5 mortar. In November 1917, during the twelfth Isonzo battle, Veitl noted in his diary that he had photographed the arrival of the famous artillery piece.[71] Finally, towards the end of the second album the visual narration crumbles at all. Not only are captions missing, but also pictures: On the last four pages—around the two photographs of the mortar—all the slots available per page are no longer filled.[72] This could indicate that Veitl had not filled them from the beginning or that he had removed some pictures from the album.

Fig. 1: Veitl's War Memorabilia which is now a permanent loan at the *Tiroler Archiv für photographische Dokumention und Kunst (TAP)* in Lienz (Photo: Martin Kofler).

It is obvious, however, that Veitl's wounding in late August 1916 marks a turning point in his visual narration—even though the wound itself and his recovery followed by his deployment at Weißenberg Castle remain completely invisible.[73] This cesura becomes visible not only in the album's form (missing captions), but also quantitively: From September 1915 until November 1918 Veitl spent circa twenty-nine months at the front: Eleven before and eighteen months after his wounding. In his visual narration, however, more total numbers of album pages (28 of 44: 63,6 %) as well as total numbers of photographs (160 of 211: 75,8 %) refer to the shorter period before. Accordingly, the Tyrolean theater of war is much more visible than the Isonzo.

In any case, experiences of mass violence at the Isonzo as well as distinct changes of Veitl's morale may explain this imbalance. According to his diary, Veitl went to war enthusiastically: he could not wait for battles, promotions, and distinctions.[74] However, his first experiences of violence sobered him and changed his attitude noticeably. After a few months, feelings of disillusionment and a longing for peace already dominate.[75] In 1918 he calls military service a serfdom and himself a dogged anti-militarist.[76]

How did Veitl narrate his war deployment? After kicking off with a symbolical prelude,[77] two portraits of him and his brother Walther[78] in uniform, he reimagined his deployment largely as a chronological journey that took him from one (un-)known region to another. At the front everything is different than at home and therefore worth recording for the photographer. In this respect, Timm Starl distinguished two major thematic areas for First World War's "snapshooters," which also apply to Bernhard Veitl. On the one hand, photographers appropriated the foreign as the familiar: for example, foreign landscapes and architectures, unfamiliar military equipment, or the unusual everyday life of war—such as leisure time with comrades or the receiving of rations—got visualized. Especially for Veitl, who was initially enthusiastic about the war, it was important to visualize his new habitus as an officer by including lots of pictures staging himself and other officers in their everyday life. On the other hand, it was a matter of presenting the near as the distant. Photographs materialized the vicinity of death and wounding. At the same time, however, photographs should reject the possibility of being harmed. Accordingly, the photographer always appears as the victor; defeat and downfall always concern the enemy.[79] The same applies, of course, to the visualization of death and violence, which is addressed by the following section.

2 In-/Visibilities of Violence

Soon after the war began, the military leadership of Austria-Hungary began to understand the enormous potential of photography as a propaganda and combat tool. This is reflected in the establishment and development of an own *Lichtbildstelle* (photo division) as part of the *k.u.k. Kriegspressequartier (KPQ)*, which was the propaganda department of the Austrian-Hungarian army, in 1917. Before that, the *KPQ* photographers had been part of the art group (*Kunstgruppe*) along with the war painters. The *Lichtbildstelle*, however, became the hub of the photographic production and distribution of the Habsburg army. The division not only employed professional photographers, but also increasingly drew on the productions of military photographers, and soldierly amateurs, who were instructed to send one copy of each photograph to the *KPQ*'s central office. With the beginning of 1917, the Viennese war archive had already collected more than 50,000 *KPQ* photographs. This number gives an idea about the enormous scale of photographic production the department conducted during the war.[80]

The *KPQ* did not leave it to chance how its photographers represented the war. It had a clear idea of how or what should be made visible and what had to remain invisible, and thus applied rigid censorship. The photographers were to present above all the army, its leaders, and its weapons in order to create an idea of military superiority. While conquests and advances were visualized, retreats and supply shortages were to remain invisible. Finally, violence was largely ignored. Making it visible, if at all, was subject to certain conditions: Only the enemy's dead were to be made visible while still lying on the battlefield. Of course, the bodies of their own dead remained invisible. If they were represented, then only removed from the battlefields, in beautifully decorated and attentively tended, personalized graves.[81]

2.1 The Staged Faces of Violence

These guidelines also influenced the practice of photo amateurs and "snapshooters." The *KPQ* distributed leaflets with strict instructions on the choice of subjects among troops.[82] Veitl's imagery shows that he followed the official guidelines precisely: He represented the war as a logistical challenge in a stunningly beautiful alpine landscape, photographed his superiors as well as his comrades and himself during leisure time. He also represented his workplace, the *Hilfsplatz*, but only when there was no fighting. In addition, he medialized their own well-built shelters and positions as well as weapons such as heavy artillery. Finally, pictures of landscapes and cityscapes, which Veitl took in the hinterland, make up a weighty part.[83]

Fig. 2: "Cemetery at [Monte] Durer", Album 1 of Bernhard Veitl, page 23, *TAP*, Lienz.

Veitl's visual narration about his war deployment at the Seven Communes Plateau in the summer of 1916 offers an ideal example for the study of the in-/visibility of violence: On the way forward—during the Austrian-Hungarian offensive in May—Veitl photographed conquered positions on Monte Durer as well as both the captured fort Campomolon and heavy artillery pieces. Compared to the visualization of Austrian-Hungarian positions, there is a decisive difference: while the own are well-built and unscathed by enemy fire, the enemy positions are marked by chaos with trees, stones and fallen walls as well as left-behind equipment lying around which points to the applied violence. Making the own presence

visible by posing in front of conquered positions, made the victorious battle evident.[84]

In the footer of Fig. 2, Veitl arranged two photographs he took of captured positions on Monte Durer. They are the prelude to a series of pictures on the following page, which were intended to demonstrate the success in the May offensive. The series closes with a picture of the church tower of Tonezza.[85] This photograph marked the town furthest ahead, that Veitl had reached during the offensive.[86] However, after the Austro-Hungarian offensive bogged down in June due to bad weather and supply difficulties, even the order to retreat to safer positions finally had to be given up after the Russian army launched an offensive to relieve the Italians on 4 June 1916.[87] The retreat admittedly remained invisible in Veitl's album.

The own dead of the victorious offensive remained almost invisible—as desired in the official guidelines. Only one picture in Fig. 2 refers to Austro-Hungarian losses. Next to three pictures showing the visit of Pisein Castle (today Beseno Castle) on the way to the front, Veitl arranged an image of an Austrian-Hungarian war cemetery on Monte Durer: the graves appear well laid out and well-tended. Some are decorated with wreaths and bouquets, indicating that their own dead will not be forgotten. The background, a row of trees, provides a peaceful setting for the buried which makes the audience forget the mortal injuries of the dead.[88]

In Veitl's albums only one photograph of a dead body occurs (see Fig. 3). This visualization is in great contrast to the dead of his own army at the cemetery: It is the body of an Italian soldier who probably lost his life during a skirmish at Monte Cimone in early July 1916. After a combat had taken place, Veitl received the order to conduct a medical patrol to the battle ground beyond the trenches in order to bury dead and to recover wounded on 6 July. On that occasion, he also encountered dead Italian soldiers.[89] Apparently, he took a photograph of one of them, just the way he had died in action. The photograph of the prisoners of war below, on the other hand, had already been taken by Veitl two days earlier, on 4 July 1916.[90]

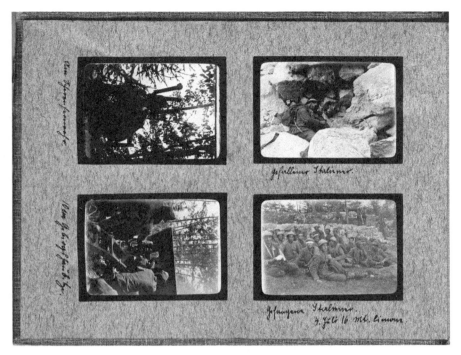

Fig. 3: "Fallen Italian" and "Captured Italians. 4 July [19]16 Mon[t.]e Cimone.",
Album 2 of Bernhard Veitl, page 2, *TAP*, Lienz.

The album page, however, develops a narrative of military superiority:
The two pictures on the left, which show well-covered Austro-Hungarian
soldiers handling a telescope and an artillery piece during battle, are juxta-
posed with the two pictures on the right, which in turn mediate killed and
captured enemies. This narrative is strongly supported by the two images'
camera perspective: The slight overhead view fosters the audience's feeling
of being superior and victorious over the men depicted.[91] Accordingly, such
images were used as war trophies. They made the supposed inferiority of the
enemy evident and affirmed the own strength. Those who photographed
devastated enemy territory, captured weapons or killed/captured enemies
and even posed in front of them and collected such photographs, counted
themselves among the military victors.[92] Dewitz considered such images not
only as trophies, but also as means of self-preservation. Thus, they would be
the product of soldiers trying to banish violence that exceeded their subjective
comprehension and to move that experience away from themselves. The cam-
era lens would have allowed soldiers to create distance towards the violence and
take themselves out of the frame, and thus out of the violent action.[93]

2.2 Beyond the Viewfinder: Invisible Mass Violence

It has already become sufficiently clear that the photographs in Veitl's album do not contain the "real" war or, if they do, then only contain carefully selected episodes of a reality of war. Besides the external censorship, there was also an internal at work, which played a significant role deciding on what (not) to photograph and which images (not) to select for the album. Narratives laid out in albums, however, strive for linearity as well as plausibility. To this end, they transform biographical breaks into causal coherences. What does not fit into a corresponding biographical interpretation is ultimately left out or is made invisible at all. In order to not risk becoming an accomplice to the biographical illusion that Veitl built in his albums, it is necessary to ask what he has left out in his visual narrative.[94] Of course, this is methodologically difficult, since those events which remained outside the camera's viewfinder and, therefore, were not to be remembered, did not leave any empirical traces.[95] In Veitl's case, however, a comprehensive diary is available. It opens up the methodological chance of bridging the gap of violence in the albums in/visible by adapting a comparative perspective.[96] The discrepancies in content between diary and photo album—especially with regard to making violence invisible—are not surprising, since the album, in addition to its presenting function, is also characterized as less intimate and self-oriented than the diary.[97]

By reading the diary, one learns that the photographed Italian was not the first dead Veitl had seen as medical officer. On the occasion of his first battle at the end of October 1915, he confided to his diary: "I saw terrible injuries. A chest shot and both feet crushed by a grenade, then leg shots, stomach shots, also dead bodies....Our positions were exactly the same as before. We had taken 30 dead, 80 wounded and achieved nothing. We were defeated."[98]

Half a year later, Veitl's battalion was moved to the Adamello section in order to recapture previously lost positions at the Fargorida Pass, which is located at a glacier at 3,100 meters above sea level. The operation failed in the end: After eleven days, the battalion had to abandon its position and disengage from the enemy.[99] The battalion's losses from heavy enemy artillery fire, cold, and snowstorms were devastating: Veitl noted in his diary that in his company besides himself only one other officer had survived the operation unscathed. Of the entire battalion, which usually had a manpower of about 1,000,[100] he estimated that only fifty (!) remained unharmed. The rest was either dead, wounded, or out of action due to frostbite.[101]

In his album, however, these losses remain invisible. This gap was filled with other imagery: Veitl arranged fourteen photographs in his album of

the fatal mission on the glacier mostly showing spectacular mountain pan-
oramas. Only three pictures depict scenes from the snowy trench: Instead
of breaking the visual taboo of not showing men in physical or psycholog-
ical pain,[102] they show smiling faces of men, smoking, cooking or posing
martially with rifle at the ready.[103] "The hardship and suffering they knew
viscerally were implicit in these images."[104]

As mentioned previously, Veitl's experiences in the eleventh and twelfth
Isonzo battles are pretty much not addressed in the albums. Only the imag-
es of the 30.5 mortar attempt to tell a story of military superiority. The
empty frames on the album pages all around the mortar pictures, albeit,
materialize the gap of violence in a different, very concrete way: Here the
void takes possession of space and refers to something invisible or to some-
thing that should have remained invisible, and thus not remembered. The
intentional emptiness opens up the space for an audience's premonitions
and conjectures. The diary, however, gives at least some glimpses of the mass
violence Veitl had encountered during his deployment at the Isonzo.

After the fighting around Monte San Gabriele in September 1917,
Veitl developed a fever and was therefore taken to a field hospital to recover.
There he had the opportunity to write down what he had experienced at
an advanced aid post on Monte San Gabriele within seven days. One day,
during a break in the fighting, he left his cavern to get an idea of what it
looked like further ahead. About this he noted:

"And the trench, what did it look like! It's so hard to write every-
thing down [...]. But I can say one thing: I would never have
thought something like that is possible. What I have seen before
was nothing. Just above my cavern it was still bearable, although
the wind carried a terrible pestilential breath. Large boulders,
hurled into the trench by the terrible impact of heavy shells, have
to be climbed over or bypassed. Pressed together there, wrapped
in the tent sheets, sit close beside mangled corpses a few infantry-
men who are to attack tonight. These corpses! You encounter them
everywhere. Here you step on a man who has not yet been buried,
a bruised sound escapes from his chest, startled, you pull your foot
back. There lies a foot, here again only the head and a hand pro-
trude from the funnel. Glassy eyes are staring at you. Their faces are
blue, bloated, already decaying. In the haste with which we strive
upwards, we are not even aware of all this horror. Only further.
We quickly get higher. Weapons, blankets, tools, armor, grenades,
blind shells, and much, much more are scattered everywhere. In

between, a few lightly wounded people hurry down the valley. Even a machine gun [...] lies abandoned at the edge of the trench. 'Edge of the trench', since a few minutes now it is no longer possible to speak of a trench. It has been levelled by the constant shelling; it no longer differs from its surroundings in any way. Only through the bodies of those killed in the trench. [...] And above, the poor cry for water."[105]

But the verbally eloquent Veitl did not always find words for the horror he experienced. Having recovered from his fever, he returned to his troops only in the middle of the twelfth Isonzo battle. On 2 November 1917, exhausted, he summed up in his diary: "I am unable to write down everything I have seen and everything that moves me. Much that is beautiful, much that is sad and ugly. I am only listing the names of places."[106] In this case, these names became placeholders for what could neither be said nor visually shot and shown. This horrific atmosphere might also be the reason for the lack of more Isonzo pictures in Veitl's album.

3 Conclusion

The face of the First World War was marked by two revolutions: Firstly, industrial inventions in metallurgy, chemistry, and light engineering produced the means to develop weapons and shells with a destructive power the world had not seen before. Secondly, cameras arrived on the war's battlefields in large numbers for the first time, mediatizing it on a scale never experienced before, used officially as well as privately.[107] Images of mass violence represent the product of both developments. However, such visualizations followed certain conditions in almost every warring state: Through censorship and guidelines, propagandists tried to produce a certain, singular image of war: Deadly wounded and mutilated soldiers lying on the battlefield and destroyed, abandoned positions were photographed, but they were always those of the enemy. The bodies of the own dead remained invisible. They only were depicted in the form of well-kept cemeteries—without a trace of the battlefields' horror. Images of commanders as well as of heavy weapons, on the other hand, were intended to support the idea of military superiority.

The war albums of photo amateurs do not – as has long been assumed— offer an insight into the "real" reality of war. They were similarly influenced by the official guidelines and, therefore, reproduced normative imagery. Violence, thus, also remains largely a gap in private war albums. This also

applies to the albums of the officer Bernhard Veitl, whose albums were at the center of this contribution. Violence and hardship remain implicit or are attributed to the others, the enemies. Although, in his case an extensive diary has survived. Its comparative reading makes the voids of violence in the visual narrative visible and shows with what the gap was filled instead. Like Veitl, to come to terms with the terrible battle past, other war veterans also primarily remembered "the pleasant things, the pleasurable moments in the circle of comrades, the missions that went well, the hardships that were overcome, the awards that were received."[108] In this way, the war lost its menace in the album, and even though it is titled "War Memories," the pictures of the war serve less the purpose of remembering than of forgetting.[109]

Endnotes

1 Anton Holzer, "Das fotografische Gesicht des Krieges: Eine Einleitung," in *Mit der Kamera bewaffnet: Krieg und Fotografie*, ed. Anton Holzer (Marburg: Jonas, 2003), 7–20, here 8.

2 Jens Jäger, *Fotografie und Geschichte* (Frankfurt am Main: Campus, 2009), 146–47.

3 Anton Holzer, *Die andere Front: Fotografie und Propaganda im Ersten Weltkrieg*, 3rd ed. (Darmstadt: Primus, 2012); Anton Holzer, *Das Lächeln der Henker: Der unbekannte Krieg gegen die Zivilbevölkerung 1914–1918*, 2nd ed. (Darmstadt: Primus, 2014).

4 Jay Winter, *War beyond Words: Languages of Remembrance from the Great War to the Present* (Cambridge: Cambridge University Press, 2017), 32.

5 Jay Winter stresses that this differentiation should not be drawn too sharply since there were many overlaps between them. Many amateurs, for instance, operated both in the public and in the private sphere; see: Winter, *War beyond Words*, 32.

6 Ibid.

7 Ibid., 33.

8 Jäger, *Fotografie*, 72; Petra Bopp, *Fremde im Visier: Fotoalben aus dem Zweiten Weltkrieg*, 2nd ed. (Bielefeld: Kerber, 2012), 40.

9 Winter, *War beyond Words*, 33.

10 For instance, see Joëlle Beurier, *14–18 Insolite: Albums-photos des soldats au repos* (Paris: Nouveau Monde Éditions et Ministère de la Défense, 2014), 237–39.

11 For an example regarding the German case see, for instance, Bodo von Dewitz, *"So wird bei uns der Krieg geführt!": Amateurfotografie im Ersten Weltkrieg* (Munich: Tuduv, 1989).

12 Markus Wurzer, *"Nachts hörten wir Hyänen und Schakale heulen." Das Tagebuch eines Südtirolers aus dem Italienisch-Abessinischen Krieg 1935–1936* (Innsbruck: Universitätsverlag Wagner, 2016), 18.

13 Language still is a core issue within the research practice on Austria-Hungary in World War I. Austrian research is mostly limited to the German-speaking sphere of the Habsburg Empire. Cross-language research initiatives which try to include different perspectives are lacking to a bigger extent. One outstanding example is Pieter Judson, *The Habsburg Empire: A New History* (Cambridge: Harvard University Press, 2018).

14 See, for instance, Sigrid Wisthaler, *Karl Außerhofer – Das Kriegstagebuch eines Soldaten im Ersten Weltkrieg* (Innsbruck: Innsbruck University Press, 2011); Isabelle Brandauer, *"Der Krieg kennt kein Erbarmen." Die Tagebücher des Kaiserschützen Erich Mayr (1913–1920)* (Innsbruck: Universitätsverlag Wagner, 2013); Isabelle Brandauer, "Die Kriegstagebücher der Brüder Erich und Rudolf

Mayr: Kriegserfahrungen an der Südwestfront im Vergleich," in *Jenseits des Schützengrabens: Der Erste Weltkrieg im Osten: Erfahrung – Wahrnehmung – Kontext*, ed. Bernhard Bachinger and Wolfram Dornik (Innsbruck: Studienverlag, 2013), 244–65.

15 Besides authors who published the photographic records of their ancestors, see, e.g., Ivo Ingram Beikircher, *Tiroler Autopioniere im Ersten Weltkrieg: Galizien, Alttirol und der Vordere Orient in Fotografien und Briefen des k.u.k. Feuerwerkers Gustav Beikircher* (Innsbruck: Haymon, 2012), a few theses exist, which address private photo collections of World War I. See, e.g., Julian Kampitsch, "Die Wahrnehmung, Beschreibung und Beurteilung der Kriegsrealität eines Offiziers der k.u.k. Armee in Feldpostbriefen und Privatfotografien: Auf Grundlage der Feldpostbriefe des k.k. Oberleutnants in der Reserve Othmar Hübl 1915–1916" (Diploma thesis, University of Graz, 2018); the most comprehensive study of private war photography in Austria is already more than two decades old: Timm Starl, *Knipser: Die Bildgeschichte der privaten Fotografie in Deutschland und Österreich von 1880 bis 1980* (Munich: Koehler & Amelang, 1995).

16 Wisthaler, *Außerhofer*, 8.

17 "Europeana 1914–1918: Aktionstag in Wien am 1. August," *Horizont* (July 28, 2014), accessed Jan. 7, 2021, https://www.horizont.at/digital/news/europeana-1914-1918-aktionstag-in-wien-am-1.-august--48945; "Europeana 1914–1918 – untold stories & official histories of WW1," *Europeana 1914–1918*, accessed Jan. 7, 2021, http://www.europeana1914-1918.eu/en.

18 I thank Anton Holzer (Vienna) for pointing my attention towards this circumstance.

19 Bernd Boll, "Vom Album ins Archiv: Zur Überlieferung privater Fotografien aus dem Zweiten Weltkrieg," in *Mit der Kamera bewaffnet: Krieg und Fotografie*, ed. Anton Holzer (Marburg: Jonas, 2003), 167–78 (here 175).

20 I thank Anton Holzer (Vienna) for this indication.

21 Winter, *War beyond Words*, 38.

22 Jens Jäger, "Überlegungen zu einer historiografischen Bildanalyse," *Historische Zeitschrift* 304, no. 3 (2017): 655–82; Elizabeth Edwards, "Photographs as Objects of Memory," in *The Object Reader*, ed. Fiona Candlin and Raiford Guins (London: Routledge, 2009), 331–42.

23 Miriam Y. Arani, "'Und an den Fotos entzündete sich die Kritik.' Die 'Wehrmachtsausstellung,' deren Kritiker und die Neukonzeption: Ein Beitrag aus fotohistorisch-quellenkritischer Sicht," *Fotogeschichte* 22, no. 85/86 (2002), 96–124; Markus Wurzer, "Fotografie," in *Österreichische Zeitgeschichte – Zeitgeschichte in Österreich: Eine Standortbestimmung in Zeiten des Umbruchs* (Vienna: Böhlau, forthcoming)

24 Jäger, "Überlegungen," 674, 677–79.

25 Fritz Fellner, "Der Krieg in den Tagebüchern und Briefen: Überlegungen zu einer wenig genützten Quellenart," in *Österreich und der Große Krieg 1914–1918: Die andere Seite der Geschichte*, ed. Klaus Amann and Hubert Lengauer (Vienna:

Brandstätter, 1989), 205–13 (here 206); see also: Reinhart Koselleck, *Zeitschichten: Studien zur Historik* (Frankfurt am Main: Suhrkamp, 2000), 67.

26 Petra Bopp, "Fremde im Visier: Private Fotografien von Wehrmachtssoldaten," in *Mit der Kamera bewaffnet: Krieg und Fotografie*, ed. Anton Holzer (Marburg: Jonas, 2003), 97–117.

27 Andreas Kröber, "Bilder als Quellen – Bilder als Darstellungen: Bilder zum Rekonstruieren von Geschichte; Geschichte in Bildern de-konstruieren," in *Bilder, die die Welt bedeuten: 'Ikonen' des Bildgedächtnisses und ihre Vermittlung über Datenbanken*, ed. Johannes Kirschenmann and Ernst Wagner (Munich: kopaed, 2006), 169–93 (here 171).

28 Luigi Tomassini, "L'album fotografico come fonte storico," in *L'impero nel cassetto: L'Italia coloniale tra album privati e archivi pubblici*, ed. Paolo Bertella Farnetti, Adolfo Mignemi, and Alessandro Triulzi (Milano: Mimesis, 2013), 59–70 (here 60).

29 Stefanie Michels, "Re-framing Photography – Some Thoughts," in *Global Photographies: Memory – History – Archives*, ed. Sissy Helff and Stefanie Michels (Bielefeld: Transcript, 2018), 9–18 (here 11); Markus Wurzer, "Die sozialen Leben kolonialer Bilder: Italienischer Kolonialismus in visuellen Alltagskulturen und Familiengedächtnissen in Südtirol/Alto Adige 1935–2015" (PhD diss., University of Graz, 2020), 269–75.

30 Cord Pagenstecher, "Private Fotoalben als historische Quellen," *Zeithistorische Forschungen* 6, no. 3 (2009): 449–63 (here 454).

31 I thank Susanna Schöberl and Sandra Redl who were a big help in putting together Bernhard Veitl's biography. I had the honor to supervise both of their excellent BA theses which dealt with Veitl's diary from different perspectives: Susanna Schöberl, "Zwischen Idylle und Inferno: Raumwahrnehmungen im Kriegstagebuch von Bernhard Veitl" (BA thesis, University of Linz, 2017); Sandra Redl, "Der Mann an der Front: (Selbst-)Repräsentationen von Geschlecht im Ersten Weltkrieg" (BA thesis, University of Linz, 2017).

32 Wolfgang Veitl, interview by Sandra Redl, July 6, 2017.

33 "Ernannt," *Linzer Volksblatt*, 28 June, 1916, 4.

34 Wolfgang Veitl, interview by Sandra Redl, July 6, 2017.

35 Wolfgang Veitl, interviews by Susanna Schöberl, July 6, 2017, and July 18, 2017; "Zehnjähriges Maturajubiläum," *Linzer Tages-Post*, July 10, 1924, 4.

36 Wolfgang Veitl, interviews by Susanna Schöberl, July 6, 2017, and July 18, 2017.

37 Bernhard Veitl, diary entry, June 18, 1916, Collection Bernhard Veitl, Tiroler Archiv für photographische Dokumentation und Kunst (TAP), Lienz; the diary was transcribed under Markus Wurzer's supervision by students in the course *Erfahrungsgeschichte* at the University of Linz in the summer semester 2017.

38 Bernhard Veitl, diary entry, June 18, 1916.

39 "Ernennung," *Grazer Volksblatt*, December 18, 1887, 3.

40 This knowledge results from Bernhard Veitl's qualification list: Vormerkblatt für die Qualifikationsbeschreibung of Bernhard Veitl, HR 3610, Qualifikationslisten (Quall), Personalunterlagen (Pers), War Archives, Austrian States Archives, Vienna; I thank Gottfried Kalser (Lienz) for this indication.

41 Bernhard Veitl, diary entry, October 21, 1915.

42 Hugo Schmid, *Handbuch für Unteroffiziere*, 12th ed. (Vienna: author's edition, 1917), 541–43, I thank Gottfried Kalser (Lienz) for providing this guideline for non-commissioned officers; Bernhard Veitl, diary entries, October 20, 1915, February 12, 1916, February 20, 1916–December 21, 1916.

43 Bernhard Veitl, diary entries, October 24, 1915–June 26, 1916; see also: Gerhard Artl, *Die "Strafexpedition": Österreich-Ungarns Südtiroloffensive 1916* (Brixen: Weger, 2015).

44 Schmid, *Handbuch für Unteroffiziere*, 938, 947–48.

45 Bernhard Veitl, diary entry, October 29, 1915.

46 Belohnungsantrag for Bernhard Veitl, MBA 647.946, Allgemeine Reihe (AR) 592, Mannschaftsbelohnungsanträge (MBA), Neue Belohnungsakten (NBA), Belohnungsakten (BA), War Archives, States Archives, Vienna.

47 Bernhard Veitl, diary entry, December 21, 1916.

48 "Auszeichnung. – Besuch," *Linzer Volksblatt*, May 12, 1916, 4.

49 Bernhard Veitl, diary entry, December 30, 1916.

50 Qualifikationsliste of Bernhard Veitl, HR 3610, Quall, Pers, War Archives, Austrian States Archives, Vienna; Belohungsantrag for Bernhard Veitl, OBA 229.184, AR 312, Offiziersbelohnunsanträge (OBA), NBA, BA, War Archives, Austrian States Archives, Vienna.

51 Schmid, *Handbuch für Unteroffiziere*, 947; Bernhard Veitl, diary entry, September 25, 1917.

52 Bernhard Veitl, diary entry, September 25, 1917.

53 Ibid., October 31, 1918–November 3, 1918.

54 Fritz Weber, *Feuer auf den Gipfeln:* Südtiroler Alpenkrieg (Regensburg: Manz, 1932); Fritz Weber, *Menschenmauer am Isonzo* (Leipzig: Styrermühl, 1932).

55 Wolfgang Veitl, interview by Markus Wurzer, March 23, 2017.

56 See Martin Kofler and Notburga Siller, "The Interreg-Project 'Lichtbild/Argento Vivo' and its Results to Promote the Importance of Historic Photography," and Martin Kofler, "Mountain Pictures: A Special Look into the Collections of the Tyrolean Photo Archive (TAP)" in this volume.

57 Among others, the archive has collected the World War I album of Anton Trixl, who had been in action in the Sesto Dolomites and had photographed the exhumation of the well-known Tyrolean mountain guide Sepp Innerkofler in 1918: Martin Kofler and Markus Wurzer, "Zur Entstehung und Entwicklung eines Mythos: Sepp Innerkofler und die Fotografien seiner Bergung 1918 von Anton Trixl," *Tiroler Heimat* 78, no. 1 (2014), 135–57.

58 Bernhard Veitl, diary entry, October 30, 1916, September 5, 1917, and November 7, 1917.

59 At the starting page of the second album, Veitl left a written note which presents him as a medical cadet. That suggests that he created both albums before he was promoted to medical ensign in December 1916.

60 Starl, *Knipser*, 79–80: Starl argues that these were usually the time periods when soldiers created their albums.

61 Pictures of Veitl were printed in both the battalion's and the regiment's chronicles: Maximilian Ehnl, *Das X. Bataillon des k. u. k. Infanterie-Regiments "Ernst Ludwig Grossherzog von Hessen und bei Rhein" Nr. 14 im Weltkrieg* (Linz: Hessen-Offiziersbund, 1932), 48–49; N.N., *IR 14: Ein Buch der Erinnerung an Große Zeiten 1914–1918* (Linz: Josef Feichtingers Erben, 1919), 367.

62 Bernhard Veitl, Album 1, 2–14.

63 Ibid., 15–18.

64 Ibid., 18–21.

65 Ibid., 21–25.

66 Bernhard Veitl, Album 2, 1–3; Bernhard Veitl, diary entry, June 25, 1916.

67 Bernhard Veitl, Album 2, 3–4.

68 Starl, *Knipser*, 154; Starl argues that people taking snapshots know the stories behind single photographs which is why they do not have to add captions necessarily. This is also true for all kinds of private albums set up nicely but without any captions at all.

69 Bernhard Veitl, Album 2, 11, 15.

70 Bernhard Veitl, diary entries, May 25, 1917, and February 14, 1918.

71 Bernhard Veitl, Album 2, 19; Bernhard Veitl, diary entry, November 18, 1917.

72 The pages 16–20 of the second album are not filled entirely: page 18 and 20 do not have any pictures while page 16 and 19 consist of 3 images. One photograph is arranged on page 17.

73 These experiences, however, are accessible via his diary: Bernhard Veitl, diary entries, December 21–30, 1916.

74 Ibid., October 22, 1915.

75 Ibid., October 29, 1915, February 21, 1916, March 3, 1916, May 30, 1916, August 10, 1916, and August 25, 1916.

76 Ibid., October 21, 1918.

77 Pagenstecher, "Private Fotoalben," 462.

78 Bernhard Veitl, diary entry, September 26, 1917.

79 Starl, *Knipser*, 73–75.

80 Holzer, *Die andere Front*, 35.

81 Ibid., 89.

82 Ibid., 46–61.

83 Bernhard Veitl, Album 1, 1–5, 15–17.

84 Bernhard Veitl, Album 2, 24.

85 Ibid., 25.

86 Bernhard Veitl, diary entry, June 21, 1916.

87 Ehnl, *X. Bataillon*, 51.

88 Starl, *Knipser*, 76.

89 Bernhard Veitl, diary entry, July 6, 1916.

90 Bernhard Veitl, Album 2, 2; Bernhard Veitl, diary entry, June 4, 1916.

91 Holzer, "Gesicht," 14–15.

92 Starl, *Knipser*, 75; Holzer, "Gesicht," 14.

93 Dewitz, *Krieg*, 263; Starl, *Knipser*, 76; Gerald Lamprecht, "Kriegsphotographie als Ort der Erinnerung: Photographie zwischen privat und öffentlich am Beispiel eines Kriegserinnerungsalbums und des Diskurses um die Photographien der Wanderausstellung 'Vernichtungskrieg: Verbrechen der Wehrmacht 1941 bis 1944,'" *eforum* 2, no. 2/3 (2002), 1–21 (here 11–18).

94 Lamprecht, "Kriegsphotographie," 11–18.

95 Astrid Erll, *Kollektives Gedächtnis und Erinnerungskulturen: Eine Einführung*, 3rd ed. (Stuttgart: Springer, 2017), 118–19.

96 Of course, the diary does not give a complete picture of Veitl's experiences. The writing is also influenced by various factors, such as external and self-censorship; see: Wurzer, *Hyänen und Schakale*, 17–24.

97 Pagenstecher, "Fotoalben," 454.

98 Bernhard Veitl, diary entry, October 29, 1915.

99 Ehnl, *X. Marschbataillon*, 46–49.

100 Wisthaler, *Außerhofer*, 177.

101 Bernhard Veitl, diary entries, April 30, 1915–May 11, 1916.

102 Winter, *War beyond Words*, 41.

103 Bernhard Veitl, Album 1, 18–21.

104 Winter, *War beyond Words*, 41.

105 Bernhard Veitl, diary entry, September 25, 1917.

106 Ibid., November 2, 1917.

107 Winter, *War beyond Words*, 37–38.

108 Starl, *Knipser*, 79–80.

109 Ibid.

World War II

Depicting "Austria's" Air War 1914–1945:
An Analysis of the Creation and Reinterpretation of the Austrian Aviation Archives and the Viennese Exhibition "Der Luftterror"[1]

Georg Hoffmann

In 2020, the *Archiv der Luftfahrtruppen*—a collection of files on aviation troops that had remained largely untouched in the Viennese War Archives of the Austrian State Archives since 1945—was fully examined and reorganized.[2] Created and compiled under the aegis of National Socialism in 1938, it mainly contains files on the former Austro-Hungarian aviation troops during World War I. It also includes a fragmented collection of images, some individual photographs, others integrated in files, along with photo albums that were added at a much later date.[3] All of them illustrate the early deployment of Austro-Hungarian aviation troops, focusing in particular on the airmen and their operations on the Italian front between 1915 and 1918. Other photographs, which stand in strong contrast to this form of war imagery, were also added during the collection process more than eighty years ago: images from 1943 that concentrate less on the heroic flying aces and more on the destruction wreaked on Italian cities like Milan by air raids during World War II.[4] This contrast in the pictorial portrayal of war, but also in the choice of place and time, is notable and shows that during the compilation of the "*Archiv*" the pictorial worlds had clearly undergone a lasting change. This small collection thus represents nothing less than National Socialist interpretations of aerial warfare and of society's role therein. The fact that Austrian subjects and narratives were the focus of this collection and were used to draw whole pictorial worlds is surprising and worth examining in more detail.

From a theoretical point of view, this analysis ties in with recent research on aerial warfare, which has been a part of research on National Socialism and studies of the social and cultural history of World War II since the early 2000s.[5] This process of development resulted from an academic discourse on pictorial worlds of aerial warfare, carried out in the public arena, that was sparked by Jörg Friedrich's 2002 publication *Der Brand* and in particular the corresponding pictorial volume, *Brandstätten*.[6] Not unusually, in this book the air raids were primarily depicted through descriptions and images of destruction and victims, but the emphasis was nonetheless surprising. Friedrich used terms like "Vernichtungskrieg" (war of annihilation) and described air-raid shelters as "Krematorien" (crematories), drawing comparisons with the

136 Hoffmann: Depicting "Austria's" Air War 1914–1945:
An Analysis of the Creation and Reinterpretation of the Austrian
Aviation Archives and the Viennese Exhibition "Der Luftterror"

Holocaust.[7] The uproar that followed resulted in an academic focus on aerial warfare and in particular on the pictorial worlds enlisted—first and foremost images of Dresden that were omnipresent in the media, encouraging society's victim perspective.[8] Visual history and memory studies took center stage in studies on aerial warfare , not least due to a focus on the concept of remembrance and the powerful visual accentuation of this area of war.[9] The goal was, and is, to explore the persistent pictorial worlds created primarily by National Socialist propaganda and to analyze their composition.[10]

Against this backdrop, this article will deal with the existing fragmentary collection of images in the *Archiv der Luftfahrtruppen* and their inherent narratives as an example of the pictorial worlds of aerial warfare. It will be necessary to discuss how and to what end images were constructed, underscored, discarded, and substituted. The starting point will be perceptions of a new kind of war that were established during World War I and their transference to the interwar period, where they found their way into everyday life, popular music, politics, and strategic military planning. This will be followed by a cohesive analysis of the National Socialist construction of aerial warfare images using two examples: the collection created in 1938 by the research facility of the *Luftwaffe*, which would later become the *Archiv der Luftfahrtruppen*, and the exhibition "Der Luftterror," shown in 1943, displaying exhibits from the "*Archiv.*" This comparison is aimed at examining the changes in the visual portrayal of aerial warfare that gradually took place between 1938 and 1943, focusing on the Austrian region. Finally, the resulting findings on these two aspects, or media, of the National Socialist narrative on aerial warfare will be carried over into post-NS history, illustrating how strongly visual depictions still influence today's approach to this area of war.

Early Images of Aerial Warfare and Horror Visions

When World War I began, aircraft had not yet been well tested in the field. Their appearance over the fronts sparked a number of feelings, at first mainly hope. They seemed to prove the respective nation's technical superiority and at the same time, owing to their dynamic power, offered a counterpoint, in the west of Europe particularly, to the mired-in trench warfare that characterised World War I.[11] More than this, aerial battles conjured up notions of "chivalrous duels," calling up ancient images of war that contrasted with the anonymous mass deaths happening on the ground.[12] However, all of this was largely a product of the propaganda efforts of the belligerent governments, which provided their interpretations and orchestrations of scenes that very few people would actually witness. The imagery that was

created was aimed at mobilizing the masses for a war that was increasingly escalating. The media and pictorial representations were of great importance at an early stage. Almost all the states involved utilised heroic constructions, manifested largely in the emergence of fighter pilots in the guise of "knights of the air."[13] Young pilots such as Manfred von Richthofen[14] in Germany or Godwin von Brumowski[15] in Austria-Hungary were exalted as flying aces and presented to the public in various pictorial forms. Photographs of aircraft, with their crew posed in front, framed these heroic constructions but could not capture the dynamic element that was needed.

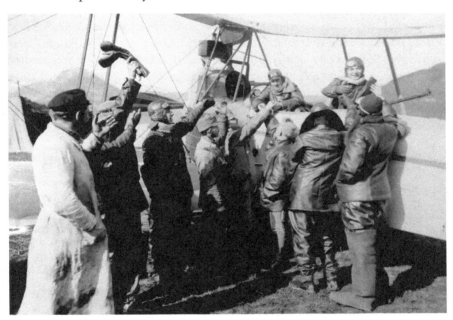

Fig. 1: "Back from Milan!" A propaganda photograph of an Austro-Hungarian aircrew from Fliegerkompanie 7 (Flik 7) returning from an air raid on Milan (Pergine, Feb. 14, 1916, unknown photographer, Picture Collection, Flik 7 – Nikolaus Wagner-Florheim, Luftfahrt-Archiv (LFT), Österreichisches Staatsarchiv/Kriegsarchiv (ÖSTA/ KA), Vienna).

This meant that most portrayals of aerial warfare took the form of drawings and sketches, mainly showing dramatic moments during aerial dogfights, making them tangible to the viewer.[16] Institutions such as the *k.u.k. Kriegspressequartier* (War Press Office) were in charge of creating, composing, and disseminating these images. This agency, which employed "war painters" among others, not only oversaw the publication of the images, but was also responsible for censorship.[17]

138 Hoffmann: Depicting "Austria's" Air War 1914–1945:
An Analysis of the Creation and Reinterpretation of the Austrian
Aviation Archives and the Viennese Exhibition "Der Luftterror"

However, apart from these heroic images, there were other pictorial worlds that were by no means meant to elicit romanticized notions. Their motifs were not carefully posed heroes, the subjugation of nature, or the mastery of technology, but instead a visualization of death and destruction. Portrayals of bombings were calculated to have psychological effects, to display the nation's military clout but mainly to instill fear and terror in the enemy. The focus of these portrayals became their effect on society, which was imagined as a living organism that, collectively panicked, could be moved to surrender.[18] The attacks on cities like London by airships and large aircraft[19] or the Austro-Hungarian airstrikes against Venice and Milan,[20] reinforced by the appropriate visual portrayals, created the desired effect. Photographs of the destruction were disseminated in the media and were generally staged as an indictment of the enemy. They were complemented by drawings of fleeing people and burning cities with bomber planes or airships flying threateningly overhead.[21] Particularly in the final years of the war, strategic bombing would already foreshadow a dark future in which wars were increasingly directed at the civilian population.

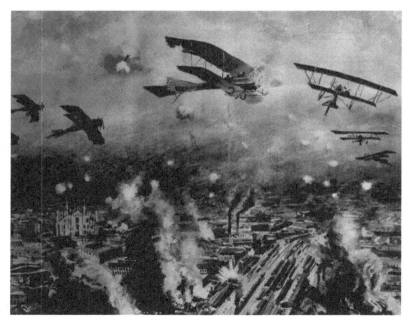

Fig. 2: Published drawing of one of the first strategic air raids in the history of aerial warfare: the Austro-Hungarian air attack on Milan on February 14, 1916. This picture was drawn by Leonard Winterowski, a "war painter" at the k.u.k. Kriegspressequartier (*Das interessante Blatt*, Feb. 24, 1916, 9).

Many of these images attained almost iconic significance, for example the drawings of German airships over London, which appeared on numerous English posters and were linked with the propaganda theme of German "baby killers."[22] Drawings and paintings of Londoners who had fled to the tube tunnels were also enduring images.[23] They created and underpinned the concept of panic throughout society as a whole, elevating the corrosion of morale within the population to a war goal. In Austria-Hungary the incursion of Italian aircraft on August 9, 1918, as far as Vienna, where the commanding officer Gabriele D'Annunzio had leaflets dropped on the city, had a similar effect.[24] Posters as well as caricatures illustrated this moment, with one photograph capturing the leaflets floating down over St. Stephen's Cathedral from above.[25] However, the actual impact of these images would not become clear until much later—tied to the question of what impact explosive bombs would have had, had they been dropped over the city centre.

The perception of aerial warfare that had been built up was then carried seamlessly over into the period after 1918. It was connected to the realization that although bombing technology in particular was developing at a furious pace, it had clearly not yet reached its full potential.[26] This generated apocalyptical foreboding of future wars. Aerial warfare became a subject relevant at many levels—military, political, and civilian—and was the crucial issue of the 1920s and 1930s.[27] Aerial warfare theorists worked on these ideas and tried to convert them into military concepts.[28] The reflections of the Italian theorist Giulio Douhet made a particular impact. In 1921 he published his "Il dominio dell'aria,"[29] which would be translated into several other languages. It defined aerial warfare as the only possible form of any future war. Douhet stressed that a nation waging war would need only to attack an enemy population with enough force to destroy their means of subsistence and strip them of the ability to conduct a war.[30] In the interwar period his work was well received, particularly in the German-speaking world, and was the impulse for a shift in the pictorial worlds.[31] It was not photography, but drawings and graphics that underscored the fatalistic visions. They didn't show past and present war images but those of an imagined future. Aerial warfare and particularly air raids were incorporated into these end-of-the-world scenarios, which appeared in newspapers, journals, books, and posters.[32] In Austria the D'Annunzio-image was rehashed in drawings of biplanes over Vienna, combined with another horror vision from World War I: "Gas over Austria."[33] Images from World War I, in particular the heroic portraits of former fighter pilots, were hardly ever included in these conceptual worlds at first—especially in Austria and Germany. Instead, the visual worlds were made up of illustrations of theoretical aerial warfare and hypothetical horror visions.

140 Hoffmann: Depicting "Austria's" Air War 1914–1945:
An Analysis of the Creation and Reinterpretation of the Austrian
Aviation Archives and the Viennese Exhibition "Der Luftterror"

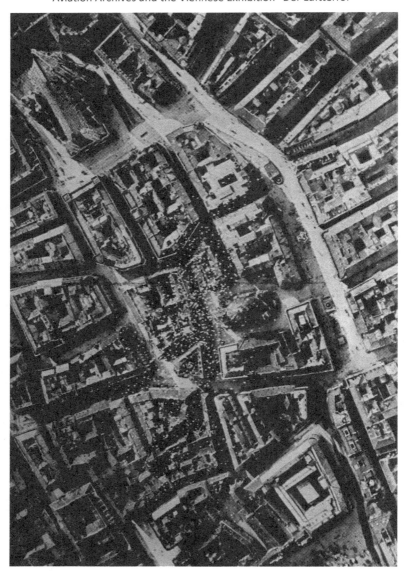

Fig. 3: This photograph was taken by an Italian pilot during the D'Annunzio-raid on Vienna on August 9, 1918, showing Italian leaflets flying down over St. Stephen's Cathedral. One month after being released by the Italian propaganda it was also shown in an Austrian newspaper (Vienna, Aug. 9, 1918, photographer: Antonio Locatelli. "Die Flugzettel-Propaganda der Italiener über Wien," *Das interessante Blatt*, Sept. 26, 1918, 7; as well as: Picture Collection, Luftfahrt-Archiv (LFT), Österreichisches Staatsarchiv/Kriegsarchiv (ÖSTA/KA), Vienna).

The consequences of these images and of Douhet's theories were far-reaching. Based on these ideas, major powers like the United Kingdom and the United States developed large air fleets for strategic warfare,[34] while Central Europe lacked the political and ultimately the financial prerequisites. In Germany and Austria, maintaining an air force was initially prohibited.[35] Here, the effects of these images arose from the perspective of a future victim of aerial warfare. This created a countercurrent, politically and in the civilian and military realms: air-raid precaution.[36] Starting in the 1930s, the predominant images used to counter the threat of aerial warfare were of public air-raid drills. Air-raid precaution became a creed, a collective guiding principle for the population, not only to minimize the effects of air attacks, but to prevent panic through systematic preparation. In Austria, military war planning was specifically aimed at this aspect. Endorsed by figures like Alexander Löhr, the first air chief of the Austrian Air Force and a former staff officer of the *k.u.k Luftfahrtruppen*, air-raid precaution grew into an independent pillar of national defense, directly linking the military with the civilian realm.[37] Löhr was surrounded by a group of officers who aimed to integrate heroic legends, in the form of the all-but-lost image of the *k.u.k.* fliers, into the emerging portrayal of aerial warfare. Among them was Jaromir Diakow, who would later be responsible for assembling the *Archiv der Luftfahrtruppen*. However, for the time being this group was primarily responsible for organizing air-raid precaution measures. Abundantly illustrated, this effort was not only a military issue. It was a particularly effective control instrument of the totalitarian state. The images—now photographs—focused mainly on demonstrating camaraderie, urging people to work as a community, and portraying the State as helper and protector.[38] Fire drills and rescue exercises dominated images of air-raid precaution measures that were presented as group events, suggesting the character of a local festival. Aerial warfare itself remained an abstract concept and was only gradually reintegrated into the pictorial world later—as a result of events such as the Italian airstrikes in Abyssinia and German bombings during the Spanish Civil War.[39] The latter resulted in a new iconic image of aerial warfare painted by Pablo Picasso in 1937, depicting the destruction of the city of Guernica.[40] The Spanish Civil War also marked another kind of change in the pictorial worlds—this time a lasting change at the hands of National Socialists, who made aerial warfare and bombings a leitmotif of war preparation and by 1935 had already subsumed the theme into the concept of "Total War."[41]

142 Hoffmann: Depicting "Austria's" Air War 1914–1945:
An Analysis of the Creation and Reinterpretation of the Austrian
Aviation Archives and the Viennese Exhibition "Der Luftterror"

National Socialism and the Creation of the *Archiv der Luftfahrtruppen*

In 1938 the "Anschluss" also meant that National Socialist interpretations of aerial warfare were now applied in Austria. In the German Reich, these interpretations had changed markedly, mainly as a result of the reconstruction and the offensive deployment of the *Luftwaffe*.[42] Germany was on the way to becoming a major power and had thus also become an active player in the air. The Spanish Civil War, which became a testing ground for German aerial warfare of the future, is evidence of this fact.[43] Germany's new role and its perception was also evident during the negotiation of the Munich Agreement of 1938, when Paris was evacuated as a precaution against possible German airstrikes.[44] Aviation in general was a high priority for the National Socialist regime. Ideologically it was included in the "Rebirth of Germany" and stood for progress and technological supremacy.[45] This was supported and implemented very early on by promoting glider flight, in the *Nationalsozialistisches Fliegerkorps* among other groups.[46] The image that developed, with the help of propaganda and the media, illustrated the active sport of flying that would open the path to a heroic military future. Horror visions of air raids as a threat were largely pushed into the background by these images. Naturally, they were retained for policy planning purposes, not least because in the event of a war, air raids on German cities were to be expected. However, here too the National Socialist regime found new approaches and began working on the image of aerial warfare that the population already had. As Alfred Rosenberg, chief ideologist of the NSDAP, put it in 1936:

> Später mögliche Kriege werden stark im Zeichen der Luftflotten stehen. Ziel der Gas- und Brisanzbomben werden immer die Großstädte sein…. Das Schicksal zwingt uns heute, wie in früheren Zeiten, daß das ganze Volk teilnehmen muß am Kampf um sein Dasein…. Die Technik…hat…das uralte organische Verhältnis zwischen Volk und Krieg wieder hergestellt.[47]

He was stating nothing less than the certainty that in any war to come German cities would be destroyed, but he saw this not as a threat but an opportunity. The Machiavellian calculation was that the more people's existence and lives are directly threatened, the more willing they are to fight and the less likely they are to question the government, realizing that the state is their only "protector." For the time being, however, it seemed prudent

for the propaganda to emphasise Germany's strength and not that of any potential enemy. For the first few years of the war at least, the National Socialist visualization of aerial warfare adhered to this view. The pictorial worlds used were a departure from the horror visions of the interwar period and a return to the old "heroic" images. In these images aerial warfare was no longer a scourge for mankind but was instead an expression of the nation's strength and superiority. This striking return to the old images was at the same time a way of legitimizing leadership, since it built bridges to the old German Empire, creating points of contact with its long history— largely ignoring the hated Weimar Republic. The "flying aces" were back in fashion, as many films of the time show.[48] The revival of the "Red Baron" myth around Manfred von Richthofen also attests to the emphasis on this historical link.[49] The images that were assembled concentrated mainly on the *Luftwaffe* and were aimed at covering two narratives: the offensive military might of the German Reich and its defensive capabilities.

Alongside this shift in the pictorial commentary on aerial warfare, the subject of air-raid precaution also remained present, but it was now used increasingly for defense education purposes and as a community-building element to prepare and train people psychologically for war.[50] Publications supported these statements in their pictorial compositions and constructed associations to images of military heroes. Bulletins from the *Reichsluftschutzbund* only peripherally touched on aerial warfare as a cause of destruction, while dealing with the consequences was heightened and hammered home with military pathos as a special way of fighting back. Probably the most well-known air-raid precaution poster, issued in 1935 on the occasion of one of Göring's speeches, bore the following statement: "Der Kämpfer im Luftschutz hat so viel Verantwortung und so viel Ehre wie jeder Soldat an der Front!"[51] This was intended to encourage a feeling of community and create a link to the National Socialist image of aerial warfare. Particularly before the outbreak of the war, the message conveyed by the pictorial portrayals on the one hand trivialized aerial warfare that was nonetheless definitely to be expected and, on the other hand, heightened the heroism of concerted defense efforts. This was in the context of the first contemplation of a "Total War," which would mobilize the whole of society to be actively involved in the war effort.

However, these visual and conceptual worlds functioned mainly on a local and regional level. This was apparent in the air-raid precaution drills, which were designed to promote and encourage local community spirit. This aspect became especially obvious in 1940, when the west of Germany was struck by the first airstrikes. While propagandistic counter measures, including the use of threatening images, were immediately taken in the

144 Hoffmann: Depicting "Austria's" Air War 1914–1945:
An Analysis of the Creation and Reinterpretation of the Austrian
Aviation Archives and the Viennese Exhibition "Der Luftterror"

areas affected, the situation in the distant Alpine regions was quite different. The National Socialist regime went to great lengths to prevent unwanted images from reaching these areas and took strict measures to silence any rumors.[52] From 1941, photographing bomb damage was a punishable offense and was permitted only for members of the police and the German propaganda apparatus.[53] There were even restrictions on building and photographing air-raid shelters.[54] District administrators were not interested in unnecessarily spreading fear among the inhabitants by taking and disseminating ominous and disastrous photographs.

In the first years, perceptions of aerial warfare were primarily generated through pictorial representations of the aeronautical deeds of the *Luftwaffe* and a reactivation of old images of heroic fliers, designed to draw direct associations with World War I and create local references. A whole initiative emerged in Vienna to focus specifically on these points. The initiator was Jaromir Diakow, who had been a general staff officer in the Austrian Air Force between the wars.[55] With the support of Alexander Löhr, who had been transferred to the *Luftwaffe* as a general, he had tried early on to instill the values of the *k.u.k.* fliers into the *Luftwaffe*. Visible signs of this endeavor include numerous extant notes for the so-called "*Heldenwerk*,"[56] as well as his association with the Austro-Hungarian "Red Baron" Godwin von Brumowski, who had died in a plane crash in 1936. In 1940, at the instigation of Diakow and the recommendation of Alexander Löhr—with the support of Hermann Göring—an honorary grave was dedicated to the pilot in Vienna's *Zentralfriedhof.* The inscription included the word "Österreich," a term otherwise forbidden throughout the German Reich, and what makes this special feature notable is that it can be seen as an exploitation of the local reference.[57] Shortly after the "Anschluss," in a second step, an office was created in Vienna's military archives: The *Kriegswissenschaftliche Abteilung der Luftwaffe-Zweigstelle Wien* was founded under Luftwaffe High Command, and Diakow was put in charge.[58] This was strictly speaking not an archive, but rather a research center. Its function was to collect information on the *k.u.k.* aviation troops and personnel, but mainly to reconstruct the old hero images. The problem was that for a long time the *k.u.k.* aviation troops had not been an independent branch of service, so no cohesive archival collection had been compiled. Diakow and his team therefore assembled files from other collections, for example from *Armeeoberkommando* (Army High Command), as well as files and images from the *Kriegspressequartier.* These were assembled into a disordered compilation, indexed simply by topic. The act of collecting was not carried out according to any specific archival considerations, not taking into account the time a record was created

but basing choices instead on the prevailing National Socialist view. This is particularly clear when one considers the fact that, alongside technical data, the focus was on the missions of German-speaking fliers from this multinational state.[59] To this end, the team contacted former airmen to try to collect information and photographs for the research center. Gradually a photographic collection grew. It was never systematically compiled, and it was hardly likely that it would ever be properly completed. The images showed fliers in front of their aircraft, at ease in the midst of their squadron, at award ceremonies, or on missions.[60] These were supplemented by photographic portraits that were clearly intended for the general public.[61] Images of the enemy were also collected—usually in the form of photographs of shot-down Italian aircraft or captured pilots.[62] One series of photographs worth mentioning is spread throughout a number of files. It centers around the desertion of the *k.u.k.* pilot Georg Kraigher in 1915, who had landed his aircraft on the Italian side. The extant photographs, files, and Italian newspaper articles paint a picture of a traitor, with emphasis on his Slovenian heritage.[63] There are Italian photographs of Kraigher, smiling, surrounded by soldiers, handing over his undamaged plane and the bomb load, which features in many pictures.[64] These images of Kraigher, who later served in the Yugoslavian Air Force and in the US Army Air Force during World War II,[65] did not find their way to Vienna at the time of the incident but were added to the *"Archiv"* after 1938. Conveniently for National Socialist propaganda purposes, an association with air raids could be made and the "traitor's" Slavic heritage could be used to construct an image of an antihero. The goal was apparently a planned media presentation—probably scheduled for shortly before the German attack on Yugoslavia in 1941. However, as far as is known, these photographs were not published during World War II, probably because by 1941 they were no longer needed.

Overall, the compiling of the *"Archiv"* was of short duration and was quickly pushed aside by war events. At the end of 1943 the department was renamed *Generalstab der Luftwaffe, 8. Abteilung, Teilkommando Wien* and was no longer used for its original purpose.[66] Nonetheless there is evidence that Diakow continued to speak frequently on the subject until 1945, relying heavily on a wide range of illustrations.[67] These came from the *"Archiv"* and were dedicated to the history of the *k.u.k.* fliers in a constructed association with "Greater Germany's War."[68] Like this pictorial collection, attempts to transfer the old Austrian airmen's canon of values to the *Luftwaffe* were patchy and ultimately failed completely. Nor did the intention of creating a research center for the entire aerial warfare ever come to fruition. Instead, an incomplete collection of files and pictures of

146 Hoffmann: Depicting "Austria's" Air War 1914–1945:
An Analysis of the Creation and Reinterpretation of the Austrian
Aviation Archives and the Viennese Exhibition "Der Luftterror"

k.u.k. aviation troops emerged. It covers World War I in a comprehensive pictorial portrayal and offers a rudimentary depiction of the early postwar era—the latter images mainly pertaining to the deployment of Austrian fliers in the Carinthian "Abwehrkampf" of 1919, which was relevant to the National Socialist narrative.[69] The images of aerial warfare and the horror scenarios of the interwar period—with the exception of the topic of air-raid precaution—are missing completely. They had no place in the German Reich's preparations for war. There are no more traces or images of this aspect to be found until 1942–43.

Influenced by external developments, it had become necessary to shift and alter the visual worlds. In this respect the *"Archiv"* apparently no longer had any significance except as an obvious storage location, because although the images that were now relevant were tailored to the Austrian region, they no longer arose from its history.

Bombings and the Exhibition "Der Luftterror"

At the end of June 1943, the *Union Nationaler Journalistenverbände* (Union of National Journalists) assembled in Vienna for a conference, at the center of which stood the Allied aerial warfare.[70] An exhibition of photographs, prepared by the *Deutsche Propaganda-Atelier GmbH* at the behest of the propaganda ministry, was displayed there. It showed images of Allied airstrikes on "deutsche und italienische Kulturdenkmäler."[71] At the root of this exhibition were developments in the air war that by the summer of 1943 had reached threatening dimensions for the National Socialist regime. Shortly after the German defeat at Stalingrad, the Allies had stepped up their aerial attacks and begun an air offensive against the Ruhr area.[72] The NS regime could see its defense capabilities dwindling, which in the near future could only lead to air attacks across the whole Reich and the destruction of entire cities. Propaganda minister Joseph Goebbels, fearing a collapse of "morale" and "spirit" in the population, elevated the interpretation and depiction of the bombings to the one pivotal topic.[73] Explanations for the increasingly visible devastation in cities had to be provided. The exhibition in Vienna, which was initially only open to journalists, was the first move in a targeted change to the pictorial worlds communicated by the media.

When Allied bomber units expanded their bombing offensive to Hamburg at the end of July 1943, destroying large areas of the city, the escalation of air war that Goebbels had feared became reality.[74] The bombing of Hamburg would become the biggest catastrophe of the air war,

immediately sending waves of fear through the German Reich.[75] The impact was amplified by the first airstrike in the Alpine region, which hit Wiener Neustadt on August 13, 1943.[76] This meant that a second aerial front had opened up in Europe that would not only stretch the *Luftwaffe* beyond its limits, but would now also encompass what had been seen as a safe area. It was here that the National Socialist regime had broadcast reassuring and calming messages. The reaction of the propaganda machinery was to make an immediate shift in the visual and conceptual worlds regarding air war. The focus on "German heroes" and the missions of the *Luftwaffe* largely gave way to images of bombings and the destruction they caused. In these portrayals the air raids and the destruction were amplified into crimes. A picture of a so-called "Luftterror" was drawn which aimed at "women and children" and at "cultural monuments."[77] The air offensives of the *Luftwaffe*, now barely perceptible, were woven into the narrative as "retaliation," defined rhetorically and pictorially as a reaction to Allied airstrikes.[78]

One place where this change was apparent was in the exhibition mentioned, which contained, in a compact form, the pictorial worlds that were to be conveyed. Not only was the exhibition now opened to the public, but it was also reworked to go on tour. This was to bring it to those people who "den Luftterror noch nicht aus dem eigenen Erlebnis kennen, [um ihnen] … ein anschauliches Bild seiner Wirkung und seiner Gefahren zu geben."[79] At the same time, however, there was a fear of creating too much regional association, which would not generate the desired anger but could instead spread fear. For this reason, the exhibition's creators did not use pictures from the Viennese *"Archiv"* or from Wiener Neustadt, but instead chose images of well-known Italian and some German cities.[80] This had the advantage of clearly and dramatically illustrating the destruction of well-known, century-old monuments, while at the same time giving the impression that local "communities" and the "Volksgemeinschaft" were not directly affected.

The exhibition itself was made up of six parts, illustrating three main concepts from the air war.[81] The title chosen was "Der Luftterror"—terror from the air—a term that had been made mandatory in everyday and official language.[82] The first part comprised photographs of destructions in Italy and in chosen German cities. Invoices show that there were more than 220 photographs, supplemented by individual objects like incendiary bombs and air-raid precaution equipment.[83] The message focused on the narrative of "Luftterror," which was declared devoid of any military logic or moral justification. The core message was that the Allied air war was not aimed at ending the war and National Socialism but was solely intended "[um] das deutsche Volk aus[zu]rotten."[84] The pictorial depiction of the narrative on

148 Hoffmann: Depicting "Austria's" Air War 1914–1945:
An Analysis of the Creation and Reinterpretation of the Austrian
Aviation Archives and the Viennese Exhibition "Der Luftterror"

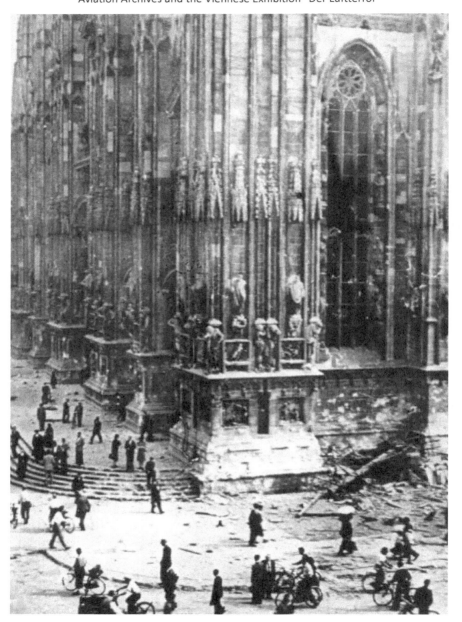

Fig. 4: Destruction around the Cathedral of Milan, soon after an Allied air attack in 1943. This photograph was shown in the German exhibition "Der Luftterror" (Milan, 1943, unknown photographer, So 17/134, Picture Archive of the Austrian National Library).

the destruction of monuments served this purpose. There was now a revival of the horror images of the interwar years, but with a new focus. These were no longer futuristic visions, they were photographic chronicles from the immediate past, their imagery aimed at eliciting a specific emotional response. At the same time, although they were images of destruction, they were not fatalistic. They were often taken on the day after an air raid and thus captured a moment when the fires were under control, victims had been pulled from the rubble, and daily life had once again begun. To this day, isolated photographs of this kind can be found in the *Archiv der Luftfahrtruppen* that must have been collected and reproduced for the exhibition.[85] One photograph shows heavy damage to the cathedral in Milan, capturing at the same time apparently unconcerned passers-by carrying on with their usual daily routine.[86]

This does not communicate powerlessness, but rather coping with the situation, in combination with the destructive factor displayed as an indictment in order to provoke anger and rage.

In the exhibition this account was paired with the narrative of air-raid precaution. These images were a follow-up to similar pictures from between the wars, except that they no longer showed cheery communal drills but rather (staged) scenes of emergency situations.[87] They were photographs of clean-up and rescue operations or putting out fires—always alluding to and demonstrating National Socialist victim welfare. The overall message was again one of "coping." The time before an air raid was also covered, mainly by interior shots of air-raid shelters. These depictions ranged in style from behavioral guidelines to patronizing lectures urging correct and compliant conduct.[88] The air-raid warden was always featured at the heart of the composition, with positioning, demeanor, and bearing designed to radiate competence and reliability.[89] At the same time, this figure was a symbol of the NSDAP, an embodiment of the central message that only the Party could guarantee survival in aerial warfare.

One part of the exhibition that dealt with survival was basically dedicated to a *"Schicksalsgemeinschaft"* ("community of fate"). In this section images showing mainly "air-raid shelter communities," combined the narrative of "Luftterror" with the apparently caring Party that was responsible for coordinating air-raid precaution measures.[90] The statement, at the same time a central element, was one of hypothetical and controlled "fellowship," often depicted in the form of a family. This part of the exhibition included numerous aphorisms and apparently had far fewer pictures. The central statement was that only a "united community" could withstand "concentrated attacks."[91] There are hardly any extant images from this section, and there are none to

150 Hoffmann: Depicting "Austria's" Air War 1914–1945:
An Analysis of the Creation and Reinterpretation of the Austrian
Aviation Archives and the Viennese Exhibition "Der Luftterror"

be found in the *Archiv der Luftfahrtruppen*, but the choice of subjects can be gleaned from propaganda posters that were circulated in 1943. These placed particular emphasis on a militarily defined "fellowship," in accentuated depictions of men, women, and children in uniform. Articles dealing with the exhibition highlight this aspect, noting the necessity for an active "fight:" "Jeder Volksgenosse muss daher im Kampf gegen die Luftgangster mitwirken."[92] The conclusion of the exhibition was climactic, framed as a vision of the future and designed to bring together all the elements of the exhibition, merging them into one active demand: an oversized photo montage showing ruins bore the caption "Wir alle arbeiten für die Vergeltung."[93]

The exhibition itself opened in Vienna in October 1943 and then toured throughout the Alpine region and went to several German towns in 1944.[94] By this time the visualization of aerial warfare had changed again, becoming even more extreme. In 1944, it was no longer necessary to show air raids in the form of an exhibition as they had become a daily event across the whole Reich, so instead National Socialist propaganda turned to shock effects, rolling out an exaggerated image of the enemy. In the spring of 1944, it was no longer taboo to show photographs of dead, sometimes horribly mutilated, Allied aircrews. Daily newspapers printed pictures of captured pilots, blaming them personally for air raids that were depicted as the deliberate "murder of women and children."[95] This created a channel for the population's anger and rage and would initiate the practice of violently lynching Allied pilots, a phenomenon that in May 1944 came to be known as *"Fliegerlynchjustiz."*[96]

There is no trace in the *Archiv der Luftfahrtruppen* of this last phase of aerial warfare propaganda. It is clear that, at least until 1943, an effort was made to create an image of aerial warfare that was based on historical references and geographical contortions, and that this was meant to be suitably archived. After this, steps of this nature can no longer be discerned, probably because the pictorial worlds of National Socialist propaganda went through an extremely dynamic development, now focusing less on aerial warfare itself and more on activating enemy stereotypes and violence. In addition, the responsibility for countermeasures in air war shifted from *Oberkommando der Luftwaffe* (Luftwaffe High Command) to the propaganda ministry under Joseph Goebbels.[97] In the meantime the ministry had even abandoned the overused term "retaliation," for which there was no pictorial evidence at the end of 1943 and the beginning of 1944.[98] It was not until the introduction of the "buzz bomb" in June 1944 that appropriate pictorial worlds could be developed that would become a pillar in the National Socialist depiction of air war.[99] From the late summer of 1944, and particularly in 1945, the NS

propaganda pushed images of victims. Shocking photographs, for example from the ruins of Dresden, showing burning piles of corpses or severely wounded children had an apocalyptic impact and were aimed at generating a fear of the approaching liberators: *"Das ist das Werk der 'Befreier,' das sind die 'Heldentaten' einer Soldateska, die aus der Luft die biologische Vernichtung des deutschen Volkes zu erreichen hofft."*[100]

These final depictions in particular provided a memorable image of aerial warfare, especially since—putting an emotionalized slant on the suffering, death, and destruction—they showed the supposed reality of the air raids.[101] This would have far-reaching consequences.

Summary and Concluding Considerations

In the postwar years there was much discourse on the Allied air war as a central perception of warfare of World War II, and it is still a subject of discussion today. This was primarily due to the pictorial worlds enlisted, which not only depicted the war, but focused on society as its target. These ranged from the first pictures of aerial warfare in World War I, through the horror scenarios of the interwar years, to the criminalization and stereotyped constructs of the enemy during the National Socialist era. The pivotal point was demonstrating the "violence of others," which functioned by assigning blame, while the national perspective functioned by creating heroes from a basis grounded in history. Thus, emotion became the guiding theme of images of aerial warfare, with the issue of "morale" as the inherent subject matter.[102] Up until the end of the Second World War "morale" was largely taken to mean the supposedly collective "conduct" of a society under attack, perceived as the innocent victims of the war. In the postwar years this shifted to become a discourse on the "moral legitimacy" of bombing cities, in which society's victim perspective was already firmly embedded.[103] Pictures like those showing the destruction of Dresden took center stage, becoming symbolic of a visual world that could be superimposed onto numerous other regions, contextualizing war experiences. These images were adopted without taking into account that they had been taken by photographers working for Joseph Goebbels.

The victim perspective, and these images of aerial warfare, functioned increasingly as a counternarrative to the societal perpetrator-victim debates about National Socialist war crimes and in particular the Holocaust.[104] The pervasiveness of these developments became clear during the Jörg-Friedrich-debate in Germany in the early 2000s, which showed that social and political alternative interpretations of World War II had been formed

152 Hoffmann: Depicting "Austria's" Air War 1914–1945:
An Analysis of the Creation and Reinterpretation of the Austrian
Aviation Archives and the Viennese Exhibition "Der Luftterror"

on the basis of these pictorial worlds depicting aerial warfare. Since then, much has changed in the debate over aerial warfare—not least due to a comprehensive analysis of images and memories. However, much remains unchanged or still lingers unnoticed in the shadows of public discourse. This includes older historical perceptions of aerial warfare—like those from World War I. To this day there are National Socialist filters in place conditioning what we see, since most endeavors to generate images of early aerial warfare took place during the National Socialist era. A look at Vienna's *Archiv der Luftfahrtruppen* provides evidence of this fact. From 1938 onwards Austrian officers tried to write the *k.u.k.* Aviation Troops into the tradition of the *Luftwaffe*, integrating them in the form of hero images in order to exploit them for National Socialism. This narrowly focused collection and the pictorial worlds developed were there as a counterpoint to the horror scenarios of the interwar years, which did not serve the National Socialist promotion of war. The National Socialist authorities created an *"Archiv"* that had neither accumulated naturally nor was it created with any archival purpose. A source base for the *k.u.k.* Aviation Troops emerged that to this day colors the perception of early aerial warfare, but so far little reflection has gone into its composition or provenance. At the same time, this *"Archiv"* also demonstrates that as the Allied air raids continued after 1943 there was a shift in the pictorial worlds conveyed, with historical and Austrian images ultimately being discarded. Now the focus was on the visualization of the destruction caused by air raids, aimed at generating and emotionally directing victim perceptions within the population. Apart from numerous propaganda offensives created by Joseph Goebbels, another vehicle for this depiction was an exhibition that started in Vienna and then went on tour, providing regions yet untouched by air raids with the appropriate visual worlds. There followed constructs of an enemy stereotype, the aspect of retaliation, calls to violence, and finally the accentuated horror images that exist to this day.

It was this final phase, not only in postwar Germany but also in Austria, that formed and consolidated today's perceptions, which have overshadowed all other perspectives. Unlike in Germany, where the Friedrich-debate yielded a lasting effect, in Austria critical debates have so far been rudimentary, particularly in the field of research but also in the public realm.[105] But these pictorial worlds in particular, and an analysis of their construction and composition, provide an approach to an emotionally charged subject that can be traced back as far as World War I. Against this backdrop, archival collections like those of the *k.u.k.* aviation troops can also be a starting point for a long overdue critical analysis of the Austrian pictorial worlds of aerial warfare.

Endnotes

1 I would like to thank Nicole-Melanie Goll and Daniel Brewing for their support and exchange of ideas as well as Gerhard Artl, Otto Kellner and Robert Rill (Austrian State Archive). Thanks also to Anne Kozeluh for the translation of the text.

2 Luftfahrt-Archiv (LFT), Österreichisches Staatsarchiv/Kriegsarchiv (ÖSTA/KA), Vienna.

3 Picture Collection, Archive LFT, ÖSTA/KA, Vienna.

4 *Unnamed Picture Milan*, 1943, ibid.

5 Claudia Baldoli et al., eds., *Bombing, States and Peoples in Western Europe 1940–1945* (New York: Continuum Publishing, 2011); Ralf Blank, "Kriegsalltag und Luftkrieg an der 'Heimatfront,'" in *Das Deutsche Reich und der Zweite Weltkrieg*, Vol. 9/1, ed. Jörg Echternkamp (Munich: DVA, 2005), 357–464; Rolf-Dieter Müller, *Der Bombenkrieg 1939–1945* (Berlin: Ch. Links Verlag, 2004); Richard J. Overy, *The Air War 1939–1945* (London: Potomac Books, 2005); Dietmar Süß, *Tod aus der Luft: Kriegsgesellschaft und Luftkrieg in Deutschland und England* (Munich: Siedler, 2011); Dietmar Süß, ed., *Deutschland im Luftkrieg: Geschichte und Erinnerung*, Zeitgeschichte im Gespräch 1 (Munich: De Gruyter, 2006).

6 Jörg Friedrich, *Der Brand: Deutschland im Bombenkrieg 1940–1945* (Berlin: List, 2002); Jörg Friedrich, *Brandstätten: Der Anblick des Bombenkrieges* (Berlin: Propyläen, 2003).

7 Friedrich, *Der Brand*, 110.

8 Rolf-Dieter Müller et al., eds., *Die Zerstörung Dresdens: 13. bis 15. Februar 1945: Gutachten und Ergebnisse der Dresdner Historikerkommission zur Ermittlung der Opferzahlen*, Hannah-Arendt-Institut Berichte und Studien 58 (Göttingen: V&R unipress, 2010).

9 Jörg Arnold, *The Allied Air War and Urban Memory: The Legacy of Strategic Bombing in Germany*, Studies in the Social and Cultural History of Modern Warfare 35 (Cambridge: Cambridge University Press, 2011); Malte Thießen, *Eingebrannt ins Gedächtnis: Hamburgs Gedenken an Luftkrieg und Kriegsende 1943 bis 2005*, Forum Zeitgeschichte 19 (Hamburg: Dölling und Galitz, 2007).

10 Arnold, *The Allied Air War*, 302–3; Lara Feigel, "'The photograph my skull might take': Bombs, Time and Photography in British and German Second World War Literature," in *Bombing, States and Peoples*, ed. Baldoli et. al., 121–35; Gerhard Paul, *Bilder des Krieges: Krieg der Bilder; Die Visualisierung des modernen Krieges* (Paderborn: Schöningh, 2004).

11 Christian *Kehrt, Moderne Krieger: Die Technikerfahrung deutscher Militärpiloten 1910–1945* (Paderborn: Schöningh, 2010), 103–6.

12 Nicole-Melanie Goll, "'… Nobel und ritterlich im Kampf, war er gleich einer Gestalt aus der Zeit des Minnegesangs und der Turniere…': Zur Konstruktion des

154 Hoffmann: Depicting "Austria's" Air War 1914–1945:
An Analysis of the Creation and Reinterpretation of the Austrian
Aviation Archives and the Viennese Exhibition "Der Luftterror"

Kriegshelden in der k.u.k. Monarchie am Beispiel von Godwin von Brumowski, Gottfried von Banfield und Egon Lerch" (PhD diss., University of Graz, 2014), 159–61.

13 Ibid., 159.

14 Joachim Castan, *Der Rote Baron: Die ganze Geschichte des Manfred von Richthofen* (Stuttgart: Klett-Cotta, 2007).

15 Goll, "Nobel und ritterlich," 175–217; Nicole-Melanie Goll, "Godwin von Brumowski (1889–1936): The Construction of an Austrian-Hungarian War Hero during World War I," in: *From the Industrial Revolution to World War II in East Central Europe*, ed. Marija Wakounig and Karlo Ruzicic-Kessler (Münster: lit, 2011), 139–57.

16 As examples of published drawings: *Ein gefährlicher Moment im Luftkampf*, *Das interessante Blatt*, Aug. 8, 1918, 7; *Ein heroischer Kampf in den Lüften*, *Das interessante Blatt*, Aug. 17, 1916, 7; *Nächtlicher Angriff zweier Zeppeline auf Bukarest*, *Das interessante Blatt*, Oct. 19, 1916, 9; Rudolf Alfred Höger, *Der Abschuss des Luftschiffs "Città di Ferrara,"* oil on canvas, 1915, Gm 94/4, Deutsches Historisches Museum (DHM), Berlin.

17 Goll, "Nobel und ritterlich," 90–105; Anton Holzer, *Die andere Front: Fotografie und Propaganda im Ersten Weltkrieg* (Darmstadt: WBG, 2012); Klaus Mayer, *Die Organisation des Kriegspressequartiers beim k.u.k. Armeeoberkommando im Ersten Weltkrieg* (PhD diss., University of Vienna, 1963).

18 Joanna Bourke, *Fear: A Cultural History* (London: S&H, 2005), 64–72.

19 Among others: Ian Castle, *London 1914–17: The Zeppelin Menace* (Oxford: Osprey Publishing, 2008); Müller, *Der Bombenkrieg*, 17–20.

20 See the exhibition at the Japanisches Palais in Dresden in 2015: "Eine Stadt im Krieg: Venedig 1915–1918," https://www.skd.museum/ausstellungen/eine-stadt-im-krieg/, accessed Dec. 16, 2020; Leonard Winterowski, *Ein Flugzeuggeschwader unserer Armee belegt den Bahnhof und Fabriksanlagen in Mailand*, *Das interessante Blatt*, Feb. 24, 1916, 9. See also: *Zurück von Mailand*, Feb. 14, 1916, picture collection Nikolaus Wagner Edler von Florheim, Archiv LFT, ÖSTA/KA, Vienna.

21 Süß, *Tod aus der Luft*, 29–30. As an example: *Die Angst der Londoner vor den Zeppelinen*, German propaganda post card, 1915.

22 Susan R. Grayzel, *At Home and under Fire: Air Raids and Culture in Britain from the Great War to the Blitz* (Cambridge: Cambridge University Press, 2012), 64–92; Susan R. Grayzel, "The Baby in the Gas Mask: Motherhood, Wartime Technology, and the Gendered Division Between the Fronts During and After the First World War," in *Gender and the First World War*, ed. Christa Hämmerle et. al. (London: Palgrave Macmillan, 2014), 127–43; Ariela Freedman, "Zeppelin Fictions and the British Home Front," *Journal of Modern Literature* 27, No. 3 (2004): 47–62; Tami D. Biddle, *Rhetoric and Reality in Air Warfare: The Evolution of British and American Ideas about Strategic Bombing, 1914–1945* (Princeton: Princeton University Press, 2002), 29–33; Süß, *Tod aus der Luft*, 28–30.

23 As an example: Walter Bayes, *The Underworld: Taking Cover in a Tube Station During a London Air Raid*, oil on canvas, 1918, Art.IWM ART 935, Imperial War Museum (IWM); Süß, *Tod aus der Luft*, 30.

24 Erwin Pitsch, *Italiens Griff über die Alpen: die Fliegerangriffe auf Wien und Tirol im 1. Weltkrieg* (Vienna: Karolinger Verlag, 1994), 86–91; Fernando Esposito, *Mythische Moderne: Aviatik, Faschismus und die Sehnsucht nach Ordnung in Deutschland und Italien* (Munich: De Gruyter Oldenbourg, 2011), 102–47.

25 *Die Flugzettel-Propaganda der Italiener über Wien*, Das interessante Blatt, Sept. 26, 1918, 7.

26 Philip S. Meilinger, "Trenchard, Slessor, and Royal Air Force Doctrine before World War II," in *The Paths of Heaven: The Evolution of Airpower Theory*, ed. Philip S. Meilinger (Maxwell AFB: Air University Press, 1997), 41–79 (here 47).

27 Christian Kehrt, *Moderne Krieger: Die Technikerfahrungen deutscher Militärpiloten 1910–1945* (Paderborn: Schöningh, 2010), 204–5.

28 Among others, see: "RAF Manual AP 1300," *Royal Air Force War Manual Part I – Operations*, July 1928, AIR 10/1910, The National Archives Kew, London; William C. Mitchell, *Winged Defense: The Development and Possibilities of Modern Air Power – Economic and Military* (New York: G. P. Putnam's sons, 1925), 31.

29 Giulio Douhet, *Il dominio dell'aria*, (Rome: L'Amministrazione Della Guerra, 1921).

30 Giulio Douhet, *Luftherrschaft*, (Leipzig: Drei Masken Verlag, 1935), 67.

31 Albert Benary, *Luftschutz: Die Gefahren aus der Luft und ihre Abwehr* (Leipzig: Reclam, 1933); Erwin Pitsch, *Alexander Löhr*, vol. 1, *Der Generalmajor und Schöpfer der Österreichischen Luftstreitkräfte* (Vienna: Österreichischer Milizverlag, 2004), 115–19.

32 Kurt Möser, *Neue Grauzonen der Technikgeschichte*, Karlsruher Studien zur Technikgeschichte 14 (Karlsruhe: KIT Scientific Publishing, 2018), 144–47. As examples: Major Helders [Robert Knauss], *Luftkrieg 1936* (Berlin: Traditionsverlag Kolk & Co., 1936); Johann von Leers, *Bomben auf Hamburg!: Vision oder Möglichkeit?* (Leipzig: R. Voigtländer, 1932).

33 Arthur Zimmer, *Gas über Österreich* (Vienna: Hans Fleischmann & Co, 1935).

34 Philip S. Meilinger, "Trenchard," 41–79; Marc A. Clodfelter, "Molding Airpower Convictions: Development and Legacy of William Mitchell's Strategic Thought," in *The Paths of Heaven*, ed. Philip S. Meilinger, 79–115.

35 Kehrt, *Moderne Krieger*, 204.

36 Bernd Lemke, "Zivile Kriegsvorbereitungen in unterschiedlichen Staats- und Gesellschaftssystemen: Der Luftschutz im 20. Jahrhundert – ein Überblick," in: *Luft- und Zivilschutz in Deutschland im 20. Jahrhundert*, ed. Bernd Lemke (Potsdam: Zentrum für Militärgeschichte und Sozialwissenschaften der Bundeswehr, 2007), 67–88.

37 Erwin Pitsch, *Alexander Löhr*, 135.

156 Hoffmann: Depicting "Austria's" Air War 1914–1945:
An Analysis of the Creation and Reinterpretation of the Austrian
Aviation Archives and the Viennese Exhibition "Der Luftterror"

38 As an example, see the periodical magazine *Der Luftschutz: Offizielles Organ des österreichischen Luft- und Gasschutzverbandes* (1934–1938).

39 "Fliegerverwendung im Zukunftskrieg," *Freie Stimmen*, Jun. 13, 1936, 1; "Der Kampf um Bilbao," *Wiener Bilder*, May 9, 1937, 2.

40 Richard Overy, *Der Bombenkrieg: Europa 1939 bis 1945* (Berlin: Rowohlt, 2014), 64.

41 Erich Ludendorff, *Der totale Krieg* (Munich: Ludendorffs Verlag 1935).

42 Peter Fritzsche, *A Nation of Fliers: German Aviation and the Popular Imagination* (Cambridge: Harvard University Press 1992), 190–92.

43 Süß, *Tod aus der Luft*, 48–50.

44 Philip S. Meilinger, "Giulio Douhet and the Origins of Airpower Theory," in *The Paths of Heaven: The Evolution of Airpower Theory*, ed. Philip S. Meilinger (Maxwell AFB: Air University Press, 1997), 1–41 (here 20).

45 Kehrt, *Moderne Krieger*, 221–24.

46 Ibid, 235–44.

47 "Future possible wars will be dominated by the air fleets. The targets of gas bombs and explosive bombs will always be the cities. […] Fate requires of us that today, as in earlier times, the whole nation must take part in the battle for survival. […] Technology […] has […] re-established the age-old, organic relationship between the populace and war." Alfred Rosenberg, *Der Mythus des 20. Jahrhunderts: Eine Wertung der seelisch-geistigen Gestaltenkämpfe unserer Zeit* (Munich: Hoheneichen-Verlag, 1936), 317.

48 Rolf Seubert, "'Junge Adler': Technikfaszination und Wehrhaftmachung im nationalsozialistischen Jugendfilm," in *Krieg und Militär im Film des 20. Jahrhunderts*, ed. Bernhard Chiari et al. (Munich: Oldenbourg, 2003), 371–400.

49 Kehrt, *Moderne Krieger*, 224–26.

50 Georg Hoffmann, *"Fliegerlynchjustiz": Gewalt gegen abgeschossene alliierte Flugzeugbesatzungen 1943–1945* (Paderborn: Schöningh, 2015), 87–90; Bernd Lemke, "Zivile Kriegsvorbereitungen in unterschiedlichen Staats- und Gesellschaftssystemen: Der Luftschutz im 20. Jahrhundert – ein Überblick," in: *Luft- und Zivilschutz in Deutschland im 20. Jahrhundert*, ed. Bernd Lemke (Potsdam: Zentrum für Militärgeschichte und Sozialwissenschaften der Bundeswehr, 2007), 67–88.

51 "An individual fighting against air-raids carries as much responsibility and as much honor as any soldier at the front!," Präsidium des Reichsluftschutzbundes, *Der Kämpfer im Luftschutz*, poster, 1935, Do 56/1595.3, DHM, Berlin.

52 Hoffmann, *Fliegerlynchjustiz*, 90.

53 Süß, *Tod aus der Luft*, 91.

54 Siegfried Beer and Stefan Karner, *Der Krieg aus der Luft: Kärnten und Steiermark* (Graz: Weishaupt, 1992), 33–36.

55 Walter Blasi, *Vom fin de siècle bis zur Ära Kreisky: Erlebte österreichische Geschichte am Beispiel des Jaromir Diakow*, Beiträge zur neueren Geschichte Österreichs 5 (Frankfurt/Main: Peter Lang GmbH, 1996).

56 Traditionswerk Studien LFT, Box 418–19, Archiv LFT, ÖSTA/KA, Vienna.

57 Goll, "Nobel und ritterlich," 296–300.

58 The main office of the *Kriegswissenschaftlichen Abteilung der Luftwaffe* was established in Potsdam in 1935: Generalstab der Luftwaffe / Kriegswissenschaftliche Abteilung 1935–1945, RL 2-IV, Bundesarchiv - Militärarchiv Freiburg/Breisgau (BArch). See also: Kriegsarchiv, ed., *Inventar des Kriegsarchivs Wien*, Vol. 1 (Vienna: F. Berger, 1953), 69.

59 Traditionswerk Studien LFT, Box 418–19, Archiv LFT, ÖSTA/KA, Vienna.

60 Picture Collection, Archiv LFT, ÖSTA/KA, Vienna.

61 Ibid. as well as Propaganda, Box 4–4a, Archiv LFT, KM, ÖSTA/KA, Vienna.

62 Picture Collection, Archiv LFT, ÖSTA/KA, Vienna.

63 Aktensammlung Georg Kraigher, Archiv LFT, KM, Box 4–5, ÖSTA/KA, Vienna.

64 Ibid.

65 Thomas W. Ennis and George Kraigher: "Pilot in Two Wars," *New York Times*, Sept. 25, 1984, 5.

66 Goll, "Nobel und ritterlich," 300; Kriegsarchiv, ed., *Inventar des Kriegsarchivs Wien*, Vol. 1 (Vienna: F. Berger, 1953), 69.

67 Studien und Vorträge zur Entwicklung LFT – Diakow, Archiv LFT, Studien, Box 418, ÖSTA/KA, Vienna.

68 As an example: "Die Luftwaffe in den beiden Weltkriegen," *Neues Wiener Tagblatt*, Apr. 24, 1942, 4.

69 Kärntner Abwehrkampf Tagesbefehle, Archiv LFT, Deutsch-Österreichische Fliegertruppe, Box 446, ÖSTA/KA, Vienna.

70 "Schandtaten der anglo-amerikanischen Luftgangster in Dokumenten," *Volks-Zeitung*, Jun. 23, 1943, 3.

71 "German and Italian cultural monuments." Exhibition "britischer Luftterror," Deutsches Propaganda-Atelier 1943, Berlin 1943, BArchB, R 55/748.

72 Horst Boog, "Strategischer Luftkrieg in Europa und Reichsluftverteidigung 1943–1944," in *Das Deutsche Reich und der Zweite Weltkrieg*, Vol. 7, ed. Horst Boog et. al. (Stuttgart: DVA, 2001), 1–418 (here 16–21).

73 Elke Fröhlich, ed., *Die Tagebücher Joseph Goebbels*, Part 2, Vol. 9 (Munich: Saur, 1995) 399.

74 Boog, *Strategischer Luftkrieg*, 35–45.

75 Hoffmann, *Fliegerlynchjustiz*, 111.

158 Hoffmann: Depicting "Austria's" Air War 1914–1945:
An Analysis of the Creation and Reinterpretation of the Austrian
Aviation Archives and the Viennese Exhibition "Der Luftterror"

76 Markus Reisner, *Bomben auf Wiener Neustadt: Die Zerstörung eines der wichtigsten Rüstungszentren des Deutschen Reiches – Der Luftkrieg über der "Allzeit Getreuen*," 3rd ed. (Berndorf: Kral, 2014), 280–330.

77 Hoffmann, *Fliegerlynchjustiz*, 113.

78 Ralf Georg Reuth, ed., *Joseph Goebbels Tagebücher*, Vol. 4 (Munich: Piper, 1999), 1472.

79 "have not yet experienced the aerial terror themselves [to give them] … a clear picture of the effects and dangers." "Ein Rundgang durch die Ausstellung," *Das kleine Blatt*, Oct. 22, 1943, 4.

80 "Ausstellung 'Der Luftterror' eröffnet," *Oberdonau-Zeitung*, Mar. 12, 1944, 4.

81 Ibid.

82 "Begriff 'Terrorangriff,'" *Der Propagandist*, Jul. 1942, 16.

83 Exhibition "britischer Luftterror," Deutsches Propaganda-Atelier 1943, Berlin 1943, BArchB, R 55/748.

84 "eradicate the German population." "Ausstellung 'Der Luftterror' eröffnet," *Oberdonau-Zeitung*, Mar. 12, 1944, 4.

85 Picture Collection, Archiv LFT, ÖSTA/KA, Vienna.

86 *Unnamed photograph*, Milan, 1943, Picture Collection, Archiv LFT, ÖSTA/KA; as well as: *Bombenschäden in Mailand nach Luftangriffen am 12. und 15. August 1943*, Aug. 15, 1943, So 17/134 POR MAG., Österreichischische Nationalbibliothek/ Bildarchiv (ÖNB/BA).

87 "Wanderschau 'Der Luftterror,'" *Der Propagandist*, Dec. 1943, 10–11.

88 Ibid.

89 "Die Psychologie des Luftschutzes," *Gasschutz und Luftschutz*, Sept. 1943, 211.

90 "Wanderschau 'Der Luftterror,'" *Der Propagandist*, Dec. 1943, 11.

91 Ibid., 10–11.

92 "Therefore, every Volksgenosse must be active in the fight against the air gangsters." "Ein Rundgang durch die Ausstellung," *Das kleine Blatt*, Oct. 22, 1943, 4."

93 "We are all working towards retaliation." Ibid.

94 Hoffmann, *Fliegerlynchjustiz*, 119.

95 Nicole-Melanie Goll and Georg Hoffmann, "'Terrorflieger': Deutungen und Wahrnehmungen des Strategischen Luftkrieges in der nationalsozialistischen Propaganda am Beispiel der sogenannten 'Fliegerlynchjustiz,'" *Journal for Intelligence, Propaganda and Security Studies*, No. 1 (2011), 71–86. As an example: "Die Gangster nennen sich selbst 'Mordverein,'" *Völkischer Beobachter* (Vienna edition), Dec. 21, 1943, 1. Detailed analysis: Hoffmann, *Fliegerlynchjustiz*, 152–54.

96 Hoffmann, *Fliegerlynchjustiz*, 161–75; Georg Hoffmann, "Verdrängte Erinnerung: Aufarbeitung und gesellschaftlicher Umgang mit dem Gewaltphänomen 'Fliegerlynchjustiz' im Kontext des alliierten Bombenkrieges," in *Luftkrieg und Heimatfront: Ein vergessener Fliegerlynchmord in der "Stadt des KdF-Wagens,"* Texte zur Geschichte Wolfsburgs 39, ed. Günter Riederer (Wolfsburg: Appelhans, 2016), 76–87.

97 Süß, *Tod aus der Luft*, 145.

98 Fröhlich, ed., *Die Tagebücher Joseph Goebbels*, Part 2, Vol. 9, 288.

99 Ralf Schabel, *Die Illusion der Wunderwaffen: Die Rolle der Düsenflugzeuge und Flugabwehrraketen in der Rüstungsindustrie des Dritten Reiches*, Beiträge zur Militärgeschichte 35 (Munich: Oldenbourg, 1993), 247–90.

100 "This is the work of the 'liberators', these are the 'heroic deeds' of a band of soldiers who hope to achieve the biological destruction of the German people from the air." "Sie sind die Avantgarde der Rache," *Tagespost*, Feb. 20, 1945, 4.

101 Jörn Glasenapp, "Nach dem Brand: Überlegungen zur deutschen Trümmerfotografie," *Fotogeschichte* 24, No. 91 (2004), 47–64.

102 Neil Gregor, "A Schicksalsgemeinschaft? Allied Bombing, Civilian Morale, and Social Dissolution in Nuremberg 1942–1945," *The Historical Journal*, No. 4 (2000), 1051–70.

103 As an example: Maximilian Czesany, *Alliierter Bombenterror: Der Luftkrieg gegen die Zivilbevölkerung Europas 1940–1945*, (Leoni: Druffel, 1986).

104 Christoph Hamann, *Visual History und Geschichtsdidaktik: Bildkompetenz in der historisch-politischen Bildung* (Munich: Centaurus Verlag & Media, Herbolzheim 2007), 133.

105 Nicole-Melanie Goll, "'Terror Pilots' and 'Bombing Holocaust': Discourses on Victimization and Remembrance in Austria in the Context of the Allied Air War," in *Austrian Environmental History*, Contemporary Austrian Studies 27, ed. Marc Landry and Patrick Kupper (New Orleans: University of New Orleans Press; Innsbruck: Innsbruck University Press, 2018), 277–92; Katrin Hammerstein, "Weiße Flecken? Österreichische Erinnerungen an den Luftkrieg," in *Luftkrieg: Erinnerungen in Deutschland und Europa*, ed. Jörg Arnold et. al. (Göttingen: Wallstein, 2009), 114–31.

The Visual Memory of Mauthausen[1]

Lukas Meissel

Visual media—photographs, movies, and pieces of art as well as other types of still and moving images—influence contemporary imaginations of the past. Therefore, they are intriguing sources for understanding the role of specific histories within a group or society. This connection between visuality and memory has been at the center of many studies, especially in the context of the so-called "iconic/pictorial turn"[2] of the 1990s. Frequently, the focus is not so much on the historical context of the respective visual media themselves, but on the roles they have played and the functions they have fulfilled in the aftermath of their production up to this day.

As is the case with history in general, the public memory of Nazi crimes and specifically of concentration camps is shaped by images. Common notions and perceptions of Nazi history are greatly influenced by visual media, ranging from historical pictures, TV shows, movies, and lately video games. Postwar depictions of the camps often relate to pictures that were taken by Allied photographers during liberation, capturing the terrible situation in the last days of the concentration camps' existence. For instance, images taken by Soviets at Majdanek and Auschwitz, photos taken by British photographers at Bergen-Belsen, and pictures taken by Americans at Dachau defined the image of the camps. The afterlife of these pictures in various societies are telling for the respective role the history of Nazi atrocities played in different and sometimes competing politics of memory.

This paper, however, does not focus on the afterlife of photographs and the connection between memory and images. It deals with the origins of a specific set of photos that are less known and have been less studied than pictures taken during the liberation of the camps: photographs that were created during the camps' existence by SS photographers. These images are interpreted amongst other reasons as sources for the production of memory by the perpetrators. However, their concrete functions changed already shortly after their creation when the majority of those photographs that are still preserved were hidden by camp inmates that used them as evidence of their suffering.

Introduction: An "Icon" from Mauthausen

This paper is a case study of the Mauthausen concentration camp[3] and exclusively deals with this camp. Mauthausen, situated in contemporary Upper Austria, is an intriguing case due to the number of preserved sources concerning SS photography, both from within the camp as well as post-war documents about these pictures. Furthermore, it will be demonstrated that the specific story of Mauthausen within the genesis of the Nazi concentration camp system sheds light on general developments in SS camp photography.

Despite the existence of a variety of pictures that were taken by liberators as well as former prisoners at Mauthausen, many pictures that shape the public iconography of the concentration camp were actually taken by SS photographers. This is not exclusive to Mauthausen, as other perpetrator pictures became seemingly unambiguous symbols for the camps and the Holocaust more broadly: Examples include SS photographs depicting so-called "selections" at the Auschwitz-Birkenau extermination camp[4] or an SS photo report about the violent suppression of the Jewish uprising at the Warsaw Ghetto.[5] They became "icons" of the Holocaust—or how Cornelia Brink termed them: "icons of annihilation."[6] However, their assumed unambiguity erases their factual context of origin and the original purpose behind the pictures for the perpetrators.

For example, Fig. 1: the image shows a photograph that is frequently used in illustrations of the Mauthausen concentration camp. It is often described as showing the "stairs of death" at the Mauthausen quarry, a central space for forced labor, punishment, and murder at the camp.

The black and white photo itself is in portrait format, a group of people in striped clothes is shown from the back, standing on broad stairs that lead up a hill. They carry stones on their backs and seem to wait. In the left foreground, a man in a white shirt, striped pants, and a cap is visible, in the shadows behind him a person in another, darker uniform, presumably a guard. Another man in white and striped pants seems to walk towards the column from a wooden shack. Up on the hill we can see a small group of people standing, a person watches the lines on the stairs from the left, perhaps leaning on a rifle or a tool, another person without a stone on his back walks in front. The shadows indicate that the picture was taken around noon. Apart from the man walking towards the column, the photographed persons seem to wait, probably for the photo to be taken.

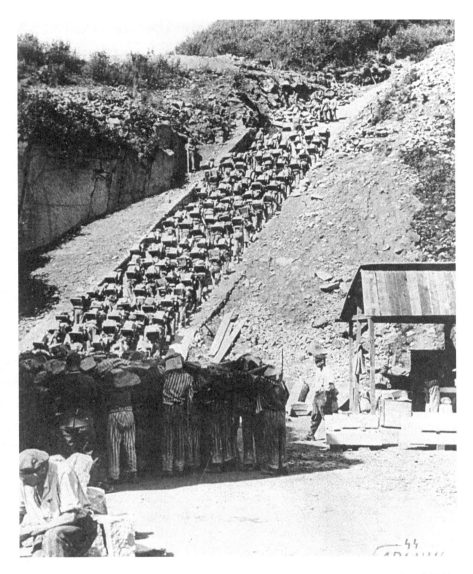

Fig. 1: "Stairs of Death" (Archive Mauthausen Memorial, Collection Hans Maršálek).

It is imperative to highlight that the horrors these stairs represent for those who were deported to Mauthausen and forced to work in the quarry are not visible in this picture. Without adding the historical context, the picture gives an impression of a work detail, perhaps in a prison facility,

doing orderly work under the supervision of very few guards. They are lifting what appear to be heavy stones, but the image does not show direct violence.

Considering additional sources, survivor testimonies, and perpetrator documents, we know that the people carrying stones in the picture are part of the so-called punishment detachment. Being transferred to this work detail was similar to a death sentence at Mauthausen, as the systematic murder through forced labor was one of the central functions of the camp for the SS. Documenting the suffering of those prisoners was, however, not the intention behind the photo. On the lower right part of the picture a mark is visible: "SS ARCHIV." The picture was part of a systematic documentation of the concentration camp system by the SS. I interpret this group of pictures among the preserved SS photos as illustrations of the camps as orderly run places of confinement and productive businesses. The images highlight their efficiency for the perpetrators, also in regard to punishment. Therefore, this specific image is not only problematic because it does not show the factual suffering of those depicted, but it also frames it as a well-organized aspect of the camp in general. The staged character of the picture becomes clear when looking closer: the prisoners wait for the photographer. The photo does not show how the "stairs of death" usually looked like, it shows how the SS wanted to document it, to commemorate their deeds. The photograph is part of the visual memory of Mauthausen that the SS actively developed during the camp's existence. And it is now part of a more general visual memory of Mauthausen, despite still containing exclusively a representation of the perpetrators.

The aim of this article is to investigate the creation of the photographic sources that are the basis for the visual memory of Mauthausen. The focus is on the years of the camp's existence; therefore, liberation photographs and post-war images are not considered. The central research question is directed towards those persons behind the photographs—not only who took them but also who preserved them. As the majority of the photos were saved by prisoners, diverging meanings that were attributed to the images will be reflected. The paper wants to raise awareness of various meanings of pictures—not only in their postwar usage but already during their creation.

Researching the Visual Memory Production at Mauthausen

Academic interest in questions concerning photography and Nazi atrocities was initially closely connected to memory studies. Early works by Sybil Milton focused on the act of photography itself,[7] however—especially in the 1990s—influential studies by Cornelia Brink[8] and Habbo Knoch[9] dealt with the afterlife of Holocaust photography. These works raised important questions concerning how influential visual media were in postwar Germany's dealing with its past. Later studies by Daniel Uziel[10] and Ute Wrocklage[11] as well as Janina Struk's general history of Holocaust photography[12] focused on perpetrator photography more specifically. Uziel wrote an extensive analysis on propaganda photography and its role in the "German home front," whereas Wrocklage investigated photographs from concentration camps—therefore, her in-depth analyses are highly relevant to this study specifically.

Recently, new insightful studies were published that dealt with perpetrator photo albums. Tal Bruttmann, Stefan Hördler, and Christoph Kreutzmüller wrote a detailed analysis of the so-called Auschwitz Album that consists of pictures taken by SS men of the Auschwitz *Erkennungsdienst*. Hördler also published another significant contribution to the visual history of the Holocaust together with Christophe Busch and Rober Jan van Pelt about a perpetrator album created at the same time: the so-called Höcker Album, consisting of pictures of perpetrators enjoying themselves in the vicinity of the Auschwitz camp complex.[13] Their important contributions prove the huge potential of photo analysis and using pictures as sources beyond illustrations, specifically in reconstructing networks. Researchers connected to the *Bildungswerk Stanisław Hantz* association and the *Forschungsstelle Ludwigsburg* published a profound analysis of a rare perpetrator album created at the Sobibor death camp. This private album of a perpetrator—who was taking part not only in the genocides of the Jews and Roma and Sinti but also the Nazi euthanasia murders—gives exceptional insight into the career of a perpetrator and his visual narration of his interconnected private and professional life.[14]

Concerning photographs from the Mauthausen concentration camp, the most influential work has been the photo exhibition "das sichtbare unfassbare" that was first shown in 2005 at the Mauthausen Memorial.[15] Stephan Matyus, who served as the memorial's photo archivist, is the expert on these specific photographic holdings and has further published about prisoner photographer Francisco Boix as well as a private SS album from Mauthausen.[16] Benito Bermejo wrote a biography about Boix that mainly focuses on his time as a prisoner at the Mauthausen photo studio and

provides unique insight into the biography of a camp inmate who was central in preserving SS photographs.[17] My own MA thesis about photographs from Mauthausen, that serves as the basis for this article, was published as a monograph and as a shortened English translation in an edited volume.[18]

This article wants to focus on a specific aspect of the Mauthausen SS photographs: the dualism of photographs taken at Mauthausen between perpetrator documents and visual evidence saved by survivors that both shape the contemporary visual memory of the camp. Survivors of the camp transformed the initial meaning of the pictures fundamentally.

Visual-historical Context

Researching photographs requires to reflect on their context of origin. The pictures that were taken by SS photographers of the Mauthausen *Erkennungsdienst* are directly connected to the development of these departments and the Mauthausen camp complex.

Erkennungdienst is the German term for identification department. The history of these facilities and their conceptualization are closely linked to the development of so-called scientific police work in the 19th century. Modern police units incorporated departments that collected data of individuals for identification according to seemingly objective categorizations. The idea behind that was to identify types of criminals beyond individual suspects, often in connection to racist, antisemitic, classist, and sexist stereotypes. Identification departments incorporated photography as a new medium to capture visual documents and create visual evidence. Consequently, a standardized procedure of taking pictures was developed that led to the creation of so-called mugshots that are still in use in modern police forces worldwide.[19]

In concentration camps, special departments modeled after police identification bureaus were introduced in the standardized design of the camps according to the Dachau model. The SS created their camps with a predefined set of departments and general layout. Despite this theoretical standardization, the camps varied in details from each other. However, the general design was the same from 1936 onwards. *Erkennungsdienste* were subordinated to the "Political Departments" that served as the representation of the *Geheime Staatspolizei* (Gestapo) in concentration camps.[20] Their tasks were closely linked to their superior departments and consisted primarily in identifying—meaning, categorizing and administering—files of individual deportees according to a standardized procedure that included the creation of mugshots upon arrival.

The administration of the camp inmates included all files concerning an individual. This meant that the identification departments were also responsible for administrating the paperwork in case of death of prisoners. Corresponding with their design as (pseudo-) police units, they were also obliged to take photographs of dead inmates when their circumstance of death was defined as "unnatural," meaning in case of (alleged) escape attempts or suicides.[21] SS photographers took pictures of the scene of death and attached them to reports to higher SS institutions. Survivors testified that these pictures were often staged, and the position of corpses changed to make the scenes look more like escapes or suicides.[22] Therefore, the SS photographers and the identification departments were directly involved in covering up crimes committed in the camps as many of those photographed were in fact murdered by camp personnel.

Beyond the core tasks of the identification departments as police-like facilities, the *Erkennungsdienste* served as the official photo studios in concentration camps. SS photographers were responsible for taking pictures within the camp perimeter where photography was forbidden without a permit. They photographed the construction of the camps, their topography, production facilities, prisoners conducting work, special events at the camps, celebrations of the SS, and products created by inmates among other motifs.

The respective pictures correlate to the main tasks of the camps for the SS in the specific time period. For instance, SS photographers captured pictures of the expansion of the concentration camps towards more "productivity" in the context of the restructuring of the camp system in the middle of the war when the German Reich's war effort came to a halt, directly working towards documenting the success of this restructuring in the eyes of the SS. Individual pictures as well as photo series, therefore, need to be analyzed in their concrete context, since the camps changed dramatically during the time of their existence.

Camp Photography at Mauthausen

The concentration camp at Mauthausen was established shortly after the so-called Anschluss, the incorporation of Austria into the German Reich. Eventually, the camp existed between August 8, 1938, and it's liberation by American soldiers on May 5, 1945. During this time period, the function of the concentration camp changed within the broader context of the camp system on the one hand, and the specific functions of Mauthausen for the SS on the other hand. Hans Maršálek, an Austrian resistance fighter and Mauthausen survivor as well as the author of a monograph about Mauthausen, divided the

camp's history in four phases:[23] First, between its founding and late summer 1939, Mauthausen was primarily a building site: the main task of the prisoners was the construction of the main camp. Afterwards, until June 1943, Mauthausen was defined by the SS's categorization as a concentration camp of tier three (*Stufe III*), a category created by the SS to define Mauthausen as the toughest of their camps. During this phase, the death toll—specifically at the camp's quarry—was especially high, and the camp administration abused the prisoner's work force relentlessly. In 1943, the concentration camp system was refigured, and a new focus on forced labor in the armament industry was introduced. Mauthausen became the center of a network of subcamps that were often connected to local factories and industry. These new camps served as satellite facilities, the main camp remained the administrative center where deportees were registered at the *Erkennungsdienst* and transferred further. The last stage of Mauthausen, in the winter of 1944 until liberation in May, was characterized by so-called death marches of Jews that were forced by local Nazi authorities to march throughout Austria to Mauthausen, as well as transports of prisoners from other camps that the Nazis "evacuated" before fleeing advancing Allied troops. Mauthausen was overcrowded by newly arriving deportees, the already terrible living conditions became worse; the death rates rose significantly.

The Mauthausen *Erkennungsdienst* documented these phases of the concentration camp, and the motifs changed respectively. The department itself is first documented in records in 1940, many photographs are preserved dating from 1941 onwards.[24] In general, it needs to be pointed out that the majority of the photographs that were taken at concentration camps by perpetrators and developed at the camps' identification department photo laboratories are lost: whether they were destroyed in the last stage of the war, never stored at the camps, or taken away by SS men or others, only a small percentage of the original photographic holdings are publicly accessible today. It can only be hoped that in the near future more pictures and albums will be handed over to archives and research institutions since a large part of the generation of both survivors and perpetrators has already died.

Since written documents from identification departments were seldom preserved, the remaining pictures and postwar documentation are usually the only available sources. Scholars[25] who conducted research on perpetrator photography at concentration camps identified certain groups of pictures. In reference to these studies as well as my own research on Mauthausen, the following motifs are representative for the majority of SS pictures from Mauthausen, despite being taken in different time periods and out of different intentions:

– Prisoners: This group of motif consists of mugshots, racist-anthropometric pictures, as well as other images that focus on individuals or groups of deportees. Despite the vast difference in contexts of origin, these photos all focus on prisoners.

– Concentration camp: Images belonging to this group include pictures of the construction of the camp, building sites, and aspects of the camp's topography. The focus is on the camp, not on people. Therefore, people are rarely seen in these images.

– Violence and death: These groups of motifs visualize theoretical concepts that are not representative of how the original photographers might have categorized their own pictures. Photos summarized here show various forms of violence, including staged suicides and escape attempts, humiliations, and executions within the camp.

– SS events: SS photographers documented special events at the camp. This included celebrations and holidays, promotion ceremonies or visits by a variety of delegations. In general, the identification department photographers became the official camp photographers and were responsible for the photographic documentation of events within the concentration camp.

– Private motifs: Pictures summarized under this category are specifically ambiguous. A central challenge in analyzing visual sources is that there is often no additional information about the context of origin beyond the image itself. Recent studies prove that many pictures have been too quickly misinterpreted, often leading to conclusions that are not rooted in historical facts but rather in uncritical usage of visual sources. However, as historians naturally reflect on written sources critically, it is also imperative to do so with visual sources. Photographs that ostensibly document private moments seem to give an unfiltered window into the self-conception of an individual. However, when taking into consideration the broader picture, often quite literally, more can be learned from such images. As private motifs are frequently linked to commemoration and memory, an example from this group of motifs will serve as an introduction to the SS photographs from Mauthausen, as well as the story of the construction of the visual memory of Mauthausen.

The Merging of Private and Official Memory of the Camps

Fig. 2: "Photo album Albert Elßer" (Archive Mauthausen Memorial, Collection Bruno Biermann).

The picture shows a page from the private photo album of Albert Elßer from Stuttgart, born in 1921 and a trained butcher. He joined the SS and eventually made it to the rank of *Rottenführer*. In 1941, Elßer was transferred from the main camp Mauthausen to the subcamp Bretstein; later on in the war, he was sent to a tank division. He never faced any juridical consequences for his service at concentration camps or in the SS and died in 1987 in Germany. Like so many others of his generation, Albert Elßer created a photo album, documenting central episodes of his life and kept it as memorabilia until his death. The twenty page album, from which the above picture was taken, consisted of seventy-five photographs that were glued in and seven additional pictures. The album, despite including pictures from the postwar period, starts and ends with Elßer in SS uniform, highlighting the significance of this part of his life.[26]

The page shown here consists of two photos in landscape format and a colorful description: "*Ernennung zum Sturmman [sic!]. 20. April 1941*" (Promotion to *Sturmman*). The page's design and the proud gesture of the six men with a guard dog (Elßer is the third man from the right) indicate

the positive connotation of the occasion for the album's author and reflect his pride in the promotion. The group portrait is only preserved in this album, as it shows Elßer together with other guards in a more intimate setting, it can be assumed that it was taken specifically for these six men. However, the other picture was already known before the album was given to the Mauthausen archives in 2013. Stephan Matyus, an expert on photography at the Mauthausen Memorial, recognized the image as a positive taken from a negative that is stored at the memorial. This negative was saved by prisoners who stole it from the identification department, proving that individual SS men could receive pictures from the camp's photo studio. Representative pictures taken for official purposes were incorporated into Elßer's and probably many others' albums, indicating the merging of private memory and official visual narrations created by the centrally organized photo studios of the camps.

This connection between official images and private commemorative albums was widespread throughout the Third Reich. As a matter of fact, it was encouraged by the promotion of amateur photography.[27] Manuals for creating albums were created, propaganda companies handed out pictures to soldiers for their private purpose,[28] and standardized photo albums were presented and advertised.[29] Intriguingly, those who created the albums were probably not aware that they indirectly followed the image politics of the state, reproducing official narratives of the war, the assumed realities of Nazi Germany and the concentration camps. They created visual evidence for the rightfulness of their deeds and as confirmatory proofs of their own worldview, acting in compliance with Nazi ideas. Therefore, despite the personal character of albums like the one of Albert Elßer, they need to be interpreted with regard to the wider context of image politics during the Third Reich and the close connection between official imagery and private visual memory.

Fig. 3: "SS men dozing in the sun" (Archive Mauthausen Memorial, Collection Museu d'Història de Catalunya, fons de Amical de Mauthausen y otros campos).

This photograph, taken at the Mauthausen concentration camp shows two SS men dozing in the sun outside a barracks. They seem to not be aware of the photographer's presence, enjoying a moment of quiet at the camp. Pictures like this that convey the impression of a private moment seem to be of special interest not only for historians but also a broader general public. For instance, pictures of the so-called Höcker-album that consists of a variety of pictures taken in the vicinity of the Auschwitz camp complex that show male and female camp personnel celebrating at a cabin were highly discussed in the press.[30] Assumingly, photos like these break specific images and stereotypes that are frequently associated with Nazi perpetrators. However, premature interpretations and hasty explanations of supposedly explicit messages of such pictures obstruct critical analysis of the actual images. Christophe Busch, Robert Jan van Pelt, and Stefan Hördler, for instance, uncovered the network of core perpetrators in the murder of Jews from Hungary at Birkenau with the Höcker-album pictures, highlighting the specific nature of the celebration commemorated in the album.[31] Critical analysis should be a standard procedure in the usage of any source for historians, the same is true for seemingly clear private images. The picture above, for instance, was taken by one of the official camp photographers at Mauthausen. As the image is preserved on a negative film

strip, the original sequence of the film can be reconstructed. It seems that the photographer walked around the camp, taking pictures of various working sites of prisoners and upon returning to the identification department saw his comrades taking a break.[32] The picture was most probably not taken for any official purpose, however its context of origin shows that besides official assignments, the camp photographers had the possibility to take pictures for themselves and others, specifically as they could walk around the camp freely. A critical analysis of such pictures on the edge between official and private motifs allows conclusions about the connections between SS men and sometimes female auxiliary, a reconstruction of private and professional networks among the perpetrators and a glimpse into the concentration camps as working and living spaces for the SS.

Those Behind the Cameras

A central question in every photo analysis and every study of photography must address those behind the cameras: the photographers but also those who commissioned a picture and other persons who were involved in the creation of an image. This is the base for further research questions concerning contextualization, meaning, function, usage, and interpretation.

In the case of the photographs from the Mauthausen concentration camp, the persons taking the pictures can be identified as the three known SS men who were assigned to the identification department: Friedrich (Fritz) Kornacz (or Kornatz), Paul Ricken, and Hermann Schinlauer.[33] The three men were part of the *Politische Abteilung*, the so-called political department. Relatively little is known about the first head of the identification department, Friedrich Kornacz. He was drafted in 1943 to a combat unit and killed in action. Survivor Antonio García reported after liberation that Kornacz was brutal towards prisoners, highlighting the literal violence behind the camera's frame.[34]

Paul Ricken is the best documented of the three SS photographers. He took over after Kornacz was transferred to the front. After liberation, he was charged at the Mauthausen Trial at Dachau for his later position as deputy to the commandant of the Leibnitz subcamp. During his trial, his role at the identification department was discussed as well. Ricken, who was born in 1892, was older than other SS men at Mauthausen and seems to have had knowledge of photography before his assignment to the identification department. Antonio García, a trained photographer, described Ricken as a professional photographer, despite him being not a photographer by profession.[35] In his trial, Ricken stated that he took around 40,000

photographs at Mauthausen.[36] Stephan Matyus, as the head of the photo archive of the Mauthausen Memorial, estimated that the archive stores around 4,000 pictures from Mauthausen, however this number includes pictures taken during liberation and many duplicates.[37] This emphasizes that only a small percentage of the photographs of the *Erkennungsdienst* are preserved to the general public.

The last head of the *Erkennungsdienst*, Hermann Schinlauer, took over after Ricken was transferred to the Leibnitz subcamp. He was in charge of the photo studio as well as the record of so-called "unnatural death cases."[38] Despite not being a trained photographer, Schinlauer was a druggist and might have had some knowledge required in laboratory work necessary for developing pictures.[39]

In conclusion, it is indicative that according to the records, only one of the three photographers had at least amateur knowledge of photography prior to his assignment to the identification department. As their task consisted of taking standardized police photographs as well as pictures according to orders from above, it seems that their individual skills were not the decisive factor for choosing them for the position. Especially since professional photographers among the camp inmates were chosen to conduct the more sophisticated work in the photo studio.

The prisoners who were forced to work at the identification department and its superior department, the *Politische Abteilung*, had a relatively "privileged" position within the general group of camp inmates.[40] As they worked closely with the SS photographers, their relationship was more personal compared to other prisoners and guards. For instance, Hermann Schinlauer called three of the *Erkennungsdienst* prisoners "Franz," "Toni," and "Josef" and not by their prisoner number[41]— this, however, does not mean that the prisoners did not live under constant danger of death, specifically as these three men specifically, unbeknown to the SS man Schinlauer, were actively involved in illegal resistance activities.

Franz, Toni, and Josef were actually called Francisco Boix, Antonio García, and José Cereceda. They were Republican Spaniards and deported to Mauthausen as part of the group of Spanish refugees interned in German-occupied France. Their story is closely linked to the story of the SS photographs, not only because they had to develop many of them in the photo studio, but primarily because they are the ones who are responsible for their preservation. Together with other Spaniards, they systematically hid negatives and positives in various sites in the camp and managed to smuggle some pictures outside to Anna Pointner, an Austrian resistance fighter who lived in the town of Mauthausen. Despite various divergent

details in the narration of these outstanding acts of defiance—as is often the case in resistance historiography—the activities of the *Erkennungsdienst* prisoners were essential in the saving of the pictures that are still available today, and consequently in the establishment of the visual memory of the camp beyond the perpetrators' narratives.

Francisco Boix served as a witness during the Nuremberg Trials and elaborated on the story of the photographs. His testimony refers to the criteria he chose in what pictures he saved:

> "Those that had no meaning I burned, and I put the others in my pocket because they were very small Leica negatives."[42]

This quote is of high significance to contemporary analysis of the SS pictures: Assumably the majority of preserved photographs were chosen according to meanings that Boix and his comrades assigned to the images. Therefore, a new level of meaning beyond the initial intentions of the SS photographers and those who commissioned the images needs to be reflected.

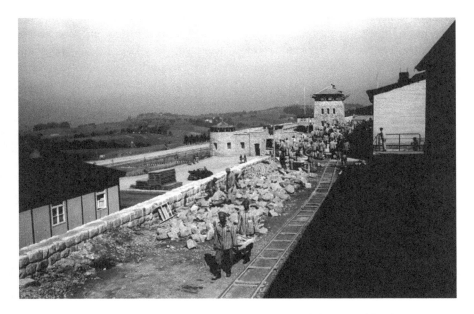

Fig. 4: "Spanish prisoners conducting forced labor" (Archive Mauthausen Memorial, Collection Museu d'Història de Catalunya, fons de Amical de Mauthausen y otros campos).

This photograph in landscape format above was taken at the beginning of 1941. Resembling industrial pictures and designed according to classical conventions of diagonals, the image is centered around the camp's gate to the so-called *Garagenhof* or garage courtyard in the middle. In the foreground, two men in striped uniforms carry stones on a bar next to a construction site. Further behind, a group of other people is visible, seemingly during the construction of a wall that forms the diagonal of the picture and resembles the stone wall surrounding the garage courtyard. The photograph was most probably intended to document the construction of the main camp's wall, avoiding depictions of the harsh and often deadly working environment for the prisoners by focusing on a scenery reminiscent of ordinary building sites. Similar pictures are known from other camps and were part of the general administrative documentation.

However, the photograph documents something else that the SS photographer might not have been aware of. When zooming in, the initials of the triangle on the prisoners' uniforms becomes clear: "S" for Spaniard. Most probably, this picture was chosen by the Spanish prisoners working at the photo studio because it showed a central forced labor site for this specific prisoner group. Survivor Manuel Garcia, who became the head of the Mauthausen Memorial after liberation, testified that almost all stone walls and guard towers were built by Spaniards.[43] The photograph as an example of many illustrates a unique aspect of the story behind the pictures from Mauthausen: right upon their development, contradictory meanings were attributed to them, and their functions changed fundamentally. The specific circumstances of their saving—the acts of resistance by prisoners and their selection of images—are essential to reflect on the pictures available today.

The double inscription of meaning on the photographs becomes even clearer in other examples:

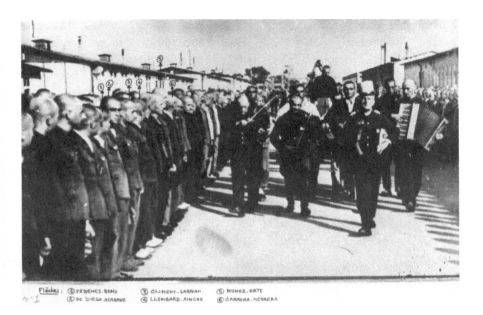

Fig. 5: "Execution of Hans Bonarewitz" (Archive Mauthausen Memorial, Collection Centre Historique des Archives Nationales, fonds del'Amicale de Mauthausen, déportés, familles et amis).

This photo is of exceptional violence and an outstanding example from the visual history of concentration camps in general. It was taken by a SS photographer during a mock parade of Austrian prisoner Hans Bonarewitz. It is part of a series that was done after Bonarewitz's unfortunately unsuccessful escape attempt from the camp and subsequent public execution. He was escorted by the camp orchestra on a wagon carrying the wooden box in which he tried to flee on the roll call square at Mauthausen; all prisoners had to watch the macabre spectacle. Usually, photos referring to direct violence were destroyed by SS personnel in the last stages of the camps' existence, however due to the courage of the Spanish prisoners of the *Erkennungsdienst*, parts of the photo series were saved. The lack of visible violence in photographs preserved today is, however, not representative for the photographs actually taken at camps, highlighting a central difficulty in interpreting photography at camps due to the lack of the majority of original pictures.[44]

After liberation, survivors identified other camp inmates in the picture and marked their names on the positive, turning the original perpetrator pictures into visual evidence of their comrades' presence at the camp and

during that specific occasion. The reason behind this was—according to Stephan Matyus[45]—that due to the exceptional nature of the image, self-described "revisionists," better described as right-wing agitators and antisemites, cast doubt on the authenticity of the picture. The names and marks on the picture were intended to confirm the authenticity of the image and eventually the murder depicted on them. Beyond the initial reason for hiding and preserving the photo, new meanings were literally inscribed on it post-liberation, leading away from the core focus of this paper on the years of the camp's existence and opening up a variety of new questions concerning the afterlife of the pictures beyond the downfall of the Third Reich.

Concluding Remarks

At the Mauthausen concentration camp, two diverging meanings were attributed to photographs developed at the identification department's photo studio. First, images created there were taken according to specific reasons of the perpetrators: identification, policing, documentation, commemoration, sadism, etc. Also amongst perpetrators, the meanings of photos changed, as illustrated by the private usage of official pictures in photo albums. Furthermore, right after the development of photos at the identification department, prisoners chose to hide certain motifs that had specific meanings to them beyond the perpetrators' perspective: evidence, commemoration, and documentation of crimes. Despite the initial intentions behind the pictures, different meanings were attributed to them already in the process of their creation and during the camp's existence, creating a complex visual basis for the postwar visual memory of Mauthausen.

The case study of pictures from Mauthausen shows that the context of origin of preserved concentration camp photography does not only include the perpetrators' perspective, but also the agency of those who saved them. They include contradictory meanings that need to be uncovered in photo analysis in order to use their full potential as visual sources. The dual memory inscribed on them opens up perspectives beyond the focus of the SS photographers. The visual memory of Mauthausen and iconographic pictures like the "stairs of deaths" photo is not only created by perpetrator sources, but also shaped by the resistance of prisoners by saving these documents from destruction.

Endnotes

1 I would like to thank Daniel Simon (Amicale de Mauthausen – déportés, familles et amis de Mauthausen) for giving me the permission to use a photo from the Amicale collection for free and Lucile Chartain (Archives nationales, France) for her help in locating a scan of said picture. My sincere thanks go also to Enric Garriga and Laura Fontcuberta (Amical de Mauthausen y otros campos y de todas las víctimas del nazismo de España) and Bruno Biermann (University of Bern) for giving me the authorization to use photographs from their collections without charges and Ralf Lechner (Mauthausen Memorial) for his support.

2 W.J.T. Mitchell, *Picture Theory: Essays on Verbal and Visual Representation* (Chicago: The University of Chicago Press, 1994).

3 The paper is based on the author's MA thesis that was published as a monograph, a shortened English version was published as an article: Lukas Meissel, "Perpetrator Photography: The Pictures of the Erkennungsdienst at Mauthausen Concentration Camp," in *Fotografien aus den Lagern des NS-Regimes: Beweissicherung und ästhetische Praxis*, Schriften des Centrums für jüdische Studien 31, ed. Hildegard Frübis, Clara Oberle, and Agnieszka Pufelska (Graz: Böhlau, 2018), 25–48; Lukas Meissel, *Mauthausen im Bild: Fotografien der Lager-SS: Entstehung – Motive – Deutungen* (Vienna: edition Mauthausen, 2019).

4 Israel Gutman and Bella Gutterman, eds., *Das Auschwitz Album: Die Geschichte eines Transports* (Göttingen: Wallenstein, 2005).

5 Andrzej Żbikowski, ed., *Jürgen Stroop, Żydowska Dzielnica Mieszkaniowa W Warszawie Już Nie Istnieje!* (Warsaw: Instytut Pamięci Narodowej Żydowski Instytut Historyczny, 2009).

6 Cornelia Brink, *Ikonen der Vernichtung: Öffentlicher Gebrauch von Fotografien aus nationalsozialistischen Konzentrationslagern nach 1945* (Berlin: Akademie Verlag, 1998).

7 Sybil Milton, "The Camera as Weapon: Documentary, Photography and the Holocaust," *Simon Wiesenthal Annual* 1 (1984): 45–68.

8 Brink, *Ikonen*.

9 Habbo Knoch, *Die Tat als Bild: Fotografien des Holocaust in der deutschen Erinnerungskultur* (Hamburg: Hamburger Edition, 2001).

10 Daniel Uziel, *The Propaganda Warriors: The Wehrmacht and the Consolidation of the German Home Front* (Bern: Peter Lang AG, 2008).

11 For instance: Ute Wrocklage, "Das SS-Fotoalbum des Frauen-Konzentrationslagers Ravensbrück," in *Im Gefolge der SS: Aufseherinnen des Frauen-KZ Ravensbrück: Begleitband zur Ausstellung*, ed. Simone Erpel (Berlin: Metropol, 2011), 233–51.

12 Janina Struk, *Photographing the Holocaust: Interpretations of the Evidence* (London: I.B. Tauris, 2004).

13 Tal Bruttmann, Stefan Hördler, and Christoph Kreutzmüller, *Die fotografische Inszenierung des Verbrechens: Ein Album aus Auschwitz* (Darmstadt: wbg Academic, 2019); Christophe Busch, Robert Jan van Pelt, and Stefan Hördler, *Das Höcker-Album: Auschwitz durch die Linse der SS* (Darmstadt: wbg Academic, 2016).

14 Bildungswerk Stanisław Hantz e.V./Forschungsstelle Ludwigsburg der Universität Stuttgart, eds., *Fotos aus Sobibor: Die Niemann-Sammlung zu Holocaust und Nationalsozialismus* (Berlin: Metropol, 2020).

15 *Das sichtbare Unfassbare: Fotografien vom Konzentrationslager Mauthausen*, exhibition catalog (Vienna: Mandelbaum, 2005).

16 Stephan Matyus, "Auszeit vom KZ-Alltag: Das Bretstein-Album," in *Täter: Österreichische Akteure im Nationalsozialismus*, Jahrbuch 2014, ed. Dokumentationsarchiv des österreichischen Widerstandes (Vienna: DÖW, 2014), 107–33; Stephan Matyus, "Die Befreiung von Mauthausen, die fotografische Perspektive eines Häftlings: Francisco Boix," in: *Fotografien aus den Lagern des NS-Regimes: Beweissicherung und ästhetische Praxis*, Schriften des Centrums für jüdische Studien 31, ed. Hildegard Frübis, Clara Oberle and Agnieszka Pufelska, (Graz: Böhlau, 2018), 159–78.

17 Benito Bermejo, *Francisco Boix: der Fotograf von Mauthausen*, trans. Judith Moser-Kroiss (Vienna: Mandelbaum, 2007).

18 Mitchell, *Picture Theory*.

19 Jens Jäger, *Fotografie und Geschichte* (Frankfurt: Campus, 2009), 165.

20 Karin Orth, *Die Konzentrationslager-SS: Sozialstrukturelle Analysen und biographische Studien* (Göttingen: Wallenstein, 2001), 47.

21 Jutta Fuchshuber: "'Auf der Flucht erschossen?' Tötungen im KZ-Komplex Mauthausen," *Innenansichten*, no. 1/1 (Vienna 2012), 9-26; Gregor Holzinger: "'… da mordqualifizierende Umstände nicht hinreichend sicher nachgewiesen werden können…': Die juristische Verfolgung von Angehörigen der SS-Wachmannschaft des Konzentrationslagers Mauthausen wegen 'Erschießungen auf der Flucht,'" in *Täter: Österreichische Akteure im Nationalsozialismus*, Jahrbuch 2014, ed. Dokumentationsarchiv des österreichischen Widerstandes (Vienna: DÖW, 2014), 135–63.

22 Archive Mauthausen Memorial, copy, original: NARA, RG 549, US Army Europe, Cases tried, Case 000-50-5-14 (Mauthausen), US vs. Eduard Dlouhy et al., Box 381 1/2, p. 25032.

23 Hans Maršálek, *Die Geschichte des Konzentrationslagers Mauthausen: Dokumentation* (Vienna: edition Mauthausen, 2006), 26.

24 Bermejo, *Francisco Boix*, 103.

25 Knoch, *Tat als Bild*, 92; *Das sichtbare unfassbare*, 29; Bermejo, *Francisco Boix*, 239.

26 Matyus, *Bretstein-Album*, 110.

27 Petra Bopp, *Fremde im Visier: Fotoalben aus dem Zweiten Weltkrieg* (Bielefeld: Kerber, 2009), 47.

28 Bernd Boll, "Das Adlerauge des Soldaten: Zur Fotopraxis deutscher Amateure im Zweiten Weltkrieg," *Fotogeschichte* 85–86, no. 22 (2002): 75–87, (here 81).

29 Bopp, *Fremde im Visier*, 37.

30 The German weekly *Der Spiegel*, for instance, used a photograph from the Höcker-album for their cover with the title "Die Täter: Warum so viele Deutsche zu Mördern wurden" (The Perpetrators: Why so many Germans became murderers): *Der Spiegel*, 11/2008.

31 Busch, van Pelt, and Hördler, *Höcker-Album*.

32 Thanks to Stephan Matyus for his insightful analysis of the picture.

33 Archive Mauthausen Memorial, P/03/08. List of SS men, amongst them those working in the "political department," Sept. 30, 1944.

34 David Wingeate Pike, *Spaniards in the Holocaust: Mauthausen, the Horror on the Danube* (London: Taylor & Francis, 2000), 136.

35 Ibid, 136.

36 Archive Mauthausen Memorial, copy, original: NARA, RG 549, US Army Europe, Cases tried, Case 000-50-5-14. (Mauthausen), US vs. Eduard Dlouhy et al., Box 381 1/2, p. 25354.

37 Stephan Matyus to the author, Dec. 18, 2014.

38 Archive Mauthausen Memorial, copy, original: NARA, RG 549, US Army Europe, Cases tried, Case 000-50-5. (Mauthausen), US vs. Altfuldisch et al., Box 336, Folder 1.

39 Bermejo, *Francisco Boix*, 115–16.

40 Maršálek, *Mauthausen*, 360.

41 Bermejo, *Francisco Boix*, 20.

42 Archive Mauthausen Memorial, copy, original: NARA, RG 549, US Army Europe, Cases tried, Case 000-50-5 (Mauthausen), US vs. Altfuldisch et al., Trial Transcripts, p. 3444.

43 Archive Mauthausen Memorial, V/03/03, p. 2. Transcript of an interview with Dr. Manuel Garcia, 05.05.1966, probably by Hans Maršálek.

44 For instance, a series of photographs showing the murder of Soviet POWs with axes at Auschwitz is only known via the testimony of survivor Wilhelm Brasse, who was forced to work at the camp's identification department. Struk, *Photographing the Holocaust*, 105.

45 Confirmation by head of the photo archive Stephan Matyus at the Archive of the Mauthausen Memorial, Sept. 08, 2016.

Visualizing "Zero Hour" 1945:
End of War vs. Liberation in Austrian Visual Memory, 1945–2005

Ina Markova

Liberating Austria: Introductory Remarks

April 13, 1945, was a turning point in Austrian history. That day, the Red Army liberated the city of Vienna after seven years of National Socialist rule; in the beginning of May 1945, US, British, and French armies overpowered the remaining *Wehrmacht* and SS forces in Austria's Western provinces. After the war—and especially in view of the ensuing Allied occupation of the country—Austrians had to face up to an ambivalent past. Naming the victims and victimizers in a country whose population had been *both* victims and perpetrators would preoccupy the country for a long time. Undoubtedly, Austrians had been thoroughly infused with Nazi ideology; many had been rank-and-file party members, some high-echelon war criminals. Out of a population of about six million, 537,632 had to register their Nazi affiliations in the Allied "de-Nazification" program.[1] Coping with this toxic past was a tall order: prompted by the impending Cold War, Austria's political elite quickly devised the potent narrative of "Austria as Nazism's first victim" (*Opferthese*).[2] Politicians tried to downplay Austrian involvement in the Nazi regime by singling out the allegedly few "traitors to the fatherland." In the Declaration of Independence proclaimed on April 27, 1945, the postwar founding parties claimed the "Anschluss," the country's annexation to Germany in 1938, had been accomplished by a foreign military force with the assistance of only a small, treacherous stratum of the population.[3] To back up this lopsided *Opferthese*, Austrians could also draw on a document drafted by the Allies themselves. In the "Moscow Declaration on Austria" of 1943, the Allied foreign ministers stated that "Austria, the first free country to fall victim to Hitlerite aggression, shall be liberated from German domination." However, Austria was reminded "that she has a responsibility which she cannot evade for participation in the war on the side of Hitlerite Germany, and that in the final settlement, account will inevitably be taken of her own contribution to her liberation."[4] After said liberation, Austrians took this wartime propaganda statement at face value, wilfully ignoring the passage reminding Austria of her participation in World War II.[5] The Cold War reshuffled the cards for victims and perpetrators of the Nazi era alike, and the Allies contented

themselves with following the Austrian reading of the Moscow Declaration. Over the course of only a few years, this unexpected turn of events left its imprint on the reading of 1945. As responsibility for the Nazi era was negated, the liberation of Austria was reinterpreted as "zero hour" ("*Stunde Null*"), as only the starting point of yet another foreign occupation that left the country victimized by both the Nazis in 1938 *and* the Allied powers in 1945.

Against this backdrop, this paper argues that analyzing visual representations[6] of 1945 is paramount when discussing the afterlife of Austria's Nazi past. For seventy years, 1945 has been referred to as the end of the war, the onset of hardships caused by the Allied occupation, and outward defeat, but only rarely as liberation. Literature has provided ample support for the assertion that Austrian memory politics have organized for a long time around the "victim theory."[7] While most of the research grapples with the discursive construction of collective memory, this article sheds light on powerful *visual* representations of 1945 and the different layers of meaning they convey. For the sake of my argument, I will explore pictures of the country's military liberation as well as specific imagery linked to the immediate postwar era. Occasionally, events preceding 1945, such as the Allied bombing campaigns, will also be taken into consideration. For Austrians, 1945 carries interwoven and contradictory meanings; in order to fully grasp its place in memory politics,[8] one has to look beyond the military act of ending the Nazi regime.

This paper follows ideas articulated by scholars of memory politics. Cultural memory is seen as shaped by socio-political, dynamic, and ultimately antagonistic processes. The article refers to photographs as "shared cultural reference points"[9] and thus focuses on their strategic uses and functions. Gillian Rose describes "visuality" as a "discourse." This specific field of the visual "will make certain things visible in particular ways, and other things unseeable, for example, and subjects will be produced and act within that field of vision."[10] Focusing on visual references to 1945 taken from a larger corpus of approximately 6,000 historical photographs, this paper sheds light on the visible and the unseeable at certain times in Austrian history after 1945.[11] Elke Grittmann has developed the method of "quantitative picture content analysis," which seems appropriate in order to grapple with the large sample of visual data at hand.[12] Despite remarkable change in the Austrian self-image as a country of victims and perpetrators, 1945 remains an ambiguous year, a year that to this day incites memories of defeat. However, this paper will also introduce the latest visual approaches to 1945 in 2015 that put forward a more nuanced perspective on 1945 and Austria's role in World War II. Whether or not this transformed Austrian war narrative is here to stay remains to be seen.

Setting the Stage:
"Gazing at Ruins"[13] during the Allied Occupation

In the immediate aftermath of the war, two key pictures seem to have perfectly symbolized feelings hard to express on a textual level. Many journalists opted for the photograph of the destroyed Floridsdorfer Bridge as a visual signifier of the distress the country faced in 1945. This photograph shows people traversing a winding pedestrian overpass; the water flowing underneath them is filled with debris caused by the edifice's recent demolition.[14] Shortly after 1945, for instance in the 1946 "anti-Fascist" exhibit *Niemals vergessen!* (Never forget!), these generic photographs visually condemned the policy of scorched earth the retreating *Wehrmacht* employed.[15] The Danube, the sullied river shown in the photograph, is by no means just any river in the Austrian mindset; along with the Alps, this Austrian landmark serves as a poignant emblem of the country's landscape and "essence" at large.[16]

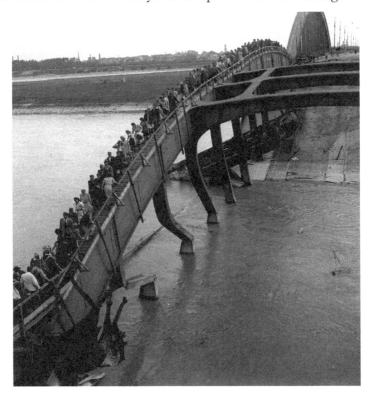

Fig. 1: Pedestrian Bridge in Floridsdorf, Vienna (Photographer: unknown, United States Information Service (USIS); ÖNB / US 147)

Juxtaposing destruction and reconstruction in visual before-after comparisons was a recurrent postwar strategy, as becomes apparent in *Österreichs Wiedergeburt: 4 Jahre Wiederaufbau* (Austria's Rebirth: Four Years of Reconstruction).[17] Paralleling images of destruction and evidence of the reconstructive efforts produces meaning because of the way our perception moves from the left to right.[18] On a subconscious level, before-after narratives showcase the alleged process of overcoming the past—not by facing up to it, but by burying its remnants. An array of newspaper articles covered reconstruction efforts, and almost all used before-after narratives. For instance, the *Oberösterreichische Nachrichten* retold the events of the massive Allied airstrikes on Upper Austria's provincial capital, Linz, in April 1945 and of the city's ongoing rebuilding program. In view of their electorate, both the Socialists' *Arbeiter-Zeitung* (AZ) as well as the Communist Party's *Österreichische Volksstimme* printed photos of workers in the midst of the rubble.[19] As Jens Jäger avers, images of rubble and debris (for which the German language has coined the term *Trümmerbilder*) ideally represent a version of the war and its consequences stripped of perpetrators and victims alike.[20] They evoke a feeling of being at the mercy of uncontrollable powers, without linking the devastation to the previous crimes committed by Germans or Austrians. Only the *Tiroler Tageszeitung* implied a different kind of reconstruction, hinting at the political level of Austria's "coming to terms" with her past: on July 20, 1946, the caption of a photo showing workers amidst the vast devastation in an unknown town indicates these men were former members of an SS unit, whose participation in the rebuilding was a postwar punitive measure.[21]

Yet another *Trümmerbild*, Albert Hilscher's photograph of St. Stephen's Cathedral aflame in April 1945, is the cover image of *Österreichs Wiedergeburt*.[22] The very first copy of the Soviet *Österreichische Zeitung* on April 15, 1945 tried to combine the manifold connotations this Viennese landmark carried: a drawing of the unscathed cathedral was printed next to the text of the Moscow Declaration. A banner on the cathedral's steeple proclaimed the church—and thus the Austrians—to be *"Wieder frei!"* or "free again." Not only is St. Stephen's intrinsically tied to Vienna's landscape—as a prewar photo of the cathedral on the cover of Hans Riemer's *Ewiges Wien* (Eternal Vienna) published shortly after the end of the war makes abundantly clear[23]—it also functioned as a national symbol of both destruction and resurrection, for instance in the *Salzburger Nachrichten*.[24]

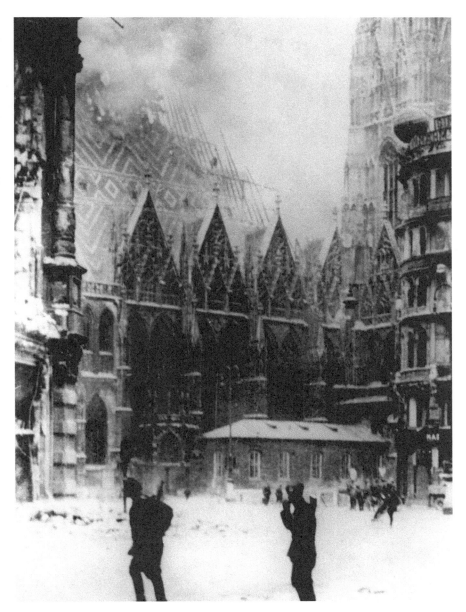

Fig. 2: St. Stephen's Aflame (Photographer: Albert Hilscher; ÖNB / Hilscher, H 8951/2)

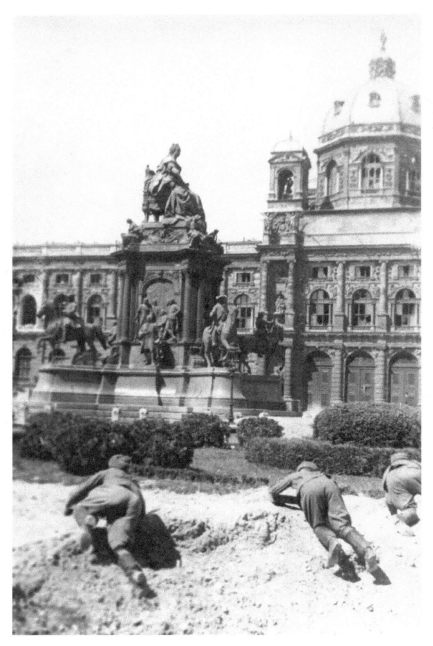

Fig. 3: Red Army Soldiers in front of the Maria Theresia Statue in Vienna
(Photographer: Simon Raskin; ÖNB /Raskin, Ra-Nhm)

Karl Klambauer highlights the cathedral's potential to separate the alleged "catholic Austria" from the "barbarian, pagan, and anti-Austrian" German National Socialists and the war for which they alone would have to atone. St. Stephen's postwar symbolism was further enhanced because of its placement at the "propagandistic juncture" between the "victim theory" and the "diversionary rhetoric" of reconstruction.[25] Consequently, the burning "Steffl," as the Viennese lovingly call the cathedral, marks the definitive "ground zero" of twentieth century Austrian history.[26] But the cornucopia of mixed messages does not end here: shortly before the end of the war, members of a short-lived but highly mythologized cross-party resistance group left their slogan, "O5,"[27] on the cathedral's outer wall. After 1945, this visual "evidence" of Austrian resistance was preserved and is still visible even today, hence making the "Steffl" the primary topographic reference of opposition to the Nazi regime.[28] In a survey conducted in 1994, ninety percent of participants declared they deemed St. Stephen's to be quintessentially Austrian.[29] If the "Steffl" is a symbol of Austria at large, its destruction strikes the nation at her very core.

Only the communist newspapers visualized how and why the demolition of bridges and cathedrals came about in the first place; it is only here that warfare, the military liberation itself, is represented on a visual level. April 13, 1945, is the primary communist *lieu de mémoire*, endorsed by the Soviets and the Austrian communists.[30] *Österreichische Zeitung* and *Österreichische Volksstimme* commemorated this day of liberation for two reasons: on the one hand, communist journalists wanted to remind the Austrians of Soviet military prowess and of the human cost Austria's liberators had to pay.[31] On the other hand, it was necessary to rebrand 1945 as a year of liberation and not defeat. Winning the Austrians over was no easy task. Newspaper editors were keenly aware of their compatriots' role within the perpetrator society of the "Third Reich;" furthermore, visually defining an event inextricably linked with photographs of attacking soldiers, death, and general devastation was a challenge. Captions referring to the "advance of the liberators' tanks"[32] were paramount to channelling the aggressive iconography of war. To what extent even the communist acolytes accepted this reading of the war is unknown. Confronted with this dilemma, the *Volksstimme* editors tried tracing an altogether different visual path by founding a new pictorial tradition. Jubilant Austrians were shown dancing around the national flag, while the adjacent text pinpointed the picture's intended message: "Liberated!"[33] While elsewhere in the 1950s, the day of liberation turned into what Oliver Rathkolb has poignantly termed the "day of forgetting,"[34] *Volksstimme* and *Österreichische Zeitung* continued in their

previous efforts, hence annually commemorating the liberation of Vienna. As Cold War tensions mounted, Austrians took advantage of the favorable situation, reveled in their "first victim" identity and assertively asked for the alleged "final" liberation. The *Volksstimme* fought back on the occasion of the ninth anniversary of Vienna's liberation. An article elaborated that the Red Army had freed tens of thousands in concentration camps, where thousands had been killed before. A fraction of these victims, a heap of indiscriminate, emaciated corpses, is visually present in the *Volksstimme*. Many Austrian politicians, the article continued, owed the Red Army their lives—"this is liberation," the anonymous journalist was adamant.[35]

In the 1950s, a few tentative socialist voices tried to define 1945 as a year of liberation. The photo book *Österreich: Land im Aufstieg* (Austria: A Country on the Rise), published in 1955 just a few months before the signing of the State Treaty, made use of already well-known photographic representations of 1945. Although St. Stephen's aflame (the "acme" of Austrian suffering)[36] and various pictures of demolished bridges set the stage, the author clearly communicated a hopeful reading of 1945. Accompanied by images of US and Soviet officers celebrating their military feat, Socialist Robert Stern also printed a powerful image of Austria's political rebirth. If the country's military liberation posed a challenge for those seeking "spin-free" images to accompany their writing, there was one Austrian politician who symbolically embodied this complex process of transition from dictatorship to supervised democracy: Karl Renner, the "*pater patriae*,"[37] a rightist Social Democrat who had served as chancellor in the First Republic and whom the Soviets commissioned with forming a provisional government in 1945. The possibly best known photographic portrayal of postwar politicians depicts Renner and other party representatives on April 29, 1945, on their way from city hall to parliament, where the provisional government was appointed two days after the proclamation of the Declaration of Independence. The Austrian photographer Wilhelm Obransky captured Renner and the Viennese Socialist mayor Theodor Körner as they were cheered on by bystanders. The provisional government was formed by the three postwar founding parties: the People's Party (ÖVP), the Socialist Party (SPÖ), and the Communist Party (KPÖ). Although there are photographs of this event that also show Leopold Figl (ÖVP) and Johann Koplenig (KPÖ), both Figl and Koplenig are almost always visually omitted,[38] thus making the "birth" of the Second Republic an exclusively socialist *lieu de mémoire*.

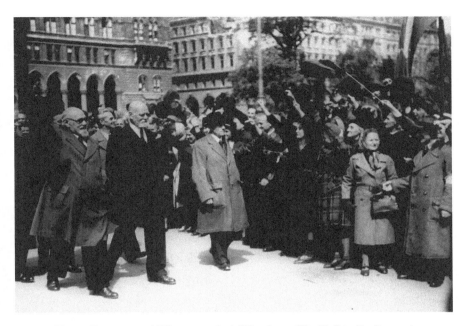

Fig. 4: Renner and Körner on their Way from City Hall to Parliament
(Photographer: Wilhelm Obransky; ÖNB / 058/5)

In his publication, Stern toned down this positive reading of the liberation and introduced a new narrative, which, in the years to come, structured the collective memory of the end of the war: while recognizing the Allies' efforts, he described 1945 as the beginning of a "peculiar transitional stage between liberation and liberty."[39] In the 1950s, newspapers went even further and started portraying the Allied occupation as unjustified and even criminal. Clearly, the negative focus began with the Soviets, but soon newspapers' extensive coverage of Allied aerial warfare also held an accusatory note. The image of St. Stephen's aflame is a recurrent motif in this period,[40] even though the cathedral had been destroyed not by Allied bombardment, but because of a barrage launched by retreating *Wehrmacht* troops.[41] The tide had turned: from now on, commemorating the liberation in non-communist newspapers was unheard of, whereas March 12, 1945, a day which had seen a heavy bombardment of the capital, would turn into an annually recurring point of reference in Austrian media. Obviously, for many hardened Austrian National Socialists, their defeat was no cause for celebration. Nonetheless, even former Nazi victims found it difficult to openly call the end of the war "liberation." A few weeks after the end of the war, the former Gestapo internee and later chancellor and foreign minister

of Austria, Leopold Figl, pointed to the seven years the "Austrian people
had languished under the Hitlerite barbarism," seven years in which they
had been "subjugated and oppressed" and forced to "blindly obey because
of brutal terror."[42] Ten years later, the political landscape had dramatically
shifted: the same Figl spoke of a "seventeen year (sic) long thorny path of
bondage (*Unfreiheit*)," thus lumping together the Nazi period (1938–1945)
and the Allied occupation (1945–1955).[43] If, in fact, Austria had been
Hitler's first victim, the postwar occupation only prolonged the country's
plight, a sentiment voiced more and more frankly by Austrian politicians
the longer the Allied presence lasted. From this perspective, 1945 merely
marked a threshold on the path to real liberation—the signing of the State
Treaty in 1955.

Austria, Doubly Victimized Country: 1945 after 1955

Jacques Hannak, who had been persecuted as a Jew and a Socialist, had
fled to the US after being imprisoned in Buchenwald and Dachau. After
his return to Austria, Hannak worked as a journalist for the *AZ*; in 1965,
he edited a photo book entitled *Der Weg ins Heute* (The Path until Today).
Here, Hannak offered a conciliatory perspective on Austria as victim of
both the Nazis in 1938 *and* the Soviet troops in 1945. First, Hannak asserts,
it was the retreating Nazis who murdered and pillaged, only to be followed
by the murdering, plundering, and raping "Russian conquerors."[44] Visually,
Hannak equates war captivity in the Soviet Union and imprisonment in
concentration camps: two pictures of seemingly endless columns of POWs
and former concentration camp inmates interact with each other, thus
making all Austrians part of a community of suffering.[45]

Again, 1945 is ambiguous: the photograph of Renner on his way to
parliament denotes the political rebirth of Austria. Nonetheless, these
signifiers of 1945 as liberation are outnumbered by pictures pointing to
the hardships associated with this very same year, such as St. Stephen's in
flames or the Floridsdorfer overpass.[46] Other photo books published in the
1960s also grappled with how to make sense of 1945. In 1967, Herbert
Zippe's *Illustrierte Geschichte* (Illustrated History) gave its audience all the
iconic pictures one would expect in this context: the burning "Steffl" and
the Floridsdorfer Bridge as well as civilians amidst a dystopian rubble land-
scape.[47] When visualizing warfare, Zippe juxtaposed images of Soviet sol-
diers with a very peculiar representation of *Wehrmacht* members: here, it was
not the propagandistic self-portrayal of the war-hardened "Aryan" soldier,
but a teenage boy in the *Volkssturm* facing the surge of the Red Army. Pars

pro toto, the crying child is faced with the results of world politics he—and presumably the Austrians in general—certainly had no part in.

If photo books published in the 1960s can be described by their ambivalent position on 1945, ambivalence may also be the best description of this decade's memory culture in general. A more stable national consciousness led to a rejection of Pan-German views: the State Treaty had initiated a "take off" of nation-building.[48] Austrian memory was being renegotiated, without, however, unravelling its very foundation: the "victim myth." Shortly after the war, the Austrian resistance, with its strong communist basis, had quickly turned into a political nuisance in view of Cold War tensions;[49] in the 1960s, it would be remodeled as a patriotic deed and reintegrated into official memory politics.[50] In 1963, the *Dokumentationsarchiv des österreichischen Widerstandes* (Documentation Center of Austrian Resistance, DÖW) was founded, and in 1965, a monument commemorating the Austrian "struggle for freedom" was inaugurated at the outer gate of the Heldenplatz, the very location of Adolf Hitler's speech before a quarter of a million enthusiastic Austrian listeners on March 15, 1938.

While the 1960s are generally attributed with making the Nazi past visible again, the 1970s considerably widened the scope of visual representations. With the SPÖ as the sole party in power, the "long socialist decade"[51] was a critical, yet ambiguous, turning point. Various outrageous verdicts in trials against former war criminals illustrated a desire to wipe the slate clean.[52] However, the 1970s also witnessed two major "critical discourse moments"[53] that, in the long-term, contributed to a distinctive change in memory politics. First, the US TV series "Holocaust" in 1979 has rightfully been described as a powerful external intervention into the discursive order of Austrian memory.[54] Furthermore, the Kreisky-Peter-Wiesenthal "affair" in 1975 led to considerable debate in Austria. While the fact that the FPÖ's party chairman Friedrich Peter had volunteered for the *Waffen*-SS was widely known, Peter had kept quiet about having been a member of the First SS Infantry Brigade that had murdered 10,000 Soviet civilians (8,000 of them Jews). In 1970, the FPÖ had backed a SPÖ minority government and was conceived of as a possible coalition partner before the Socialists' outstanding victory in the parliamentary elections in 1975, securing the SPÖ's decade-long absolute majority. After Jewish survivor and postwar "Nazi hunter" Simon Wiesenthal alerted the public to Peter's past, Chancellor Bruno Kreisky stepped into the breach for Peter and intimated that Wiesenthal had been a Gestapo agent, an untenable accusation.[55] Kreisky, who also had a Jewish family background, thus laid the foundations for a conflict which would preoccupy Austrian newspapers for a long time.

The 1970s also saw the opening of three permanent exhibitions dealing with Austria's Nazi past. In 1970, Mauthausen, the former concentration camp in Upper Austria, was turned into a museum. Even though the exhibit was conceptualized by former resistance fighters such as Hans Maršalek, the memorial preeminently propounded the narrative of Austria as victim,[56] a storyline in sync with the prevailing official stance. In the 1970s, it was possible and even encouraged to remember the Nazi past—if, however, Austrians were represented as victims. Or heroes, for that matter: in 1978, the DÖW presented its exhibition *Der Österreichische Freiheitskampf 1934–1945* (The Austrian Struggle for Freedom 1934–1945) to the public.[57] Again, the former resistance fighters' view of the past as a heroic struggle against a foreign occupation was easily compatible with the official agenda. Also in 1978, Minister of Justice Christian Broda (SPÖ) inaugurated the Austrian pavilion of the Auschwitz-Birkenau memorial. The very first display made the intentions of the exhibit clear: Austria's contours were being stomped by German military boots while the captions indicated that Austria had been "the first victim of National Socialism." The exhibit closed with visual representations of 1945, including not only pictures of Allied tank battalions but also of Austrian partisans and the executed Lieutenant Karl Biedermann, clearly alluding to Austria's contribution to her own liberation, as the Moscow Declaration had asked for. Biedermann had been executed a few days before the liberation of Vienna after he and two other *Wehrmacht* officers negotiated the city's surrender to the Soviets. In the 1960s and alongside the "O5" graffito, he turned into Austria's most widely recognized shorthand for the resistance movement *and* a powerful, yet tragic symbol of 1945. Against the backdrop of St. Stephen's aflame, Renner's and Körner's gloomy facial expressions on their way to parliament appear understandable. Biedermann and the "Steffl" also structured almost all textbook accounts of 1945 in the 1970s;[58] only one manual explicitly stated that "Soviet soldiers liberated Vienna from the Nazi yoke."[59]

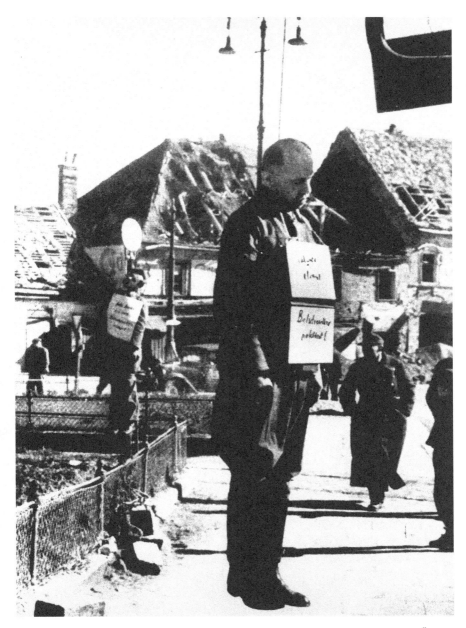

Fig. 5: Resistance Fighter Karl Biedermann (Photographer: Albert Hilscher; ÖNB / Hilscher, H 12563/1)

Waldheim and no Consequences: 1945 in Light of the "Co-Responsibility Thesis"

In the 1986 presidential race, former U.N. general secretary Kurt Waldheim appeared to be the perfect candidate for the ÖVP. However, shortly after his nomination, the journal *profil* started to uncover Waldheim's troubled past as a member of the SA and the National Socialist Students' Association. Furthermore, journalist Hubertus Czernin made public that the successful diplomat had served as an officer under General Alexander Löhr's army group E. As such, Waldheim had been stationed in the Greek town of Arsakli where, in 1943, 40,000 Jews had been deported to annihilation camps,[60] a crime Waldheim claimed to have had no knowledge of. Despite the resultant turmoil, Waldheim was elected president in June 1986. What followed was highly emotional criticism, both from the Austrian civil society as well as international organizations like the World Jewish Congress. Waldheim only made matters worse by stubbornly claiming he had only done his "duty" as a soldier.[61] In the end, a historical commission was charged with shedding light on Waldheim's biography.[62] The team led by the Swiss historian Hans-Rudolf Kurz came to the conclusion that Waldheim had never personally participated in war crimes. However, the commission also made clear that in no event had Waldheim objected to criminal activities he must have certainly interpreted as such.[63] Grosso modo, the Waldheim affair considerably changed Austrians' perception on the Nazi past—but not 1945.

Questions of just how to address Austria's history from 1938–1945 resurfaced during the newspaper coverage of the fiftieth anniversary of the beginning of World War II in 1989. The year 1989 also interacted with 1985, when numerous journals had launched series commemorating the fortieth anniversary of the end of the war. Even the liberal *Kurier* centred its series *Das war 1945* (That was 1945) around images of bombing campaigns over Austrian soil.[64] Both 1939/1989 and 1945/1985—the beginning and, respectively, the end of the war—showcase two different historical perspectives, linked to diverging visual representations. While images denoting defeat and suffering structure the recollections of the end of the war, the beginning of World War II offers a very different photographic vantage point. Nowadays, 1939 is most commonly associated with one specific picture that shows cheerful *Wehrmacht* soldiers dismantling the border-post barrier between Germany and Poland. Gerhard Paul puts forward that this iconic image stands for a war bereft of violence. The German invasion of Poland is portrayed as an allegedly harmless and victimless settling of

border disputes that had met no resistance.[65] Especially in textbooks, it was propagandistic images denoting fantasies of Nazi spatial acquisition that earmarked 1939, while the end of the war continued to be associated with imagery depicting Allied aerial warfare and the suffering and destruction it caused.[66] In many cases, 1938 to 1945 were still the "uncounted years," as Oliver Marchart concisely highlights.[67] After a blatant visual and textual gap, Biedermann and the "O5" graffito symbolized the budding of an autochthonous Austrian history. *Trümmerbilder*, especially the "Steffl," supposedly represented the "terrible ending of the war."[68]

Ever so slowly mnemonic platitudes were beginning to shift, though. Against the backdrop of the Waldheim affair, Chancellor Franz Vranitzky (SPÖ) immensely contributed to the "erosion of the victim theory" (Heidemarie Uhl). In a speech before parliament in 1991, he differentiated between Austrians who had been victims and those who had been perpetrators,[69] thus shaping the "co-responsibility thesis (*Mitverantwortungsthese*)." Still, the admission of guilt remained vague and turned into what Bertrand Perz has called a "concession of guilt."[70]

1945 from a Twenty-First Century Perspective

In 2005, an array of events celebrated three major caesurae: the end of the war, the signing of the State Treaty, and Austria's accession to the EU in 1995. However, difficulties in balancing Austria's identity as victim *and* perpetrator were inherent in many official commemorative activities. Without any doubt, the "*Gedankenjahr*," a "year of thoughts," can only be fully understood in view of the highly criticized formation of a coalition government between the ÖVP and the right-wing Freedom Party (FPÖ), and, after the latter's split-up in 2005, the *Bündnis Zukunft Österreich* (Alliance for the Future of Austria, BZÖ) in 1999/2000. Günter Bischof and Michael Maier have advanced the argument that the FPÖ/BZÖ could best be described as "silent coalition partner[s]."[71] As for the ÖVP, Chancellor Wolfgang Schüssel plainly alluded to the country's alleged status as the "Nazi's first victim." While highlighting the many "guilty" Austrians,[72] Schüssel simultaneously affirmed that the "average Austrian Joe" had been "forced into a foreign uniform."[73] Paraphrasing Figl, Schüssel also claimed it was in fact the State Treaty that made Austria truly "free"—yet again, "after seventeen years."[74]

According to Anton Pelinka, the "*Gedankenjahr*'s" marathon of state-sponsored self-celebrations as well as its two major exhibitions[75]— both focussing on the State Treaty—should be measured against three

yardsticks: avoiding obvious embarrassments, openly addressing contradictions, and honouring Austria's liberators.[76] Misinterpreting 1945 as only the end of the war and not liberation, Pelinka highlights, was the most noticeable embarrassment.[77] Oliver Marchart speaks of a "defiant revival of the victim theory."[78] Thus, 1945 continued to be one of the most contested arenas in Austrian memory politics.[79] Dissident voices were faint: in the preface to the catalog for the Carinthian exhibition *Heiß umfehdet, wild umstritten* (Strongly feuded for, fiercely hard-fought for), President Heinz Fischer (SPÖ) referred to April 27, 1945, the day the Declaration of Independence was proclaimed, as Austria's "birthday," as a day that laid the foundations "for everything else."[80] However, even in Fischer's rendition of 1945, the military liberation of the country seems to be of only secondary importance.

In many respects, the coverage of 1945 in the liberal journal *profil*—as well as in *Kurier*—is symptomatic of how 1945 is remembered in the twenty-first century. In March and April of 2005, Herbert Lackner's multipart series *Die Stunde Null* (Zero Hour) was out in newsstands. Visually, April 13, 1945, is pinpointed as a conquest by the Red Army, whose victorious soldiers roamed the streets of Vienna and symbolically occupied landmarks like the *Hofburg*. Images of death and destruction caused by Allied bombing campaigns, of partisans marching into Carinthia, and of NSDAP members who had committed suicide to avoid punishment clearly position 1945 as—literally—"zero hour." Only one picture, which depicts the Red Army's cheered-on entrance into the city of Melk, contradicts this negative perspective.[81] Even though *Kurier* journalist Otto Klambauer also makes use of many somber visual representations of 1945 (Biedermann, the Floridsdorfer Bridge), one tiny word makes all the difference between Lackner's and Klambauer's accounts: "liberation." This word, which refers to the liberation of Vienna, timidly tries to settle a dispute over the interpretation of 1945, a dispute which by then had been going on for over sixty years.[82]

Concluding Remarks: 1945's Troubled Past

In the 1940s and the 1950s, politicians, journalists, and authors concocted a central Austrian discourse about the country's Nazi past. Ironically, this powerful narrative is in fact a visual discourse about the presumably dire legacy of the country's liberation in 1945, the so-called "zero hour." Photographs alluding to the reconstruction of the country's infrastructure are instrumental in blotting out Austria's previous involvement in Nazi

crimes, thus portraying Austrians as victims of both the Nazis in 1938 and the Allies in 1945. As apparent in before-after comparisons, Austrians seem to have heroically mastered their country's rebuilding not because of their military liberation but "in spite of the Allies."[83] While the Soviet liberation of Vienna and the former's following occupation of Austria are the major bones of contention, pictures of the Western Allies' bombing campaigns on Austrian cities overshadow 1945's interpretation as well. The early strategic decision to align 1945 with these photographs of destruction continues to exert influence on today's scope of visual representations of that year. Even though major clashes in memory politics have led to a decisive change in the view of Austrians' roles within the perpetrator society of Nazi Germany 1945 continues to be drenched in ambiguities. Researchers have advanced the argument that, in fact, photographs of the signing of the State Treaty in 1955 mark the alleged final liberation, the presumed final chapter of World War II.[84] In this respect, the history of the State Treaty appears to be a truly joyful collective journey with a happy ending in 1955. Although Austrians had to smooth over many obstacles until 1955, these are rarely seen as causal consequence of the Nazi period.[85] In 2005, Erich Lessing, who photographed the fateful events on May 15, 1955, published a photo book on the occupational era. It should come as no surprise that its title claims to portray Austrian history *Von der Befreiung zur Freiheit* (From Liberation to Liberty).[86] May 15, 1955, not the liberation in April/May 1945, is in fact Austria's "central *lieu de mémoire*."[87] The State Treaty functioned as a counter-image to 1945, thus overwriting the "controversial" 1945 with the "consensual historical point of reference," 1955.[88] Because of Leopold Figl's cardinal role in the historical events as well as in their photographic representations, it can be argued that, in addition to being a national symbol, the State Treaty also serves as a People's Party *lieu de mémoire*.[89]

While the State Treaty's status as *the* Austrian icon of the twentieth century remains mostly unchallenged, there is still an ongoing debate about whether 1945 constitutes a day of liberation or only symbolizes the end of the war. Equipped with a set of highly canonized "key images,"[90] journalists, textbook authors, exhibition makers, and photo book editors will continue to address this issue by combining visual representations that convey contradictory perspectives upon 1945. As Otto Klambauer's and Herbert Lackner's accounts of 1945 illustrate, sometimes the devil is in the details or, more precisely, in the choice of words.

In 2015, for instance, two Viennese exhibits made reference to the end of World War II. Small, yet located at a deeply symbolic venue, the Heldenplatz-based National Library on the one hand and the outer gate of

the very same square on the other hand, both exhibits excelled in bringing together diverging visual and textual narratives about 1945. Both *1945: Zurück in die Zukunft* (1945: Back to the Future) as well as *41 Tage* (41 Days)[91] clearly depicted 1945 as a year of liberation. Both exhibits, in different ways, focus on the long avoided topic of warfare, thus narrating the story of how Austria and Nazi Germany had to be militarily crushed in order to restore peace, liberty, and Austria in general. Conceptualized by Oliver Rathkolb, both the catalog as well as the website of *Zurück in die Zukunft* for instance open with a picture that clearly goes against common Austrian visual patterns. Joyful, smiling Soviet soldiers on a tank jubilantly enter the city of Vienna represented by the heavily damaged house of parliament in the background.[92] However, in most cases it is not so much an entirely different visual approach to 1945 that leads to a reassessment of the end of the war, but a careful textual contextualisation of iconic images. Topics such as the postwar shunning of émigrés and death marches, causing thousands of predominantly Jewish victims only a few weeks before the liberation, are incorporated as equally important pieces of the puzzle that all make up what 1945 should be about. Finding a modus vivendi with 1945 will also be paramount to the renewal of the Austrian pavilion in the Auschwitz-Birkenau memorial. The curators of "Far Removed" ("*Entfernt*"), the new Austrian Auschwitz-exhibition that (should have been opened years ago and) is supposed to open in 2021,[93] have won the international bid by conceptualizing interwoven portrayals of Austrians as victims and perpetrators. Nevertheless and without any doubt, the tensions between the interpretations of 1945 as either liberation and/or the end of the war will also leave their imprints on these major upcoming Austrian self-representations.

Endnotes

1 Karl Vocelka, *Geschichte Österreichs: Kultur–Gesellschaft–Politik* (Munich: Heyne, 2006), 302.

2 Günter Bischof, "'Opfer Österreich?' Zur moralischen Ökonomie des österreichischen historischen Gedächtnisses," in *Die politische Ökonomie des Holocaust: Zur wirtschaftlichen Logik von Verfolgung und "Wiedergutmachung,"* ed. Dieter Stiefel (Vienna: Verlag für Geschichte und Politik, 2001), 305–35 (here 308).

3 StGBl. n° 1/1945.

4 Robert H. Keyserlingk, *Austria in World War II: An Anglo-American Dilemma* (Kingston: McGill-Queen's University Press, 1988), 207–8.

5 Thomas Albrich, "Holocaust und Schuldabwehr: Vom Judenmord zum kollektiven Opferstatus," in *Österreich im 20. Jahrhundert: Ein Studienbuch in zwei Bänden*, ed. Rolf Steininger and Michael Gehler (Vienna: Böhlau, 1997), 39–106 (here 58).

6 See Stuart Hall, "The Work of Representation," in *Representation: Cultural Representations and Signifying Practices*, ed. Stuart Hall (London: Sage, 1997), 13–74.

7 See Hannes Heer et al., eds., *Wie Geschichte gemacht wird: Zur Konstruktion von Erinnerungen an Wehrmacht und Zweitem Weltkrieg* (Vienna: Czernin, 2003); Rudolf de Cilia and Ruth Wodak, eds., *Gedenken im "Gedankenjahr": Zur diskursiven Konstruktion österreichischer Identitäten im Jubiläumsjahr 2005* (Innsbruck: StudienVerlag, 2009).

8 See Harald Schmid, ed., *Geschichtspolitik und kollektives Gedächtnis: Erinnerungskulturen in Theorie und Praxis* (Göttingen: V & R unipress, 2009).

9 Patrick Hagopian, "Vietnam War Photography as a Locus of Memory," in *Locating Memory: Photographic Act*, ed. Annette Kuhn and Kirsten Emiko MacAllister (New York: Berghahn Books, 2008), 201–22 (here 219).

10 Gillian Rose, *Visual Methodologies: An Introduction to the Interpretation of Visual Materials*, 2nd ed. (London: Sage, 2007), 143.

11 See Ina Markova, *Die NS-Zeit im Bildgedächtnis der Zweiten Republik*, Der Nationalsozialismus und seine Folgen 6 (Innsbruck: StudienVerlag, 2018).

12 Elke Grittmann, "Fotojournalismus und Ikonographie: Zur Inhaltsanalyse von Pressefotos," in *Inhaltsanalyse: Perspektiven, Probleme, Potentiale*, ed. Werner Wirth and Edmund Lauf (Cologne: Halem, 2001), 262–79 (here 264).

13 See Stefan-Ludwig Hoffmann, "Gazing at Ruins: German Defeat as Visual Experience," *Journal of Modern European History* 9, no. 3 (2011): 328–50.

14 *Bildarchiv* Austria, OEGZ/076/1.

15 See Viktor Matejka and Gemeinde Wien, eds., *"Niemals vergessen!"*: *Ein Buch der Anklage, Mahnung und Verpflichtung* (Vienna: Verlag für Jugend und Volk, 1946); also: Wolfgang Kos, "Die Schau mit dem Hammer: Zur antifaschistischen Ausstellung 'Niemals vergessen!' in Wien 1946," in *Kunst und Diktatur: Architektur, Bildhauerei und Malerei in Österreich, Deutschland, Italien und der Sowjetunion 1922–1956*, ed. Jan Tabor, 2 vols. (Baden: Grasl, 1994), 950–65; Wolfgang Kos, *Eigenheim Österreich: Zu Politik, Kultur und Alltag nach 1945* (Vienna: Sonderzahl, 1994).

16 Christian Stadelmann, "Die Donau," in *Memoria Austriae II: Bauten, Orte, Regionen*, ed. Emil Brix, Ernst Bruckmüller, and Hannes Stekl, vol. 2 (Vienna: Verlag für Geschichte und Politik, 2005), 236–264 (here 248).

17 See *4 Jahre Wiederaufbau* (Vienna: Verlag der Österreichischen Staatsdruckerei, 1949).

18 Christoph Hamann, *Visual History und Geschichtsdidaktik* (Herbolzheim: Centaurus, 2007), 70.

19 "Linz baut auf," *Oberösterreichische Nachrichten*, Aug. 28, 1948, 5–6; "Wiederaufbau in Linz," *Oberösterreichische Nachrichten*, Oct. 3, 1945, 3; "Wiederaufbau, Umbau, Produktion," *Oberösterreichische Nachrichten*, July 9, 1946, 6; "Der erste Tag der großen Schuttaktion," *Österreichische Volksstimme*, Sept. 4, 1945, 2; "Erster Tag der Schuttaktion der Kommunistischen Partei," *Österreichische Volksstimme*, Sept. 23, 1945, 3; "Beseitigung der Kriegsspuren aus Wien," *AZ*, Aug. 22, 1945, 1.

20 See Jens Jäger, "1945: Die Trümmeridentität deutscher Städte," in *Fotografie als Quelle der Zeitgeschichte: Kategorien, Schauplätze, Akteure*, ed. Daniela Kneissl (Munich: Meidenbauer, 2010), 95–110.

21 Stand-alone photo, *Tiroler Tageszeitung*, July 20, 1946, 1.

22 *Bildarchiv* Austria, ÖNB / Hilscher, H 8951/2.

23 See Hans Riemer, *Ewiges Wien: Eine kommunalpolitische Skizze* (Vienna: Deutscher Verlag für Jugend und Volk, 1945).

24 "Rund um den Steffl," *Salzburger Nachrichten*, Aug. 27, 1945, 4; "Nicht vergessen!," *Salzburger Nachrichten*, Nov. 10/11, 1951, 9.

25 Karl Klambauer, *Österreichische Gedenkkultur zu Widerstand und Krieg: Denkmäler und Gedächtnisorte in Wien 1945–1986*, Der Nationalsozialismus und seine Folgen 4 (Innsbruck: StudienVerlag, 2006), 16, 103.

26 Kos, *Eigenheim*, 23.

27 The number five stands for the letter "e." Thus, the slogan can be deciphered as "Oe," shorthand for Österreich (Austria).

28 Klambauer, *Gedenkkultur*, 110.

29 Heinz Kienzl, "Die starke Republik," in *Österreichische Nationalgeschichte nach 1945: Der Spiegel der Erinnerung: Die Sicht von innen*, ed. Robert Kriechbaumer (Vienna: Böhlau, 1998), 467–88 (here 479).

30 Klambauer, *Gedenkkultur*, 88.

31　"… im Kampf um die Befreiung Wiens," *Österreichische Volksstimme*, April 13, 1947, 3; "Im Kampf um Oesterreichs Befreiung," *Österreichische Zeitung*, April 13, 1947, 5. Vocelka estimates that approx. 18.000 Red Army soldiers died in the course of the liberation of the city of Vienna, see Vocelka, *Geschichte*, 318.

32　"Die letzten Kämpfe," *Österreichische Volksstimme*, April 13, 1946, 3.

33　Stand-alone photo, *Österreichische Volksstimme*, April 14, 1946, 1.

34　See Oliver Rathkolb, "13. April 1945: Tag des Vergessens?," in *Was bleibt: Schreiben im Gedankenjahr*, ed. Helene Maimann (Vienna: Czernin, 2005), 142–45.

35　"Vor neun Jahren: Hauptkampflinie in Wien beim Gürtel," *Österreichische Volksstimme*, April 8, 1954, 3.

36　Robert Stern, ed., *Österreich: Land im Aufstieg* (Vienna: Europa-Verlag, 1955), 6–7.

37　Anton Pelinka, "Tabus in der Politik: Zur politischen Funktion von Tabuisierung und Enttabuisierung," in *Tabu und Geschichte: Zur Kultur des kollektiven Erinnerns*, ed. Peter Bettelheim and Robert Streibel (Vienna: Picus, 1994), 21–28 (here 25).

38　Ernst Machek and Wilhelm Obransky, *Wie Wien wieder Wien wurde* (Vienna: Verlag Karl Kühne, 1945), 37; *Bildarchiv* Austria, O58/5, Obransky.

39　Stern, *Österreich*, 15.

40　Stand-alone photo, *Die Presse*, June 3, 1951, 3; stand-alone photo, *Die Presse*, Oct. 18, 1953, III; "April 1945: Kampffeld Wien," *Wochenpresse*, March 26, 1955, 1.

41　Ernst Bruckmüller, "Stephansdom und Stephansturm," in *Memoria Austriae II: Bauten, Orte, Regionen*, ed. Emil Brix, Ernst Bruckmüller, and Hannes Stekl, vol. 2 (Vienna: Verlag für Geschichte und Politik, 2005), 40–74.

42　Figl quoted in Heidemarie Uhl, "Vom Opfermythos zur Mitverantwortungsthese: Die Transformationen des österreichischen Gedächtnisses," in *Mythen der Nationen: 1945–Arena der Erinnerungen*, ed. Monika Flacke, 2 vols. (Berlin: Deutsches Historisches Museum, 2004), 481–508 (here 481).

43　Figl quoted in Manfred Jochum and Ferdinand Olbort, *80 Jahre Republik Österreich: 1918 bis 1938 und 1945 bis 1998 in Reden und Statements* (Vienna: Verlag E. Ketterl, 1998), 76.

44　Jacques Hannak, *Der Weg ins Heute: Zwanzig Jahre Zweite Republik, 1945–1965* (Vienna: Europa-Verlag, 1965), 8.

45　Ibid., 16.

46　Ibid., 8–19.

47　Herbert Zippe, ed., *Bildband zur Geschichte Österreichs* (Innsbruck: Pinguin-Verlag, 1967), 234–40.

48　Ernst Hanisch, "Kontinuitäten und Brüche: Die innere Geschichte," in *Handbuch des politischen Systems Österreichs*, ed. Herbert Dachs (Vienna: Manz, 1992), 11–19 (here 18).

49 See Wolfgang Neugebauer, *Der österreichische Widerstand 1938–1945* (Vienna: Ed. Steinbauer, 2008).

50 See Heidemarie Uhl, "Der 'österreichische Freiheitskampf': Zu den Transformationen und zum Verblassen eines Narrativs," in *Österreichische Nation, Kultur, Exil und Widerstand: In memoriam Felix Kreissler*, ed. Helmut Kramer, Karin Liebhart, and Friedrich Stadler (Vienna: Lit-Verlag, 2006), 303–12.

51 Peter Berger, *Kurze Geschichte Österreichs im 20. Jahrhundert*, 2nd ed. (Vienna: Facultas.wuv, 2008), 326.

52 Sabine Loitfellner, "Auschwitz-Verfahren in Österreich: Hintergründe und Ursachen eines Scheiterns," in *Holocaust und Kriegsverbrechen vor Gericht: Der Fall Österreich*, ed. Thomas Albrich, Winfried R. Garscha, and Martin F. Polaschek (Innsbruck: StudienVerlag, 2006), 183–197 (here 186).

53 See Paul Chilton, "Metaphor, Euphemism, and the Militarization of Language," *Current Research on Peace and Violence* 10 (1987): 7–19.

54 See Heidemarie Uhl, "Von 'Endlösung' zu 'Holocaust': Die TV-Ausstrahlung von 'Holocaust' und die Transformationen des österreichischen Gedächtnisses," in *Zivilisationsbruch und Gedächtniskultur: Das 20. Jahrhundert in der Erinnerung des beginnenden 21. Jahrhunderts*, ed. Heidemarie Uhl (Innsbruck: StudienVerlag, 2003), 153–80.

55 See Ingrid Böhler, "'Wenn die Juden ein Volk sind, so ist es ein mieses Volk': Die Kreisky-Peter-Wiesenthal-Affäre 1975," in *Politische Affären und Skandale in Österreich: Von Mayerling bis Waldheim*, ed. Michael Gehler and Hubert Sickinger (Thaur: Kulturverlag, 1995), 502–31.

56 Bertrand Perz, *Die KZ-Gedenkstätte Mauthausen: 1945 bis zur Gegenwart* (Innsbruck: StudienVerlag, 2006), 233.

57 Peter Larndorfer, "Gedächtnis und Musealisierung: Die Inszenierung von Gedächtnis am Beispiel der Ausstellung 'Der Österreichische Freiheitskampf 1934–1945' im Dokumentationsarchiv des österreichischen Widerstandes 1978–2005," (M.A. thesis, University of Vienna, 2009), 91–92.

58 Franz Berger and Norbert Schausberger, *Zeiten, Völker und Kulturen: Geschichte des 20. Jahrhunderts*, 2nd ed. (Vienna: Österreichischer Bundesverlag, 1977), 122; Herbert Hasenmayer, Erich Scheithauer, and Werner Tscherne, *Aus Vergangenheit und Gegenwart: Ein approbiertes Arbeits- und Lehrbuch für Geschichte und Sozialkunde* (Vienna: Hirt, 1977), 95–96.; Herbert Hasenmayr and Walter Göhring, *Zeitgeschichte: Ein approbiertes Arbeits- und Lehrbuch für Geschichte und Sozialkunde*, 2nd ed. (Vienna: Hirt, 1979), 100; Josef Maderner and August Walzl, *Zeitgeschichte: Für die 2. Klasse der Handelsschulen* (Vienna: Manz, 1979), 131.

59 Maderner and Walzl, *Zeitgeschichte*, 127.

60 Michael Gehler, "'… eine grotesk überzogene Dämonisierung eines Mannes …': Die Waldheim-Affäre 1986–1992," in *Politische Affären und Skandale in Österreich: Von Mayerling bis Waldheim*, ed. Michael Gehler and Hubert Sickinger (Thaur: Kulturverlag, 1995), 614–65 (here 623).

61 Oliver Rathkolb, *Die paradoxe Republik: Österreich 1945 bis 2005* (Vienna: Zsolnay, 2005), 390.

62 James L. Collins et al., "Bericht der internationalen Historikerkommission," *profil*, Feb. 15, 1988, 1–48 (here 1).

63 Ibid., 43.

64 "Als Tod und Feuer vom Himmel fielen," *Kurier*, April 1, 1985, 5; "Burgenland: Der 'Wall,' der den Krieg nicht dämmte," *Kurier*, April 2, 1985, 9.

65 Gerhard Paul, "Idylle mit Schlagbaum," *Zeit.de* (September 1, 2014), accessed Sept. 8, 2019, https://www.zeit.de/2014/36/zweiter-weltkrieg-beginn-foto.

66 Franz Göbhart and Erwin Chvojka, *Zeitbilder: Geschichte und Sozialkunde 8* (Vienna: Ueberreuter, 1984), 117, 151; Herbert Hasenmayer, Johann Payr, and Kurt Tschegg, *Epochen der Weltgeschichte 3: Vom Ersten Weltkrieg bis zur Gegenwart* (Vienna: Hirt, 1983), 65; Leopold Rettinger and Fritz Weissensteiner, *Zeitbilder: Geschichte und Sozialkunde 4* (Vienna: Ueberreuter, 1988), 57; Felix Riccabona et al., *Geschichte, Sozialkunde, Politische Bildung: 8. Schulstufe* (Linz: Veritas, 1982), 65; Arnold Schimper et al., *Geschichte miterlebt: Ein Lehr- und Arbeitsbuch für Geschichte und Sozialkunde* (Vienna: Ed. Hölzl, 1989).

67 See Oliver Marchart, "Die ungezählten Jahre: Opfermythos und Täterversöhnung im österreichischen 'Jubiläumsjahr 2005,'" in *Rebranding images: Ein streitbares Lesebuch zu Geschichtspolitik und Erinnerungskultur in Österreich*, ed. Martin Wassermair and Katharina Wegan (Innsbruck: StudienVerlag, 2006), 51–60.

68 Rettinger and Weissensteiner, *Zeitbilder*, 58; Anna Schödl and Renate Forstner, *SWZ: Sozialkunde, Wirtschaftskunde, Zeitgeschichte* (Vienna: Jugend und Volk, 1984), 111.

69 Franz Vranitzky, "Gegen den Strom," in *Österreichische Nationalgeschichte nach 1945: Der Spiegel der Erinnerung: Die Sicht von innen*, ed. Robert Kriechbaumer (Vienna: Böhlau, 1998), 87–102 (here 97-98).

70 Bertrand Perz, "Österreich," in *Verbrechen erinnern: Die Auseinandersetzung mit Holocaust und Völkermord*, ed. Volkhard Knigge and Norbert Frei (Bonn: Bundeszentrale für Politische Bildung, 2005), 170–82 (here 180).

71 Günter Bischof and Michael S. Maier, "Reinventing Tradition and the Politics of History: Schüssel's Restitution and Commemoration Policies," in *The Schüssel Era in Austria*, Contemporary Austrian Studies 18, ed. Günter Bischof and Fritz Plasser (New Orleans: uno press; Innsbruck: Innsbruck University Press, 2010), 206–34 (here 262).

72 Schüssel quoted in Theresia Distelberger, Rudolf de Cillia, and Ruth Wodak, "Österreichische Identitäten in politischen Gedenkreden des Jubiläumsjahres 2005," in *Gedenken im "Gedankenjahr": Zur diskursiven Konstruktion österreichischer Identitäten im Jubiläumsjahr 2005*, ed. Rudolf de Cillia (Innsbruck: StudienVerlag, 2009), 29–78 (here 49).

73 Wolfgang Schüssel, "Erinnern und Erneuern," in *Österreich 2005: Das Lesebuch zum Jubiläumsjahr mit Programmübersicht*, ed. Bundeskanzleramt (Vienna: Residenz-Verlag, 2005), 54–57 (here 55).

74 Schüssel quoted in Distelberger, de Cillia and Wodak, "Identitäten," 51.

75 Günter Düriegl and Gerbert Frodl, eds., *Das neue Österreich: Die Ausstellung zum Staatsvertragsjubiläum 1955/2005* (Vienna: Österreichische Galerie Belvedere, 2005); Stefan Karner and Gottfried Stangler, eds., *"Österreich ist frei!" Der österreichische Staatsvertrag 1955* (Horn: Berger, 2005).

76 Anton Pelinka, "Die Gedanken sind frei: Na und?," in *Was bleibt: Schreiben im Gedankenjahr*, ed. Helene Maimann (Vienna: Czernin, 2005), 22–30 (here 24).

77 Ibid., 25.

78 Marchart, "Jahre," 55.

79 Heidemarie Uhl, "Europäische Tendenzen, regionale Verwerfungen: Österreichisches Gedächtnis und das Jubiläumsjahr 2005," in *"Heiss umfehdet, wild umstritten ...": Geschichtsmythen in Rot-Weiß-Rot*, ed. Werner Koroschitz and Lisa Rettl (Klagenfurt: Drava, 2005), 21–26 (here 21).

80 "Bundespräsident Dr. Heinz Fischer im Gespräch mit Michael Fleischhacker: Anstelle eines Vorwortes," in *"Heiss umfehdet, wild umstritten ...": Geschichtsmythen in Rot-Weiß-Rot*, ed. Werner Koroschitz and Lisa Rettl (Klagenfurt: Drava, 2005), 13–20 (here 13).

81 Herbert Lackner, "Die Stunde Null," *profil*, March 21, 2005, 32–44.

82 Otto Klambauer, "Endkampf zur Befreiung Wiens," *Kurier*, April 7, 2005, 17.

83 Peter Utgaard, *Remembering and Forgetting Nazism: Education, National Identity, and the Victim Myth in Postwar Austria* (New York: Berghahn Books, 2003), 126.

84 See Katharina Wegan, "'Heilige Zeiten': Der österreichische Staatsvertrag und seine Jubiläen," *zeitgeschichte* 28, no. 5 (2001): 277–97.

85 Robert Knight, "Staatsvertrag und Nationalsozialismus: Ein unvermeidbarer Zusammenhang," *zeitgeschichte* 32, no. 4 (2005): 215–27 (here 215).

86 See Erich Lessing, *Von der Befreiung zur Freiheit: Ein Photoalbum 1945–1960* (Vienna: Verlag der Metamorphosen, 2005).

87 See Heidemarie Uhl, "'Österreich ist frei!': Die Re-Inszenierung der österreichischen Nachkriegsmythen im Jubiläumsjahr 2005," in *Bedenkliches Gedenken: 1945–2005: Zwischen Mythos und Geschichte*, Schulheft 120, ed. Josef Seiter, Elke Renner, and Grete Anzengruber (Innsbruck: StudienVerlag, 2005), 29–39.

88 Uhl, "Europäische Tendenzen," 21.

89 See Dieter Binder, "Julius Raab und Leopold Figl," in *Memoria Austriae I: Menschen, Mythen, Zeiten*, ed. Emil Brix, Ernst Stekl, and Hannes Bruckmüller (Vienna: Verlag für Geschichte und Politik, 2004), 79–104.

90 See Peter Ludes, *Schlüsselbilder: Fernsehnachrichten und World Wide Web—Medienzivilisierung in der Europäischen Währungsunion* (Wiesbaden: Westdeutscher Verlag, 2001).

91 Dieter Binder et al., *41 Tage Kriegsende – Verdichtung der Gewalt: Eine Ausstellung zu den letzten Wochen des NS-Terrors in Österreich*, Vienna 2016.

92 Oliver Rathkolb, *1945: Zurück in die Zukunft: 70 Jahre Ende Zweiter Weltkrieg*, Vienna 2015; "1945: Zurück in die Zukunft: 70 Jahre Ende Zweiter Weltkrieg," Österreichische Nationalbibliothek Prunksaal, accessed Februar 9, 2021, https://www.onb.ac.at/museen/prunksaal/sonderausstellungen/vergangene-ausstellungen/1945-zurueck-in-die-zukunft/.

93 "Aufbauarbeiten für neue österreichische Ausstellung in KZ-Gedenkstätte Auschwitz," ots.at (Jan. 27, 2021), accessed February 9, 2021, https://www.ots.at/presseaussendung/OTS_20210127_OTS0078/aufbauarbeiten-fuer-neue-oesterreichische-ausstellung-in-kz-gedenkstaette-auschwitz.

Postwar

Yoichi Okamoto's Eye on Austria in Postwar Europe

Hans Petschar

In 2019, the Austrian National Library acquired the personal photographic estate of Yoichi R. Okamoto (1915–1985). The Japanese American, who became the official photographer of the White House under President Lyndon B. Johnson, came to Europe in the spring of 1945 during the last days of the German Reich and became the personal photographer of General Mark W. Clark in Austria. From 1948 to 1954, he was the head of the Pictorial Section of the United States Information Services branch in Austria.

The estate—with over 22,000 negatives and 900 photographic prints—forms in its entirety a unique source, documenting the beginnings of the Second Republic of Austria and postwar Europe. Okamoto's photographic estate has been digitized by the Austrian National Library and will me made accessible to the public subsequently. This essay gives first impressions on Okamoto's striking photographic oeuvre and on his early biography.

Formative Years

Yoichi Robert Okamoto was born on July 5, 1915, in Yonkers, New York as the elder of two boys.[1] His father, Chobun Yonezo, was a wealthy businessman who emigrated from Japan to the United States in 1904 and settled with his wife Shina in the New York area. Yonezo was a real estate magnate, a patron of art, and a publisher of Japanese textbooks. In his early childhood, Yoichi Okamoto traveled to Japan twice together with his parents who had strong roots in their home country: in 1920, when he was five years old, and in 1923 when the Okamotos again returned for a visit to Japan. The then eight-year-old Yoichi was caught up in the giant Kanto earthquake. He was evacuated on an American warship and brought back to the United States. In 1938 he told his story to the local newspaper *Syracuse Herald*, when he was looking for a job as photographer.[2] The paper brought his story with the headline "Japanese, 23, Tells Horror of Quake", underlining that the Colgate graduate was a photographer in Syracuse now and a New York State native. Okamoto's childhood memories were featured nicely with the then twenty-three-year-old youngster portrayed with his camera. The story was published a few months after Okamoto

had finished his university studies at Colgate and may well be seen as the starting point of his career as press photographer. The story starts with a biographical information: he was born as the son of a wealthy Japanese importer, he attended the Roosevelt High School and studied at Colgate University. He graduated from Colgate in June 1938, where he majored in politics and economics. The article continues with his Japan visits and his recollections of the earthquake and it finishes with a reference to his truly American habits and finally mentions Okamoto's ambition to work as commercial photographer:

> "More thoroughly American than his name would indicate, Okamoto is interested in photography and men's clothing. For a while during high school he enjoyed a minor reputation as a magician, but now his ambition is to become an expert commercial photographer. He looks upon his candid camera job as a means to an end, using his spare time to study the technique of taking pictures."[3]

At Colgate, the *Syracuse Herald* reports, Okamoto wrote a men's fashion column for the *Colgate Banter*, campus monthly and as a stylist, "he predicts the return of velvet vests this fall for the well-dressed man." The final statement again stresses how "thoroughly American" he was: "The people who annoy Okamoto most, he says, are those who ask him to speak Japanese, for he doesn't know how."[4]

Already during his Colgate years, Okamoto had shown great interest in photography, maybe influenced by his father, who owned a photography business in Japan. After graduation, Yoichi moved to Syracuse, New York and worked as a candid photographer in local nightclubs. His private studies and his skills in photography finally payed off when he was hired as news photographer by the *Syracuse Post-Standard* in August 1939. Okamoto worked for the paper until January 1942, when he successfully enlisted for the US Army on January 6, 1942, becoming the first New York-area Nisei enlistee.

On January 6 and on January 8, 1942, the *Syracuse Herald Journal* published an article on his enlistment, stating that Okamoto hoped "to get a chance to fight against Japan."[5] The article "Camera Man Of Syracuse Joins Service. American-Born Japanese, Colgate Graduate, Goes to Camp" showcases the photograph from 1938 of young Yoichi Okamoto with his camera, this time with the header "To fight for U.S." and with his name in capital letters: YOICHI R. OKAMATO.

The first enlistment of a New York native with Japanese origin shortly after Pearl Harbor was of course sensational news for the local papers and the articles make sure to ascertain that Okamoto was a patriotic American citizen, eager to join the Army. On January 8, 1942, the Bronxville Review Press reported that "Yoichi Robert Okamoto, 26, American-born Japanese newspaper photographer, was inducted into the United States Army at the Syracuse induction center on Monday. Okamoto, who volunteered, several weeks ago, is the son of Mrs. Shina Okamura of Bronxville."[6]

Later Okamoto stated that it took interventions from the Mayor of Syracuse and from a friendly Army major to secure his entry to the US army.[7]

Okamoto was sent for training at the Quartermaster School at Camp Lee.[8] Already on February 5, the Bronxville Review Press reported, that he was transferred to the Signal Corps detachment at Fort Monmouth, N. J.[9]

Okamoto, who to his great disappointment[10] was dismissed initially from the Officer Candidate School because of his Japanese descent, finally was accepted and continued his military formation in the US army. He came to Germany in the spring of 1945 as Second Lieutenant of a supply company.[11] Because of his interest and of his skills in photography he was soon able to change to the Press Service of the Signal Corps.[12] In the summer of 1945, Okamoto moved to Salzburg and onwards to Vienna as a military photographer. In Vienna he became the head of the "US Forces Official Photographers" of the USFA headquarters in Austria. He led a team of twenty-six people, with their offices at the Vienna Film studios in Wien Sievering.[13] The photographers toured through the American occupation zone with their own cars and supported the Public Relations team of General Mark W. Clark with photographs and documentaries. In March 1946, Okamoto eventually became the press officer of General Mark W. Clark. He moved with his office to the USFA headquarters at the Allianz-building, where Clark resided.

This change marked another career step, which Okamoto immediately posted to his local newspaper in the US. In March 1946, the Syracuse Post Standard reported: "First Lt. Yoichi Okamoto, former photographer on The Post Standard, has been discharged from his army post as photo officer of Gen. Mark W. Clark's United States forces in Austria headquarters in Vienna to accept civilian employment with USFA headquarters."[14]

In September 1948, Yoichi Okamoto started his most important professional activity in Austria. He became the Head of the Pictorial Section of the United States Information Services in Austria, a position he held until 1954.

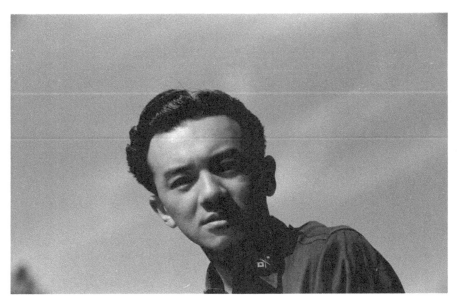

Fig. 1: Yoichi R. Okamoto. Portrait in uniform with US Army Signal Corps branch insignia July 1945 (Photo: US Army Photographer; Austrian National Library Picture Archives and Graphics Department [ANL–PAGD], OKA01_026_04.

Fig. 2: The members of Yoichi Okamoto's truck company in May 1945 (ANL–PAGD, OKA01_020_27).

Early Photographs 1945–1947

Okamoto reported his early days in Europe and his company's itinerary via Germany to Austria with his own camera. Archival information on the original envelopes of his negative slides suggest that Okamoto arrived in Europe with a Quartermaster truck company in April 1945. Unfortunately, only few slides are dated and they barely give locations or further information.

Nevertheless, the photos, which Okamoto took with his private camera, give us a vivid picture of his first impressions in Europe, and much more impressively than purely military pictures taken by army photographers could. The earliest pictures, mostly undated, still show the last remnants of the fighting: downed or abandoned German planes, street and landscape shots, the entrance to villages and bombed-out cities, disarmed German soldiers gathered in a meadow waiting to be taken away, American GIs taking a rest.

For a better understanding of Okamoto's photographs of April and May 1945, a short digression into military history seems appropriate.

In the spring of 1945, the fighting all over the European theatres of war came to a climax. From the west, General Eisenhower's Allied armies were marching towards the Rhine, from the east the Red Army was rolling across Poland and through the Balkans, and from the South, General Mark W. Clark's armies, after liberating Rome on June 5, 1944, were heading towards the north of Italy and Austria.

After the crossing of the Rhine in March 1945 and the advance of Allied troops to the Elbe in the East and the Danube Valley in the South, victory for the Western Allies was definitely within reach.[15]

By the end of March, General Patton's 3rd Army had also broken out from its bridgehead, crossed the Rhine, and advanced to Frankfurt, Gotha, Kassel, and as far as the Thuringian Forest. On March 29, 1945, the VIII Corps of General Patton's 3rd Army captured Frankfurt am Main. The German airfield in the South of Frankfurt had been attacked in advance and already had been captured by Patton's armored forces. While the troops were advancing, sixty aircraft troop carriers were landing hourly west of Limburg at the VIII Corps command post airfield to provide fuel supplies.[16] The advance went so smoothly that Patton wanted to advance as far as Czechoslovakia. Eisenhower, concerned about securing the flanks for the 12th Army Group, favored in principle an advance as far as the Carlsbad-Pilsen-Budweis line, but ordered Patton to advance no further than the Bohemian Forest in order to meet with the Soviets in the Danube Valley. This advance was to be coordinated with the 6th Army Group, which had begun the clearing of southern Germany.

Fig. 3: Yoichi Okamtoto's truck company in Germany in May 1945 (ANL–PAGD, OKA01_020_02).

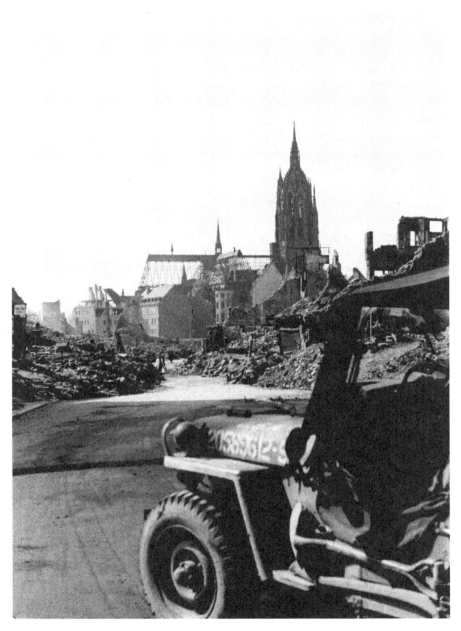

Fig. 4: Entrance to Frankfurt with bombed out Cathedral in April 1945 (ANL–
PAGD, OKA01_027_10).

The daredevil Patton was more than unhappy about this decision, to put it mildly: "I was very unhappy, because my feeling then, and my feeling now, is, that we should have gone all the way to the Moldau and, if they didn't like it, send the Russians to the devil."[17] He complied with the order, however. On April 4, they reached Gotha, on April 12, Erfurt, and advanced further as far as the Mulde River to Chemnitz. More to the South finally, on May 6, 1945, Pilsen was liberated by the 3rd Army and a holding line was drawn here for the Western Army's offensive to the East.

Keeping the itinerary of the US 3rd Army on their way to Bavaria and to Austria in mind, we can now take a closer look at Okamoto's early photographs.

An entire series of photos is devoted to Yoichi's truck company from April 1945 onwards, on their way through Germany to Bad Kreuth in Bavaria, where they arrived in July 1945 after the end of hostilities.

What we see on the photos from April 1945, is the US air force in action, downed German planes and American air troop carriers on the ground of an airfield, most likely in the area of Frankfurt am Main. While smoke is still rising from downed planes, a crowd of locals and soldiers observe the territory. Okamoto takes photographs from his jeep: pictures of the truck company on their way, the landscape and the entrance to bombed-out Frankfurt with the destroyed cathedral in the background. When the company takes a rest in a village, the GIs are surrounded by curious locals, who seem to be happy that the war has ended. A series of undated photographs, marked with "unknown place," depicts disarmed German prisoners of war assembled on a meadow and awaiting their removal to prisoner of war camps. In close ups we can see the GIs observing German officers and soldiers getting on a truck. We see a similar scene on a series labelled "Pilsen 45." And indeed, among these "Pilsen" photographs, we find photographs with street scenes from Frankfurt as the starting point, followed by photographs with the truck company on their way. Okamoto's Signal Corps comrades observe prisoners of war getting on their trucks, taking a rest and have a Pilsener beer and local food. On two photographs Okamoto appears, a comrade took the picture.

For the time being, it is not possible to reconstruct the precise itinerary of Okamoto's company in Germany, since too many photographs remain unidentified. However, we can assume that from the most likely starting point in the area of Frankfurt, they were following the 3rd Army units who had advanced forward to Fulda, Gotha, Erfurt, Hof, and Pilsen[18]. From there they moved to the South, heading to Munic, where Okamoto photographed the destroyed Victory Gate, and further on to Bad Kreuth.

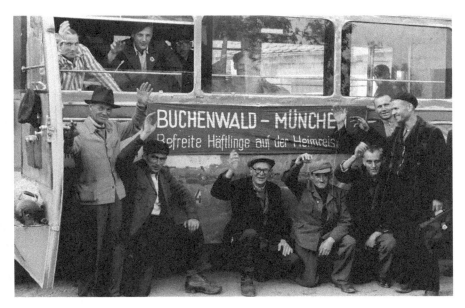

Fig. 5: Liberated concentration camp prisoners from Buchenwald taking a rest in Bad Kreuth in July 1945 (ANL–PAGD, OKA01_021_24).

When Eisenhower had stopped Patton in Pilsen from moving forward to Prague and further to the East, Patton according to plan moved South. Parts of Patton's 3rd Army supported the 6th Army Group along the line Hof–Nuremberg–Ulm, while other parts of the 3rd Army together with the 7th US Army and the French 1st Army reached Western Austria (Vorarlberg, Tyrol, Salzburg, und Upper Austria) by early May.[19]

In Bavaria, units of the 7th Army had moved into Nuremberg on April 16 and into Munich on April 30. The SS and remnants of German troops retreated to the Tegernsee Valley. The SS command was located in Bad Kreuth. The commander of the approaching US troops, William Evans, delivered his surrender terms to the valley mayors: "Disarming of the Volkssturm, white flags on houses upon the approach of American troops, no hostilities during or after the occupation."[20]

On the night of May 4, the Germans accepted the Americans' terms and they moved into Tegernsee and the surrounding area without enemy contact.

Meanwhile, on May 2, Patton's 3rd Army units had moved into Passau, heading further forward to Linz and to Berchtesgaden. After the hostilities had ended, Patton became the first military governor of Bavaria. He

returned to the US for a victory tour, and when he came back in the summer of 1945, he took up quarters in the former SS Junker School at Bad Tölz.[21]

Okamoto and his company arrived in Bavaria in July 1945 and took quarters in Bad Kreuth. Two months after the German surrender, the Americans had everything under control and the American soldiers were a familiar sight to the population. Again and again Okamoto photographed the locals, the friendly contact of the American GIs with children, and drew character studies of old women and men.

From Bad Kreuth were the first excursions into the mountains. Okamoto photographed his comrade on a mountain meadow and the latter photographed him looking into the camera.

Two photos commemorate the end of National Socialist terror. A group of liberated concentration camp prisoners from Buchenwald is making a stop in Bad Kreuth on their way to Munich.

Other travel stops for Okamoto and some of his comrades in the early summer of 1945 were Augsburg, Heidelberg and, above all, Paris. Okamoto documented trips to Paris between 1945 and 1947 in several series. Among the earliest Paris photos of 1945, there are three photos depicting African American soldiers in front of the Gare de l'Est, who probably were here on their vacation. Since the photos are not marked and dated it is likely, but not sure, that they show members of Okamoto's truck company. At least once, however, Okamoto and his comrades arrived in Paris on an American plane, as aerial views of Paris and the Eiffel Tower taken from the plane and pictures of the crew in front of the plane document.

Okamoto's Paris street photography depictures dynamic traffic scenes with women on their bikes, everyday life on the markets, the joie de vivre of the Parisians and the good-humored GIs. A visit to the Louvre with a photo of visitors in front of the Mona Lisa is not missing, as well as photos with the sights of Paris: the Eiffel tower, Montmartre, and strollers along the Seine. There are, however, also pictures that still remind us of the war and Nazism. On two photos with the Arc de Triomphe du Carrousel, located between the Louvre and the Tuileries Garden, we can see a field with grown vegetables in the foreground, and in one photo we see a large stele in front of the entrance to the Grand Palais with the inscription "SS Crimes hitlériens." The exhibition catalog documents that the exhibit took place in Paris from June 10 to July 31, 1945,[22] which indicates that the visit must have taken place somewhere around that date.

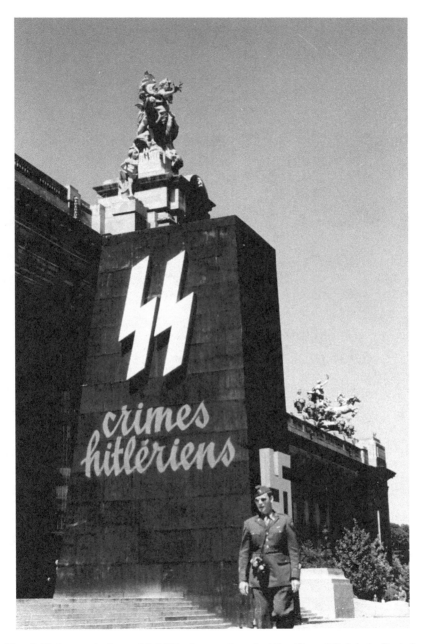

Fig. 6: Entrance to the exhibit "Nazi war crimes" at the Grand Palais in Paris in June/July 1945 (ANL–PAGD, OKA01_016_26).

Fig. 7: A field of vegetables in front of the Grand Carrousel in Paris in June/July 1945 (ANL–PAGD, OKA01_018_03).

From Salzburg to Vienna

In his Interview with Michael Mauracher in 1982, Okamoto rightfully remembered that he came to Europe with a supply company during the Second World War. However, he mixed up his memories when he stated that he came to Austria in February or March 1945 with General Clark, who actually established his headquarters in Salzburg only in August 1945.[23]

The precise date of Okamoto's arrival in Austria remain unclear to this day.

On May 4, 1945, American troops of the 7th Army occupied the city of Salzburg without a fight. [24] This was much to the chagrin of Patton, who wanted to take the "Alpine fortress" largely with his troops and portrayed it as such in his memoirs.[25] In fact, the units of the 3rd Army remained confined to Upper Austria and the area north of the Danube.[26] Crucial to further developments in Austria, after the military occupation, was the reorganization of the US Army and the establishment of the civil administration under Allied occupation. On July 5, the US Army's 15th Army Group in Italy was officially disbanded, and General Mark W. Clark was appointed commander in chief of United States Forces in Austria USFA).[27]

On May 14, the male personal of the United States Information Service Branch (ISB) moved from Clarks headquarters in Verona to Salzburg. In the following years, the Pictorial Section of the ISB produced and archived photographs for other ISB units and provided national and international agencies with pictures and documentation of all aspects of the political, economic, and cultural life in Austria.[28]

General Clark, who became the High Commissioner of Austria on July 7, arrived in Salzburg on August 1, where he took a parade of the 42nd infantry division ("The Rainbow division"). On August 4, 1945, the first American Information Center was opened in Salzburg at a prominent location at Alter Markt 11. The Pictorial Section of the Information Services Branch documented the recovery of Salzburg and the beginnings of the civilian life: the reopening of the post office, clean-up work after bomb damage at the cathedral, military parades at the Residenzplatz.[29] Clark played a prominent role in establishing a quick reopening of the Salzburg Festival after the War on August 12, 1945. He gave the opening speech and invited the representatives of the Allied Forces Sir Richard L. McCreery (GB), Alexis-Marie Zheltov (UdSSR) and Emile-Marie Béthouart (F) to a concert and a reception. This was the first informal meeting of the High Representatives of all four Allied Forces in Austria.[30]

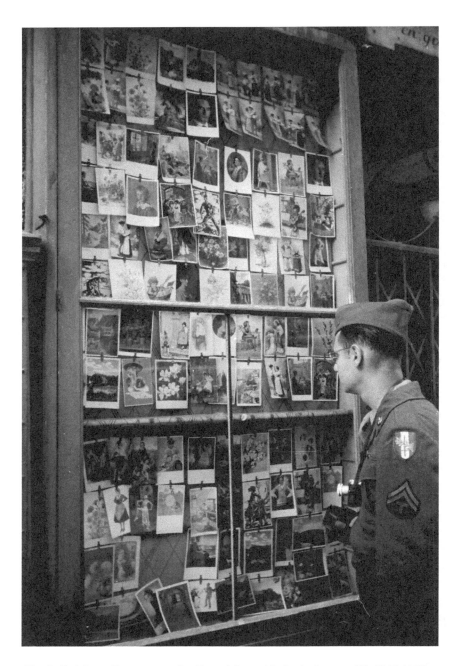

Fig. 8: Salzburg Entrance to the Franziskanerkirche in August (?) 1945 (ANL–
PAGD, OKA01_004_07).

Fig. 9: Jewish worship. Commemoration at the Great Hall of the Mozarteum in
September (?) 1945 (ANL–PAGD, OKA01_012_04).

It was only from mid-August onwards that the American photographers moved forward to Upper Austria and later on to Vienna, where Clark finally established his headquarters in autumn 1945.

There are no Okamoto credits among the ISB photographs from June to September 1945, though. Therefore, we have to assume that Okamoto was still operating as a Signal Corps photographer, when he came to Salzburg in summer 1945 and before Clark detected his talent and hired him as his personal photographer.[31] Okamoto kept only a few early photographs from Salzburg in his private photo archive. We see two old women in local costume sitting on a church bench, Okamotos Signal Corps comrade watching a wall with prayers to Mother Mary at the entrance of the Franziskanerkirche (Franciscan Church), the interior of the church with the statue of Mary, GIs on the street, and a small boy in leather pants watching the military parade at the Residenzplatz. Three negatives depict a Jewish worship held at the Great Hall of the Mozarteum. In the audience we see mostly American GIs. In September 1945, the Jewish Committee had organized a series of commemorations, the photographs might show one of them.[32]

Fig. 10: General Mark Clark and General Eisenhower arriving at the Tulln airfield in September 1945. (ANL–PAGD, OKA01_009_07).

Fig. 11: US Army Official Photographers awaiting the arrival of General Mark Clark
and General Eisenhower at the Tulln airfield in September 1945 (ANL–PAGD,
OKA01_09_09).

In September 1945, Okamoto photographed General Clark with
Eisenhower arriving at the Tulln Airfield, which was controlled by the
Americans. A train called "The Mozart Express" marked with American
flags once a day carried American personnel to Vienna. The train had to
pass the Soviet Zone and carried signs in Russian and German saying it
was for the exclusive use of American personnel.[33] Okamoto photographed
the two Generals on their way from the plane to the train and the awaiting
team of the "official photographers" in their Jeep.

In autumn 1945, Yoichi Okamoto followed Clark to Vienna. Since then
and over the years, he portrayed postwar Vienna in a fascinating manner.

The photographs of first encounters with Vienna guide us through a
city, where the damages of the war are visually still present. In front of St.
Stephen's cathedral, a stonemason sits with statues. A female artist paints
the destroyed cathedral surrounded by rubble in front of the cathedral.
A woman washes linen in a lake. The war damaged Vienna Riesenrad
(Giant Ferris Wheel) looks naked in the winter 1945–46. The carriages
have been dismantled, only the hangers are visible. In the foreground of
the photograph, we see a dead tree. Together with the Ferris wheel in the

background, the tree symbolizes the destruction of nature and culture by the war. Okamoto's Riesenrad became an iconic symbol of Vienna in the immediate postwar period.

Only very few photographs are dedicated to politics. Okamoto photographed a few conferences of the Allied Council and members of the Austrian Government. Federal Chancellor Leopold Figl is caught in a vivid discussion with the Soviet High Commissioner at a Heurigen scene. Family photos, friends, and American visitors to Austria complete the collection of early photographs until 1948.

Fig. 12: Stonemason with statues in front of St. Stephan's Cathedral in Vienna
1945 (ANL–PAGD, OKA3B).

Fig. 13: The Vienna Riesenrad in Winter 1945/1946 (ANL–PAGD, OKA1B).

The Golden Years 1948–1954

In September 1948, Yoichi Okamoto became the head of the Pictorial Section of the United States Information Services in Austria (USIS). Okamoto hired young Austrian photographers and trained them in American style documentary photography. From 1948 onwards Okamoto's Pictorial Division documented the European Recovery Program in Austria with extraordinary depth and great artistic innovation. [34]

Comprehensive photographic documentations of Marshall Plan projects were produced by Okamoto's team for Styria, Carinthia, Salzburg, Tyrol, Vorarlberg, and Upper Austria. The photos were distributed license-free to Austrian and international media. River regulations, drainage works,

road building, and measures to support tourism were depicted as well as educational programs of the United States, local festivals, and everyday life in the Austrian provinces. Even regions in the Soviet occupation zone were covered in stories with faint echoes of Cold War themes. Okamoto oversaw the production as supervisor and made sure that the photo documentaries published in the *Wiener Kurier*, the principal daily newspaper promulgating US policies and the American way of life in Austria, followed his idea of photojournalism: "All picture stories will present a fundamental idea and leave the reader with a mental impression of an idea. Therefore, an idea in propaganda is more apt to leave a lasting impression."[35] According to Okamoto, the objectives were to tell the truth in pictures, to be subtle, to present a fundamental idea, and carry on American journalistic progressiveness.[36]

While Okamoto as a photographer himself was not very much involved in the production of documentaries, with his leadership and his management qualities he made sure that the Photo Section of the United States Information Services became the by far most important distributor of press photography in Austria between 1948 and 1955.[37]

As the head of the Pictorial Section he held excellent contacts to Austrian and American politicians and to celebrities in art, culture, and the media. Okamoto met Vienna's avant-garde frequently at the Vienna Art Club. Its members chilled out regularly at the "Strohkoffer," a nightclub in a cellar room of the famous "Loos Bar" in Vienna frequented by artists, writers, and jazz musicians. Okamoto portrayed nearly all of them: Gustav K. Beck, Wander Bertoni, Maria Billjan-Bilgers, Albert Paris Gütersloh, Rudolf Hoflehner, Wolfang Hutter, Heinz Leinfellner, Kurt Moldovan, Arnulf Neuwirth, Fritz Riedl, Johanna Schidlo, Carl Unger.[38] All portraits are fabulous compositions, conveying the vivid impression of being more of a painting than a photograph. Okamoto met the artists in their ateliers, talked to them about their work and finally arranged the artists in the midst of their artwork.

When Okamamoto was about to leave Austria and to move with his family back to the United States in 1954, the famous Galerie Würthle in Vienna honored his photographic artwork in an exhibition.[39] Okamoto presented his eye on postwar Austria from art to culture, politics, and daily life. In his photo archive he kept the negatives, and he documented the opening of the exhibition and the media reception. We see family photos of his son Philip as a baby on a toilet and photographs of the honeymoon travel to Venice with Okamoto's beloved Viennese wife Paula. The family photos are mixed up with political ones and with impressions of postwar Vienna. Crowds on the streets of Vienna at the funeral of Austrian President Karl Renner are covered, as well as a horse race at the Freudenau, with people's

faces full of tension, hope, and despair. We see Wilhelm Furthwängler studying a music sheet, we see a mighty demonstration of catholic Austria at the Heldenplatz on occasion of the Austrian Katholikentag 1952 and members of the Vienna Boys Choir playing in the snow. The artist portraits, Austrian landscapes, street photography in occupied Austria, and the military presence of the Allied Forces in Austria complete the show.

Fig. 14: Wilhelm Furtwängler studying a music score ca. 1954 (ANL–PAGD, OKA01vp08_01).

Fig. 15: Portrait of Maria Biljan-Bilger with her ceramic sculptures in 1954 (ANL–PAGD, OKA01vp05_01).

Fig. 16: Night procession with nuns on the Austrian Catholic Day September 11, 1952 (ANL–PAGD, OKA07vp_022).

When Okamoto left Vienna he had not only to a large degree designed and influenced American press photography in postwar Austria, but also created a remarkable artwork himself. He would continue to exercise his professional skills as a formidable press photographer as Acting Chief of the Visual Materials Branch of the Press Service in the United States Information Agency in Washington and later as the official photographer

of President Johnson. His personal work as photo artist and teacher in the art of photography was honored in an exhibition of the Museum of Modern Art. Edward Steichen, whom Okamoto had invited to Vienna in 1950, selected his portrait of the dancer Harald Kreutzberg for the legendary exhibition "The Family of Man."[40]

Postscriptum:

Yoichi Okamoto and his wife Paula came back to Vienna and Austria in the 1970s and 1980s, taking photographs and visiting friends. As a result, and as tribute to his artwork, his wife Paula published the book *Okamto's Vienna: The City since the Fifties* posthumously in 1987.[41] The complete photographic documentation for this book project has been preserved in Okamoto's archive.

List of cited images

Okamoto's Photos are available online at the Digital Reading Room of the Austrian National Library:
German: https://www.onb.ac.at/digitaler-lesesaal;
English: https://www.onb.ac.at/digitaler-lesesaal.
Search for Okamoto or Image ID:

Germany / Europe: OKA01_026_04 ; OKA01_020_27 ; OKA01_020_02; OKA01_027_10; OKA01_020_03 ; OKA01_003_03 ; OKA01_097_10 ; OKA01_097_15 ; OKA01_021_24 ; OKA01_21_25 ; OKA01_016_26 ; OKA01_018_03 ; OKA01_003_12 ;

Salzburg : OKA01_004_07 ; OKA01_004_05 ; OKA01_012_04 ; OKA01_012_18 ; OKA01_012_22 ;

Vienna: OKA01_009_07 ; OKA01_09_09 OKA3B ; OKA1B ; OKA01vp08_01 ; OKA07vp_022 ; OKA07vp002 ; OKA04vp012 ; OKA04vp07 ; OKA04vp016 ;

Artists : OKA 1, 17, 1 vp ; OKA01vp05_01 ; OKA 1, 39, 1 vp ; OKA 1, 4, 1 vp ; OKA 1, 10, 1 vp OKA 1, 13, 1 vp ; OKA 1, 15, 1 vp ; OKA 1, 19, 1 vp ; OKA 1, 21, 1 vp ; OKA 1, 22, 1 vp ; OKA 1, 31, 5 vp

Endnotes

1 While there exist a few biographical articles on Yoichi R. Okamoto, a comprehensive biography of Okamoto is still lacking, as well as study on his work as a professional photographer. Besides the literature listed below, newspaper articles and an interview with Philip Okamoto, the son of Yoichi Okamoto, has been used for this essay. A biography of Yoichi R. Okamoto has been published in Helen Zia and Susan B. Gall, *Asian American Biography* (New York: UXL, 1995), 311–13. The article falsely states that Okamoto served with the 442nd Regimental Combat Team, a regiment comprised solely of Japanese American soldiers fighting in Europe 1942–1945. The same error is repeated in Susan Gall and Irene Natividad, *The Asian American Almanac: A Reference Work on Asians in the United States* (Detroit: Gale Research, 1995), 684–85. A study on the Okamoto Family has been published in Japanese by Yumiko Murakami, *Hyakunen no Yume: Okamoto famiri no America* (*Their Dreams of Hundred Years: The Okamoto Family's America*) (Tokyo: Shinchōsha, 1989). I am grateful to Margarethe Szeless and Monika Krammer for giving me a copy of the typewritten English synopsis of the book. Recently Greg Robinson has published more seriously source-based articles on Yoichi Okamoto: Greg Robinson, "The Man Behind the Camera: The Story of Yoichi Okamoto, LBJ's Shadow," *Discovernikkei.org*, Oct. 11, 2018, accessed Apr. 09, 2021, http://www.discovernikkei.org/en/journal/2018/10/11/yoichi-okamoto/; Greg Robinson, *The Unsung Great: Stories of Extraordinary Japanese Americans* (Washington: Washington University Press, 2020); Greg Robinson, *A Tragedy of Democracy: Japanese Confinement in North America* (New York: Columbia Univ. Press, 2009).

2 *Syracuse Herald*, Nov. 13, 1938, 20.

3 Ibid.

4 Ibid.

5 *Syracuse Herald*, Jan. 6, 1942, 10.

6 *Bronxville Review Press*, Jan. 8, 1942, 3.

7 Robinson, *The Man Behind the Camera*, 2, see Fn 1.

8 Ibid.

9 *Bronxville Review Press*, Feb. 5, 1942, 12.

10 Philip Okamoto, interview by the author, September 2019.

11 Michael Mauracher, "Interview mit Yoichi R. Okamoto," *Camera Austria* 18 (1985), 82–83.

12 Ibid., 82.

13 Ibid., 82.

14 "Okamoto Leaves Army in Austria," *Syracuse Post Standard*, Mar. 1946, 7.

15 For the following, see John Zimmermann: "Die Eroberung und Besetzung des deutschen Reiches," in *Der Zusammenbruch des Deutschen Reiches 1945: Erster Halbband; Die militärische Niederwerfung der Wehrmacht; Mit Beiträgen von Horst Boog, Richard Lakowski, Werner Rahn, Manfred Zeidler, John Zimmermann*, ed. Rolf Dieter Müller (Munich: Deutsche Verlags-Anstalt, 2008), 277–489; Duncan Anderson, *Das Ende des Dritten Reiches 1944 – 1945: Von der Landung in der Normandie bis zum Fall von Berlin* (Vienna: Tosa Verlag, 2002), 235–50; Duncan Anderson, *The Fall of the Reich* (London: Amber, 2000).

16 George S. Patton, *Krieg: Wie ich ihn erlebte* (Bern: Scherz Verlag, 1950), 203. Original: George S. Patton, *War as I knew it* (Boston: Mifflin, 1947).

17 Ibid., 232.

18 See the map in Zimmermann, "Eroberung," 391.

19 Ibid, 464.

20 Klaus Wiendl, "Das letzte Gefecht im Tegernseer Tal," *Tegernseerstimme.de*, May 4, 2017, accessed Apr. 12, 2021, https://tegernseerstimme.de/das-letzte-gefecht-im-tegernseer-tal/.

21 Lutz Niethammer, "Amerikanische Besatzung und bayerische Politik (1945)," *Vierteljahreshefte für Zeitgeschichte 15*, no 2, (1967) 133–210, 184.

22 *Crimes hitlèriens*, exhibition catalog, Paris 1945. See also "Rebuilding a Nation," *Google Arts And Culture*, accessed Apr. 13, 2021, https://artsandculture.google.com/exhibit/rebuilding-a-nation/uAKCBcUXNS6HKg.

23 On Clark and his arrival in Austria see Günter Bischof, *Austria in the First Cold War 1945–55: The Leverage of the Weak* (Basingstoke: Macmillan, 1999), 49–51.

24 Ilse Lackenbauer, *Das Kriegsende in der Stadt Salzburg Ende Mai 1945*, Militärhistorische Schriftenreihe 35 (Vienna: Bundesverlag, 1985), 37.

25 Patton, *Krieg*, 221.

26 Manfried Rauchensteiner, *Der Krieg in Österreich 1945* (Vienna: Amalthea, 1995), 334.

27 Mark W. Clark, *Calculated Risk* (New York: Harper & Brothers 1950) 450. Reginald L. Williams, *15th Army Group History 16 December 1944 – 2 May 1945* (Vienna: Staatsdruckerei, 1948), 213–14.

28 Marion Krammer and Margarethe Szeless. "'Let's hit the reorientation line every time we can!' Amerikanische Bildpolitik in Österreich am Beispiel der Pictorial Section," *Medien und Zeit 1* (2017): 4–33.

29 Hans Petschar, *Die junge Republik: Alltagsbilder aus Österreich 1945–1955* (Vienna: Ueberreuter, 2005).

30 Margit Roth, et. al., "Chronik der Stadt Salzburg 1945–1955" in *Befreit und Besetzt: Stadt Salzburg 1945–1955*, ed. Erich Marx (Salzburg: Anton Pustet, 1996), 189–488, 212.

31 Okamoto was the perfect choice for Clark, who always paid great attention to his personal image building. Günter Bischof, "Mark Clark und die Aprilkrise 1946," *Zeitgeschichte* 13 (April 1986), 229–51.

32 *Salzburger Volkszeitung*, Sept. 9, 1945, 3.

33 Clark, *Calculated Risk*, 471.

34 Günter Bischof and Hans Petschar, *The Marshall Plan – Since 1947: Saving Europe, Rebuilding Austria* (New Orleans: University of New Orleans Press, 2017).

35 Cited after: Herbert Friedlmeier, Hans Petschar, and Michaela Pfunder, "U.S. Photography and the Marshall Plan," in *Images of the Marshall Plan in Europe: Films, Photographs, Exhibits, Posters*, ed. Günter Bischof and Dieter Stiefel (Innsbruck: Studienverlag, 2009). 169–201, 178.

36 Ibid.

37 Marion Krammer and Margarethe Szeless, "Yoichi Okamoto and the 'Pictorial Section': Austrian-American Relations" in *1914: Austria-Hungary, the Origins, and the First Year of World War I*, Contemporary Austrian Studies 23, ed. Günter Bischof, Ferdinand Karlhofer, and Samuel R. Williamson (New Orleans: University of New Orleans Press; Innsbruck: Innsbruck University Press, 2014), 275–92. Marion Krammer, Margarethe Szeless, and Fritz Hausjell, "Blende auf: Pressefotografie im befreiten/besetzten Österreich 1945–1955," in *Historische Perspektiven auf den Iconic Turn: Die Entwicklung der öffentlichen visuellen Kommunikation*, ed. Stephanie Geise, et. al. (Cologne: Herbert von Halem Verlag, 2016). 146–65.

38 Some of Okamoto's artist portraits have been published in Otto Breicha, ed., *Der Art Club in Österreich* (Vienna: Jugend und Volk, 1981).

39 Johanna Dichand, *Galerie Würthle: Gegründet 1864* (Vienna: Galerie Würthle, 1995), 62.

40 Jerry Mason, ed., *The Family of Man: The Photographic Exhibition Created by Edward Steichen for the Museum of Modern Art* (New York: Museum of Modern Art, 1955). (Okamoto's photo has not been published in the catalog).

41 Yoichi R. Okamoto and Paula Okamoto, *Okamoto sieht Wien: Die Stadt seit den fünfziger Jahren* (Vienna: Tafelspitz, 1987); Yoichi R. Okamoto and Paula Okamoto, *Okamoto's Vienna: The City since the Fifties* (Vienna: Tafelspitz, 1987).

Beyond the Edelweiss:
Austrian Image in the United States

Hannes Richter

Introduction

In the public mind, the Austrian image in the United States has long been dominated by the idea of classic, stereotypical variables ranging from *The Sound of Music* to images of ballroom dancing and Alpine mountain vistas. However, with a host of new, digital communication channels available in the 21st century, a reexamination of the established stereotypes seems in order. A first, proper empirical measurement of the Austrian image in the United States occurred in the late 1980s and early 1990s, when the Austrian National Bank commissioned a series of nationwide surveys to gain insight into the matter in the aftermath of the *Waldheim* affair. Since then, robust data available for analysis have been scarce. With the emergence of the nation brand literature, private enterprises like *GFK Roper*, the *Reputation Institute*, or *Brand Finance* have been compiling data with respect to country brands, including Austria, but the datasets are not readily available and also lack granular focus on Austria *per se*. Thus, in order to shed light on Austria's contemporary image in the United States, the Austrian Press and Information Service at the Austrian Embassy in Washington, DC partnered with the Sol Prize School of Public Affairs at the University of Southern California to produce three pilot studies between 2015 and 2018 utilizing new methodological approaches and social media to gauge the Austrian nation brand today. This foray into new methodologies and data sources will inform future research design that will deliver hard evidence of the contemporary Austrian image in the United States in today's digital information environment. The following sections will (1) provide a brief overview of the theoretical foundations of nation branding, (2) present key evidence from the Austrian National Bank-surveys on the Austrian image in the late 20th century, (3) present findings from the three recent pilot studies, and (4) provide recommendations for future research.

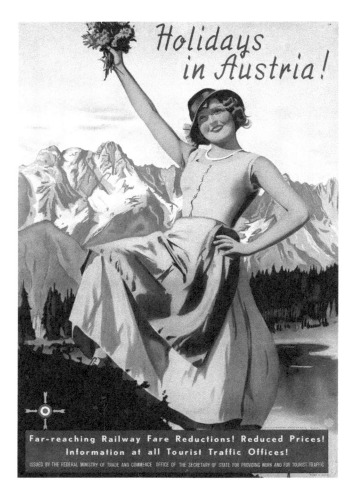

Fig. 1, *Holidays in Austria*, an early, undated tourism poster advertising holidays in Austria in the visual spirit of *The Sound of Music*. Images like this have long contributed to many Americans' old-fashioned view of Austria as a "fairytale on the Danube" (Picture Credit: Austrian Federal Ministry of Trade and Commerce).

Background

Nation branding, a conceptual neighbor of public diplomacy, is a concept and practice that has gained popularity over the past two decades. Simon Anholt began to write about the concept in the mid-1990s, observing that "the reputations of countries are analogous to the brand images of companies and products, and these reputations are equally critical to the

progress and prosperity of those countries because of their influence on the opinions and behaviors of each country's "target audience" of foreign investors, tourists, consumers, students, entrepreneurs, trading partners, the media, other governments, donors, multilateral agencies, and so on."[1] The relatively young terms of *place branding* and *nation branding*, and their relationship with a nation's public diplomacy have been subject to ongoing debate and deserve some further clarification.

Conceptual roots of nation branding can also be found in the country-of-origin literature. The country-of-origin (COO) effect holds that a product's place of origin affects consumer attitudes towards that product— think German engineering or Swiss watches—emphasizing a positive correlation between the country of origin and the product. However, it is less clear if this is a reversible effect, i.e., if a product can lead to positive sentiments towards the country of origin. For example, does Sweden bolster the image of IKEA, or does IKEA also help improve perceptions of Sweden? This question has led to a significant body of literature and methodological discourse between marketing academics.[2] It is vital to understand the difference between sectoral selling campaigns and the overall image of a country. As Simon Anholt has pointed out, specific marketing campaigns pertaining to investment opportunities or tourism can be successful while they do not have an impact on the overall image of a country. Specifically, Anholt emphasizes that countries do have brand images, but they cannot be branded. The term "nation branding" therefore refers to existing brand images of countries, not to the idea that they can be branded through public relations campaigns. What is more, Anholt underlines that there "appears to be no evidence to suggest that using marketing communications to influence international public perceptions of an entire city, region, or country is anything other than a vain and foolish waste of taxpayers' money."[3] Conversely, other definitions have specifically included this aspect; Kerr and Wiseman wrote that nation branding is "the application of corporate marketing concepts and techniques to countries, in the interests of enhancing their reputation in international relations."[4] Others, too, have referred to nation branding as the application of branding strategies at the nation state level; Ying Fan defines the term as "applying branding and marketing communications techniques to promote a nation's image."[5]

The overall concept of a nation brand according to Anholt, and the attempts to influence this brand, is a crucial distinction that one needs to bear in mind when attempting to place nation branding within any theoretical framework. Data from the *Nation Brands Index* suggest that no correlation exists between some countries' marketing campaigns and their brand

ranking, while other countries showed improvement without the applica-
tion of PR campaigns.[6] Therefore, nation branding is not marketing *per
se*. Anholt emphasizes that improvements in countries' perceptions abroad
must stem from policies and deeds, not public relations. Other scholars, too,
have emphasized this fact and help clarify the term and its exact meaning,
some by using case studies,[7] or by focusing on what is being branded and
where lines between nation branding and product branding can be drawn,
while emphasizing that countries do have a brand image anyway, with or
without nation branding.[8]

 Scholarly attention has also been devoted to identifying potential bor-
ders, similarities and conventional differences between public diplomacy
and nation branding. Public diplomacy itself has been described in dif-
ferent ways and its definition has evolved in the literature over time. The
US Department of State described pubic diplomacy as "government-spon-
sored programs intended to inform or influence public opinion in other
countries; its chief instruments are publications, motion pictures, cultural
exchanges, radio and television."[9] Another example was coined by Bruce
Gregory, who stated that public diplomacy and strategic communication
are "an instrument of statecraft that embraces diplomacy, cultural diplo-
macy, international broadcasting, political communication, democracy
building, and open military information operations."[10] Both public diplo-
macy and nation branding have been used within the same context, often
describing the same thing; however, scholars contend that they are not the
same conceptually. Public diplomacy is the older of the two concepts and
predates nation branding by several decades, with origins dating as far back
as the 19th century.[11] One distinction can be found in the origins of the
respective literatures, with public diplomacy theory being mainly developed
by American scholars, while "nation branding has a more European root
and appeal, with a clear British dominance."[12]

Digital Diplomacy & Nation Brand in the Social Media Age

 The craft of public diplomacy in the digital- and social media-age pre-
dates the forays of nation branding in this realm; it has been termed *digital
diplomacy* long before President Trump's Twitter account started making
headlines. The term digital diplomacy itself predates the social media-era;
in 2001 Wilson Dizard Jr. had already used the term, writing about the
United States' international communications and information policy from
the Morse telegraph to the emergence of the Internet.[13] Digital diplomacy
has resurfaced with the advent of social media applications like Facebook

and Twitter, as actors in foreign policy and diplomacy began utilizing these new communication channels. More recently, however, digital diplomacy has been referring to all aspects of public diplomacy on the Internet, with a heavy emphasis on social media. Scholars and practitioners alike have since begun devoting more attention to the specific characteristics of these new communications channels and their uses in diplomacy.[14] More recently, studies have also become more specific in their focus, for example counting and evaluating the Twitter-presence of countries, embassies, as well as senior diplomats, foreign ministers, and heads of state—summarized under the term "Twiplomacy."[15] Similarly, nation branding and quests for its quantification have also moved into the digital arena. One example is the *Digital Country Brand Index*, which measures the digital appeal of a country, last published by *Bloom Consulting* in 2017.[16] With the basic concept and the roots of nation branding outlined, I will now turn to Austria as a specific case and present the available evidence regarding the Austrian nation brand in the United States.

The Austrian Image in the United States: Historical Evidence

Austria dropped off the radar of general public awareness in the United States after the *Anschluss* in 1938 and its aftermath, and mainly remained enshrined in Americans' postwar brains through the iconic movie *The Sound of Music*, giving way to images of a mystical "sound of music nation on the Danube rather than a historical reality."[17] In the late 1980s, the Austrian National Bank commissioned a series of representative, nationwide surveys to gauge the Austrian image in the United States in the wake of the *Waldheim* affair.[18] These surveys yielded the first thorough data on the subject and are to date still the methodologically most finely grained evidence available. The data provide solid insights into the Austrian image in the United States during a politically volatile era in the country's relations with the United States and the key findings are summarized here.

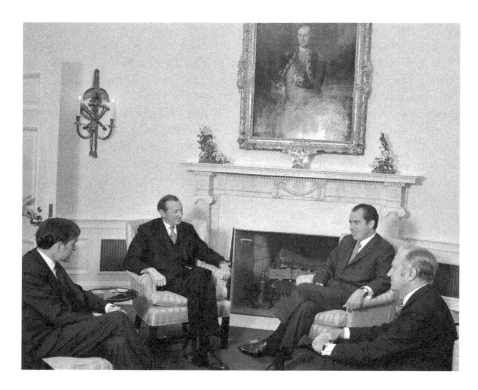

Fig. 2: "Waldheim meeting Nixon," (Credit: UN Photo). Before the affair, January 24, 1972: UN Secretary-General Kurt Waldheim is seen during his meeting with President Richard Nixon at the White House. At left is Ambassador George H. W. Bush, Permanent Representative of the United States to the United Nations. At right is Secretary of State William Rogers. Waldheim was elected Federal President of Austria in 1986. Amidst claims of his involvement in and knowledge of Nazi War crimes, the United States Department of Justice had established a *prima facie* case against Waldheim in 1987, who subsequently was prohibited from entering the United States by federal statute. This marked the first time in US history that an acting head of state was put on the immigration watchlist. The affair received substantial media echo in the United States, affecting public opinion of Austria.

According to the data, Austria's nation brand in the United States in the past has been informed mostly by aesthetic variables pertaining to natural aspects of the country like picturesque images of the Alps, palaces, and monuments, as well as its cultural heritage, yielding an overall positive, albeit old-fashioned, image. As far as a "political image" could be determined, Kurt Waldheim was omnipresent outside of these aesthetic variables at the time: "Rolling hills and Viennese operas are sufficient for maintaining a

positive image in the absence of other, negative images, but their influence will pale by comparison to a debate over Waldheim's past and by implication, Austria's Nazi past."[19] The Waldheim affair therefore was a wake-up call for many Americans and it put modern-day Austria back on the map for some. Somewhat more recently, the rise of the Freedom Party under the late Jörg Haider, too, made headlines in the United States, as is evident in reporting from the *New Republic*, who labeled him a "unabashed Nazi admirer" when Mr. Haider was attending Harvard University for a six-week seminar, while meeting American political figures such as Jack Kemp and Trent Lott in an effort to soften his extremist image.[20] This evidence suggests that the country's Nazi past has been informing part of the Austrian image in the United States besides the "classic" variables, depending on media prevalence.

Besides the exogenous shock variables like Waldheim, the survey data suggest that Austria at that time enjoyed a solid, positive overall reputation in the United States. Table 1 presents the results for both soft and hard name recognition of the country in comparison with Switzerland, Germany, Russia, Belgium, and Hungary, where soft name recognition refers to those who have simply heard of the country, and hard name recognition to those who can also rate it.

Table 1. Austria Name Identification 1992		
Country	SOFT	HARD
Switzerland	95	88
Germany	95	86
Russia	94	81
Austria	91	78
Belgium	85	69
Hungary	82	62
Source: "The Political Image of Austria", Track V. Cell entries are percentages		

Among the countries tested in the survey, Switzerland displayed the highest name recognition with 95 percent (soft), and 88 percent (hard), followed by Germany and Russia. Austria enjoyed a solid 91 percent (soft) and 78 percent (hard) name recognition in 1992. However, name recognition alone says little about favorability, thus respondents were also asked whether they hold a "favorable" or "unfavorable" opinion of Austria; those results are presented in Table 2. Compared with the other countries tested, Austria enjoyed high levels of favorability (72 percent), with only 6 percent of respondents attesting a negative view of the country, while Hungary, in comparison, was only viewed favorably by 34 percent at that time.

Table 2. 1992 Austrian Favorability Ratings in the U.S.

	Favorable	Unfavorable	Can't Rate	Never Heard
Switzerland	83	5	7	5
Austria	**72**	**6**	**13**	**9**
Germany	70	16	9	5
Belgium	60	9	16	15
Russia	45	36	13	7
Hungary	34	28	20	17

Source: "The Political Image of Austria", Track V. Cell entries are percentages

Table 3. Austria – Top of Mind Opinions 1989 & 1992

*Why do you have a (**Favorable/ Unfavorable**) Opinion of Austria?*

	3/89	9/92
Beautiful/ Environment/Alps	15	23
Never been/ like to	3	10
Nice People	9	9
Art/Music/Culture	5	7
Friends/Relatives Austrian	4	7
General Positive	14	4
Politics/ History	-	4
Films/Pictures/Read/Seen	3	3
Skiing	2	3
Neutrality	2	2
General Negative	1	2
Strong Economy	1	2
Clean	-	2
Hitler/Germans/General WWII	1	1
Never Communist	3	1
Sound of Music	-	1
Been there/Like	3	1
Weather	-	1
Good Beer	-	1
Politics/General Good	-	1
Politics/General Bad	-	1
New President	-	1
Nazis and Jews	1	0
Nothing	10	5
Don't Know	-	9

Source: "The Political Image of Austria", Track V. Cell entries are percentages

Respondents were further asked to provide up to three reasons for their favorable or unfavorable rating of Austria. The top response (23 percent) relates to Austria's natural environment, including its beauty and references to the Alps. On the non-aesthetical side, a combined 8 percent of responses can be classified as political in nature and include references to Austria's past. These include references to Hitler and World War II, National Socialism and the Jews, and other, more general mentions regarding Austrian politics. None of the individual issues mentioned, however, are statistically significant determinants of the Austrian image as a whole. These results, summarized in Table 3, underscore the importance of aesthetics and natural beauty as determinants of American opinion formation on Austria in the 1990s and before.

In addition, Table 4 summarizes the results of a specific set of questions asked to determine basic levels of knowledge about Austria. A solid majority, 74 percent, knew that Austria is an independent country rather than part of another country, while a combined 25 percent either got the answer wrong or said they didn't know.

Table 4. Specific Knowledge Questions on Austria

Q1 Is Austria an independent country or is it part of another country?

Independent	74
Part of Other	7
Don't Know	18

Q2 How would you describe Austria's geographic location – Do you think of Austria as being a part of Central Europe, Eastern Europe, or Western Europe?

Central Europe	41
Eastern Europe	18
Western Europe	17
Don't Know	24

Q3 Do you think Austria is a country which welcomes political and economic refugees from all over the world, especially from Eastern Europe, or do you think Austria's borders are closed to outsiders?

Welcomes	34
Closed	27
Don't Know	39

Source: "The Political Image of Austria", Track V. Cell entries are percentages

Regarding Austria's exact location, opinions differed. 41 percent said it was a Central European country, 18 percent put it into Eastern Europe, and 17 percent into Western Europe, while 24 percent did not know. In addition, 34 percent identified Austria as a country that welcomes refugees

(not knowing how important this aspect would become once more in 2015), while 27 percent thought Austria's borders are closed. If we include the sizeable number of respondents who didn't know, the data suggest that some two-thirds of Americans (66 percent) did not think that Austria was a country that welcomed refugees. This result could be regarded as another deficit in the country's image at the time, inviting answers from public diplomacy and information policy.

Americans' basic perceptions regarding Austria were tested with a series of four semantic differentials—sets of words or phrases with opposite meanings. Those included (1) *old-fashioned* or *modern*, (2) *rich* or *poor*, (3) *glorious* or *controversial*, and (4) *a country rich in culture, music, and art* or *no more rich in culture, music, and art than the others*. Respondents were asked to choose the one that best describes Austria. In sum, Austria's image in the United States at that time was very much seen as old-fashioned. A large majority of respondents, 72 percent, thought so in 1992, compared to 67 percent in 1989 (see Table 5). Moreover, a fairly large number of respondents, 41 percent in 1992, thought Austria was a poor rather than rich country, and a strong majority classified its past as *controversial* rather than *glorious*. On the cultural dimension, however, a majority of 64 percent in 1992 thought of Austria as being rich in culture, music, and art compared to other nations. While the latter underlines Austria's perception as a cultural nation, the other results drastically illuminate Austria's old-fashioned and also controversial image at that time.

Table 5. Austria's Image – Semantic Differentials

	Old-Fashioned	Modern
1992	72	22
1989	67	24
	Rich	Poor
1992	48	41
1989	47	22
	Glorious	Controversial
1992	34	55
1989	29	50
	Rich in culture, music & art	No more than other countries
1992	64	29
1989	60	29

Source: "The Political Image of Austria", Track V. Cell entries are percentages.

In order to further gauge the image of Austria in the United States, the survey asked respondents a series of six statements (one positive and five negative). The results from 1989 and 1992 are summarized in Table 6 and show that Austria in 1992 was seen as a more stable and democratic political system compared with the past, displaying a 5 percent increase in the *very well* category over three years. The five negative statements, on the other hand, were aimed to measure potential negative attitudes on issues like anti-Semitism, a rise in the popularity of neo-Nazi ideas, and negative effects of the recent turmoil in Eastern Europe, including potential environmental damage stemming from nuclear reactors operating there. The data show that in 1992, 36 percent of respondents believed in increasing popularity of neo-Nazi ideas in Austria, compared to 33 percent who though the statement does not describe Austria well. Again, a significant number, 35 percent, could not or refused to answer the question. This constitutes a significant increase compared to 1989, when only 28 percent thought this describes Austria well, and 28 percent disagreed. In addition, the number of those without an answer was also significantly higher at 44 percent. A similar trend is observable on the related anti-Semitism statement, where respondents contributed to a similar increase in negative opinions: in 1992, 39 percent said that Austria being anti-Semitic describes the country *very or somewhat well*, with only 26 percent negating that claim. In 1989, these numbers were lower and almost even at 30 percent and 29 percent, respectively. In concert with the results from the semantic differentials section, it becomes clear that some areas in Austria's image in the US could have been better. A significant number of Americans still associated the country with being old-fashioned with a controversial past, as anti-Semitic and a breeding ground for neo-Nazi ideas. Given the fact that these data were collected before the advent of the late Jörg Haider and his successor, Heinz-Christian Strache, both of whom have received ample media coverage in the United States, the question remains if substantial headway has since been made in these issue areas.

In general, however, relations between Austria and the United States were predominantly perceived as good and friendly. The data on the issue are straightforward. During the late 1980s a clear majority thought of the relations between the two countries as friendly, both economically and politically, and in 1992, 61 percent thought this had not changed, while 14 percent saw an improvement, and only 4 percent said Austrian-American relations had worsened. While these surveys provide meaningful insights into the Austrian image in the United States in the late 1980s and early 1990s, little is known about the Austrian image today beyond assumptions informed by past evidence. In the following section, I will introduce contemporary efforts to gather new data on the issue.

Table 6. Image of Austria Descriptions

I would like to read you some statements about Austria. Please tell me whether you think each statement describes Austria Very Well, describes Austria Somewhat Well, or if it does not describe Austria Well at All

		Very Well	Somewhat well	Not very Well	Don't Know
Positive					
Has a stable and a democratic political system					
	1989	15	35	20	31
	1992	20	37	19	22
Negative					
Is endangered from the environmental damage and nuclear reactors operating in Eastern and Central Europe					
	1989	n/a	-	-	-
	1992	16	33	24	27
Is suffering because of the turmoil in eastern and central Europe					
	1989	n/a	-	-	-
	1992	15	38	24	23
Suffers from high unemployment					
	1989	n/a	-	-	-
	1992	15	26	25	35
Is facing an increase in the popularity of Neo-Nazi ideas.					
	1989	7	21	28	44
	1992	10	26	33	31
Anti-Semitic					
	1989	8	22	29	42
	1992	9	30	26	35

Source: "The Political Image of Austria", Track V. Cell entries are percentages.

Austria's Contemporary Image in the United States: Social Media Pilot Studies

To gain further insights into the Austrian nation brand today, the Austrian Press & Information Service at the Austrian Embassy in Washington, DC partnered with the University of Southern California's Sol Price School of Public Policy on three pilot studies. Data collection and analysis were performed by a team of graduate students under the direction of Professor Dora Kingsley Vertenten as a capstone project prior to their graduation. The first (2015) and second (2016) pilot studies analyzed the

Austrian nation brand on social media (specifically on *Facebook*, *Twitter*, and *Instagram*). Data collection for the first [21] and second [22] pilot study occurred during six-week periods in June and July 2015 and 2016, respectively. The third pilot study[23] (2016/17) focused on sentiment towards Austria's role during the Syrian refugee crisis. The following section provides a summary of the studies and highlights some of their most important results. Data from Facebook, Twitter, and Instagram (Pilot 1), as well as Twitter, Facebook and major US newspapers (Pilots 2 and 3) were utilized to gain new insights by identifying the major themes that define the Austrian image in the United States, as well as their tonality by performing a sentiment analysis, which is "the process of determining and measuring the tone, attitude, opinion, and emotional state of responses."[24] The mining of data found within social media content can be achieved relatively efficiently and inexpensively compared with traditional polling methods,[25] and sentiment analysis derived from social media content provides a means to evaluate the opinions and perspectives of social media users related to a given subject in real time, and on an ongoing basis.

Fig. 3: Screenshot by author, March 2, 2021. An Instagram post depicting Hallstatt – in early 2021 one of the most-liked and shared posts on that platform for the search term #austria. Social media has grown increasingly influential in informing the Austrian nation brand.

In general, data show that sentiment towards Austria in the United States was overwhelmingly positive in nature during the collection periods. There was no evidence of negative sentiment expressed directly toward Austria or the Austrian people. Only four of the 122 relevant data points were negative, and three of those were directed at Arnold Schwarzenegger. Specifically, the 2015 pilot data show that 83 percent of the applicable data points indicate a positive sentiment towards Austria, while 17 percent show a negative sentiment.[26] Using the analytic process, the research team found particular information and patterns in the data, including specific themes (issue clusters) that were identified, specifically: previous travel experiences in Austria, Austrian pop culture items, and customer service interactions associated with Austrian companies. Furthermore, keywords, official social media pages, hashtags, and influencers were classified into one of four national branding categories: (1) commerce, (2) culture and heritage, (3) government, and (4) tourism. The commerce input criteria included information regarding the several hundred US companies that have invested resources in Austria, and Austrian companies that have a visible presence in the United States. The criteria for cultural inputs and influencers were selected based on information about Austria's history, cultural exports (sports, food, clothing, etc.), and pop culture. Inputs were also selected to specifically target Austria's modern image and contrasted that with Austria's image of the late 20th and early 21st centuries. Governance inputs focused on official diplomatic social media pages, official Austrian organizations, and major Austrian politicians. Finally, official Austrian tourist social media pages, popular tourist events, and popular Austrian attractions were the basis for tourism criteria findings.

The commerce data revealed that American social media users did not reference or associate Austrian companies with Austria. Sentiment identifications from the commerce category reveal a higher level of positive sentiment than negative or objective sentiment with overall sentiment across the commerce category being 58 percent positive, 25 percent negative, and 17 percent objective. Austrian Airlines is the sole business found in the customer service theme; the company used Facebook for customer service-related issues and is the cause for the higher level of negative sentiment when compared to positive and objective sentiment found in the customer service theme. The customer service theme displayed seven negative, four positive, and two objective posts during the sample period. Austrian Airlines has limited service in the US as it operates primarily in the European region, causing the amount of relevant content to be small.

Analysis of the relevant culture inputs reveals themes based on sentiment directed towards Austria and the country's culture. Three major themes with

three sub-themes emerged: The data showed that Americans identified with three Austrian pop icons: Arnold Schwarzenegger, the movie *The Sound of Music*, and Mozart. Combined, these sub-themes amounted to 57 percent of the collected data. While using social media to discuss the identified themes, Americans did not directly connect or associate them with Austria; however, the Austrian icons were viewed favorably. Of the approved relevant inputs captured in the culture and heritage category, 39 percent of the content was captured from Facebook and 61 percent from Twitter.

Sentiment identifications overall reveal a roughly 20:1 positive to negative sentiment ratio excluding objective data over the course of the study. Positive sentiment is primarily derived from responses to official government promotions including landmarks/locations, and food and cuisine, while negative sentiment resulted from posts about travel experiences. The high occurrence of objective data are the points and content generated from official Austrian sources, and are thus not related to American sentiment, but are still important in engagement of social media.

The tourism category captured 1,251 inputs over the six-week data collection period, with 359 meeting the criteria established by the research team relevant for sentiment analysis, resulting in a 28.5 percent acceptance rate. Through an analysis of the relevant tourism inputs, five themes emerged: (1) beauty of location/scenery; (2) pending travel plans; (3) previous travel, (4) travel recommendations, and (5) desired travel. The tourism category revealed overwhelmingly positive sentiment for Austria. Although posts by *Vienna.info* and *Austria Official Travel Info* were classified as objective, a handful of responses by individuals were also classified as objective in nature with declarations of fact rather than opinion. There were no negative postings identified in the tourism category.

In the third pilot study, with data collection occurring in 2016, and presented in 2017, the research team at the Sol Price School performed an analysis of American sentiment specifically focused on Austria's role in the Syrian refugee crisis, both in print news media and social media. The team applied a mixed-methods approach combining quantitative and qualitative methodologies, including (1) sentiment analysis, providing a classification (positive, negative, neutral) of words and phrases, (2) a content analysis of six US newspapers,[27] identifying themes and patterns, and (3) descriptive statistics, providing a graphical presentation of quantitative and qualitative data. Research was conducted via *Zoomph* (a social media sentiment tool), *LexisNexis* (newspaper keyword search), as well as *Lexalytics, a* text-to-data analytics software. The data for this pilot study were collected between September 19, and November 22, 2016.

Over half of the stories shared on social media during that period carried a negative sentiment. Most of those negative stories projected a negative sentiment towards refugees and migrants—to illustrate this finding, Table 7 lists the five most retweeted stories during the duration of the data collection. It is noteworthy, however, that the negative sentiment was not directed at Austria *per se*, but mostly at refugees and migrants, and their perceived criminal behavior. The findings show that Americans were sharing more negative (60 percent) than positive (5 percent) and objective (35 percent) content regarding Austria and the refugee crisis. This finding mirrors the overall negative views Americans had towards refugees on social media at that time. Newspaper reporting in this context, too, exhibited a trend towards negative content (60 percent), with the number of neutral articles at 35 percent, and positive content at only 4 percent. A majority of newspaper articles (55 percent) published during the study period focused mostly on political and electoral consequences of the crisis, while social media content was more focused on violence and crime as it related to the crisis (57 percent). Furthermore, newspapers frequently published articles that detailed the personal stories of refugees and their struggles, whereas social media content reflected anti-migrant stories. During the time of the data collection, US President-Elect Donald Trump was associated with 86 percent of the negative sentiment; 19 percent of the negative sentiment was in support of Austria's plans to deport 50,000 refugees. Fifty-eight percent of the negative sentiment appeared to be fear-driven. Specifically, 77 percent of negative posts on Twitter objected to Hillary Clinton's proposed policies and implied that Austria's involvement in the Syrian refugee crisis was a representation of what the United States would look like if Clinton won the US presidential election.

The results of the analysis also indicated demographic differences in American users posting content relating to Austria and the refugee crisis: While the general social media population tends to be slightly more female and between the ages of 18 and 29, the majority of social media users posting on Austria were White (77 percent), male (59 percent), and millennials (37 percent). Furthermore, on Twitter, Americans retweeted content from twelve prominent users, each of whom had thousands of followers, were highly active on the platform, and were linked with predominantly conservative associations, such as right-leaning political figures and news sources. In general, the research team concluded that social media during the time of data collection was a repository of negative sentiment; over half of the shared content exhibited negative sentiment towards migrants and refugees.

While only some findings of these pilot studies can be presented here, they do illuminate certain trends: The Austrian image can still be defined along battle-tested, positive connotations that have stood the test of time. At the same time, however, the factors that inform sentiment towards the country have become multifaceted as the availability of information and sources has proliferated. With regard to social media, this can also introduce negative aspects, like negative experiences while travelling, or a bad customer service interaction with an airline. Such sentiments become available both to the public and for analysis through social media, and thus they are counted. If they affect the overall nation brand over time may remain doubtful.

Table 7. Top 5 Retweeted Stories – Austria & Syrian Refugee Crisis, 2016	
Content	**# of Shares**
Iraqui Muslim Migrant who raped 10-year-old boy has conviction overturned #SexualEmergency	576
Woman, 72, raped by #asylum seeker has "lost will to live" #Rapefugees #Austria #TheyHaveToGoBack	322
Austria: 2 Muslim migrant enter hospital to rape psychiatric patient and threatened to cut of head of psychologist	294
BREAKING: Austria is FED UP With Muslim "refugees", Prepares to DEPORT 50,000	248
Frenzied refugee shozs "Allahu Akbar" as he throws himself in front of Car.	231

Source: Butts, et al. *Austria and the Refugee Crisis. An Analysis of American Sentiment in Social versus print Media.* (2016): Embassy of Austria, Washington, DC

Conclusion

Examination of the available evidence suggests certain continuities in the Austrian nation brand in the United States over the past decades, while it also highlights the importance of current events in shaping those attitudes at least temporarily. Tourism, culture, and Alpine landscapes continue to positively influence American attitudes towards the country. At the same time, the often negative influences of exogenous factors—events that

overshadow the positive aspects—can be clearly seen; in the past they often were related to the country's World War II-era history; more recently, the influx of the Syrian refugee crisis is a good example. Needless to say, recent events like the Covid-19 pandemic would also tilt any results gathered from social media. At the same time, the availability of these new data sources today allows for continued measurement of trends and attitudes informing the Austrian nation brand. The comparatively inexpensive methodologies employed can be a motivating factor to create institutionalized, constant monitoring. On one hand this could be utilized by decision makers to identify potential problem areas in real time when they arise; on the other hand, scholars employing such methodologies can generate a wealth of longitudinal data allowing for a granular analysis in order to better understand the Austrian nation brand and to identify its strengths and weaknesses. At the same time, this does not imply that survey research has become obsolete in this scenario—the methodology should remain in the arsenal of any serious inquiry into the matter, specifically in the light of more cost-effective deployment online. Such mixed method approaches can deliver valuable insights and can be tailored to specific issue areas if necessary. While the Edelweiss will likely remain a symbol for the continued influence of aesthetic variables, research and practitioners alike will continue to adapt to the ever-evolving, multi-pronged information environments.

Endnotes

1 Anholt, Simon. "A Political Perspective on Place Branding," in *International Place Branding Yearbook 2010: Place Branding in the New Age of Innovation*, eds. Frank Go and Robert Govers (New York: Palgrave Macmillan, 2010): 13.

2 For a good overview of the original arguments in this debate see, e.g., Keith Dinnie, ed., *Nation Branding: Concepts, Issues, Practice* (Burlington, MA: Butterworth-Heinemann, 2008); and Jean-Claude Usunier, "Relevance in Business Research: The Case of Country-of-Origin Research in Marketing," *European Management Review* 3, no. 1, (2006): 60–73.

3 Simon Anholt, "Place Branding: Is It Marketing, or Isn't It?" *Place Branding and Public Diplomacy* 4 (2008): 1–6.

4 Pauline Kerr and Geoffrey Wisemann, *Diplomacy in a Globalizing World* (Cary, NC: Oxford University Press, 2013), 354.

5 Ying Fan, "Branding the Nation: What is Being Branded?," *Journal of Vacation Marketing* 12, no. 1 (January 2006): 6.

6 Simon Anholt, "Place Branding," 1–6.

7 See, e.g., a case study for Iceland in Hlynur Gudjunsson, "Nation Branding," *Place Branding* 1 (2005): 283–98.

8 Ying Fan, "Branding the Nation," 5–14.

9 *Dictionary of International Relations Terms* (US Department of State, 1987), s.v. "public diplomacy," 85.

10 Bruce Gregory, "Public Diplomacy and Strategic Communication: Cultures, Firewalls, and Imported Norms," paper presented at the American Political Science Association Conference on International Communication and Conflict (Washington, DC, August 31, 2005).

11 Nicholas J. Cull, "'Public Diplomacy' Before Gullion: The Evolution of a Phrase," *uscpublicdiplomacy.org*, accessed Apr. 13, 2021, https://uscpublicdiplomacy. org/blog/public-diplomacy-gullion-evolution-phrase/.

12 György Szondi, "The Role and Challenges of Country Branding in Transition Countries: The Central and Eastern European Experience," *Place Branding and Public Diplomacy*, 3 (2007): 8–20.

13 Wilson P. Dizard, *Digital Diplomacy: U.S. Foreign Policy in the Information Age* (Washington, DC: Center for Strategic & International Studies, 2001).

14 See, e.g., Colleen P. Graffy, "The Rise of Public Diplomacy 2.0.," *The Journal of International Security Affairs* 17 (Fall 2009): 47–53; E.H. Potter, "Web 2.0 and the New Public Diplomacy: Impact and Opportunities" in *Engagement: Public Diplomacy in a Globalised World*, ed. Jolyon Welsh and Daniel Fearn (London: Foreign and Commonwealth Office, 2008); or Hannes Richter, "Web 2.0 and Public Diplomacy" in *Cyberspaces and Global Affairs*, ed. Jean S. Costigan and Jake Perry (Surrey, UK: Ashgate, 2012).

15 Matthias Lüfkens, *Twiplomacy Study 2017* (London: Burson Marsteller, 2017).

16 Bloom Consulting and Digital Demand. *The Digital Country Index 2017*. Available Online: https://www.digitalcountryindex.com/

17 Thomas O. Schlesinger, review of John Bunzl, Wolfgang Hirczy, and Jacqueline Vansant, *The Sound of Austria: Österreichpolitik und Öffentliche Meinung in den USA*, (*HABSBURG, H-Net Reviews*, 1996).

18 Janine Prader, *The Political Image of Austria in the USA, Track I–IV* (Washington, DC: Evans Mc Donough, 1988 and 1992).

19 Prader, *Track I*, 13.

20 Jacob Heilbrunn, "Heil Harvard," *The New Republic*, Sep 1, 1997.

21 Justin Braun, Elly Garner, Matthew Mason, and Erik Newland, *Sentiment Analysis of Austria Based on American Social Media*, research report prepared for the Austrian Embassy (Washington, DC: 2015).

22 *Analysis of Encouraging Austrian Content Sharing Through the Use of Digital and Print Media Platforms in the U.S.*, research report prepared for the Austrian Embassy (Washington, DC, 2016).

23 Kristin Butts, Maggie Ferrill, Kristina Hummer, and Steve Ozinga, *Austria and the Refugee Crisis: An Analysis of American Sentiment in Social Versus Print Media*, research report prepared for the Austrian Embassy (Washington, DC, 2017).

24 Rushabh Mehta, et. al., "Sentiment Analysis and Influence Tracking using Twitter," *International Journal of Advanced Research in Computer Science and Electronics Engineering* 1, no. 2 (2012): 72–79.

25 Brendan O'Connor, et. al., "From Tweets to Polls: Linking Text Sentiment to Public Opinion Time Series," in *Proceedings of the Fourth International AAAI Conference on Weblogs and Social Media* (Association for the Advancement of Artificial Intelligence, 2010): 122–29.

26 The research team did code 31% of data points from organizations or from hashtags where sentiment could not be effectively determined as "objective" and omitted those from the subsequent sentiment analysis.

27 The newspapers included in the content analysis were *USA Today*, *The Washington Post*, *The New York Times*, the *Los Angeles Times*, the *New York Daily News*, and the *New York Post*.

Mountain Pictures:
A Special Look into the Collections
of the Tyrolean Photo Archive (TAP)

Martin Kofler

Introduction

The "discovery" of the mountains in Europe came in the late 18th century with first climbing ("Alpinism"), mostly by the British and the French in the Western Alps.[1] Soon after the invention of photography in 1839, all sorts of high peaks were shot by camera. Pioneers in mountain photography—stemming from France, Switzerland, Italy, or Austria-Hungary, from Jules Beck and Vittorio Sella, the brothers Louis-Auguste and Auguste-Rosalie Bisson, and Gustav Jägermayer, to Joseph Tairraz[2]—realized they could make money from photographed glaciers and summits. You can really recall their thirst for adventure as well as closeness to nature—despite the massive challenges when carrying heavy glass negative plates way beyond 3,000 meters above sea level (in bad weather, with difficult light situations), and even after it became easier to make photographs with the invention of celluloid roll film in the 1890s.[3]

Photographers realized the magnetic attraction of the mountains. Beginning tourism with wealthy guests proved to be the trigger—for instance, "foreigners" came en masse to Tyrol/South Tyrol with the construction of the railways in the 1860-70s. The expansion of the mountain paths (completion of the "Große Dolomitenstraße" Bozen–Cortina d'Ampezzo in 1909[4]) and the mountain ranges' marketing went hand in hand.[5] Photos drawn up on cardboard, specially compiled photo books and richly illustrated travel guides reached the big cities and made individual regions and valleys known. These "goodies" were purchased while in the Alps and then taken home.

Besides atelier shootings photographers could also make quite a living from producing and selling picture postcards—mountain pictures were part of the game. From the 1880s-90s onwards, the invention and enormous distribution of the picture postcard meant an immense upswing in terms of popularity and commercialization for mountains as well as mountain photography. For historical Tyrol (Tyrol/South Tyrol/Trentino)[6], we have the following mountain photography pioneers: Franz Dantone (Fassa), Anton

Gratl (Innsbruck), Josef Gugler (Bozen), Bernhard Johannes (Meran), Johann Unterrainer[7] (Windisch-Matrei and Lienz), and Giovanni Battista Unterveger (Trento).

The following insights into the stocks of the Tyrolean Photo Archive (TAP, www.tiroler-photoarchiv.eu) show the constant need to get hold of previously unknown collections. We can also reflect the pictures' wide time range starting long before WWI and leading way into the 20th century as well as the importance of the entire contextual range of holdings.

Contrary to a conventional approach presenting different mountain photographers,[8] this article focuses on the wide range of content—both soft emotional, even philosophical, aspects and historic (technical) developments. This was also the basis TAP used when planning and setting-up the new LUMEN mountain photography museum on Bruneck's Kronplatz/ Plan de Corones (www.lumenmuseum.it). Parallel to the opening an essay collection was published that refers to the main impetus of the upcoming sections in this essay.[9]

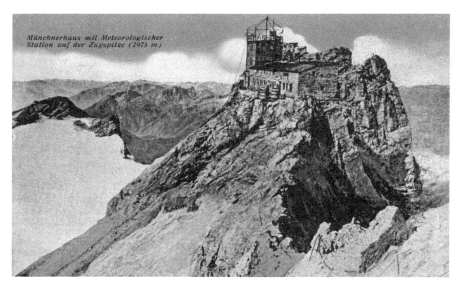

Fig. 1: Münchnerhaus at Zugspitze/Bavaria, about 1925 (Publishing Company Monopol, L19185; Sammlung Alpenraute Lienz, TAP).

Dimensions of Mountain Pictures

Picture Postcards

After introducing the postcard in Austria-Hungary in 1869, the Post Office Department in Vienna approved the use of the picture postcard sixteen years later. This medium became very, very popular—for private and touristic use, produced cheaply by photographers as well as publishing companies (See Fig. 1).

Taking a Break

Quite soon after alpinists discovered the mountains for their climbing adventures, (rich) tourists followed to make a trip there to enjoy the countryside, already in the second half of the 19th century. The photographed rocky areas were perceived as an ideal counterworld to the increasingly growing cities. As oncoming skiing attraction and with the building of cable cars after 1945, local people as well as guests went upwards on the mountains for relaxation.

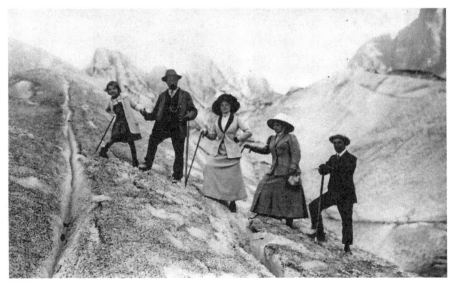

Fig. 2: Family hike in the Alps, about 1910 (Photo: Unknown, L53942; Collection Richard Piock, TAP).

Mountain & Marketing

Mountain commercialization ranges from postcards of the ridges to the naming of skiing boots or companies after certain summits. Some firms even sponsored mountain climbers and their expeditions to set their logo over 8,000 meters above sea level. Today's Photoshop enables all sorts of photomontage, around 1900 you could also create a quite new sight of your hotel in your surroundings.

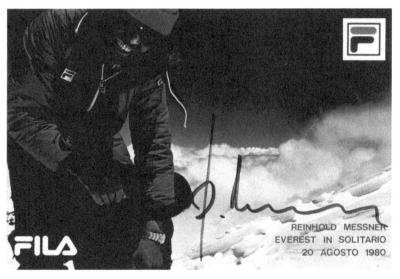

Fig. 3: With FILA solo on top of the world, Mount Everest, 1980
(Photo: Reinhold Messner, L66083; Collection Richard Piock, TAP).

The Mountain is pushed/acts/is fine

Man has used technology to continuously improve means of transportation from the Middle Ages onwards just as well as for power lines or oil pipelines in the 20th century. If mountain ranges were sort of "disturbing," they were cut through by tunnels or crossed by roads. Compared to the massive eternal mountain, man seems strangely insignificant. Therefore, the mountain does not react to technical breakthrough by man, but instead it acts, and always will—by avalanches, landslides and other natural disasters. In between the poles of "submission" and "catastrophes" is symbiosis: man and mountain coexisting in harmony—a coexistence that has also always been photographed and sometimes been used for propagandistic instrumentalization by politics and tourism.

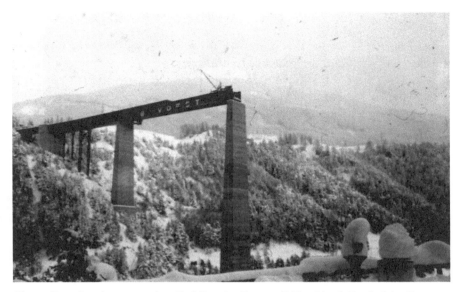

Fig. 4: Crossing the mountains: Building the Europa Bridge/North Tyrol of the Brenner Highway, around 1962 (Photo: Erich Kneußl, L46460; Collection Kneußl, TAP).

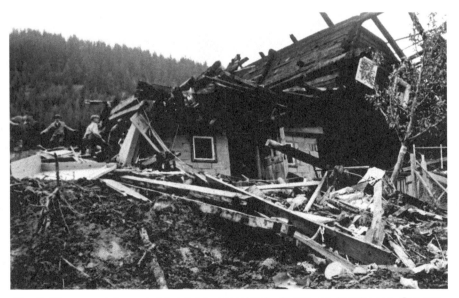

Fig. 5: The mountains act: A landslide completely destroys a farmhouse, Gassen, Defereggen Valley/East Tyrol, 1965 (Photo: Gabriel Ortner, L38176; Collection Gabriel Ortner, TAP).

Film production photographs and expedition documentation

In the 1920s and 1930s mountain films were a major factor in mountain marketing—one director mastermind proved to be Arnold Fanck, for example with his "Storm over Mont Blanc" (1930) with Leni Riefenstahl. Photographs made during the movie shooting as well as during a scientific expedition to Pamir in 1913 are valuable historic sources and have to be secured, indexed, and presented to the public.

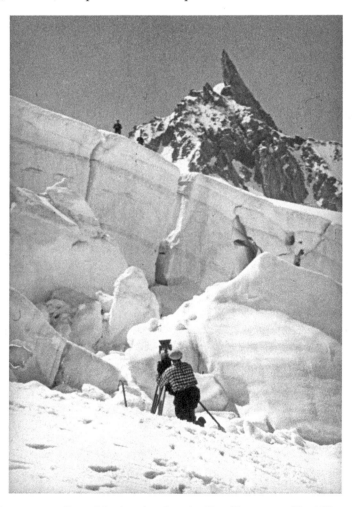

Fig. 6: Cameraman Sepp Allgeier shooting the film *Storm over Mont Blanc* starring Leni Riefenstahl, Sepp Rist, and Ernst Udet, 1930 (Photo: Unknown, L58847; Collection Leubner, TAP).

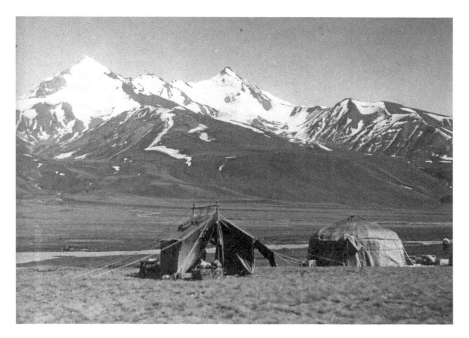

Fig. 7: High steppes of Tuptschek with Peter the First ridge, Pamir/Tajikistan, 16 July 1913—one of more than 600 photographs of the first Pamir expedition of the Deutscher und Österreichischer Alpenverein under Willi Rickmer Rickmers (Photo: Raimund von Klebelsberg, L62059; Collection Klebelsberg, Institute of Geology, University of Innsbruck, TAP).

Climate Change and Iconic Views

Glacial retreat due to climate change is a fact. Photographs document this shocking development in the Alpine landscape. This important subject of research (in visual history as well) also tangles the aspect of the "iconic view": This refers to the right angle to view a specific mountain panorama. But on the one hand this perspective can change because of glacier retreat and on the other hand—next to the stereotype (the constant repetition of the "classic" angle) set by pictures in travel literature or on postcards—there may be different perspectives that irritate or make curious.

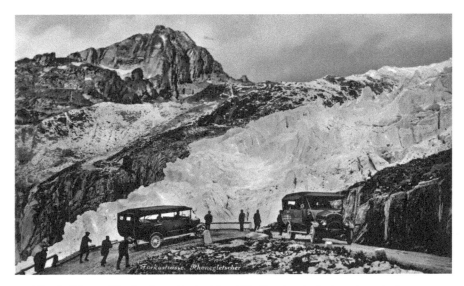

Fig. 8: Rhone Glacier from Furka Road/Switzerland—today almost all gone, around 1930 (Photo: Edition Photoglob, L66085; Collection Richard Piock, TAP)

Fig. 9: Drei Zinnen, Sexten Dolomites/South Tyrol—"classic view", about 1910 (Photo: Fritz Gratl, B25890; Collection Erich Wurmböck, TAP)

Endnotes

1 Gabriele Seitz, *Wo Europa den Himmel berührt: Die Entdeckung der Alpen* (Munich: Artemis-Verlag, 1987).

2 Maren Gröning, "Gustav Jägermayers Österreichische Alpen," in *Die Weite des Eises: Arktis und Alpen 1860 bis heute,* ed. Monika Faber (Ostfildern: Hatje Cantz Verlag, 2008), 24–33.

3 See: Anton Holzer, "Hinaus! Fotografie im Hochgebirge (1849–1914)," in *Berge im Kasten: Fotografien aus der Sammlung des Deutschen Alpenvereins, 1870–1914,* ed. Deutscher Alpenverein e. V. (Munich: Deutscher Alpenverein, 2006), 14–31; Ute Pfanner, "Berge in Schwarz-Weiß: Im Fokus der frühen Alpenfotografie," in *Jenseits der Ansichtskarte: Die Alpen in der Fotografie* (Munich: Hirmer Verlag, 2013), 27–34.

4 Matthias Egger, "Die Große Dolomitenstraße (1890–1918): Eine Straße im Spannungsfeld von Tourismus und Militär," in *Krieg und Tourismus: Im Spannungsfeld des Ersten Weltkrieges,* ed. Patrick Gasser, Andrea Leonardi, and Gunda Barth-Scalmani (Innsbruck: Studienverlag, 2014), 159–79.

5 Martin Kofler, "Fahr-Abenteuer pur: Pässe und Jöcher der Ostalpen im Lichtbild," in *Die touristische Eroberung der Alpenpässe,* ed. Touriseum (Meran: Touriseum, 2017), 62–73.

6 Michael Forcher and Meinrad Pizzinini, eds., *Tiroler Fotografie 1854–2011* (Innsbruck: Haymon Verlag, 2012); Meinrad Pizzinini and Michael Forcher, Alt-Tiroler Photoalbum (Salzburg: Verlag St. Peter, 1979); on the photo history of a mountain range as well as one single mountain chain see: Martin Kofler, "Lichtbild-Geschichte der Dolomiten: Entdeckung und Vermarktung 1870–1914," in *Alpenreisen: Erlebnis, Raumtransformationen, Imagination,* ed. Kurt Luger and Franz Rest (Innsbruck: Studienverlag, 2017), 513–32; Anton Holzer, *Die Bewaffnung des Auges: Drei Zinnen oder Eine kleine Geschichte vom Blick auf das Gebirge* (Vienna: Turia+Kant, 1996).

7 Martin Bitschnau, "Johann Unterrainer (1848–1912) – Fotograf in Matrei und Lienz," in *Osttirol: Geschichte – Volkskunde – Kunst,* ed. Rudolf Ingruber (Innsbruck: Studienverlag, 2005), 137–57.

8 Martin Kofler, "Fokus: Bergfotografie: Einblicke in die Bestände des Tiroler Photoarchivs (TAP)," *Tiroler Heimatblätter,* no. 1 (2019): 20–25.

9 For further information on the presented "dimensions" see the articles in Martin Kofler, Richard Piock, and LUMEN Museum der Bergfotografie, eds., *LUMEN: Museum of Mountain Photography, Velatum: Kulturzeitschrift für den Raum zwischen Dolomiten und Tauern* 3 (Iselsberg-Stronach: Verein Velatum: 2019).

Book Reviews

Rudolf Agstner, *Handbuch des k.k. / k.u.k. Konsulardienstes: Die Konsulate der Donaumonarchie vom 18. Jh. bis 1918*, ed. Gerhard Gonsa (Vienna: new academic press, 2018)

Alison Frank Johnson

Despite its utilitarian title and hefty size, this book represents as much passion and love as dedication to sometimes dreary labor. Its author, Rudolf Agstner, was born into a diplomatic family and spent his adult life traveling between the Federal Ministry of Foreign Affairs in Vienna and postings in Europe and Africa. History was a hobby for Dr. Agstner, and it was one he pursued with tremendous dedication. According to a short biography provided by his wife, herself a cultural diplomat, Agstner published twenty-five books and over 200 articles related to the Austrian and Austro-Hungarian foreign service—all told about 15,000 pages of meticulous research. After Agstner's sudden and unexpected death just before his sixty-fifth birthday, this handbook of the imperial-royal and imperial and royal consular service, from the eighteenth century to the dissolution of the monarchy in 1918, was loyally edited by his longtime colleague, Gerhard Gonsa. Gonsa is the long-serving archivist responsible for oversight of the diplomatic and foreign policy papers stored in the *Haus-, Hof- und Staatsarchiv* within the Austrian State Archive. A dedicated civil servant well-known to scholars who have done work in that archive, Gonsa was all too aware of the many decades of research Agstner had dedicated to compiling the data represented by this handbook. With a small team from the archive and the support of the Federal Ministry for European and International Affairs, Gonsa carefully edited and completed Agstner's extensive materials where it was possible for him to ascertain the author's own intent.

Over the course of its modern history (from roughly 1718 to 1918), the Habsburg Monarchy maintained consulates in about 725 different cities and towns around the world. When were they founded and in what years were they active? Who worked in them, in what years and for how long? Where were they physically located? Where, within the Austrian State Archives, are their files and documents to be found today? Recreation of this data, for over seven hundred discrete consular locations and through a period lasting two centuries, required a literal "(professional) lifetime" (xi). Their presentation here, gathered together in one weighty volume, will save many a researcher countless hours of labor.

Agstner's collection begins in the year when Austria and the Sublime Porte reached a commercial and shipping agreement, only a few days before the Peace Treaty of Passarowitz (Požarevac). That trade agreement allowed the Habsburgs to establish their first consulates in the Ottoman Empire. As Agstner notes, Austria was "late to the game": Prussia had already established its first consulates in the Ottoman Empire ten years previously. Nor was the Habsburg Monarchy overeager to take advantage of strong consular representation in Western Europe. Joseph II's advisors dissuaded him from paying consuls, for example, even while noting that in the absence of any compensation, their enthusiasm for their work suffered: "The influence of consuls on national trade is in and of itself only theoretical" (1). It was, in contrast, deemed worthwhile and important to approve uniforms for the consuls that would mirror, although be easily distinguished from, military uniforms. The uniforms were duly approved, their colors apparently determined by the emperor himself. By the middle of the nineteenth-century, there were professional, salaried consuls serving in many locations, and unpaid, honorary consuls serving in others; all wore uniforms. Agstner outlines several changes to the required colors, as well as the exact height of the flagpoles that were prescribed.

As Agstner notes in a clearly unfinished introduction, consuls were responsible for promoting exports, supporting domestic shipping, and reporting on economic matters including likely competitors, local harvest failures, and potential markets. In some areas, one of their most important tasks was to redirect the import/export and passenger traffic towards the Austrian shipping giant, the Austrian Lloyd, and its transit station of Trieste. Consuls were also responsible for protecting and assisting citizens of Austria, Hungary, and, after 1878, Bosnia and Herzegovina. Sometimes, as with the enforcement of military service requirements for men, that support may have been unwelcome, but it could also mean the difference between life and death.

The heart of the book, however, are the one hundred separate entries for countries ranging from Egypt and Albania to Yemen and Cyprus. Some are only a few words long, like the entry for Honduras, where the only Austro-Hungarian consulate opened in 1871, temporarily shuttered from 1880 to 1909, and reopened from 1909 to 1918. Others outline longer and more complicated relationships. There were, for example, six consulates in India. The first, along the Bay of Bengal and the Malabar Coast, were opened in the 1780s under Joseph II. The consulate in Chennai (Madras) was opened in 1807, the consulate in Kolkata (Calcutta) in 1848, the consulate in Mumbai (Bombay) in 1851, and the short-lived

consulate in Kakinada (Cocanada) in 1872. An index of names completes the volume.

In our digital age it is simple enough to take for granted the availability and accessibility of thorough factual information about government offices. It is also foolish. For historians who must assess the reliability of every piece of data before they grant it the status of a fact, the reliability of basic research is essential. This carefully compiled volume will help many researchers find their way to the archives and publications they need, trace the careers of individual civil servants, and reconstruct a sense of the scale of the consular operations of one of Europe's most overlooked great powers. Its creation was a labor of love; its posthumous completion an act of great respect. Its existence is a boon to those hoping to understand the overseas presence of Austria-Hungary.

Andreas Weigl, *Von der Existenzsicherung zur Wohlstandsgesellschaft: Überlebensbedingungen und Lebenschancen in Wien und Niederösterreich von der Mitte des 19. Jahrhunderts bis zur Gegenwart* (Vienna: Böhlau, 2020)

Gary B. Cohen

This succinct and lucidly written monograph compares trends in life expectancy, consumption levels, and overall prosperity in Vienna and Lower Austria against the backdrop of economic development from the middle of the nineteenth century to the present. The author, a university docent in the Institute for Economic and Social History at the University of Vienna and leader of the Ludwig Boltzmann Institute for Urban History in Vienna, employs methods drawn from population studies, historical demography, and economic history. The argumentation depends heavily on statistics, and the book is rich in tables, which are typically simply drawn and readily intelligible. Any such study faces impediments due to gaps in the statistics available for the period before the introduction of modern census practices in Austria at the end of the 1860s. Later changes in the boundaries of administrative units and in the statistical rubrics used from one period to the next create additional hurdles. In the face of such challenges, Weigl is scrupulous and resourceful in making the best of the sources. Ego documents and examples of individual experience do not come into play in the book, leading in places to a somewhat dry discussion. The presentation in parts of the later chapters tends to proceed simply from one statistical table to the next. Nonetheless, historians of social relations and social policy in modern Austria will gain much of value from the empirical findings and analytic insights offered in this book.

The book's title sums up well the trajectory of development traced in the six chapters and short conclusion. During the late eighteenth century and the first waves of industrialization in the early and mid-nineteenth century, much of the Viennese and Lower Austrian populations experienced low living standards, poor nutrition, and high infant mortality. The early modern urban penalty for life expectancy continued in Vienna during the early phases of the Industrial Age. The already low life expectancy declined further during the middle decades of the nineteenth century, due largely to crowded housing conditions, poor sanitation, and disease. Weigl shows how the economic growth registered in Vienna and Lower

Austria between 1830 and 1890 failed to produce any significant rise in real income up to the middle and late 1850s. Conditions changed significantly over the following half century with improvements in sanitation, popular nutrition levels, public health services, and eventually medical care. Infant mortality and the incidence of tuberculosis declined significantly by the beginning of the twentieth century. These developments proceeded more rapidly in Vienna than in the smaller towns and villages of Lower Austria. Popular wellbeing rose significantly in both Vienna and Lower Austria during the last decades of the nineteenth century and the beginning of the twentieth. However, infant mortality in Lower Austria during the 1920s was still twenty-five percent higher than in the city of Vienna (p. 183–84). Measures of mortality, life expectancy, and real income are of greatest concern to Weigl. Somewhat surprisingly for a study of demographic trends and popular wellbeing, fertility and overall rates of population growth get little attention in the book.

Beyond rising levels of nutrition and general consumption and the development of public health services, investments in community infrastructure had a significant impact on improving popular wellbeing during the late nineteenth and early twentieth centuries. Complaints about inadequate and impure water supplies were common in cities large and small in Austria and elsewhere in Central Europe during the middle and late nineteenth century. Weigl discusses how the Vienna city government after the late 1860s launched expensive projects for constructing new aqueducts, local water mains, and improved sewer systems. In contrast, many smaller cities and towns in Lower Austria struggled over longer periods to make such investments. Many Lower Austrian locales saw major improvements in the supply of drinking water in a wave of new projects during the 1920s, but in some places improvements in sewers and waste drainage had to wait until after World War II (p. 185).

In overall terms Weigl points to slow, uneven processes of convergence in popular consumption levels and general wellbeing between Vienna and Lower Austria, beginning at the end of the nineteenth century and continuing to the end of the twentieth century despite the interruptions of the two world wars and the immediate aftermath of each. General economic development, improving nutrition and sanitation, and rising levels of education led to a gradual, if uneven, convergence of mortality rates and life expectancy among people in different occupational categories, urban and rural, even though such trends among large segments of the Lower Austrian population tended to lag behind the Viennese experience until after 1950. The tendency for convergence between Vienna and Lower

Austria accelerated with the Austrian economic recovery and boom after the mid-1950s and the end of the Allied occupation. Weigl explains how the broad convergence thereafter in income, consumption levels, and life expectancy resulted from general improvements in nutrition and medical care, increased educational opportunities in the countryside, general expansion of employment in the service sector, movement of some industries from Vienna into Lower Austria, and migration of poorer rural elements to the metropolitan center while some more prosperous Viennese decamped to Lower Austrian locales. All this benefited from the strong economic growth in Austria as a whole between 1953 and the early 1960s which, behind the rapid expansion of the West German economy, ranked among the highest in Europe. By the mid-1970s Austrians enjoyed a per capita gross domestic product that was among the highest in the world. Such great affluence in Austria in recent decades could not have been foreseen in the modest circumstances which the great majority of the Viennese and Lower Austrian populations experienced in the early and mid-nineteenth century.

Bernhard Bachinger, *Die Mittelmächte an der Saloniki-Front 1915–1918: Zwischen Zweck, Zwang und Zwist*, Krieg in der Geschichte 106 (Paderborn: Schöningh, 2019)

Oswald Überegger

Studies on the history of World War I have been experiencing a boom for quite some time in many countries, including Austria. The Europe-wide paradigm change of the 1990s, which in the context of the so called "new military history" marked the transition to operationalizing everyday-, mental- and cultural-historical research designs, has in the long run revived the research of World War I in two respects. On the one hand, this reorientation moved away from those classical military and political history studies that had up to then characterized the research. On the other hand, the spatial horizon of interests was extended—in particular prior to the 2014–18 centennial. This again not only resulted in a clear tendency towards a global history view on the war, which in the context of the centennial resulted in quite a number of remarkable studies, but also had the effect that the previous research focus on the Western Front was weakened and other war theatres moved increasingly into focus. To this new trend of the research on World War I, there also belongs the valuable study by young Austrian historian Bernhard Bachinger which—initially written as a dissertation thesis—has now been published by Schöningh Verlag in the context of the "Krieg in der Geschichte" publication series.

In his study, Bernhard Bachinger deals with the Macedonian war theatre, which has gone down in history as the "Salonica Front." Apart from punctual references, for a long time the international historiography of World War I has barely dealt with this front in southeast Europe. Given the focus on the Western Front, its status was only that of a sideshow. However, this was an extremely complex, heterogeneous front that showed a great national and ethnic diversity of troops involved. Until September 1918, there was a kind of stalemate on the Salonica Front between the Entente and the Central Powers, which came to an end only because of the Entente's breakthrough at Dobro Polje and the resulting collapse of Bulgaria. Finally, the collapse of the Bulgarian front considerably influenced the destabilization of the Central Powers' armies on the other fronts—such as on the Austrian-Italian Front.

In addition to already existing studies on the Bulgarian, Greek, or British views, Bachinger analyzes the German and Austrian-Hungarian

part, in particular under the perspective of (military) cooperation with the Bulgarian alliance partner. Accordingly, the focus is on the nature of the Central Powers' coalition war on the Macedonian front. In this context, it is an achievement by Bachinger that his view, as well as his historical scientific analysis, goes well beyond the conventional horizon of interests, beyond structural, political, and military alliance policy and coalition warfare. This way he is able to reasonably combine conventional research interests with methods of new military history. Consequently, the author succeeds in deciphering the complex picture of heterogeneous motivations, objectives, and conditions as they were typical for this front. He also succeeds in pointing out the interactions of fundamentally different, mental and cultural group identities and their significance for the development of (sources of) frictions and disputes in the context of coalition warfare.

The study works out the nature of coalition warfare on the Salonica Front in much detail. It was something like a German-Bulgarian community of fate and purpose. The longer the war lasted, the more the German supremacy within this coalition created ever bigger problems, which were mostly results of a cooperation of "unequal partners." The German Supreme Army Command (Oberste Heeresleitung) determined the strategic military concept, occupied almost all key positions of the military command hierarchy, and provided the bulk of the military equipment; whereas ordinary combat was overwhelmingly shouldered by Bulgarian troops. The thus resulting uneasiness, general differences, and different mental dispositions and group identities prevented the development of any kind of collective and shared "regimental spirit." As a result, there was never any real "brotherhood in arms," like the propaganda during World War I—as well as a number of recollections after 1918—tried to pretend. This finding strongly resembles similar research results for other fronts and constellations of coalition warfare, such as the conflict-ridden cooperation of German and Austrian-Hungarian troops on the Eastern Front. Different war aims reciprocal resentment, and asymmetrical military capability caused the German-Bulgarian cooperation partners to have regularly falling outs with each other. A growing longing for peace and war-weariness, as well as the gradually petering out of material support by Germany, created wide-spread disillusionment among the Bulgarian troops. Anti-German resentment was growing as the Bulgarian side had the impression they were being abandoned by the Germans. The functionality of the German-Bulgarian alliance on the Salonica Front—this is worked out in detail by the author—was severely damaged even in the first half of 1918. "Thus, militarily seen, the German-Bulgarian alliance," as is Bernhard Bachinger's conclusion, "had

become a failure even months before the collapse of the Salonica Front" (p. 344). This failure was not only—as it has previously been emphasized by research—the consequence of political and economic alienation between Bulgaria and her alliance partners, but also the result of problems, differences, and disputes concerning the genuinely military realm, as the author succeeds in demonstrating.

Bernhard Bachinger has produced an interesting study, extensively researched, which represents an important contribution to a theater of World War I that has been neglected in terms of research until now.

Stefan Karner and Peter Ruggenthaler, eds., *1938: Der "Anschluss" im internationalen Kontext* (Graz: Leykam, 2020)

Ingrid Böhler

There is ample evidence to suggest that the Anschluss should be understood as the central, and, in a negative sense, the most momentous chapter in the history of 20th century Austria. Dealing with this event remains an indispensable focus of contemporary historical research and contributes to maintaining the importance of the Anschluss in the public consciousness. This is why the interconnection of contemporary historical research, commemorative culture and politics of memory remains particularly close for this topic, thanks to the wide range of events that took place in the 2018 "Year of Remembrance and Commemoration" with the participation of scientific, political and media representatives.

The renowned Ludwig Boltzmann Institut für Kriegsfolgenforschung [Ludwig Boltzmann Institute for Research on the Consequences of War] was one of the institutions that addressed the Anschluss on its 80th anniversary. In cooperation with the Russian Academy of Sciences and other partners, the Institute held an international conference on March 9, 2018, at the Diplomatische Akademie Wien [Vienna School of International Studies]. The anthology at hand is the product of this conference, which approached the finis austriae, i.e., the seizure of power by the National Socialists in March 1938, from an outside perspective. The keynote address, which is part of the anthology, was given by Emil Brix, Director of the Vienna School of International Studies, who got to the heart of the matter by posing the question: „How [could] Austria simply disappear from the map in March 1938 without major international resistance?" (p. 25).

In their foreword, the two editors point out that the Anschluss has been well-researched in many respects; this concerns the details of its implementation as well as the increasing threat to Austria's independence once Adolph Hitler took office in the German Reich in 1933. When Germany's Third Reich annexed its southern neighbor in 1938, protests from leading European powers and the United States failed to materialize, even though it was these powers that, in the 1919–20 Treaty of Paris, determined the post-World War I European order, obliging Austria to maintain its independence and prohibiting the German Reich from merging with Austria.

Other countries' attitudes mirrored the half-hearted, passive position of the dominant nations. With the onset of massive rearmament, and after the invasion of the demilitarized Rhineland, the Third Reich had violated central tenets of the Treaty of Versailles without consequence, which is all the more remarkable because international observers were aware of the coup's significance. As a consequence of the Anschluss, the world witnessed the emergence of a new geopolitical order in Central Europe; Germany's point of departure for further expansion had improved considerably. Most expected that Hitler would continue his aggressive course and further challenge safety and peace. Particularly for countries with ethnic German minorities, this involved very specific and alarming risk scenarios, numerous historical studies have found. The anthology at hand attempts to take a deeper dive behind the scenes of official or public statements. The editors emphasize that, especially in Austria's neighboring countries, research has not yet dealt with the assessments, fears, weight of interests, and dynamics that led to Austria's disappearance from the map.

The anthology's twenty-three articles have been divided into seven sections. The first part is made up of four articles that deal with the Anschluss itself, including its history. Erwin A. Schmidl explores the change of government to the National Socialists and the subsequent invasion by German troops. It cannot be emphasized enough that the invasion happened only after the change of government.

Franz Cede assesses Austria's loss of independence according to international law, discussing the international legal norms that the German military violated by its occupation of Austria. Cede concludes by pointing out that Chancellor Schuschnigg's behavior also raises questions; in his dramatic resignation speech on March 11, Schuschnigg announced that he had expressly instructed the Austrian army to remain in the barracks, thus waiving the right to self-defense provided for in international law. Chancellor Schuschnigg did not appeal to any other country for military assistance. The Western powers, with Great Britain and France leading the way, were not yet ready for a new war. Viewed in this way, Schuschnigg provided them with an explanation for why Austria did not receive any help and was left to its fate. However, the implications of Schuschnigg resigning weighed less gravely than the National Socialists' large following in Austria, highlighted by the cheering masses who welcomed the Wehrmacht and the anti-Semitic excesses in place even before the first German soldier had crossed the border.

Susanne Heim gives a concise description of the Anschluss's effects on the approx. 200,000 Austrian Jews, while Hannes Leidinger's article on

Austria's importance within Europe considers the entire period between the wars. The Austrian population, which viewed itself as ethnically German, famously did not identify with the new microstate (or, in part, with the new form of government). It wasn't much different abroad. In view of the economic crisis that never really abated during the 1920s and 1930s on the continent, few wanted to believe in the viability of the newly created "dwarf" in Europe's center; few considered its importance within the global community. Nevertheless, Leidinger identifies some opportunities (e.g., a confederation with the Danube states; Vienna as neutral grounds for encounters and mediation) and attempts for Austria to position itself as an international actor and take on a recognized role (which would prove successful in the Second Republic).

All attempts failed, however, albeit for different reasons. The most important factor was Austria's own political instability, while abroad there were additional influencing factors, including considerable fear in neighboring states regarding a potential restoration of the Habsburg monarchy. Additionally, national pride and special interests of individual states reared their heads. The major powers were concerned with their hegemonic intentions, while last but not least, the ideological confrontations that were dominating the continent during the "Age of Extremes" limited any potential options for alliances. In this minefield, Austria's foreign-policy flexibility was diminished even before Hitler appeared on the scene. Chancellor Dollfuss's transformation of Austria into a dictatorship only increased the distance between Vienna and both London and Paris, while Rome proved to be a fickle ally, making it increasingly difficult for Austria to counter and oppose the constant pressure of the Third Reich.

This nexus is addressed in Leidinger's contribution, and it also appears in the sixteen articles addressing the Anschluss from the viewpoint of indirectly affected countries, always referring to the respective case. A special case is Mexico, which was the only country in the world to protest against the Anschluss in writing before the League of Nations. Stefan Müller portrays both the background and motives of Mexico's foreign policy. He makes it clear that life with its (also overpowering) neighbor, the US, to whose detriment the authoritarian ruling President Cárdenas had just nationalized the oil industry, falls far too short as an explanation.

The Soviet position is addressed in particular detail by no less than six authors (Verena Moritz, Julia Köstenberger, Vladimir Švejcer, Vasilij Christoforov, Olga Pavlenko and Peter Ruggenthaler). Soviet Russia was not invited to the negotiating table in Paris and, from an early stage, did not count on the political survival of Austria as envisioned in the Treaty of

Versailles. Moscow's stance was determined by the Soviet Union's ideologically hostile relationships with both democratic and Fascist states as well as its need to preserve its influence regarding foreign affairs. However, there was no basis for concerted measures, let alone powerful alliances between the USSR and the West to confront the increasing danger posed by the Third Reich. More than anything else, from the onset offers of cooperation served as tactics or self-posturing; their seriousness was questioned reciprocally.

Compared to the Soviet Union, the reactions of the Western powers are addressed rather briefly, with France being neglected completely. Siegfried Beer highlights the limits of British commitment with regards to Austrian sovereignty. In his interpretation, Neville Chamberlain's policy of appeasement towards Hitler was a continuum. London would have been willing to agree to the unification of Germany and Austria as early as 1919. However, the French, with their aim to weaken Germany as far as possible, prevailed. Even then, Austria was no *causa prima* for the Foreign Office. As illustrated by the US files evaluated by Günter Bischof, Roosevelt simply followed Chamberlain's course while the overall US foreign policy moved within narrow boundaries. Roosevelt bowed to the isolationist mood prevalent in the country and tried to keep a distance from Europe's problems for as long as possible. Additionally, his hands were tied by US laws (the immigration quota system adopted in 1924 and the Neutrality Acts of 1935–37). Although the embassy staff in particular lacked neither understanding nor compassion regarding the persecution and expulsion of the Jewish population, effective help failed to materialize.

Michael Gehler and Stefan Karner focus on Italy, the former "protecting power." Both emphasize the policies regarding South Tyrol with their particular urgency caused by the new German-Italian border. Gehler portrays the path to resettlement of the 'Austrian' minority in South Tyrol. For Hitler, the solution to the South Tyrol question was the price of the steel pact; he needed this comprehensive military alliance with Italy for his expansion and war plans.

Stefan Karner focuses on a subgroup of the radical ethnic cleansing program that began in 1939: the Ladin-speaking residents of Val Gardena. It is somewhat confusing that Gehler's and Karner's accounts differ in two points. The first difference is the dating of the resettlement agreement negotiated between Rome and Berlin, while the second is the assessment of the so-called "Sicilian legend," which was synonymous for a rumor that those South Tyroleans of Austrian descent who did not opt for Germany would be forcibly relocated to southern Italy. Paolo Valvo analyzes the *Anschluss*

from the perspective of the Vatican. While the Holy See may have been extremely dissatisfied with Austrian bishops' April 10, 1938, appeal to all Catholics to vote for the *Anschluss*, it was not able to prevent the declaration.

Among Austria's neighboring states the *Anschluss* was particularly worrying for Czechoslovakia, and the radicalization of its German-speaking minority was an immediate result. Vít Smetana describes the development in the months between March and late September 1938, when Hitler, Chamberlain, Daladier, and Mussolini agreed upon the cession of the Sudetenland to Germany at their meeting in Munich. Long before the *Anschluss* the Horthy regime in Hungary had concluded that it was a historical necessity and "associated its fate with the enemies of Austria and Czechoslovakia" (p. 265), as Robert Fiziker aptly put it.

Belgrade officially called the *Anschluss* an internal German affair, while the assessments made internally were strongly influenced by the country's own domestic dissent. The Prime Minister hoped for the Croatian nationalism to abate, due to the increased external threat, and for the communist exile organization, which operated from Austria, to fall apart. The Slovenes rightly worried about their compatriots in Carinthia. Politicians in Serbia voiced fear about disadvantages for the "Little Entente," its alliance with Czechoslovakia and Romania that had existed since 1920. Yugoslavia, which was domestically torn, wanted to maintain a neutral position towards the Third Reich in order to avoid getting drawn into a war. Tamara Griesser-Pečar's very lucid overview investigates the period until the spring of 1941, focusing on reasons that led to the failure of these efforts.

Martina Hermann's contribution regarding Switzerland is also very concise: the diplomatic reporting from Vienna, the Swiss Media's response to the *Anschluss* and the Swiss government's official reaction are all presented clearly and neatly, while the refugee issue remains unmentioned. Numerous Austrian Nazi opponents tried to get to safety across the Swiss border within days of the *Anschluss*, and it is difficult to imagine that this dimension has been neglected by the sources as well.

Wanda Jarząbek's focus is on Poland. Her essay, which ends with the executed *Anschluss*, is based on the country's situation during the interwar period. Poland had been engaged in border disputes with almost all of its neighbors since its rebirth after World War I. The revisionist territorial aspirations of its large neighbors, Germany and the Soviet Union, represented a major permanent threat, which is why it was a declared main objective of Warsaw's foreign policy to secure its own borders through strong allies. Even though Austria may not have been a candidate, Poland kept a close eye on Austria's advancing rapprochement with the Third Reich starting

from 1936. Warsaw had to acknowledge that the Western powers were not ready to vouchsafe a guarantee for Austria. As early as February 1938, the *Anschluss* was considered inevitable. However, Warsaw clung to the hope that the integration of Austria would take its time, and that Hitler would therefore not be able to immediately deal with the issues of either the Sudeten Germans or Gdansk. In this same way, Poland remained steadfast in its calculated optimism that Hitler meant what he said when he asserted that he wanted to "only" correct the unjust provisions of the Treaty of Versailles. Warsaw was not alone in this attitude.

It is one of the characteristics of anthologies that individual articles are somewhat inconsistent in terms of length, footnotes, source material, depth of analysis, or the chosen approach to the topic. The quality of the articles translated from Russian also varies. When looking at the content, the abundance of conflicts, rivalries and unsolved problems that existed in Europe on the eve of World War II becomes obvious. It is also apparent that the other countries primarily judged the *Anschluss* on the basis of what it meant for their own relations with the Third Reich. *The 'Anschluss' in an International Context* gives detailed information on why Austria was no more than a sideshow on the stage of international politics. Last but not least, it provides exciting insights into the internal and external circumstances of the individual countries.

Dieter J. Hecht, Michaela Raggam-Blesch, and Heidemarie Uhl, eds., *Letzte Orte: Die Wiener Sammellager und die Deportationen 1941/42* (Vienna: Mandelbaum Verlag, 2019)

Evan B. Bukey

Between February 1941 and October 1942 some 61,000 Viennese Jews were deported to ghettos and extermination camps in Nazi occupied Poland, where all but a handful were subsequently murdered. Seized without warning from congested quarters in the Second District, they were driven in trucks in broad daylight through streets lined by jeering onlookers to four collections camps located in the Kleine Sperlgasse, Castellerzgasse, and Malzgasse. Here they were incarcerated for a few days to several weeks until taken to the Aspang depot, locked in cattle cars, and shipped off to be shot or gassed.

Although numerous studies have described and analyzed Hitler's persecution of Viennese Jews, including the contentious issues of collaboration by officials of the Jewish Community Council (*Israelitische Kultusgemeinde - IKG*), the essays in this outstanding book are the first to be based on newly discovered documents, letters, diaries, postcards, interviews, and even photographs. After recounting the tribulations of the Jewish population imposed by Adolf Eichmann's "Central Agency for Jewish Emigration" (*Zentralstelle für jüdische Auswanderung*), characterized by the authors as the "Viennese Model" for the deportation of Jews throughout Hitler's realm, the authors provide details on the organization and operation of roundups by teams of SS and Jewish detainees. The victims were given two hours to pack their belongings before being taken to overcrowded collection camps. Here they were stripped of most of their clothing and forced to spend time on straw mattresses. They were also forbidden to wash and supplied with meagre quantities of food by the Jewish Community Council. Survivors recall beatings and other brutalities at the hands of SS officials Alois and Anton Brunner, even by those later released as *Mischlinge*. To maintain the facade of legality the Nazis kept meticulous records of those few consigned to work, and the majority doomed to "evacuation."

Subsequent essays provide details on the process of deportation. Anton Brunner, for example, personally prided himself on dispatching 48,000 Jews, insulting and slapping them as Jewish "swine" and "parasites." Victims were then brought to two tables, one for males, another for females. Gestapo

agents classified them as "Full Jews," handing them a document stamped "Evacuated." At a third counter the Jews were stripped of all assets, including cash and even opera glasses. From there they were locked in a holding cell to spend the night before boarding trains to killing centers in Poland.

That said, Walter Manoschek explains that the 2003 men, women, and children deported by Baldur von Schirach in February and March to Opole, a Polish Shtetl, were not initially murdered. Forced to sleep on straw mattresses in overcrowded buildings without electricity, heating or other necessities, they were brutally treated, but enjoyed a certain freedom of movement. In June, however, the Nazis erected a ghetto surrounded by barbed wire, where many starved to death or died of typhus. Similar conditions prevailed in towns such as Medliberze, Opaw, and Kilice until August 1942 when the Jews were dispatched to Treblinka and Sobibor to be gassed upon arrival.

In two microstudies Dieter H. Hecht and Gabrielle Hecht examine the carriers and ambivalent motives of three Jewish functionaries who collaborated with the Nazis in preparing lists of coreligionists to be deported, assisting the SS in roundups, and acting as scouts to ferret out Jews in hiding. Were they motivated by self-preservation or a desire to protect their coreligionists? One of them, Kurt Mezi a nineteen-year-old trained electrician, volunteered to work for the IKG after the *Anschluss* in order to maintain Jewish facilities, including hospitals and nursing homes. Over time he was coopted in preparing lists of deportees in alphabetical order. Mezi sensed that the deported would be murdered, as revealed by a poem suggesting that he had no other choice but continue collaboration with the IKG in the hope of saving some lives. An associate, Walter Lindenbaum, was one of a dozen who worked in collection camps, until April 1943 when he himself was shipped off to Theresienstadt. Here he became one of the camp's cultural elites, known also for assisting other inmates. In early 1945 both he and Mezi perished shortly before liberation.

The career of a third Jewish functionary, Robert Prochnik, discussed in a lengthy essay by Gabriela Anderl, is more comprehensible. Long before the *Anschluss* Prochnik had served as an active member of the Jewish Community Council, effactually becoming the right hand man of Rabbi Benjamin Murmelstein, the de facto head of the Council. Like Murmelstein, Prochnick chose to stay in Vienna after the Nazi takeover, working tirelessly in following years to secure foreign visas for émigrés, most notably in China. He also secured funds from Berlin, for which he was criticized by the American Joint Distribution Committee and the Reich German *Reichsvereinigung*. In September 1942 Prochnik was deported to

Thersienstdat, where he was despised for his autocratic collaborative behavior. Joined by Murmelstein the following year, both survived the Holocaust only to be charged by survivors as "Jewish Nazis." Prochnik then moved to England where he lived until his death in 1977. Without downplaying Prochnik's brutal behavior, such as forcing inmates to work exhausting daily hours, Anderl tends to agree with Israeli historian Doran Rabinovici that like Murmelstein, Prochnik could have fled Vienna but chose to stay and, through collaborative behavior, did indeed save many lives.

Using photo albums, postwar trial records, and other documentary evidence, Markus Brosch examines the careers and behaviors of eight SS officials in the Viennese Jewish deportation collection camps. Foremost among them were Alois and Anton Brunner, discussed in numerous other articles in this volume. Nearly all came from lower-middle class backgrounds, such as a furniture maker, a carpenter, an electrician, a book dealer, or, like Eichmann, a salesman. Most had been members of the illegal Nazi party, although Anton Brunner had been a Social Democrat attracted to Hitler's movement only after being dismissed from his job by the Christian Corporative regime. As *"Eichmann–Männer"* they became operational executives of the Holocaust throughout Europe after October 1942. Letters, postcards, and photo albums reveal that they shared a sense of camaraderie and relished their duty assignments.

Michaela Raggam-Blesch's essay is difficult to assess. The author disingenuously claims that research on the plight of intermarried families and *Mischlinge* between 1943 and 1945 has been ignored by historical scholarship, knowing full well that my 2011 book *Jews and Intermarriage in Nazi Austria* devotes twenty-six pages to this topic.[1] That said, the author reminds readers that the status of mixed couples and their hybrid off-spring confounded Nazi officials from the promulgation of the Nuremberg laws in 1935 until the collapse of Hitler's regime ten years later. At the Wannsee Conference in January 1942, for example, two-fifths of the discussion focused on Reinhard Heydrich's proposal to include *Mischlinge* in the Final Solution. Here, and in a number of follow-up conferences, officials hesitated to deport half-Jews for fear of provoking social unrest, particularly in Catholic regions, such as incorporated Austria.

In January 1943, the Jewish Council of Elders in Vienna employed 5,564 racial Jews, who were either married to Aryans or held foreign citizenship. Only 2,425 of the total practiced the Jewish faith. According to a recently discovered document, Rabbi Löwenherz described the tensions within the Council, as over half of his charges lived in "privileged mixed marriages," considered themselves Catholic, and were free to come and go

without wearing the Jewish Star. Shortly thereafter the Nazis tightened the screws, most notably on "non-privileged" couples and their children, who were compelled to wear stars, sustain a cut in food rations, and forbidden to buy clothes or soap. Pressure was also put on gentiles to divorce their Jewish partners. This enabled the Gestapo to snatch individuals on the street for not wearing the star in order to deport them from collecting camps to Theresienstadt or Auschwitz. In addition, some 1,500 adult *Geltungsjuden* were rounded up and dispatched to Auschwitz In October 1944. The remaining intermarried Jews were conscripted to work sixty-hour weeks in the *Organisation Todt*, either in local enterprises or constructing the South East Wall on the Hungarian border. While much of the information in Raggam-Blesch's article is well known or discussed by me, the author does provide many new details and insights using archival research and personal interviews throughout Europe, the United States, and Israel.

Brigitte Ungar Klein ignores Gwyn Moser's pioneering study of "Jewish U-boats in Austria,"[2] instead relying on Gestapo reports, documents in Yad Vashem, and numerous interviews to greatly expand our knowledge of those Jews who survived in hiding and those non-Jews who hid or protected them. Her meticulous research reveals that 1,634 persons hid out following the *Anschluss*, of whom one-third perished in the Holocaust. Women and young children stood a better chance of survival than men, as they were not subject to conscription. Many avoided detection riding trams in daylight hours, spending nights in churches or cemeteries, and eating fruits and vegetables in remote places. After the outbreak of Hitler's war, a number found "helpers," who sold ration stamps on the black market, permitted others to live in allotment gardens, or in few cases provided room and board in their apartments, much like the Franks in Amsterdam. In late 1944 a good many "U-boats" were able to emerge from the rubble caused by Allied air raids, tear off the Jewish Star, and after 1945 resume or attempt to resume normal lives. Klein does not provide much information on those non-Jews who provided protection, a number of whom were farming families. Instead, she stresses both the psychological damage suffered by the victims and the shameful refusal of Austrian courts to recognize them as such or provide restitution.

In a capstone chapter Eva Holpfer provides a detailed account and analysis of trials undertaken by the Austrian judiciary (*Volksgerichtshof*) according to the War Crimes Act of 16 June 1945. Those prosecuted were thirteen SS officials who had belonged to Eichmann's Central Agency for Jewish Emigration and thus were responsible for the deportations of 49,000 Viennese Jews. Of these, Anton Brunner and Siegfried Seidl were

sentenced to death and executed, Alois Brunner fled to Syria, Anton Burger escaped and lived the rest of his life in Bremen. Another, Rudolf Hunds, was extradited to Czechoslovakia and executed in 1947. The rest received sentences ranging from life to ten years in prison. Although trials continued following the Amnesty Act in 1948, Holpfer stresses that most perpetrators escaped prosecution. The most egregious case was that of Franz Novak, responsible for dispatching 476,000 Hungarian Jews to Auschwitz in 1944. The following year, he evaded the authorities by returning to Vienna under a fictitious name. After the repeal of the Prohibition Act 1n 1957, he resumed his real name but was left alone until brought to attention of the judiciary during the Eichmann trial in Jerusalem. Thereafter, he was tried and convicted in numerous trials in Frankfurt and Vienna, but was released in 1972 on a technicality.

In the final pages of *Letzte Orte*, Heidemarie Uhl summarizes the authors' findings, stressing that in 1941-42 a large number of Viennese citizens both witnessed and endorsed the deportation of the Jews, but after 1945 they fell prey to collective amnesia. Even after the Waldheim affair compelled Austria to come to terms with its Nazi past, the four collective camps were either forgotten or ignored. To be sure, a few plaques were erected by the small Jewish community, but not until the twenty-first century were memorials, landscape designs, and *Stolpersteine* installed in the four collective camps as well as the former Aspang train station. Overall, this fascinating and depressing book illuminates previously unexplored details of the Holocaust in Austria.

Endnotes

1 Evan Burr Bukey, *Jews and Intermarriage in Nazi Austria* (Cambridge: Cambridge University Press, 2011).

2 Gwyn C. Moser, "Jewish U-Boote in Austria, 1938-1945," *Simon Wiesenthal Center Annual*, 2 (1985): 53-62.

Margit Reiter, *Die Ehemaligen: Der Nationalsozialismus und die Anfänge der FPÖ* (Göttingen: Wallstein, 2019)

Anton Pelinka

Margit Reiter's book closes a gap. Her book is an excellent study about the transformation of Austria's "third camp" after 1945. The Pan-German ideological tradition, represented by Georg Schönerer at the end of the monarchy and politically in the first republic by the *Großdeutsche Volkspartei* and the Landbund, had become integrated into the NSDAP. Most of the Pan-German activists in Austria had joined the Nazi movement; some rose to prominence in the SS and other parts of the machinery of the Third Empire. Two of them were hanged in Nuremberg, 1946.

But what should the second Austrian republic do with the more than two-hundred thousand registered members of the NSDAP, who were citizens of Austria? In the elections of November 1945, they were excluded from the electoral process. But most of them were re-enfranchised for the elections of 1949. Only high-ranking former Nazis were still excluded until 1955. The political parties which had signed the declaration of independence on 27 April, 1945, started to woo the *Ehemaligen* – the Austrians registered as members of the NSDAP in 1945. Their votes were seen decisive for the outcome of the elections beginning in 1949.

The competition for the votes of former Nazis explains main aspects of the second republic's ambivalence in confronting Austria's history. The discourse about perpetrators, victims, and bystanders in the years between 1938 and 1945 has been blurred by the electoral interests of ÖVP and SPÖ in an effort to avoid the most sensitive parts of the self-understanding of the social segment both parties wanted to win. There were many more former Nazis in Austria than survivors of concentration camps. Some of the former Nazis became ÖVP- or SPÖ-voters – under the condition of forgiving and forgetting. Others who were not won by the two main-stream parties created their own party.

Some of the former members of the NSDAP were successfully won over by the existing parties – by the ÖVP and the SPÖ, and even the communists succeeded to a small degree to convince former Nazis that their future would best be protected by the KPÖ. But those among the *Ehemaligen* who did not want to vote for any of the anti-Fascist parties created their one organisation – the *Verband der Unabhängigen* (VdU). This

party, led by Herbert Kraus—one of the few in the VdU who had not been a member of the NSDAP, succeeded in the elections of 1949 and 1953. Internal differences resulted in the breakup of the VdU and the foundation of the FPÖ, whose chairman was Anton Reinthaller, one of the most prominent figures of the NSDAP in Austria before and after 1938. The FPÖ was even more than the VDU the visible continuity of the NSDAP – not institutionally but personally.

Margit Reiter documents this personal continuity. Research concerning the developments of ÖVP and SPÖ has shown "brown spots" in the history of the two main-stream parties, former Nazis in the ranks of both. The FPÖ has been a party with some non-brown spots. Former Nazis were the rule in the party's leadership, non-Nazis the exception to that rule.

The book was published at the right moment. In 2017, the FPÖ had established the *Historikerkommission*; a commission to deal with the party's history. When the findings of the commission were published in 2020, the too-sensitive taboos had not been touched. The open anti-Semitism and existing neo-Nazi- traditions in the *Burschenschaften*, the duelling fraternities – the most important reservoir for the recruitment of the party's leadership – could not be analysed because archives were kept closed. Margit Reiter's book is, in some respects, the necessary alternative to the commission's report, touching the issues the party itself has not dared to.

Reiter discusses the rather painful aspects of the years after 1955. It is important that the informal alliance between Bruno Kreisky and Friedrich Peter, Reinthaller's successor as the FPÖ's chairman, is described – including the consequences. These include the SPÖ's inclination to forgive and forget Peter's role in a murderous SS-unit; Kreisky's willingness to pay a price for Peter tolerating the first Kreisky cabinet in 1970; and the preparation for the SPÖ-FPÖ coalition from 1983 to 1986.

Reiter's extremely important book is not free of some minor mistakes. For example, Lujo Toncic-Sorinj was not Minister of Education in the ÖVP-government of 1966, but Minister of Foreign Affairs, Kreisky's immediate successor in that function. Not so minor is Reiter's use of the term *Belastete*—a term she uses to indicate some link to Nazism but not explaining which kind of burden. *Ehemalige* had been defined as former members of the NSDAP. But which criteria Reiter used to define *Belastete*? This term creates a grey zone between *Ehemalige* and non-Nazis.

Margit Reiter's publication, widens and deepens the discourse about the history of post-1945 Austria. Reiter clarifies the perception of Nazism, which as a mind-set was not simply overcome in 1945. It helps to understand the FPÖ as a party growing to European prominence out of the ashes

of Nazism. In the 1980s and 1990s, the FPÖ became – together with the French Front National – the model case for successful right-wing populist parties. Reiter demonstrates the roots of that party. The party's history leads from Georg Schönerer to Adolf Hitler, to the SS-officers Anton Reinthaller and Friedrich Peter and on to Jörg Haider and Heinz-Christian Strache. The FPÖ hesitates—for understandable reasons—to confront its own history.

Gundolf Graml, *Revisiting Austria: Tourism, Space and National Identity, 1945 to the Present* (New York: Berghahn Books, 2020)

Laura Morowitz

As both an economic engine of society and a realm of the imaginary, the subject of tourism makes for fascinating study. Paying close attention to both aspects, while exploring in new and multi-faceted ways the intersection between Austrian national identity and the tourist industry, Gundolf Graml's *Revisiting Austria: Tourism, Space and National Identity, 1945 to the Present* is a nuanced, complex and astonishingly well-researched book. Spanning the immediate post-war years until the packaged tours of today, the book provides keen analysis and criticism while opening up new avenues of inquiry.

In his introduction, Graml sets out the central goal of this lengthy study, to show "how the multifaceted interconnections between tourists and locals, between places and spaces of history and culture, and between notions of reality and inauthenticity have shaped the construction of Austria's national and cultural image after 1945" (p. 25). From the start Graml refuses to reduce tourism to simple nostalgia and romantic escapism (although he doesn't deny those aspects either), rejecting early scholars like Hans Magnus Enzensberger who saw tourism as a form of "false consciousness," or Dean McCannell whose classic study portrayed tourism as a failed antidote to modernist alienation. Instead, he cites as influence books like Peter Thaler's

The Ambivalence of Identity (2001) and Alan Confino's writings, which understand tourism as an attempt to establish "normalcy" after the shock of war, while simultaneously reshaping national identity (p. 133). The book is also deeply informed by related texts on German place and identity such as those of Rudy Koshar on the Baedeker guides and Confino's writings on the Heimat.

For Graml, tourism is a lens through which to look at the shifting landscape—both literal and metaphorical—of Austrian identity, among Austrians themselves and in the perception of foreigners. Graml is particularly well suited for this task: a scholar at an American university, he is also a native Austrian, and former inhabitant of the Austrian tourist locus par excellence of Salzburg. This gives him a unique vantage point to appreciate that the artifice of a tourist site does not always break its spell. His ability to

consider the function and meanings of tourism for both outsiders and for natives is one of the great strengths of the book.

The book is divided into three sections, each of which has the richness and heft to stand on its own (the eBook totals 772 pages). One of the truly extraordinary merits of the book is that, while conveying much about Austrian post-war, Cold War, and contemporary politics, Graml's study could almost serve as a microcosm of the varied methodologies and approaches in the humanities today. For each chapter Graml has digested an entirely new bibliography (smartly provided at the end of their respective chapters). While Part II relies on the literature of collective memory, other chapters range through the most important theoretical texts in film studies, while still others examine the interplay between gender, the disciplining of bodies and national identity. Returning to classic studies, Graml also looks at concrete manifestations of tourism through guidebooks and interviews with tour guides.

Part I, "'Where Is This Much-Talked-Of Austria?' Remapping Post-World War II Austria," reveals how tourist books, films, and practices worked to establish an independent Austria as a pre-existing entity. The bucolic, sublime landscape of the Tyrol would be a central feature in bestowing a new identity on the country, separating it from Germany. By its very nature, the tourist industry relies on a welcoming and friendly ethos, an image that would help to distinguish it from the hostile and aggressive German "invader" and help rewrite Austria's role as Germany's first victim. Graml deftly reveals how the image of lederhosen and *Dirndl*-clad peasants strolling through snow-capped mountains was shifted from an emblem of the *Volksgemeinschaft* to a picturesque, self-enclosed rural culture that had little in common with known German sensibilities. The alpine landscape—upheld during the Third Reich as a "racial barrier" to the East and the imagined site of the last Nazi holdout—came to be refitted for the pleasures of sport and wholesome nature loving. Graml explores the fascinating gendering of this landscape as "feminine" to further play down its aggression (p. 88–89). The *Book of Austria*, a 1948 publication by the official Austrian press service, is carefully analyzed. Graml notes that the book cleverly opens with a photo of the Venus of Willendorf to establish an Austria *avant-la-lettre*. (In my own research I have seen how this move is paralleled in art history books of the period, which open with works from the Hallstatt culture as evidence of "Austrian" style millenia before modern nationhood.)

These chapters are followed by analysis of two post-war tourist films. Graml's approach differs from Maria Fritsche's chapter on "The Tourist

Film" in her *Homemade Men in Postwar Austrian Cinema* (Berghahn, 2013), which sees the primary function of such films as deflection and escape. Her argument that such films also fostered female independence and gender equality through the emphasis on mobility and adventure is countered by Graml. Her thesis might have been interestingly contrasted with Graml's arguments about the "masculine gaze" of the *Book of Austria* and the gendering of landscape as feminine "to enforce gender norms through tourist images" (p. 118). Graml's analysis of *Der Hofrat Geiger (*1947) is worthy but a bit too long at forty pages for a book not exclusively devoted to film theory but to tourism in general. The *Echo der Berge/Der Förster vom Silberwald* (1954) is discussed for the ways in which it attempts to negotiate Austro-German relations, in the face of National Socialist crimes. Graml sees the "awkwardness, contrived nostalgia and gaps in dialogue" (p. 301) within the film as indicative of the difficulty in Austrian attempts to forge a new and separate national identity.

The book shifts gears in Part II, "Dark Places: Tourism and the Representation of Austria's Involvement in National Socialism and the Holocaust." The first chapter looks at the European Capital of Culture program organized by Linz in 2009 to acknowledge its history as *Führerstadt*. Graml offers criticism of the program for failing to successfully reach a compromise between historical accuracy and empathetic, secondhand "witness," drawing on the literature of "prosthetic" and embodied memory. The argument is hampered by the lack of good images to help the reader understand how the works functioned (Hito Steyerl's *Unter uns: Dekonstruktion eines Gebäudes; Eine Installation* [In our Midst: Deconstruction of a Building; An installation] is photographed from an angle which makes it hard to "read.") The larger issue, however, is that this chapter seems somewhat out of place in the book, less about tourism per se, than about heritage and memorial culture. It is the only chapter which veers away from alpine landscape tourism to focus on a city.

Graml's thesis is better served in the following two chapters on literary works. "Alpine Vampires: The Haunted Landscapes of Elfriede Jelinek's *Die Kinder der Toten* (The Children of the Dead)," convincingly shows how the author paints the alpine landscape of tourism as one of violence, haunted by ghosts of Austrian Jews murdered in the Holocaust. (This approach might yield interesting results if applied to contemporary landscape paintings.) "The Blind Shores of Austrian History: Christoph Ransmayr's *Morbus Kitahara* (The Dog King)," explores the Salzkammergut as a "ghost map," citing the fascinating literature on the presence/absence of the Jew in this region.

The final section of the book is devoted to "Austrian Narratives of Place and Identity in the Context of Globalization" and brings the reader into the present day. It offers an engrossing reading of the film *Suzie Washington* (1998), revealing the gap between the friendly tourist image and the experience of outsiders, a film even more poignant in the wake of the migrant crisis throughout Europe. The bulk of the section is taken up by two compelling chapters framed around *The Sound of Music* (1965), whose draw has become near synonymous with tourism in the Salzburg region (and which allows Graml to circle back to the theme of tourism and performativity). Admirably summing up the vast stores of literature on the subject, which has shown how the von Trapps came to stand for the "good Austrians," as well as a host of family values, from patriarchy to women's empowerment, Graml aims to add a new layer of understanding: "Instead of treating Sound of Music tourism as an event that happens within an already defined place—for instance in the Austrian nation-state—I consider it a set of practices that enables ever new manifestations of Austrian-ness" (p 596). If always appealing to tourists, Graml notes the way in which the phenomenon has transformed for Austrians. While once recoiling from it as an example of kitsch and cliche, many Austrians have now come to embrace it as a genuine part of their (national) identity. Probing the packaged SOM tours as examples of "existential authenticity" and "embodied experience," Graml makes clear the pointlessness of condemning or dismissing them for not being "accurate;" tourists after all are in not in search of the "real" von Trapps but their fictional counterparts. What difference does it really make, Graml asks, if the glass pavilion at which they pause to take photos is "original" (p. 643)? The landscape they are seeking exists as much in their childhood fantasies as it ever did in reality. (This line of inquiry reminded me of medievalist Keith Kelly's point that to quibble over the "accuracy" of medieval films is somewhat misplaced since what we know of the "truth" often comes from epic poetry and other fictionalized accounts.) This section raises many interesting points in regard to issues of national identity, historical truth and myth-making. Is the Warsaw Royal Castle, for example, having been utterly destroyed and is in essence now a facsimile, less of a symbol for national pride because of that reconstruction?

It seems somewhat unfair to complain about the length of a book so full of insights, but it *is* truly long. The conclusion of chapter one puts us at page 175 of the book; the discussion of Sound of Music tourism totals nearly 200 pages. I wondered if the middle section on "Dark Places" might not form its own separate study? This might have left room for a section on that "other" Austrian tourist draw, imperial Vienna, the city of Sissi and

Schlag. How did this tourist image of the country, both against and in conjunction with, the rolling sound-of-music hills of Austria, work to effectuate the post-war myths of the *Opfernation* and the *Stunde Null*? Among others, scholars Michael Steinberg, Jill Steward and Matthew Finch have argued that the post-war emphasis on alpine Austria was precisely to deflect from that other—and Jewish—Austria of Vienna 1900. In contrast to Salzburg, how does Vienna 1900 tourism function today as a model for a multicultural model of Austrian diversity and cosmopolitanism? How do Austrians themselves, including Austrian Jews, feel about the image of Vienna sold in tourist packages and advertisements?

A work of serious scholarship, and a model of interdisciplinary cultural history, *Revisiting Austria* will no doubt be revisited time and again by those with an interest in Austrian post-war history, the literature on national identity, and the growing field of tourism studies.

Manfred Mugrauer, *Die Politik der KPÖ 1945–1955: Von der Regierungsbank in die innenpolitische Isolation* **(Göttingen: V&R unipress/Vienna University Press, 2020)**

Günter Bischof

This is a thoroughly researched book, based on the author's University of Vienna dissertation. It is a long and detailed narrative, probably a direct publication of the dissertation without making an effort to boil down the publication to the essential arguments. As the subtitle suggests the main argument is that the Austrian Communist Party (KPÖ) was part of the Provisional Renner Government; given the bad election results for the KPÖ in the 1945 and 1949 elections the Communists were increasingly isolated and concentrated as an opposition party their work on "mass action," after the last Communist minister resigned from the Cabinet in November 1947 over the currency reform issues.

The high point of the KPÖ's role after World War II clearly was its representation in the provisional Renner government. This was allowed by the Red Army and Stalin in the Kremlin to form in late April, after the liberation of Vienna by the Red Army, and therefore not recognized by the Western powers. Unlike the Socialist and the Conservative People's Party, also represented in the Provisional Renner Government, the Communist leadership returned from their wartime exile in Moscow (Ernst Fischer and Johann Koplenig) and from Slovenia, where they fought in the resistance (Franz Honner and Friedl Fürnberg). Koplenig was part of the Cabinet Council (de facto a Vice-Chancellor), Honner was appointed Interior State Secretary, and Fischer State Secretary for Education (*Volksaufklärung*) (p. 45), so the Communists had a strong representation in the Renner Cabinet. For this reason the Western powers did not recognize the Renner Government until October 1945. The Communists set out to put their agenda into practice: denazification, nationalization of industries owned by Germans and foreign capitalists, cooperation with Socialists in achieving an anti-Fascist consensus, as well as close cooperation with Soviet Union and Eastern Neighbors (p. 47).

The KPÖ's principal goal was a "step-by-step advancement towards socialism" (p. 49) and the establishment of a "people's democracy" (p. 49). Mugrauer is beating about the bush when admitting that establishing a *Volksdemokratie* was the ultimate goal because by 1947-48 it had become

the bugbear of anti-Communist propaganda (p. 500). At that time the people's democracies of Eastern Europe (otherwise known as the Soviet satellites) served as "models" (*Vorbild*) for the Communists towards Austria's "better future" (p. 500). At the end of 1949 Ernst Fischer was convinced that a "people's democracy" would come to Austria too, as a result of "the struggle of the Austrian workers" and without the help of the Soviet Union or neighbors to the East (p. 616). The big issue for the Communists, then, was how to establish a "people's democracy" if you do not have the support of the electorate, short of seizing power?

The first big issue to be tackled by the Renner Government was a new constitution. One was to be written for the re-established Austrian Republic. As early as May 16, when the rest of Austria had been liberated from the Nazis too, the Cabinet Council decided on the constitutional transition to the Constitution of 1920 (revised in 1929). The Socialist Adolf Schärf did not want to give the Communists a chance to start a basic constitutional debate (p. 53). The Communists wanted an "up-to-date democratic constitution" with stronger basic rights that would reflect the move to the left occurring in Europe at the time, not a restoration of authoritarian conditions prevailing in Austria prior to 1933 (pp. 53f). Given that the Communists and the rest had very different ideas of what constituted "democracy," this debate still almost ended in the break-up of the three-power coalition in the Provisional Renner Government (p. 54). Mugrauer asserts that this decision was a "early move towards restoration" and put the KPÖ on the defensive (p. 57).

Nationalization of industries was another item in the Communist program that they failed in. Already in exile, they advocated for nationalizing the "German assets" and eventually nationalizing all basic industries (p. 233). The "new class struggle" occurred between all "great capitalist monopolies" that were "enemies" of the rest of the people (pp, 235f). The Potsdam Conference allowed occupation powers to exploit the "German assets" in their respective zones (p. 239). Still, the Communists kept insisting on a quick nationalization of industries, even though the Soviets has been seizing "German assets" in their zones and dismantling them to be shipped to the Soviet Union. In the case of the Austrian oil industry, the Soviets wanted to form a "mixed corporation" with the Austrian government to control it. The Western powers stopped the Renner Government in the last minute from signing such a deal. The Soviets simply seized the entire oil industry (pp. 242-45). As a result of the dismantling of vital Austrian industrial assets, the KPÖ suffered egregious damage to its image in Austria. As Mugrauer admits "the economic interests of the Soviet Union had a higher

priority than any negative repercussions for the Austrian Communists" (p. 259). Koplenig pressured Marshall Koniev to stop removing machinery and industrial assets. The removal of assets, after all, "robbed the workers of their livelihood" (pp. 259f).

Here was one of the principal reasons the Communists lost their credibility among the Austrian people and were branded as "the Russian Party" (*Russenpartei*), feeding Austrian anti-Communism (p. 557). In the Austrian perception "Russians and Communists" were identical, with the consequence that "anti-Communist prejudices could be seamlessly transferred to the [Austrian] Communists" (p. 566). Mugrauer bemoans the fact that until today the "negative image of the Soviet occupiers as pillagers and rapists dominates Austrian mass consciousness" (pp. 555f). Austrian anti-Communism thus became the "integrational ideology of the Austrian era of reconstruction"; this anti-Communist consensus, he insists, even became part of Austrian identity (pp. 552f).

The KPÖ was a leading party in postwar Austria in insisting on swift and thorough denazification. The Communists differentiated between "Nazi bigwigs," who had been involved in committing war crimes, and the "small fry" of regular party members. Whereas the big Nazis ought to be persecuted and severely punished, the *Mitläufer* should not be punished and be "won for democratic reconstruction" (p. 201 and *passim*). The Communists developed these ideas about denazification in exile and pushed them in the provisional Renner government. Before the capitulation of the German Wehrmacht, the Renner Government passed the *Verbotsgesetz*, banning the Nazi Party and its suborganizations and forcing former Nazis to register (only to amnesty them one-by-one later). Mugrauer argues that this "bureaucratized" the denazification process (p. 212) and watered it down. The *Kriegsverbrechergesetz* was passed on June 26, 1945, allowing for the persecution of war criminals (p. 215). Mugrauer than goes through the tergiversations of mild Austrian denazification and the various amnesties for Nazis. He concludes that the ÖVP's and SPÖ's policy of "integrating the former Nazis amounted to a failure in dealing with the National Socialist past" (p. 232), which was never the anti-Fascist KPÖ's intention.

The KPÖ became notorious as the "Party of the Russians" (*Russenpartei*). Mugrauer notes somewhat begrudgingly that Soviet "occupation practices" of "pillaging, raping, and kidnapping" (*Plünderungen, Vergewaltigungen und Veschleppungen*), "negatively affected the KPÖ" (p. 492). This seems the only time in a book of 800+ pages that Mugrauer mentions kidnappings. Yet, the terroristic Soviet practice of arresting Austrians on the way to work, out of their offices, or in their homes without any warning —and often on

trumped-up charges—created as much a fear of the Russians as anything else they did. Based on Russian archival sources, Harald Knoll and Barbara Stelzl-Marx have accumulated a database of some 2,201 such kidnappings of civilians. Among them were high-level officials such as Margarethe Ottillinger, snatched out of the car of the Minister she was travelling with, or the police officials Anton Marek and Franz Kiridus. The Soviets justified such apprehensions with putting people on trial for espionage, "Werewolf activities," illegal possession of arms, war crimes, or even for "being related to Hitler." Most of them were men, some women who had affairs with Red Army soldiers also landed in the Gulag. Among the 2,201 people seized, 751 are unaccounted for to this day. When people disappeared, they went into Soviet jails and were put on trial by military courts. Many were executed or landed in the Gulag for years, with their loved ones uninformed about their whereabouts. Most were returned in 1955-56 after the signing of the State Treaty.[1]

Make no mistake, the issue of these intimidating abductions was regularly discussed and fretted about in the Austrian Cabinet. Mugrauer, who has mined the published Cabinet protocols prodigiously, seems to have missed these frequent discussions. On September 16, 1947, the Cabinet discussed the abductions of the Lower Austrian deputies Franz Gruber and Ferdinand Riefler. Gruber was apprehended in his apartment for illegally carrying weapons. He was convicted and had to serve five years of forced labor. He died in Soviet captivity and his family wasn't informed until 1955. Herbert Schretter had criticized the Soviet occupiers in meetings with wine growers. He and Riefler were denounced to the local Soviet commander and apprehended. Riefler has to serve four years years of forced labor, while Schretter faced seven. Interior Minister Oskar Helmer commented that the "punishment [of these men] reminded him of medieval methods" and the Allied Council should be confronted with these Soviet practices. Josef Gerö, the Minister of Justice, noted that in the occupation regime "power is trumping the law."[2]

In the meeting of December 23, 1947, the disappearance of the high ministry official and Austrian Railroads executive Paul Katscher was discussed. He was likely put on trial for "espionage", having participated in discussions about the Marshall Plan in Paris earlier in the year. He passed away in a transit camp in Lemberg/Lwow (today's Ukraine) on his way to the Gulag. Interior Minister Helmer noted in the Cabinet discussions: "People disappear every day. You cannot do anything, maybe protest." Chancellor Leopold Figl remarked: "The Katscher case has moved the population for weeks now. This puts the government into a very difficult situation. Next

Thursday I will meet with [Soviet Deputy High Commissioner Alexej] Zheltov and complain."[3] Not only does Mugrauer ignore the details of these numerous abductions, in the same vein he ignores the many incidents of rape by Red Army soldiers during and after the liberation of Austria in 1945. Of course, such Soviet actions have produced a seering anti-Communist memory in the Austrian population.

Mugrauer, however, dwells on the European Recovery Program (ERP) and Soviet and echoing KPÖ propaganda against the "Marshallization" of Austria. The Marshall Plan was seen as a strategy to colonize and enslave Austria. The Austrian Communists, now in opposition, attacked the Figl Government to serve foreign interests and denounced them as "agents and lackeys of American capitalism." The KPÖ argued that the ERP was "deindustrializing" Austria, cutting its trade with the East, and giving preference to Western Austria (pp. 624f). They further argued that the ERP was "diminishing the standard of living," leading to mass unemployment and the "impoverishment of the masses" (p. 628). The Austrian Communists stubbornly followed Stalin's ideological lead that capitalism would be reaching a crisis point after World War II and would die (p. 629). Never mind that most histories of postwar Austria and Western Europe argue that the Marshall Plan helped ring in what Eric Hobsbawm calls "the golden age" (1950-70) and Ian Kershaw "the good times" of rising living standards and high employment, alongsidea sound rebounding of capitalism.[4] The Marshall plan helped the Grand Coalition government to push the country towards "a Western orientation, restoration of capitalism and anticommunism" (p. 18), which left the KPÖ on the margins of Austrian politics, is one of Mugrauer's principal thesis.

Mugrauer spends a lot of time and space acknowledging that the Communists wanted to move the masses towards a "people's democracy" but never harbored any putsch plans to take over the Austrian government like their Hungarian brethren did in May 1947, or their Czechoslovak brothers in February 1948. Mugrauer argues that, as a result of the outbreak of the Cold War (especially 1947-50), rumors of a Communist putsch and takeover of the government were spread "to discredit the KPÖ" and "to raise fears of a Communist danger" (p. 586). Whereas politicians like Socialist Vice Chancellor Adolf Schärf spread such rumors, Mugrauer argues that inside the SPÖ and the ÖVP "Communist Putsch attempts were considered unlikely" (p. 591). Yet, he argues putsch rumors were spread as a means to disqualify Communist "mass action" against the government's four wage price agreements of 1948-50 (p. 592). The fourth such agreement was passed on September 26, 1950, precipitating the strike that contemporaries and

many historians have been considering as the final putsch attempt fostered
by the Communists. The Austrian press called it "ten days of red terror."
Even though the Austrian government asked the Western powers for help,
those powers did not want to get involved in the Austrian riots, fearing an
escalation in the middle of the West while fighting Communists halfway
around the world in Korea (North Koreans supported by China and the
Soviet Union).[5] He goes to considerable length to dismiss a "Communist
plan of action" from November 1948 that an author found in the French
military archives as a "clumsy forgery" (*plumpe Fälschung*) (p. 594-599, here
595). Mugrauer insists that all talks of Communist putsch attempts in
Austria are simply Cold War legends.

In a similar fashion the conversation between the Communist lead-
ers Koplenig and Fürnberg with Andrej Zhdanov in Moscow in February
1948, where the Austrian Communists suggest they considered a division
(*Teilung*) of Austria at the end of 1947 orbeginning of 1948. Zhdanov was
critical of the KPÖ and its policies and wanted to hear nothing of a par-
tition of Austria. Mugrauer argues that no evidence exists of such a plan
in the Communist Party Archives (as if such "hot" evidence would not be
purged from party archives). He has no doubt in his mind that the KPÖ
was a patriotic party that pursued a national course towards sovereignty and
"ideas about a division of Austria played at no time a role in the political
practice" of the party. To the contrary, the KPÖ's participation in the Figl
government was based on the calculus of "prohibiting an impending tearing
apart" of Austria. If the partition of the country was ever discussed, argues
Mugrauer defensively, then it was only as one option among others (pp.
606-618).

A note on sources. Mugrauer insists that documents from Moscow
Archives like the conversation with Zhdanov about a "partition of Austria"
require a "full measure of critical approach to sources" (*auch die sowjetischen
Quellen [erfordern] ein hohes Maß an Quellenkritik*) (p. 35), but he obvious-
ly does not practice what he preaches in applying such source critique to
the Communist Party records, the principal source base for his book. Thus,
whatever he quotes from the Communist Central Committee meetings
and the Communist newspaper *Volksstimme*, is reported as the unalloyed
truth (the KPÖ propaganda line was usually announced in such meetings
and in the *Volksstimme*). Mugrauer is the Secretary of the Alfred-Klahr-
Society and, in that function, considers himself lucky to have had unlimit-
ed access to the KPÖ Archives (p. 31). Historians hitherto have not been
permitted to the see the Communist Party's Archives. Mugrauer, however,
who has done his homework well in Austrian archives has not consulted

a single foreign archive. He has mined published Russian and American records. They may be rich, but—particularly for the four-power occupation decade—the archival records of all four occupation powers are crucial in understanding Austrian affairs.[6] Historians such as Wolfgang Mueller and Peter Ruggenthaler, who have prodigiously mined the Moscow Archives and whose published compilation of sources Mugrauer heavily relies on, he often disagrees with. Worse still, Mueller and this author are simply dismissed as "conservative" historians (p. 20).

Endnotes

1 Harald Knoll and Barbara Stelzl-Marx, "Sowjetische Strafjustiz in Österreich: Verhaftungen und Verurteilungen 1945-1955," in *Die Rote Armee in Österreich: Sowjetische Besatzung 1945-1955*, ed. Stefan Karner and Barbara Stelzl-Marx (Graz: Oldenbourg, 2005), 275-321; this essay is now also available in English "Stalin's Judiciary in Austria: Arrests and Convictions during the Occupation," in *The Red Army in Austria*, The Harvard Cold War Studies Book Series, ed. Stefan Karner and Barbara Stelzl-Marx, transl. Alex J. Kay (Lanham: Lexington Books, 2020), 165-92.

2 Minutes of 80th Meeting of the Ministerial Council, Nov. 16, 1947, in *Protokolle des Ministerrates der Zweiten Republik Österreich: Kabinett Leopold Figl I: 20 Dezember 1945 bis 8. November 1949*, vol, 7: *9 September 1947 bis 18. November 1947*, ed. Elisabeth Gmoser, Peter Melichar, and Stefan Samotan (Vienna: Verlag der Österreichischen Akadmie der Wissenschaften, 2016), 1-71 (here 49), on the Schretter case, see also 10-40.

3 Minutes of 93rd Meeting of the Ministerial Council, Dec., 23, 1947, in *Protokolle des Ministerrates der Zweiten Republik Österreich: Kabinett Leopold Figl I: 20 Dezember 1945 bis 8. November 1949*, vol, 8: *25 November 1947 bis 20. Jänner 1948*, ed. Elisabeth Gmoser, Peter Melichar, and Stefan Samotan (Vienna: Verlag der Österreichischen Akadmie der Wissenschaften, 2017), 195-242 (here 223-25); see also the biographical note on Katscher, 499.

4 Eric Hobsbawm, *The Age of Extremes: A History of the World, 1914-1991* (New York: Vintage Books, 1996), 257-86; Ian Kershaw, *The Global Age: Europe 1950-2017* (New York: Penguin Books, 2018), 131-68; Ernst Hanisch, *Der Lange Schatten des Staates: Österreichische Gesellschaftsgeschichte im 20. Jahrhundert* (Vienna: Ueberreuter, 1994), 395-489; Hans Seidel, *Österreichs Wirtschaft und Wirtschaftspolitik nach dem Zweiten Weltkrieg* (Vienna: Manz, 2005); Günter Bischof and Hans Petschar, *The Marshall Plan – Since 1947: The Recovery of Europe & the Reconstruction of Austria* (Vienna: Brandstätter, 2017).

5 Even though Mugrauer proclaims that the "putsch legend" has had somewhat of a comeback among historians recently (pp. 681-704), he ignores recent scholarship from non-Left historians based on Anglo-American sources that speak of "riots" and "disturbances," not more, see Günter Bischof, "'Austria Looks to the West': Kommunistische Putschgefahr, geheime Wiederbewaffnung und Westorientierung am Anfang der fünfziger Jahre," in *Österreich in den Fünfzigern*, ed. Thomas Albrich, Innsbrucker Forschungen zur Zeitgeschichte, vol. 11 (Innsbruck: StudienVerlag, 1995), 191-96; Warren Williams, "Flashpoint Austria: The Communist-Inspired Strike of 1950," *Journal of Cold War Studies* 9, no. 3 (Summer 2007): 115-36.

6 See my review essay "The Post–World War II Allied Occupation of Austria: What Can We Learn about It for Iraq in Successful Nation Building?," *Journal of Austrian-American History* 4, no. 2 (2020): 38-72, https://www.jstor.org/stable/pdf/10.5325/jaustamerhist.4.0038.

Joshua Parker, ed., *Blossoms in Snow: Austrian Refugee Poets in Manhattan* (New Orleans: University of New Orleans Press, 2020)

Stefan Maurer

In his essay "How Much Home Does a Person Need?" Jean Améry answers this question with a simple yet grave premise, stating "all the more, the less of it he can carry with him," for there is "something like a transportable home, or at least an ersatz for home."[1] An experience that is evident and all the more illustrated by Joshua Parker's anthology on Austrian refugee poets in Manhattan published in the Series "Studies in Central European History, Culture, and Literature." Heritage was not the exclusive ersatz for lost *Heimat* in light of political, religious, and ethnic persecution for those Austrians of Jewish descent who were forced to flee the country in the aftermath of the *Anschluss* in 1938. For many of them it was also their way of writing, insofar as trying to regain space and time of their lost homeland if only in letters. Their status of not belonging to this foreign state after escaping the Nazi terror in Europe on a strenuous journey, their arrival, as well as their conditions of living in a strange new world could not be measured by one standard alone but had to take into consideration age, education, prior knowledge of a new language and also previous professions. The means of earning a livelihood could break away in the context of exile.

There are innumerable experiences and perceptions of exile, and the status as a refugee could in fact differ in many significant ways ranging from economical issues to psychological trauma. This becomes all the more apparent as the reader of the volume will encounter close to eighty poems and texts by thirty-five different writers with fates as dissimilar as they are tragic, yet with poems optimistic, ironic and even hopeful now and then. As Parker points out in the preface, his endeavor was to compensate the long-ignored writings of Austrian refugee authors by American readers by also claiming a body of poetry that bears significance for both countries and reflects on the contemporary refugee crisis in Europe. Another additional value of the anthology is that it collects poems that were published in scattered places and therefore have long been out of print. A critical re-reading of this poetry collection will be in order. Parker did a superb job by translating the poems carefully and conscientious to English and giving an implicit thematic structure to the volume although it is arranged via respective writers.

As Günter Bischof notes in his foreword accompanying the volume, families were broken up; the refugees became an anonymous mass and struggled for survival. The short but instructive biograms introducing the writers point this out in many cases. There are tragic interwoven family stories, f. e. with Julius Buchwald whose poem "I Travel Through the World" starts off the volume, and his sister Mimi Grossberg who— alongside her husband Norbert— is also prominently featured in the collection. The parents of these siblings were murdered in Auschwitz.

While the renowned anti-Fascist publicist and psychologist Alfred Farau was forced to make a living as a factory worker, Maria Berl-Lee had the chance to study at Fordham University. Margarete Kollisch worked as a massage therapist. Others such as Fritz Brainin served in the US Army during World War II only recovered his use of German at the age of seventy, having lost it from suffering serious psychological trauma as a prisoner of war. Albert Ehrenstein founded a committee for refugee aid but died in 1941 in a pauper hospice. Poems like Franzi Ascher-Nash's "Summer Night" reads like an inflammation of trauma caused by the persecution of the Nazis, but the US grants a kind of safe haven, because "That hand doesn't reach across the sea."

Gertrude Urzidil, wife of Johannes Urzidil who was a regular at the Café Arco in Prague and friend of Franz Kafka, took US citizenship. For others like Ernst Waldinger, circumstances were easier not only since his wife was a niece of Sigmund Freud, but also had been born in the US. Waldinger, like his counterpart Theodor Kramer, was a great influence on the younger Austrian generation of writers after World War II. Still, he had to work odd jobs before gaining a professorship for German literature at Skidmore College. Sanel Beer would continue working as a physician and began literary production in exile. A literary ambitious politician like Guido Zernatto did not live to see the end of the war. Franz Carl Weiskopf, a native of Prague, remained in New York until 1949 before working as a Czechoslovakian ambassador to Sweden and China.

Other reasons for escaping Europe in the aftermath of World War II and the rise of the Cold War are demonstrated by the likes of Alfred Gong. Born in Czernowitz and friend of Paul Celan, Gong survived a ghetto in Moldavia before hiding in Bucharest and fleeing to New York before the Iron Curtain came down.

Exile never is a closed chapter, but following this current volume leads to a dislocated national memory on both sides of the Atlantic. While the biographies of the writers read differently regarding their respective fates in the US, a number of poems share quite the same motifs and substance.

The inherent structure of the volume is more implicit than explicit, starting with poems accentuating the escape from Europe, arrival in New York and the bureaucratic burden of immigration. Life in New York itself thereby is confronted by disconcerting new environment and social status. While some poems broach the subject of precarious economic circumstances (f. e. "Apartment House Deep in Queens" by Gertrude Urzidil), and the social inequality framing the New World as a "capitalistic fortress and rat-infested slums" (159) like Norbert Grossberg in "Metropolis". Other poems might be more of a religious color, such as Alfred Gong's ironically describing the Big Apple as the new Babel while Max Roden has the countryside of Austria overlap with the deep canyons of New York skyscrapers as a "mountain range of houses" ("*Häusergebirge*"). Some touch on the aspect of acculturation like "Short Monologue in a Foreign Land" by Friedrich Bergammer, together with Ernst Schönwiese, co-founder of literary magazine *Das Silberboot*: "Oh, the accent's gone flat. / First it was strong. Now it wanes, / that false tone, which used to give you away."

The New York subway, a means of transportation unbeknownst to the Viennese refugees, also occupies some poems in a metaphorical and narrative sense, f. e. in "Intermezzo in the New York Subway" by Mimi Grossberg, "A Kid's Question" by Gertrude Urzidil, or "Song of a Minor Employee" by Otto Fürth. Safe havens come into play with 42nd Street Library and the New York Library in the poems by Fritz Brainin and Stefan Zweig.

Some of the refugees returned to Austria. Some only for a short period of time, a few others permanently, as poems by Theodor Kramer, Alfred Schick, Anna Krommer, Eva Kollisch, and Greta Hartwig-Manschinger show. Especially Manschinger's "A man is homesick" dissolves and subsides the borders of her former home country and her new homeland. One was becoming the other. Screenwriter and director Berthold Viertel came back to Vienna in 1948 but had to endure the rising of Cold War tensions and defamation by hard-boiled anti-Communists like Friedrich Torberg.

Parker's anthology is an important work and accomplishes the notable task of conveying the hardships that refugees had and still have to face by connecting the catastrophes of the past to the present.

Endnotes

1 Jean Améry, *At the Mind's Limits: Contemplations by a Survivor on Auschwitz and its Realities*, transl. Sidney Rosenfeld and Stella P. Rosenfeld (Bloomington: Indiana University Press, 1980), 44.

Jens Malte Fischer,
Karl Kraus: Der Widersprecher (Vienna: Zsolnay, 2020)

Peter Berger

Around 1900, Vienna witnessed the rise of Karl Kraus, a talented young columnist who became the most notable polemicist and satirist writing in the German language. *Die Fackel*, a periodical he launched in 1899, survived until Kraus's death in 1936 and, during the 1920s, sold an average ten thousand copies per issue. From December 1911 onward, all its content flowed from the editor's pen. Besides writing for *Die Fackel*, Kraus also performed seven hundred public readings in his lifetime. These were not just of his own literary production, but also of works of Shakespeare, Nestroy, Wedekind, and Offenbach, among others. At the peak of this activity, each performance drew up to two thousand enthusiastic listeners. A significant percentage both of the readers of *Die Fackel* and of the audience of Kraus's lectures belonged to Vienna's educated upper-middle class, and the assimilated Jewish element was strongly represented. Among those who confessed to have been, at least temporarily, under Kraus's magic spell, were names that shine until today: Elias Canetti and his wife Veza, Arnold Schönberg, Ernst Krenek—and, somewhat less so, Sigmund Freud.

Kraus's premature death from cardiac failure at sixty-two came at a time when his celebrity status was on the wane. This was mainly due to the fact that he chose to express his support for the gravedigger of Austrian democracy in 1933, chancellor Engelbert Dollfuß. Upon the advice of Benito Mussolini, Dollfuß and his cabinet not only proceeded to eliminate parliamentary rule in Austria, but also engaged in a crusade against the country's largest political party, the Social Democrats, whose armed wing (the *Schutzbund*) was crushed in a three-day-long bloody civil war in 1934. Kraus obviously accepted Dollfuß' reasoning that Hitler and his clique would be impressed by a show of strength on the part of the Austrian government, and thus forfeit their ambitions to overthrow it by means of violence. With hindsight, this was a nonsensical, or at best naïve, assessment. For Kraus, his idolization of Dollfuß as a heroic fighter against Nazism (and his aversion of Socialist "weakness" clad in radical speech, a reproach he repeatedly voiced in the *Fackel*) resulted in the loss of many formerly faithful followers who were sympathetic towards the Left. Ironically, the murder of Dollfuß by Nazi conspirators preceded Kraus's death by two

years. And not long after Kraus had passed away, the German *Wehrmacht* liquidated Austrian independent statehood.

In the wake of this *Anschluss,* the Nazis, deprived of the opportunity to catch and kill "the Jew" Karl Kraus (despite murdering two of his siblings), allowed his work and personality to fall into near complete oblivion. Nazi hooligans ransacked a Kraus memorial room created by his long-time lawyer Oskar Samek, while Kraus's closest confidants were driven into exile. Via the US and Switzerland, parts of his private archive and other relevant documents which had been saved by Samek and Kraus's secretary, Helene Kann, returned to Vienna after World War II. Together with Heinrich Fischer's new edition of Kraus's complete works, soon joined by a reprint of all volumes of *Die Fackel,* they laid the groundwork for an academic Kraus revival starting in the late 1960s. Two additional factors helped to extend interest in Kraus and his work beyond the strict boundaries of academe. As of the 1980s, culture and politics of the Habsburg Empire's final stages began to fascinate an ever-larger public outside of Austria. Nonfiction bestsellers like Carl E. Schorske's *Fin-de-Siècle Vienna*, William M. Johnston's *The Austrian Mind: an Intellectual and Social History 1848-1938*, and Allan Janik's and Stephen Toulmin's *Wittgenstein's Vienna* bore witness to this trend, as did the 1986 blockbuster exhibition devoted to "Vienna around 1900" at the *Centre Pompidou* in Paris. Another factor was the slow but steady erosion of a tacit agreement among Austrian opinion leaders to avoid controversies over the country's troubled history in the first half of the twentieth century, for fear that they might harm the fragile domestic peace required for postwar economic and political reconstruction. In the first two decades after 1945, obvious Austrian traumas, like the dissolution of the Dual Monarchy and the tragic failure to establish a culture of political compromise during the short-lived First Republic, were scarcely addressed in the arts, education, or popular culture. Instead, sugarcoated travesties of the past, such as the "Sisi"-films starring Romy Schneider as Empress Elizabeth, drew crowds to the movie theaters. In 1964 the conservative Austrian minister of education, Heinrich Drimmel, intervened to prevent the performance of Karl Kraus's satiric World War One stage play *The Last Days of Mankind* by Vienna's *Burgtheater*, since it depicted the Habsburg Court and its generals in an all but favorable light. Fifteen years later, the mood had changed. Actor and cabaret legend Helmut Qualtinger read many of the two hundred and twenty scenes of *The Last Days* in front of enthusiastic audiences, and his recorded version of the complete drama sold in large numbers. The 1970s also saw the return of Karl Kraus to Austrian school instruction. Teachers were encouraged to deal with him

as an uncompromising enemy of trashy journalism and slipshod language, a pacifist, and a man with strong, if not always easily digestible, political convictions. A string of Kraus biographies (by, inter alia, Hans Weigel in Austria, Edward Timms in Great Britain, Charlotte Kohn in France, and Harry Zohn in the United States) offered splendid opportunities to learn about almost every detail of the man's life and work.

Why, then, another weighty tome dedicated to "the greatest and sternest man living in Vienna" (Canetti about Kraus), this time by Jens Malte Fischer, professor emeritus of cultural studies at the University of Munich? With few, if any, hidden facts to be unearthed given the considerable size and depth of the existing literature each new attempt at telling Kraus's story begs for an explanation. Historians are familiar with the argument that every generation is bound to address the past afresh and to find out what it has to say to a world in constant change. In this respect, a new biography of Karl Kraus may indeed have been overdue, since the last major effort, Edward Timms's second volume of *The Apocalyptic Satirist* (2005) has already come of age. When Timms published his book, the people currently known as "millenials" were in their infancy. The challenges awaiting them in the future—man-made climate change, the corrupting effect of the internet and social media, the rise of authoritarian politics—were already on the radar screens but received scant attention. How would a romantic conservative and machine-age critic like Kraus have reacted to the spoliation of nature in the name of technical progress? What would Kraus, whose dominant life interest was purity of the language, have said to the degeneration of vocabulary and syntax prompted by electronic messenger services? Would he, the raging polemicist and outspoken critic of Nazi-barbarianism, remain silent to the phraseology of politicians who stand for "illiberal democracy" and the vilification of refugees and migrants? In a note on the cover flap of *Karl Kraus: Der Widersprecher* we read that, despite his still illustrious name, Kraus's legacy seems to fade from collective memory. Bringing it back to our young generation would thus be a task fitting the biographer. How does Fischer live up to the job, or rather: is he willing to accept it?

In 2005, Sven Hanuschek, a philologist and colleague of Fischer's at the University of Munich, published a highly acclaimed biography of Elias Canetti, the early admirer of Kraus and winner of the Nobel Prize in Literature in 1981. It is hard to imagine Fischer failing to notice a work which in so many ways overlapped with his own Kraus project. Now that both books are on the market, a cursory comparison suffices to detect similarities in structure. In both cases, the narrative follows a chronology defined by the changes in focus of Canetti's and Kraus's literary work. However, when

dealing with their heroes' private lives, our authors walk different paths. For Hanuschek many aspects of Canetti's life story are still shrouded in mystery, something he feels should be mentioned but otherwise left as it is. In contrast, Fischer is keen to illuminate even the remotest niches of Kraus's private existence, sometimes at the risk of sounding chatty (as in more than one digression devoted to the satirist's alleged physical handicaps).

In five chapters Fischer deals with Kraus, the private individual. With Balzac, Proust and the lesser known Egon Friedell, cabaret artist and self-trained historian-philosopher, Kraus shared the habit of working at night and sleeping far into the day, in his own words "to escape life under a sun shining indiscriminately on all citizens irrespective of their merits." In 1912 he rented an apartment near Vienna's famed Hotel Imperial, and resided there until he died. He rarely travelled, apart from occasional excursions to the manors of aristocratic families he befriended. Most notable of these households was the Bohemian castle of Janovice/Janowitz, owned by Sidonie Nádherná de Borutín, one of two women to leave an indelible impression upon him. The other was actress Annie Kalmar, who died of tuberculosis in 1901, being only twenty-four. The park surrounding Janowitz Castle, and the Swiss Engadine valley where Kraus and Nádherná vacationed in 1916 while the Great War was raging, inspired some of Kraus's most touching poems celebrating nature and the idea of "origin" (*Ursprung*), a key concept of his artistic philosophy.

As a merciless polemicist whose vitriolic pen targeted corrupted language and moral duplicity in every walk of life, Kraus made many enemies. Early victims of his ethical furor were writers Hermann Bahr, Hugo von Hofmannsthal, Arthur Schnitzler, and Franz Werfel, some of them originally well-disposed towards "that little man" (Schnitzler about Kraus). Later came his epic battles with art critic Alfred Kerr and Maximilian Harden, whose Berlin based weekly *Die Zukunft* (The Future) had in the beginning served as a paragon for *Die Fackel*. But there was also Karl Kraus, the man with a considerable talent for friendship. Adolf Loos, the architect who abhorred useless ornamentation for the same reasons that caused Kraus to fight against the empty phrase, could count on Kraus's friendly feelings despite his support for the war party in 1914. Another friend enjoying a jester's license with Kraus was the eccentric essayist Peter Altenberg. Kraus delivered a funeral oration for both of these friends. Other men who belonged to the "bubble" surrounding the master were lawyer Oskar Samek, and composer Ernst Krenek. In his memoirs Krenek, who outlived Kraus by fifty-six years, claims to have enjoyed the satirist's benevolent interest but adds that the latter's friendship could be revoked in an instant if one appeared to stray from the path of unconditional loyalty.

Kraus's approach to his ancestral faith and the role of Jews in society has frequently been discussed. For some, he deserves being called an anti-Semite (or even a prime example of the Jewish self-hater as defined by Theodor Lessing). Their reasoning consists of his contempt for the "Jewish jargon" he detected in Austrian "journalese," his choice of Jewish targets for *Die Fackel*'s polemics (such as Moriz Benedikt, editor-in-chief of the liberal daily *Neue Freie Presse*, Alice Schalek, a notorious frontline correspondent in World War I, and Emmerich/Imre Békessy, a Hungarian-born press magnate accused of bribery and blackmail), and his fascination with Otto Weininger, author of a bestselling anti-feminist, anti-Semitic pamphlet "Sex and Character: A Fundamental Inquiry."

Others object, pointing at the many instances where Kraus defended Jews under attack from anti-Semites, chastised the atrocities committed and the lack of culture displayed by Hitler's followers, and insisted not to know a single supposedly Jewish quality that gentiles were incapable of sharing. One of Kraus's most intelligent biographers, Hans Weigel, described the satirist's attitude with a pun: Kraus disliked Jews, but not *the* Jews. He scorned stock jobbers, inflation profiteers, corrupt journalists, and stage directors who in his opinion put spectacle above substance (such as Max Reinhardt), many of them Jewish. But should he have remained silent only to avoid undesired applause from racists?

Weigel's chapter about "Kraus and the Jews" counts eight pages. In Fischer's biography, thirty-five are devoted to the subject. Not that Weigel and Fischer tell different stories, on the contrary. In both their books we are informed about Kraus's view of the Dreyfus-affair, a litmus test for *fin-de-siècle* intellectuals (Kraus refused to join the pro-Dreyfus party and welcomed a contribution to the *Fackel* by Wilhelm Liebknecht who questioned the colonel's innocence). Both books discuss Kraus's conversion from Judaism to the Catholic faith in 1899, and his subsequent disappointment with a church he decided to leave again in 1923. And both Weigel and Fischer, mention a bizarre episode involving Kraus and a certain Jörg Lanz von Liebenfels, known as a source of inspiration for Hitler's hatred of Jews, who praised the satirist for giving "Aryo-Germans" a voice in the struggle for European culture. What Fischer does (and Weigel does not) is to garnish his narrative with plenty of information only marginally related to his prime subject. Thus, we learn about the origins of Austrian anti-Judaism, about the affinity of Mayor Karl Lueger with "*Herr Karl*," the epitome of the backboneless Viennese invented by cabaret authors Merz and Qualtinger. We are reminded of Theodor Mommsen's dictum that anti-Semitism is the attitude of the scum, of Arthur Schnitzler's play *Professor Bernhardi* and of

the "Hilsner-affair," a justice scandal involving a Bohemian Jewish shoe-
maker accused of the ritual murder of a nineteen-year-old Christian girl
and the future President of the Czechoslovak Republic, Tomáš G. Masaryk,
who famously pleaded for Hilsner's innocence. Is there anything wrong
with plenty of flesh on the bone of a personal history? After all, Fischer
was recently awarded the Bavarian Book Prize, impressing the jury with
his skillful handling of historical detail. But opulence as a program has its
pitfalls. It risks being redundant. And it can be no substitute for accuracy,
or else it is embarrassing. A case in point, I am afraid, is Fischer's lengthy
discussion of Austrian politics from 1927 to the *Anschluss* as a backdrop to
his account of the notorious Kraus-Dollfuß-relationship. To be sure, what
Fischer tells us is by-and-large correct. However, his story is littered with
minor mistakes and casual judgments. The bank whose collapse in 1931
brought the Great Depression to Austria was called Credit-Anstalt, not
Credit-Bank. The event that caused Austria's government to ultimately
ban the local Nazi party was a bomb attack against Catholic gymnasts, not
policemen. To claim, as Fischer does, that Dollfuß was "the most radical
opponent of German National Socialism *among all Austrian politicians*"
(which would also include those of the Left) seems grossly exaggerated.
Finally, Fischer's reluctance to recognize Fascist traits of the Dollfuß-
Schuschnigg regime ignores the findings of prominent scholars of Fascism
such as Stanley Payne and Robert Paxton, and of specialists in Austrian
interwar history like Martin Kitchen and Francis Carsten.

By far the largest and most convincing part of Fischer's book follows
the trajectory of Karl Kraus from junior reporter of cultural and social events,
sometimes under the pen name of *Crêpe de chine*, to scourge of all that was
foul in the state of Austria. Fischer portrays the satirist as "a fighter *against*
his times," and quotes a Nietzschean pun (from the essay "About Benefits
and Disadvantages of History for Life"), implying that biographies titled
"XY *and* his time" are unworthy of buying. Fischer's subtitle, "The Objector"
(*Der Widersprecher*) was probably chosen for similar reasons, but it may also
be read as a reference to the many unresolved contradictions in Kraus's
career: a journalist declaring war on the press; a failed actor shining on stage
in one-man performances of Shakespeare; a man reportedly without musical
talent singing Offenbach arias; a friend of aristocrats cheering the downfall
of Habsburg; a Jew who does not shy back from anti-Semitic vocabulary;
a partisan of democracy supporting a chancellor's authoritarian ambitions.
But the most important contradiction in Kraus's biography, one that should
probably leave us forever grateful, was that he could have lived comfort-
ably on the fortune of his father, a paper industry tycoon, but chose to be a

workaholic instead. Countless nights' sleep were sacrificed for nine hundred and twenty-two issues of *Die Fackel* and thirty-one books published during his lifetime, including *The Last Days of Mankind* and four minor works for the stage (but not the powerful anti-Nazi manifesto *Third Walpurgis Night*, which was withheld from print until after 1945 for fear of National Socialist reprisals against Kraus's friends). Thirty-seven years of Austrian social, political, and cultural history are reflected in the sequence of individuals, actions, and conditions drawing Kraus's wrath or ridicule, and sometimes applause. Nothing relevant that happened in Francis Joseph's Empire, or in the two decades following its demise, escaped the attention of the editor of *Die Fackel*, turning him into an indispensable source of information on subjects as diverse as nationalism and ethnical conflict, the role of prostitution in society and criminal law, moral corruption of the *intelligentsia* in wartime, and the susceptibility of politics to manipulation by mass media.

A few final remarks are in place regarding Kraus, the language purist, who frequently wrote about the abuse of German orthography and grammar in everyday life, went into extreme lengths to clear his journal from printing errors, and in 1927 devoted a long essay to the art of the rhyme. Towards the end of his book, Fischer raises the question of why Kraus was so obsessed with sloppy language that he could haul someone before the courts just because that person had omitted a comma when quoting from his work. It has been maintained that Kraus's linguistic rigorism was somehow connected to his Jewish roots, a hypothesis embraced by Berthold Viertel, Walter Benjamin, and (if only temporarily) Gershom Scholem. Fischer deserves praise for refusing to believe such nonsense, his protest sounding very much like Ernst Gombrich's famous rebuttal of the notions of "Jewish art" and "Jewish culture" during a talk held at the Austrian Culture Institute in London (1996). For Gombrich, to label a person's artistic or cultural expressions as Jewish was tantamount to finishing Hitler's business.

Whatever his reasons, Kraus believed in his duty as self-appointed guardian of the temple of language. As a consequence, many who later wrote about him put all their sentences on the gold scale. Sadly enough, the copyeditors of Fischer's publisher, Zsolnay, made too little effort to save their author from avoidable gaffes that would certainly have spurred Kraus into punitive action (like, for instance, a missing "o" in a poem bewailing the death of a dog—"o heart stand still"—in the absence of which the verse meter is ruined). But who cares, modern readers might say? Fischer's biography helps keeping Kraus on our radar, and that, more than anything else, makes it worthy of reading.

Kurt Bauer, *Der Februaraufstand 1934: Fakten und Mythen* (Vienna: Böhlau, 2019)

Tim Kirk

During the course of 1933 and 1934, Austria's governing Christian Social Party (CSP), led by Chancellor Engelbert Dollfuss, staged a prolonged coup d'état, deploying both procedural chicanery to dissolve parliament and armed forces against their opponents. Against a background of economic depression and escalating political tension, the party's electoral support had been eroded by Nazi successes at the polls, which had first engulfed its German Nationalist coalition partners and then the CSP constituency itself. What the government feared most, however, was that this might lead by default to a victory for the Social Democrats, the second largest party. Encouraged by Mussolini, Dollfuss moved to crush the opposition with overwhelming military force. It was not an unusual course of events in the Europe of the 1930s, which saw one parliamentary democracy after another succumb to a right-wing putsch. Post-war political expediency determined that the dictatorship which followed February 1934, whose brutality and criminality had in any case been eclipsed by that of the Nazi regime, be strategically forgotten in order to establish the working relationship between Conservatives and Social Democrats that formed the basis of post-war stability and prosperity. This political consensus collapsed in the 1980s with the Waldheim presidency and the FPÖ's lurch to the radical right under Haider. The founding mythology has only more recently been subject to sustained critical scholarship, and this in turn has prompted a vociferous response, not least from conservative journalists and popular historians. In Austria, as in so many parts of Europe, the myths of the 1930s are the site of proxy battles in present-day politics. It is in this context that Kurt Bauer's history of the February "uprising" must be seen. It is not so much the compact scholarly monograph offering a non-partisan overview that the publisher's marketing blurb would have it – after all there is little new research here. It is instead an extended polemical essay, albeit a very readable one, which makes a number of perceptive points. For between the lines of the post-war consensus, each side clung to its own hagiographies: in the case of the ÖVP, post-war successor of the CSP, this was the "martyrdom" of Dollfuss. For the Social Democrats it was the number of victims of February 1934; and it is the latter of the two that Bauer sets out to dismantle here.

The book falls broadly into five parts: an extended introduction on the politics of the First Republic, a detailed narrative of the events of the conflict in February, an analysis of the victims, followed by more detailed accounts of individual cases, and finally a reckoning with the "myths." In setting the scene, however, Bauer already reheats a few of the myths of the period himself, not least the canard that radical rhetoric of the Social Democrats – despite the party's leading role in suppressing the revolutionary left in the spring of 1919 – posed a threat to Austrian democracy equal to that of the country's thriving and much more menacing Fascisms. He also perpetuates the myth, long laid to rest, that the Social Democrats had supposedly spurned the offer of a coalition from Ignaz Seipel. Rather more problematic, however, especially for an ostensibly non-partisan perspective claiming to debunk myth-making in the interests of objective scholarship, is the approach to historical evidence. One of the principal sources for the central narrative—alongside the conservative press, which is frequently cited—appears to be the magazine Öffentliche *Sicherheit* the in-house journal of the police themselves, published by the interior ministry and containing the "eye-witness" accounts of those who were actively involved in suppressing the opposition. A rather unconvincing case is made (p.82) for the use of police reports as objective evidence on the grounds that inconsistencies between different police perspectives attest a diversity of political views—overlooking the more glaring problem that these are accounts given by active participants in one side of the conflict. The narrative account of the events is followed by an analysis of the victims, and the most striking finding here is that the number of ostensible non-combatants who fell victim to the conflict far exceeded that of the casualties on either side—although, as Bauer points out, it can never be entirely clear how innocent an innocent bystander actually was. The statistical tables, which give a breakdown by place, age and cause of death are supplemented by the presentation of individual cases of—effectively—random murder, stories that help to personalise the horrific events; and at the end of the book there is an alphabetical list of the victims whose identities are known.

The final section sets out to address "myths, legends and open questions." It seems a little superfluous to ask whether the Dollfuss regime itself provoked the conflict (p.110); the evidence is overwhelming. Bauer himself concludes the discussion a few pages later with an account of the chancellor's meeting on 10 February with Rost van Tonningen, then League of Nations envoy in Vienna (and later one of the principal Nazi collaborators during the occupation of the Netherlands), who had returned from an audience with Mussolini with the message that "the chancellor should finally

liquidate the Socialist-Marxist opposition" (p.113). Bauer rightly points out that the the this was not a "civil war," and certainly not comparable with events in Spain, but "uprising" hardly seems an appropriate term either for what was ultimately a rather hopeless act of resistance against overwhelming force. For the rest, this chapter sets out to score some rather contradictory points: the Social Democratic leaders who fled were in dereliction of their duty; those who stayed and fought were guilty of irresponsibly risking lives for a symbolically heroic gesture. Many of these "myths" seem to be men of straw, whose importance is inflated for the purpose of taking them down, and in the end it seems there is little mythology left to demolish or revise.

Jack Bray, *Alone against Hitler: Kurt von Schuschnigg's Fight to Save Austria from the Nazis* (Guilford: Prometheus, 2020)

Tim Corbett

Austria's five-year stint between republicanism and National Socialism from 1933 to 1938, variably called the *Ständestaat* or Austrofascism depending on one's political bent, remains relatively unknown in the English-speaking world. The relationship of Austria's Jewish population to the authoritarian—most scholars, both left and right, today say dictatorial—Dollfuß/Schuschnigg regime that ruled during these years is an especially complicated story that is only just beginning to be explored in Austrian scholarship. *Alone against Hitler* is presented as filling both these lacunae, introducing the history of Austria during this period to an English-language readership while highlighting how Kurt von Schuschnigg "courageously rejected the rising tide of Austrian Nazism, insisting on equal rights and respect for the Jewish minority" (blurb). As one review cited on the blurb puts it, this book tells the story of how "Hitler's WWII onslaught on Europe's democracies started with the *Anschluss*." This misleading appraisal—Austria ceased to be a democracy in 1933, when Schuschnigg's predecessor, Engelbert Dollfuß, staged a coup d'état by abolishing parliament—is characteristic of the entire book, which cannot be accepted as a constructive contribution to our understanding of this era of contemporary Austrian history.

Notably, Jack Bray is not an academic historian and this is not an academic work of historiography, but rather a popular history aimed at a general audience. Yet it is precisely because this work appeals to a broader audience and fills a lacuna in the English-speaking market that an academic review is highly warranted. A glance at the bibliography reveals that this work is based on no original research, but rather a narrow selection of mostly outdated English-language historiography. This includes prejudicial commentaries by contemporary journalists and politicians, whom the author cites throughout as objective moral and historical authorities (Bray claims at the outset that his is not a "subjective commentary," xi). One searches in vain here for any reference to serious scholarship on the Dollfuß/Schuschnigg era from Austria, such as Emmerich Tálos, Florian Wenninger, or Lucile Dreidemy (see bibliography attached). Indeed, the author clearly doesn't speak German, as repeated misrenderings of nomenclature evince. The

English-language works cited here, meanwhile, are selectively quoted to support the author's tendentious mission to exonerate Schuschnigg before history, for example claiming he was "an honest, incorruptible adherent to the rule of law who respected human rights" (xviii), and to misrepresent him as the "protect[or of] Austria's Jewish population" (blurb).

For the sake of brevity, I will focus on the three most problematic aspects of this publication. First, Bray expends many words on mischaracterizing the entire left wing in the interwar period as "communists and radical socialists" (xviii), as "Austro-Marxist revolutionaries" (xxi) who were "angry, intransigent, and volatile" (26), pushing for "Bolshevik-style revolution" orchestrated by the Soviet Union (29), and so on. Bray thus engages in a textbook perpetrator/victim reversal to blame countless thousands for their own persecution under the Dollfuß/Schuschnigg regime. This reveals itself as a tactic, reminiscent of McCarthyist/Trumpian smear campaigns, designed to pave the way for Bray's second tendentious argument: that the Dollfuß/Schuschnigg regime was a measured and appropriate response to the threefold threat of "Nazis, violent communists, and the Great Depression" (8).

While Bray cannot deny that Dollfuß abolished democratic rule, this line of reasoning allows him to cast the ensuing dictatorship as a true representative of "the people's will" (see especially Chapter 6). Dollfuß, the dictator who created internment camps for the political opposition and turned cannons on the civilian population during the February Uprising, is dubiously moralized here as "unfailingly kind and gentle to most people and very approachable" (4–5), a "good person" (12), and most egregiously as "a coalition builder and political peacemaker" (43). According to Bray, the only commentators who saw the regime as a dictatorship were "Social Democrats" (79)—a patent falsehood. A glance at the endnotes reveals a total lack of engagement with the vast field of scholarship discussing the definition and nature of Fascism, while Bray selectively (mis-)quotes a few scholars, such as Tim Kirk and Michael Mann, not to mention a couple of volumes of CAS, to support his contrived conclusion: "Dollfuß was no dictator but, instead, an honest man whose focus was the welfare of Austria"– he was "the polar opposite of Hitler, Mussolini, or Franco" (84).

The third and most contentious issue is Bray's distortion of Jewish history in the context of the Schuschnigg years. Bray, who includes a whole chapter here on what he calls "the Jewish question," repeatedly claims that Schuschnigg "insisted on full equality for the Jews" (e.g. xxi). He falsely claims that Schuschnigg and his ilk displayed "no note of religious intolerance," i.e., antisemitism (14), and that Schuschnigg, whom he characterizes

as "pro-Jewish" (96), enjoyed the full support of Austria's Jews (e.g., 94, 102). He even suggests that Dollfuß was assassinated because of his "message of tolerance ... about Jews" (104) and that Schuschnigg's main concern at Berchtesgarden was to prevent the Nuremberg Laws being introduced into Austria (162, 166–67).

Bray of course does not cite the foundational scholarship of Bruce Pauley on antisemitism in the Dollfuß/Schuschnigg regime, nor the almost 1,200-page volume on the subject edited by Gertrude Enderle-Burcel and Ilse Reiter-Zatloukal in 2018. While he does selectively (mis-)quote the work of Harriet Freidenreich, Steven Beller, John Warren, and Lisa Silverman on Jewish history in interwar Austria, Bray fails to mention that all of these scholars discussed the Dollfuß/Schuschnigg regime's thoroughly antisemitic policies in the public sector or their consensus that the Jewish community, which was purged of Social Democrats in 1934 in what Freidenreich called a "witch-hunt" (Freidenreich 1991:166), supported the regime mostly out of expedience and fear. This is characteristic of the distortions of the entire work.

Bray concludes that it was Schuschnigg's "quiet insistence on equality for Jews in even greater defiance of a monstrous power that could murder him at will for doing so that warranted a tribute few historic figures have earned" (240). On the basis of a vast body of scholarship on Fascism and the Holocaust in Austria that Bray simply ignores, this claim has to be rejected not only as an outright fabrication, but also as an egregious instrumentalization of the Holocaust to exonerate a para-Fascist simply because he "wasn't as bad" as the Nazis. With its innumerable formal, factual, and interpretative errors, this book will not be taken seriously in Austria, where the historical establishment, for all differences of opinion, basically agrees that the Dollfuß/Schuschnigg regime eviscerated the democratic system and paved the way for the societal acceptance of National Socialism. It can only be hoped that Bray's American audience will not buy into this revisionist account and that there will be more serious English-language scholarship on Austrofascism in the future.

Select Bibliography

Beller, Steven. *Vienna and the Jews: 1867–1938: A Cultural History.* Cambridge: Cambridge University Press: 1990.

Bischof, Günter, Anton Pelinka, and Lassner, Alexander, eds. *The Dollfuss/ Schuschnigg Era in Austria: A Reassessment.* Contemporary Austrian Studies Vol. 11. New Brunswick: Transaction, 2003.

Dreidemy, Lucile. *Der Dollfuß-Mythos: Eine Biographie des Posthumen.* Vienna: Böhlau, 2014.

Enderle-Burcel, Gertrude and Ilse Reiter-Zatloukal, eds. *Antisemitismus in Österreich 1933–1938.* Vienna: Böhlau, 2018.

Freidenreich, Harriet. *Jewish Politics in Vienna 1918–1938.* Bloomington: Indiana University Press, 1991.

Kirk, Tim. "Dictatorship, Fascism and the Demise of Austrian Democracy." In *Austrian Studies Today.* Contemporary Austrian Studies 25, edited by Günter Bischof and Ferdinand Karlhofer, 105–25. New Orleans: UNO Press, 2016.

Mann, Michael. *Fascists.* Cambridge: Cambridge University Press, 2004.

Pauley, Bruce. *From Prejudice to Persecution: A History of Austrian Anti-Semitism.* Chapel Hill: University of North Carolina Press, 1991.

Silverman, Lisa. *Becoming Austrians: Jews and Culture between the World Wars.* Oxford: Oxford University Press: 2012.

Tálos, Emmerich. *Das austrofaschistische Herrschaftssystem: Österreich 1933–1938.* Vienna: Lit, 2013.

Warren, John. "'Weiße Strümpfe oder neue Kutten': Cultural Decline in Vienna in the 1930s." In *Interwar Vienna: Culture between Tradition and Modernity,* edited by Deborah Holmes and Lisa Silverman. Rochester: Camden House, 2009.

Wenninger, Florian. *Das Dollfuß-Schuschnigg-Regime 1933–1938: Vermessung eines Forschungsfeldes.* Vienna: Böhlau, 2013.

Stefan Maurer, *Wolfgang Kraus und der österreichische Literaturbetrieb nach 1945* (Vienna: Böhlau, 2020)

Michael Burri

Virtually unavoidable in Austrian literary life while alive, Wolfgang Kraus has not been hotly pursued by scholars since his death in 1998. Like the few other Austrian literary power brokers whose achievements equaled his own—Rudolf Henz, Friedrich Torberg, Hans Weigel—Kraus was always half cultural impresario, half political functionary. And as befitted an Austrian postwar political functionary, Kraus was sharply anti-Communist, even as he imagined himself performing the role of intermediary between East and West. Kraus clung closely to the Austrian state, even as he tried to reconcile his conservative Catholic worldview with his service to that state.

Too successful to be ignored, yet too beset by a fossilized Austrian bonhomie that jokes about Gugelhupf from the podium to succeed in attracting sustained serious scholarly interest, Wolfgang Kraus has finally found his ideal chronicler in Stefan Maurer. His *Wolfgang Kraus und der österreichische Literaturbetrieb nach 1945* skillfully assesses the significance of Kraus for postwar Austrian literature, while delivering a detailed account of the postwar literary sector (*Literaturbetrieb*) in which he flourished. A thorough reworking and expansion of his previous work on the subject, Maurer does not indicate any particular affection for Kraus, and the portrait he presents here is far from serving any hagiographic purpose. Nor does the book present a major rereading of Kraus. But it is both a deeply researched study of the early postwar period and a fascinating account of an individual. A previous generation of scholarship on writers and writing asked "what" is Austrian literature. In this impressive work, Stefan Maurer asks "who" is Austrian literature.

To consider that question, *Wolfgang Kraus und der österreichische Literaturbetrieb nach 1945* follows its biographical introduction of Kraus in chapter one by presenting the theoretical concept of the "literary field" developed by the French sociologist Pierre Bourdieu. Via the concept of literary field, Maurer presents Kraus as occupying the position of "literature broker" (*Literaturvermittler*) within the "field" of an emerging Second Republic literary sector. Kraus was a highly capitalized player on this field, which he shared with other players, including other individuals, the public, publishing houses, other institutions. Chapter two identifies and presents

an overview of these "players," anticipating their in-depth examination that occupies later parts of the book. For his part, Kraus acted according to certain calculations, and he sought to deploy particular strategies. But his own agency constituted just one component of the literary field in which he operated.

Personally, Kraus seems to have viewed himself as a *homme de lettres*— in Bourdieu's typology, an independent figure who is neither an academic worker nor an avant-garde artist. Kraus's occasional nemesis Hans Haider captured that self-image, describing him as a *"selbständiger Beamter,"* a phrase Franz Joseph once used to describe his own vocation. Kraus himself might even have embraced such an honorific, inasmuch as his self-presentation projected an absence of "rough edges," an openness to dialogue, and an Olympian distance from political party affiliation. But of course, the *selbständiger Beamter* Franz Joseph served a supra-state ideal that he himself embodied. What ideal did Kraus serve?

To such a question, *Wolfgang Kraus und der österreichische Literaturbetrieb nach 1945* argues that there is no single response. In consequence, each of the book's chapters presents Kraus operating in relatively distinct professional spaces within the broader postwar Austrian literary sector. Chapter three, for example, examines the *Österreichische Gesellschaft für Literatur* (ÖGL), the institution Kraus helped to establish in 1961 and that he led until 1994. Of the ÖGL impact in the literary sector and importance within the literary field, Maurer writes, "opinions differ." Viktor Suchy called it "an Austrian miracle in the provincial confinement and spiritual desertification of the Second Republic" (82). Otto Basil said he never attended ÖGL events and that "its regular clientele made him vomit" (96).

On the literary field, players did not always hold their tongues. But chapter three also identifies some effects of the ÖGL that made themselves felt no matter what anyone said. In its "invitation- and event-policy" (98–124), for example, Maurer finds a "latent anticommunism" and an appreciation for Catholic perspectives, as well as an intolerance for writers from the Austrian Communist Party, an indifference towards authors who had been aligned with National Socialism, and a selective openness towards a younger generation of Austrian writers. Meanwhile, in its conception of Austrian literature (124–54), the ÖGL generally hewed to the cultural politics of the Austrian People's Party (ÖVP): high culture *affin*, Habsburg curious, suspicious of avant-garde experimentation, and tireless in its declarations of what was "Austrian" about Austrian literature. After 1945, of course, such declarations resonated poorly to the extent that the "Austrian" of "Austrian literature" was linked to the 1930s. For outside Austria it was increasingly

those Austrian authors who had been forced into exile during the 1930s—
Broch, Canetti, Musil, Werfel, Zweig—that were seen as essential to world
literature. Maurer documents how, especially in the early 1960s, Kraus and
the ÖGL succeeded in breaking with the postwar cultural doxa to reinte-
grate Austrian exile writers and exile literature into public consciousness
(155–80). In shorter sub-sections, he also explores the ÖGL and its Youth
Forum, as well as its presentation of writers from socialist countries.

The ÖGL was a creature of the Ministry of Education, which supplied
it with operating subsidies and personnel support, the latter coming notably
from the ministry's Alfred Weikert. The ethical—and legal—consequences
that might have been predicted for someone who acted on behalf of the
ÖGL, consulted for publishing houses, and at the same time served on
literary prize committees, crashed the career of Weikert early on. Kraus, an
editor with Paul Zsolnay-Verlag in the 1950s, avoided Weikert's missteps,
or at least his fate. Indeed, from 1961 onwards, he became increasingly
involved with Austrian publishers, while collecting an impressive num-
ber of seats on literary prize juries. Such activities added to the influence
of Kraus—or, to employ the Bourdieu-inflected language of Maurer, it
increased his "capital" within the literary sector.

Chapter four investigates how Kraus used this capital to influence what
was published, how it was promoted, and where it received recognition.
To be sure, flexibility belonged to his job as a literature broker; nor did his
views always carry the day. Thus, any specific conclusion about the "ideolog-
ical disposition" of Kraus can always be countered with this or that excep-
tion. Still, on such diverse issues as East bloc writers, younger Austrian
authors, and the silences of Austrian literature regarding the Nazi past, as
Maurer shows, Kraus was largely consistent. He favored East bloc writers
who shared his view of Central Europe as a common cultural heritage in
which Austria served as its spiritual home. He struggled to find common
ground with modern trends in Austrian literature, moving between pro
forma acceptance of younger authors (Handke, Jandl, Jelinek) and outright
obstructing them. Meanwhile, like many others of the period, Kraus felt
that with the early postwar works of Ilse Aichinger, Fritz Habeck, Franz
Theodor Csokor, and others, Austrian literature had never failed to remem-
ber its Nazi past.

Kraus reaped the large sum of cultural capital and the bumper crop
of enemies that accrues to someone who spends nearly four decades in
public life. For every Gerd Bacher, the ORF Director who admired Kraus,
there was a Marcel Reich-Ranicki who seethed at the mention of his name.
Between 1970 and 1980, due in part to the early success of the ÖGL, state

support for literature grew quickly, rising from 3.5 to 18.4 million schillings. But this rapid diversification of the literary sector also brought new players and fresh rivals onto the literary field. In response, Kraus increasingly positioned himself as a "cultural manager." Chapter five examines the activities that resulted from this self-positioning. From 1975 to 1981, for example, Kraus kept his position as ÖGL director but also served in the Foreign Ministry as a liaison between the ministry and the Austrian Cultural Institutes abroad. Here, Kraus found yet another career peak, as his conditions of employment granted him authority to directly contact Austrian embassies, cultural institutes, and cultural advisers. His planning for the presentation of Austrian literature at the Europalia 1988 festival in Brussels, by contrast, was a valley, as Kraus proved to be badly out of touch with a domestic cultural context radicalized by the Waldheim affair. In the 1990s, Kraus was particularly proud of his success in establishing a network of "Austrian libraries" situated at research institutes and university libraries worldwide.

Such episodes round the biography of Kraus and mark a few scattered points in the crowded landscape of initiatives undertaken by Austrian foreign cultural diplomacy from the 1970s through the 1990s. And yet in the telling, as Wolfgang Kraus the cultural manager arrives, the context for understanding why Wolfgang Kraus still matters outside Austria departs. After all, the most enduring claim of Kraus to international renown remains his organization of three famous literature congresses held in Vienna from 1965–67. Intended as a kind of cultural summit, where writers from the West and the East bloc would meet to exchange ideas, these roundtable events broke Cold War barriers and greatly elevated the cultural-political profile of Austria. The sustained attention they attracted from media abroad, including North America, is only partial testimony to their significance.

Wolfgang Kraus und der österreichische Literaturbetrieb nach 1945 does consider the Vienna literature congresses in its final chapter, "Wolfgang Kraus's Networks within the Cold War." But here the asynchronous disposition of "the field" as an analytic concept serves neither the achievement of Kraus nor the reality of his career trajectory well. For without the East-West literature congresses of the 1960s, Wolfgang Kraus would not have become the powerful broker of literature Maurer writes about. In 1966, moreover, Kraus published *Der fünfte Stand*, a treatise on intellectuals in the East and the West, and a book that was widely reviewed, translated, and seriously discussed across Europe. Indeed, though it may seem implausible today, in the mid-1960s, Wolfgang Kraus owned a reputation as a major European intellectual. Stefan Maurer has written a definitive account of

his subject and his time, drawing together newspaper clippings, archival materials, private diaries, and other hard-to-access source materials. Of Wolfgang Kraus himself, in the current age of cultural management and a national sovereignty regulated by treaties, agreements, and other structures, Austria will never again see his kind.

List of Authors

Peter Berger is Professor Emeritus of Social and Economic History at the *Wirtchafts-Universität*, the Vienna University of Economics and Business.

Günter Bischof is the Marshall Plan Chair of History and the Director of Center Austria: The Austrian Marshall Plan Center for European Studies, University of New Orleans.

Ingrid Böhler is Head of the Department of Contemporary History, University of Innsbruck.

Evan B. Bukey is Professor Emeritus of History at the University of Arkansas.

Michael Burri teaches on Central Europe in the Film and Media Arts Department at Temple University.

Gary B. Cohen is Professor Emeritus of History at the University of Minnesota, Twin Cities.

Tim Corbett is a freelance historian and translator based in Vienna.

Arno Gisinger is an artist and historian. He teaches fine-art photography in Paris at *Université Lumières*.

Severin Heinisch is a historian and did his PhD on the topic of caricature as a historical source. He was foundation director of the Karikaturmuseum

Krems (museum of caricature, Krems) from 2000–2004 and is shareholder and CEO of the Chapter 4 Group in Vienna (HQ) and Southeastern Europe since 2010.

Georg Hoffmann is a historian and curator at the National Defence Academy Vienna.

Alison Frank Johnson is Professor of History and of Germanic Languages and Literatures and Chair of the Department of Germanic Languages and Literatures at Harvard University.

Tim Kirk is Professor of European History at Newcastle University in the UK.

Martin Kofler is the Director of the Tyrolean Archives of Photographic Documentation and Art (TAP) in Lienz and Brunico.

Ina Markova is a researcher at the Austrian Adult Education Archives (Österreichisches Volkshochschularchiv) as well as a research fellow at the Department of Contemporary History at the Vienna University.

Stefan Maurer is a staff member of the Documentation Centre for Modern Austrian Literature / Literaturhaus Wien.

Lukas Meissel is a PhD candidate at the University of Haifa and currently a Junior Fellow at the Vienna Wiesenthal Institute for Holocaust Studies (VWI).

Laura Morowitz is Professor of Art History in the Department of Visual Arts at Wagner College in New York.

Anton Pelinka served as a Professor of Political Science, University of Innsbruck (1975–2006), and was a Professor of Nationalism Studies and Political Science, Central European University, Budapest (2006–2018).

Hans Petschar is the director of the Picture Archives and Graphics Department of the Austrian National Library.

Michaela Pfundner is deputy director of the Picture Archives and Graphics Department of the Austrian National Library.

Hannes Richter is a researcher at the Austrian Embassy in Washington, DC and Deputy Director of the Austrian Press and Information Service in the United States.

Notburga Siller supports and collaborates with museums, collections and archives in South Tyrol as a civil servant at the Autonomous Province of Bolzano/Bozen.

Oswald Überegger is the Director of the Competence Centre for Regional History of the Free University of Bozen-Bolzano.

Markus Wurzer is a historian and postdoctoral researcher at the Max Planck Institute for Social Anthropology in Halle/Saale.

Contemporary Austrian Studies
Günter Bischof, Anton Pelinka/Fritz Plasser/Ferdinand Karlhofer, Editors

Volume 1 (1992)
Austria in the New Europe

Volume 2 (1993)
The Kreisky Era in Austria
Oliver Rathkolb, Guest Editor

Volume 3 (1994)
Austria in the Nineteen Fifties
Rolf Steininger, Guest Editor

Volume 4 (1995)
Austro-Corporatism: Past—Present—Future

Volume 5 (1996)
Austrian Historical Memory & National Identity

Volume 6 (1997)
Women in Austria
Erika Thurner, Guest Editor

Volume 7 (1998)
The Vranitzky Era in Austria
Ferdinand Karlhofer, Guest Editor

Volume 8 (1999)
The Marshall Plan in Austria
Dieter Stiefel, Guest Editor

Volume 9 (2000)
Neutrality in Austria
Ruth Wodak, Guest Editor

Volume 10 (2001)
Austria and the EU
Michael Gehler, Guest Editor

Volume 11 (2002)
The Dollfuss/Schuschnigg Era in Austria: A Reassessment
Alexander Lassner, Guest Editor

Volume 12 (2003)
The Americanization/Westernization of Austria

Volume 13 (2004)
Religion in Austria
Hermann Denz, Guest Editor

Volume 14 (2005)
Austrian Foreign Policy in Historical Perspective
Michael Gehler, Guest Editor

Volume 15 (2006)
Sexuality in Austria
Dagmar Herzog, Guest Editor

Volume 16 (2007)
The Changing Austrian Voter

Volume 17 (2008)
New Perspectives on Austrians and World War II
Barbara Stelzl-Marx, Guest Editor

Volume 18 (2009)
The Schüssel Era in Austria

Volume 19 (2010)
From Empire to Republic: Post-World War I Austria

Volume 20 (2011)
Global Austria: Austria's Place in Europe and the World
Alexander Smith, Guest Editor

Volume 21 (2012)
Austrian Lives
Eva Maltschnig, Guest Editor

Volume 22 (2013)
Austria's International Position after the End of the Cold War

Volume 23 (2014)
1914: Austria-Hungary, the Origins, and the First Year of World War 1
Samuel R. Williamson, Jr., Guest Editor

Volume 24 (2015)
Austrian Federalism in Comparative Perspective

Volume 25 (2016)
Austrian Studies Today

Volume 26 (2017)
Migration in Austria
Dirk Rupnow, Guest Editor

Volume 27 (2018)
Austrian Environmental History
Patrick Kupper, Guest Editor

Volume 28 (2019)
Democracy in Austria
David M. Wineroither, Guest Editor

Volume 29 (2020)
Myths in Austrian History
Christian Karner, Guest Editor